RARELY SEEN

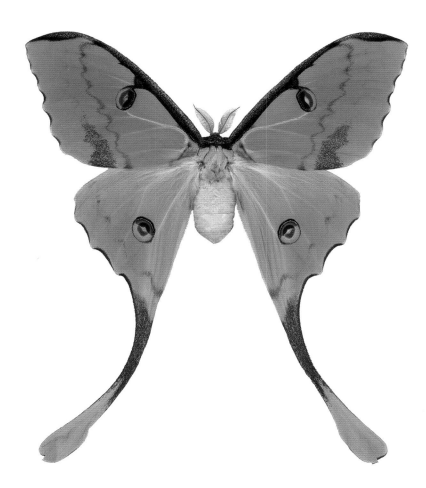

AFRICAN MOON MOTH
These silk moths *(Bombyx mandarina)* live for only about a week, just long enough to find a mate. *(Joseph Scheer)*

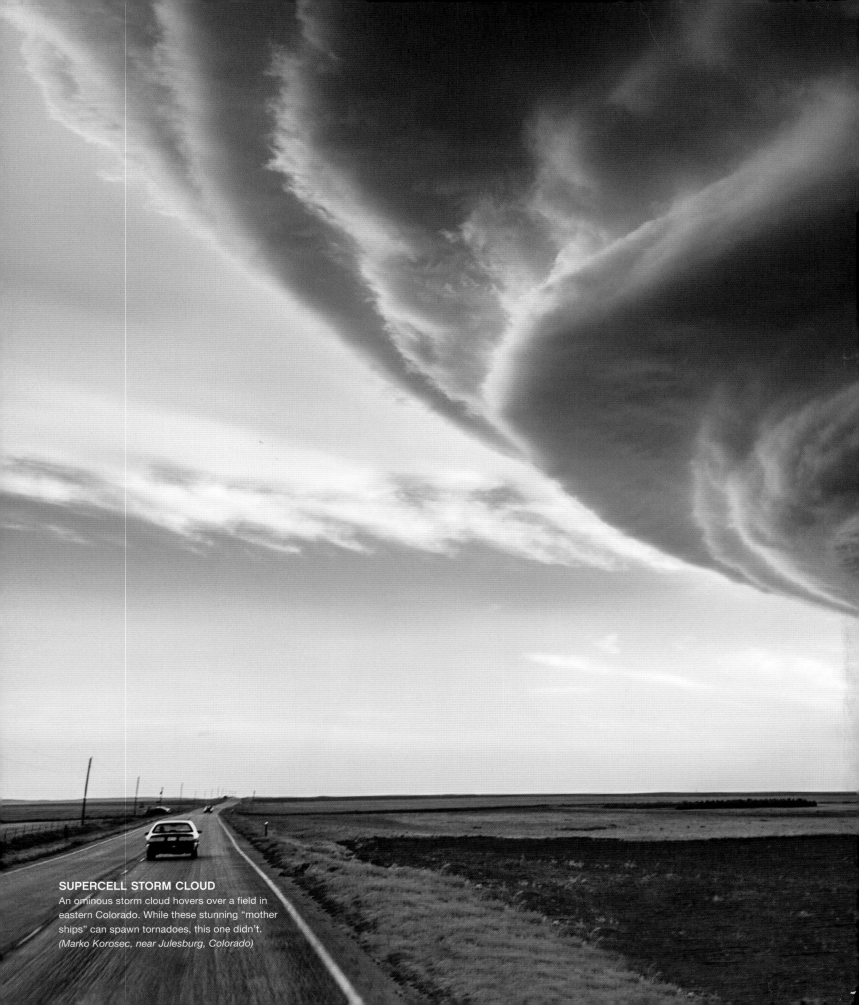

SUPERCELL STORM CLOUD
An ominous storm cloud hovers over a field in eastern Colorado. While these stunning "mother ships" can spawn tornadoes, this one didn't. (Marko Korosec, near Julesburg, Colorado)

RARELY SEEN

PHOTOGRAPHS OF THE EXTRAORDINARY

SUSAN TYLER HITCHCOCK

Foreword by
STEPHEN ALVAREZ

NATIONAL GEOGRAPHIC
WASHINGTON, D.C.

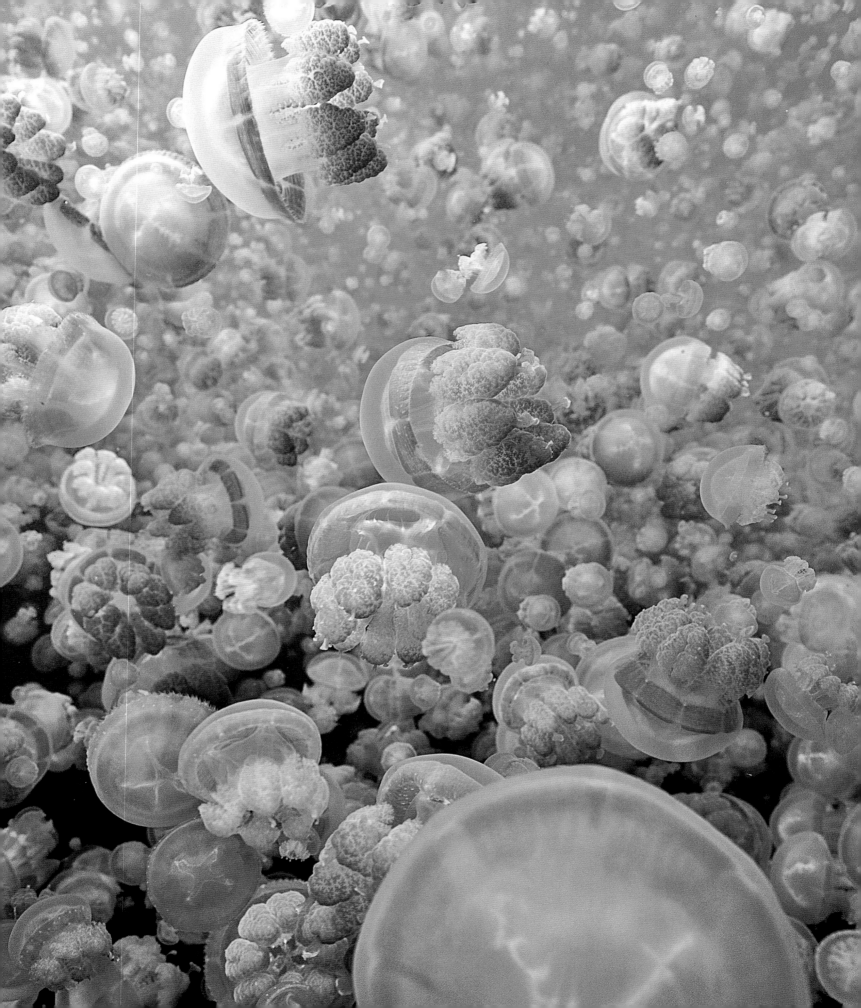

CONTENTS

OPPOSITE: **JELLYFISH LAKE**
Jellyfish pulse in a saltwater lake off the coast of the Pacific island of Palau. Because they lack access to the ocean, millions of golden jellyfish migrate across the lake daily, following the trajectory of the sun. *(Nadia Aly, Palau)*

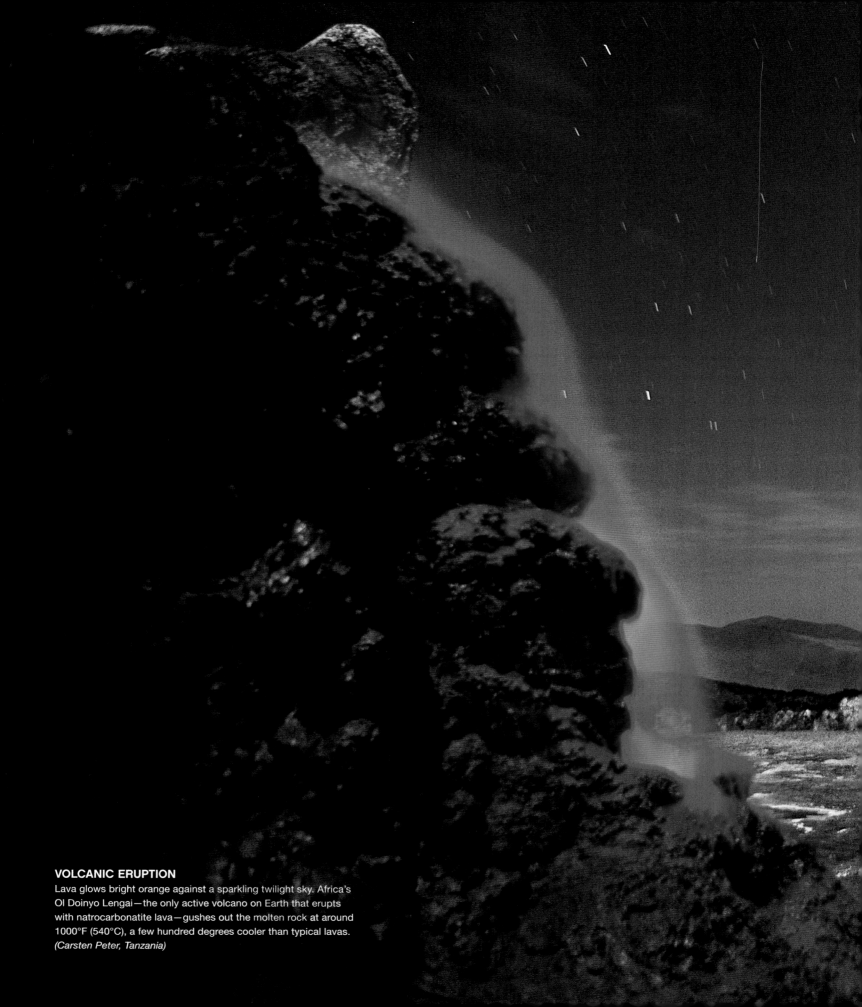

VOLCANIC ERUPTION

Lava glows bright orange against a sparkling twilight sky. Africa's
Ol Doinyo Lengai—the only active volcano on Earth that erupts
with natrocarbonatite lava—gushes out the molten rock at around
1000°F (540°C), a few hundred degrees cooler than typical lavas.
(Carsten Peter, Tanzania)

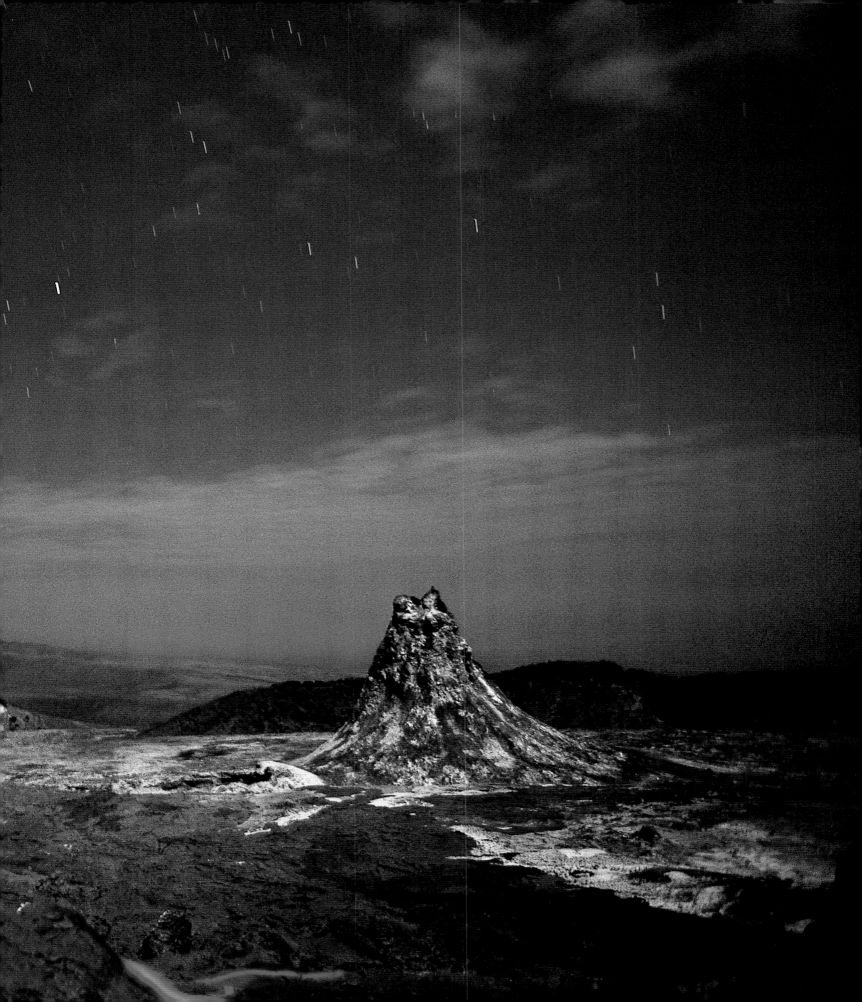

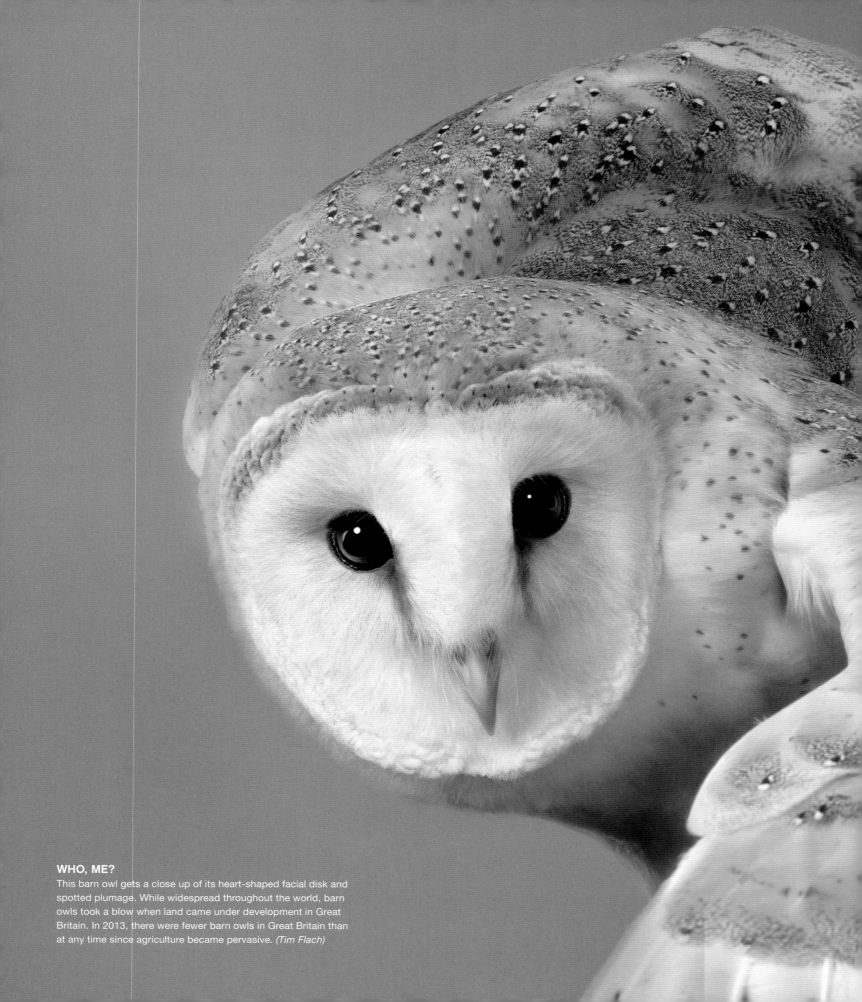

WHO, ME?
This barn owl gets a close up of its heart-shaped facial disk and spotted plumage. While widespread throughout the world, barn owls took a blow when land came under development in Great Britain. In 2013, there were fewer barn owls in Great Britain than at any time since agriculture became pervasive. *(Tim Flach)*

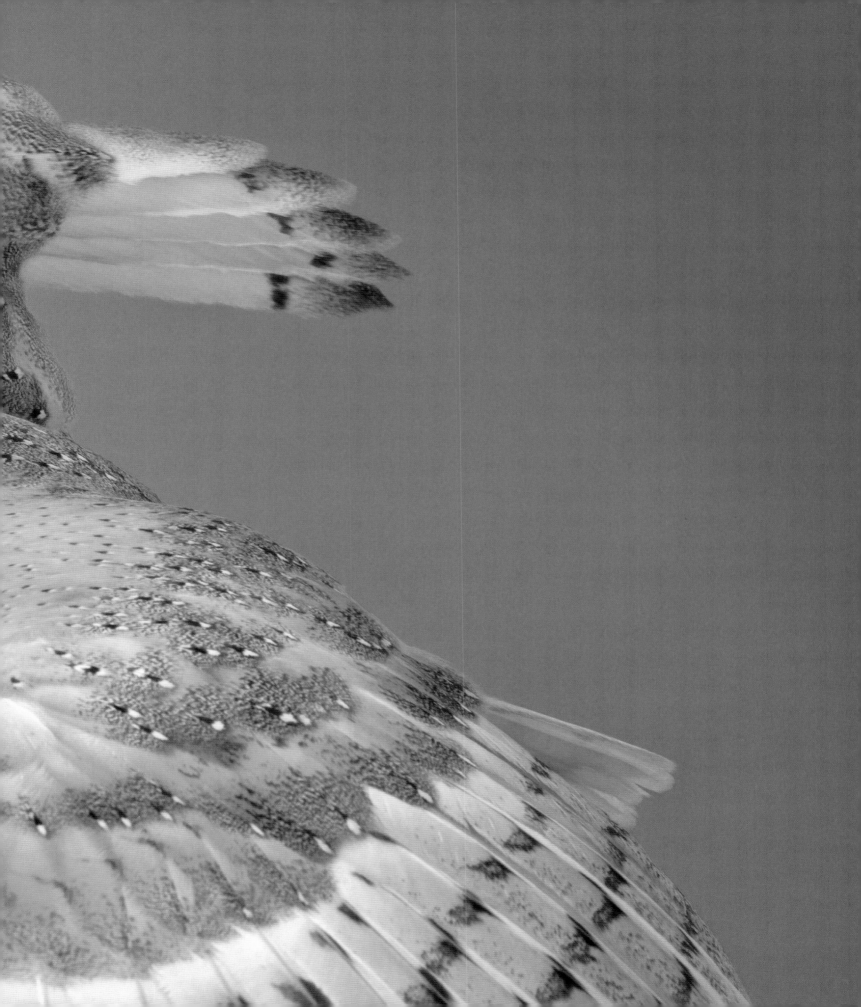

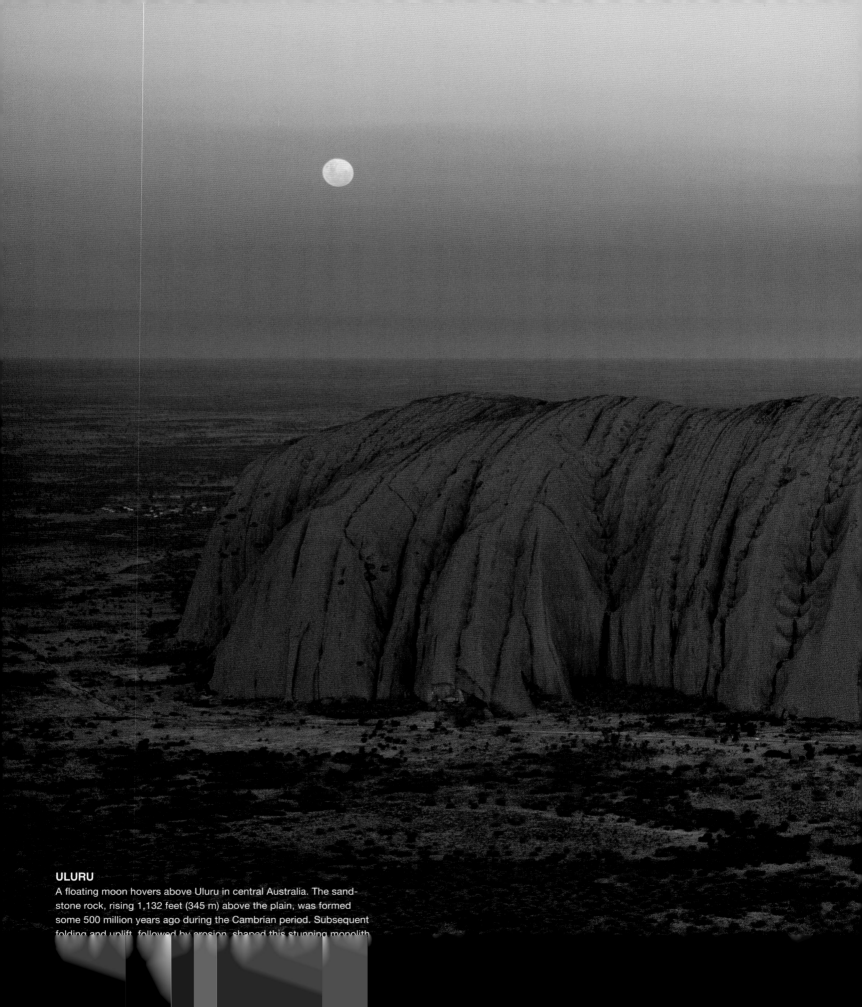

ULURU

A floating moon hovers above Uluru in central Australia. The sand-
stone rock, rising 1,132 feet (345 m) above the plain, was formed
some 500 million years ago during the Cambrian period. Subsequent
folding and uplift, followed by erosion, shaped this stunning monolith.

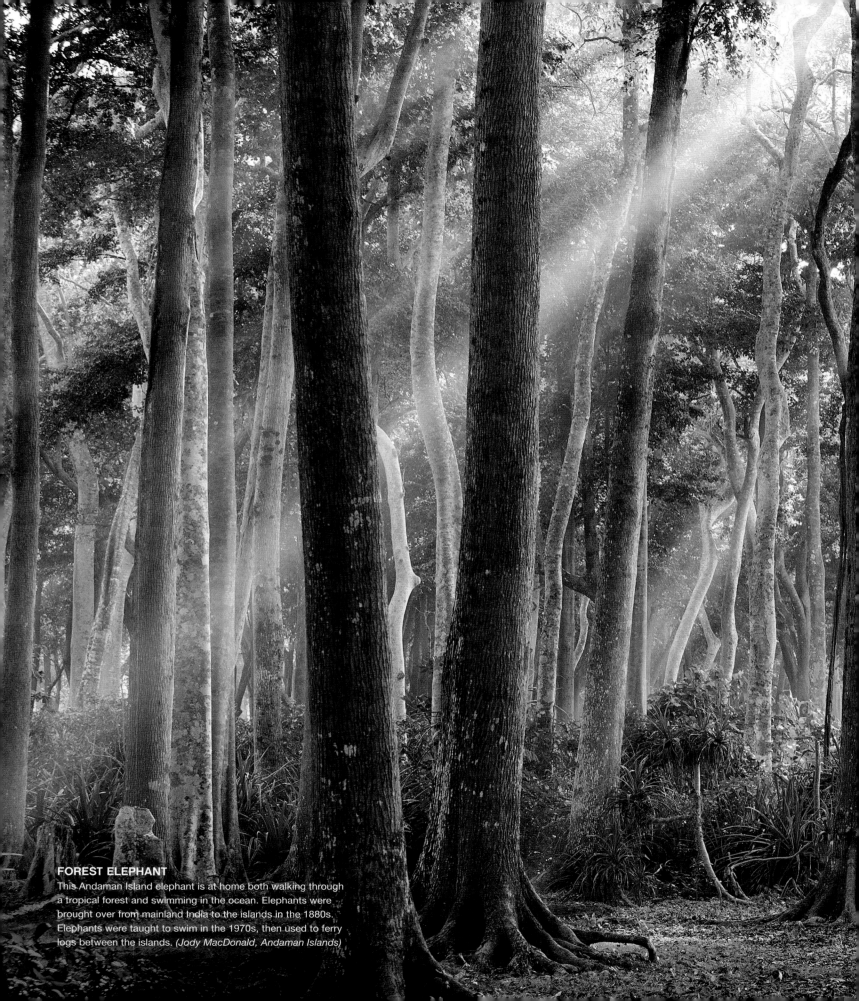

FOREST ELEPHANT
This Andaman Island elephant is at home both walking through a tropical forest and swimming in the ocean. Elephants were brought over from mainland India to the islands in the 1880s. Elephants were taught to swim in the 1970s, then used to ferry logs between the islands. *(Jody MacDonald, Andaman Islands)*

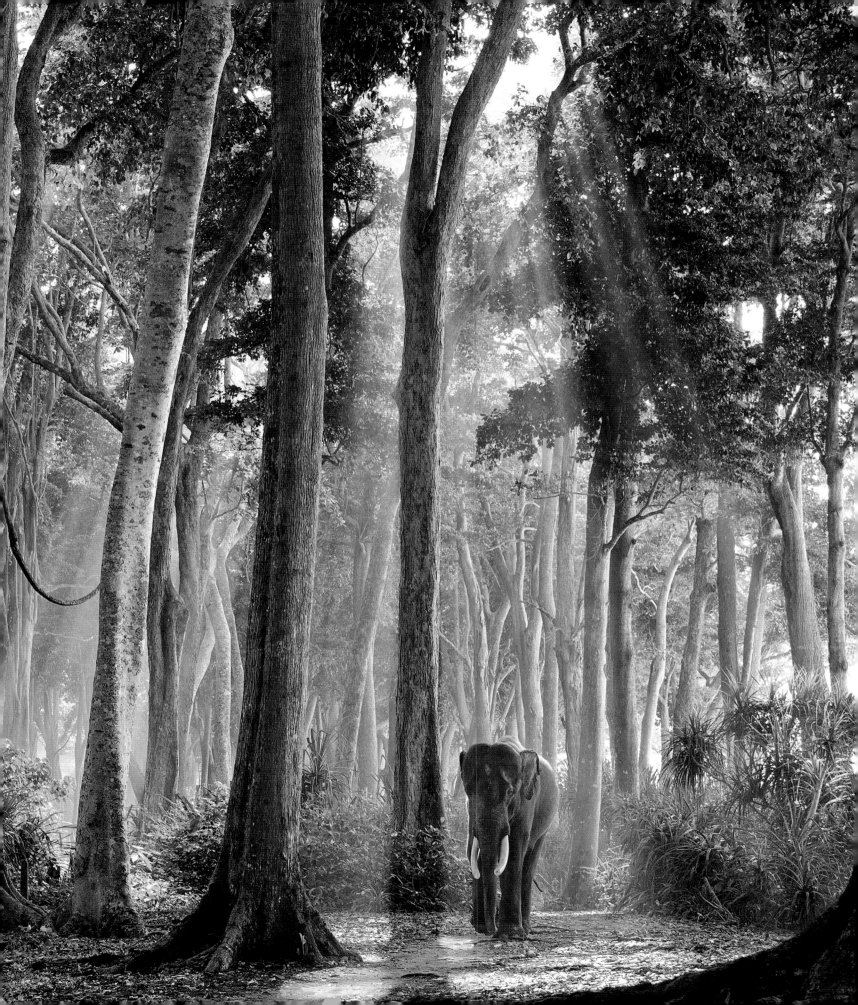

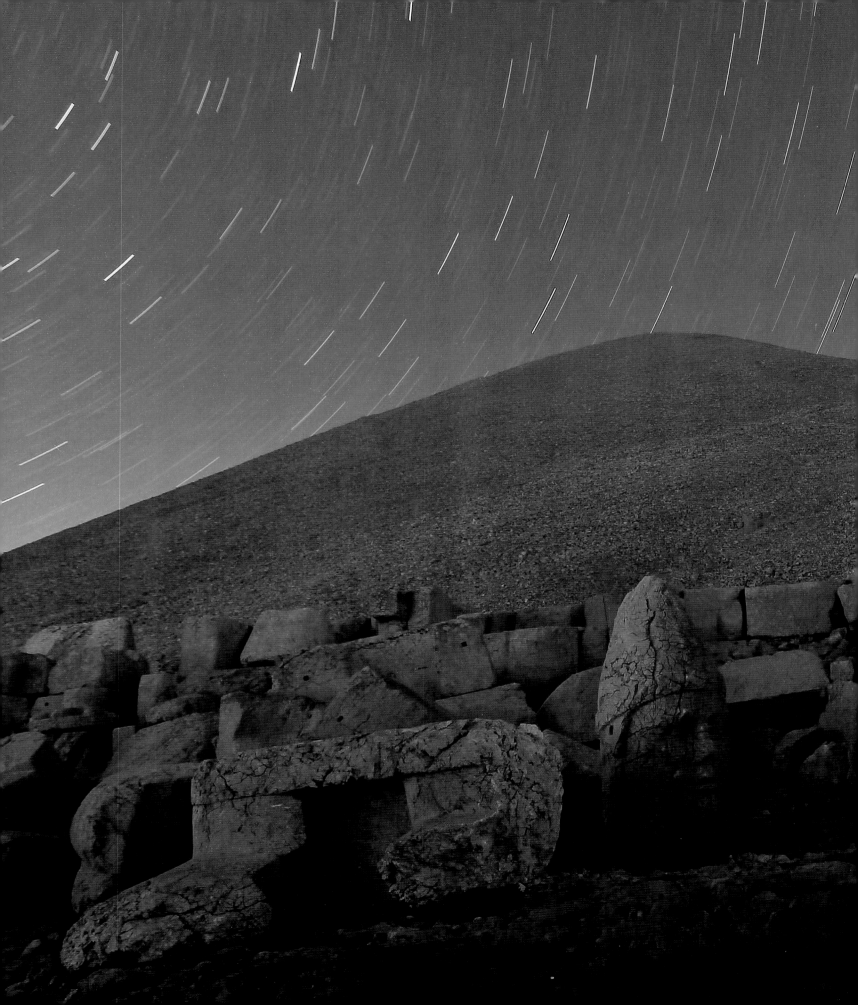

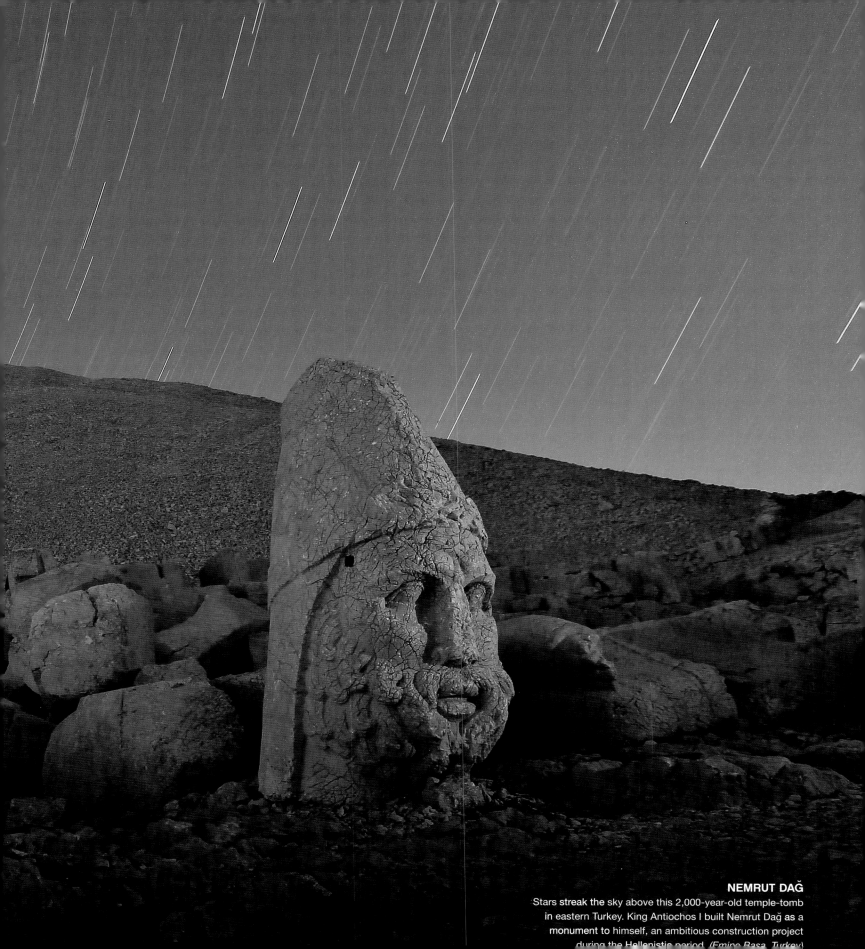

NEMRUT DAĞ
Stars streak the sky above this 2,000-year-old temple-tomb in eastern Turkey. King Antiochos I built Nemrut Dağ as a monument to himself, an ambitious construction project during the Hellenistic period. *(Emine Basa, Turkey)*

FOREWORD

How often do you see something truly new? Get to be the first person to lay eyes on a place or an event? In my career as a National Geographic photographer, I've been lucky enough to do both.

In 2006 I helped organize a caving expedition to the interior of New Britain, an island off the coast of New Guinea in the South Pacific. Though difficult to reach, it contains some of the most dramatic caves on the planet. We set out to explore the underground world of the island for three months. The place was astounding. After a month in the field, one team member came back to base camp reporting that he had discovered a four-acre underground lake with 120-foot ceilings and a thundering 30-foot waterfall. Its seclusion and the arduous journey to get there told us that no human had ever before set foot in it.

We quickly organized a return visit. The trip to Myo Lake (as it would later be named) involved a long hike through dense jungle, a daunting five hours along a terrifying crumbling canyon passage, and an hour-long swim up the underground Ora River. The farther into the cave we ventured, the more incredible it became—and the more intimidating. As the hours stretched on I was acutely aware of how isolated we were. But the place itself: Amazing. Awe-inspiring. Unbelievable!

Caves are absolutely dark; there's no light in them at all. This one was so huge we couldn't see the whole thing. Our headlamps were small pools of light in the blackness. The ceiling and far walls receded into the gloom beyond the reach of our lights. We only knew they were there because our laser rangefinder told us so.

The only way to "see" the place for the first time was to make a picture of it. I placed five people holding powerful flashes around the room. The flashes emit lots of light, but too quickly for the eye to register. Only when we made the photo could we see the cave for the

first time—displayed on my camera screen. On it, the green of the lake and the golden color of the walls came alive. The chamber was not only enormous, it was beautiful!

As our first session ended, I was left with a sense of responsibility. More people have walked on the surface of the moon than will ever be in that chamber. So it is up to me, the photographer, to carry the experience and share it with the rest of the world.

Since the invention of the camera, this has been the photographer's role: To make the unknown known. In the late 1800s, photographers making geographic surveys of the American West brought its wonders back to a gob-smacked audience. The images offered proof that landscapes beyond the imagination were real. Photographs of the Grand Canyon from John Wesley Powell's Colorado River expeditions defined the American West as a place of vast potential. William Henry Jackson captured Yellowstone's fantastic array of geysers for the first time. His pictures helped establish the first national park. Photographers fuel exploration and preservation. It is a role we have embraced with open arms at National Geographic.

Photographers thrive on pushing the boundaries of their art. We want to know both where a camera can go and what it can see. Some situations are too dangerous to witness in person. Very few people want to be close enough to a volcano to see blue lava erupt—but a photograph allows us all to experience it. Photography also reveals hidden wonders. The instant lightning strikes is too fleeting; the glowing trails left by fireflies in the woods, too faint for our eyes. But photographs illuminate both.

Last year I had the unbelievable privilege of photographing the Paleolithic art in the Chauvet-Pont-d'Arc Cave in southeastern France. The paintings are 36,000 years old but

look like they were painted yesterday. For preservation, the cave is completely closed to the public. Its ancient paintings are too fragile to risk general access. In photographing those paintings I not only saw something few others can—but my images will also be the conduit to how the rest of the world will view them.

Being in that position—whether it is capturing ancient art in France, a cave in New Britain, or the monarch butterfly migration in Mexico—is a huge privilege. As a photographer, that is what you are after: to bring the world something new, something incredible. I'm honored to bring the world the kinds of images that are in this book, moments that are rarely seen but captured here as the result of a perfectly timed, impulse shot—or of weeks, months, even years of preparation. Here are places, objects, phenomena, life, and moments from the cameras of artists and explorers. Here is a new way to see the world.

–Stephen Alvarez

MAGENI CAVE

A flashbulb illuminates the cavernous Mageni Cave on New Britain Island. It took days of travel for the team to reach the cave and then hours more to trek inside of it to arrive at this subterranean wonder. Surrounded by darkness, the team wouldn't know the full extent of the caves until they saw the images. The cave has been seen by fewer people than have walked on the moon. (Stephen Alvarez, Papua New Guinea)

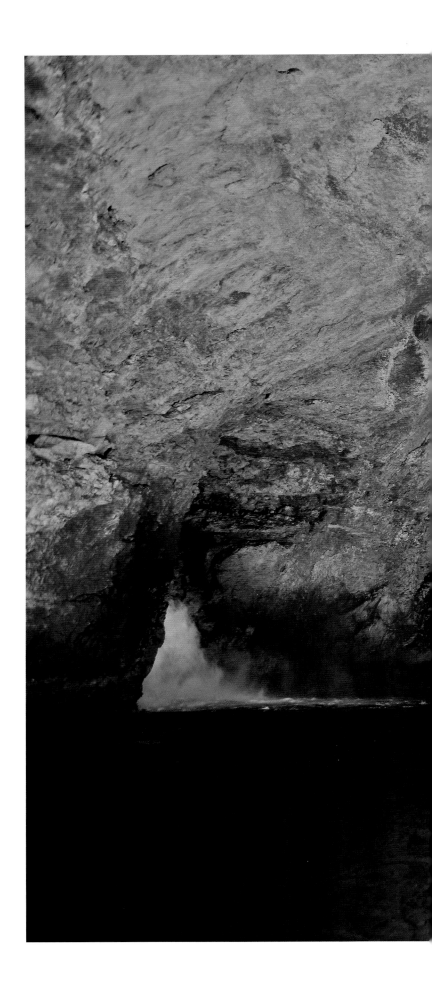

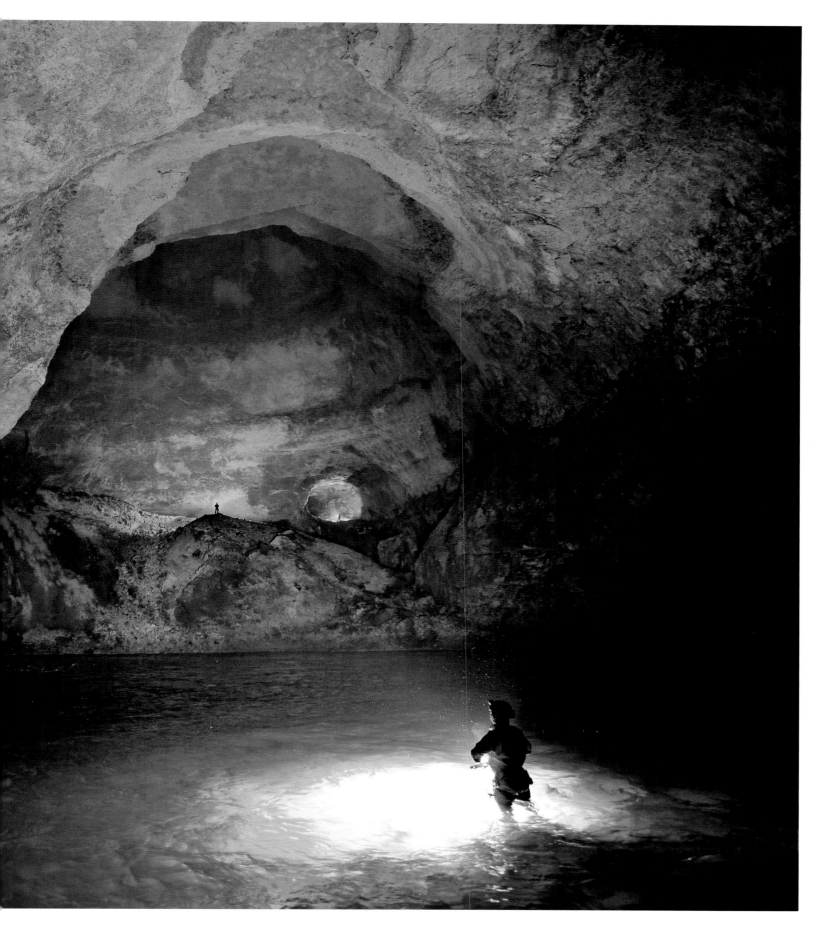

PHENOMENA

IN THE GLOW
Bioluminescence gives a blue scalloped edge to the water at Jervis Bay, Australia. The watery, electric blue veil is caused by a chemical reaction of millions of dinoflagellates, which make the water shine.
(Joanne Paquette, Australia)

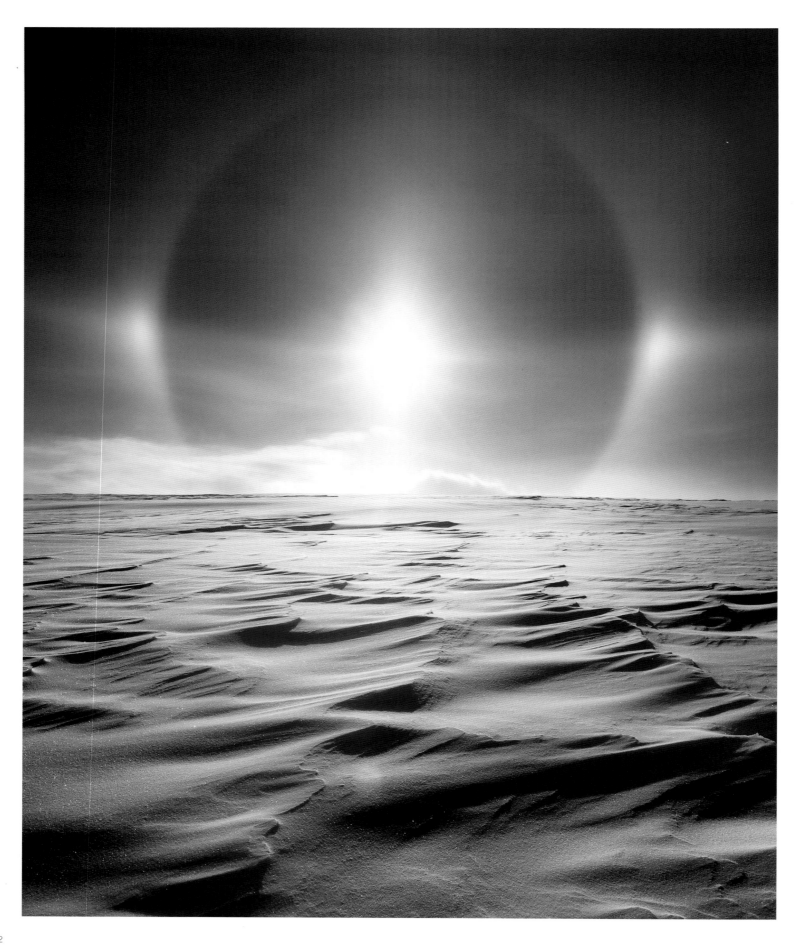

PHENOMENA

If a tree falls in the woods, does it make a sound if no one is there to hear it? Photography has an answer for that age-old question. In fact, extraordinary events happen in the natural world every day, whether or not anyone is watching. But once in a while, a photographer is there to capture it. The results are amazing.

The forces of nature pay no heed to our level of participation. Light, wind, water, rock, quake: These titanic players act upon a stage that is the universe itself, with or without human attention, let alone human intervention.

To some of these phenomena we have assigned names appropriately curious and delightful: haboob, murmuration, axolotl—all rarely seen, yet pictured on the pages that follow. But for others we have found no name at all, and so to denote them we turn to metaphor: fairy circle, deathstalker, chocolate hills, sailing rocks.

The spots on a ladybug, the teeth of a shark, the petals of a daisy, a snow-flake's shape: We see, we count, we measure, we collect, we analyze and cata-log. We think we understand, but really, our words and numbers only begin to tell the story.

Best just to marvel.

OPPOSITE: **RING AROUND THE SUN**
Sun dogs and an ice halo construct a scene of fleeting beauty above frozen waves of snow in the Grand Tetons, Wyoming.
Ice crystals in the upper atmosphere create these stunning optics. The crystals refract and reflect light,
creating sun dogs, which flank the central sun, and ice halos, which are circles around the sun. *(Chip Phillips, Wyoming)*

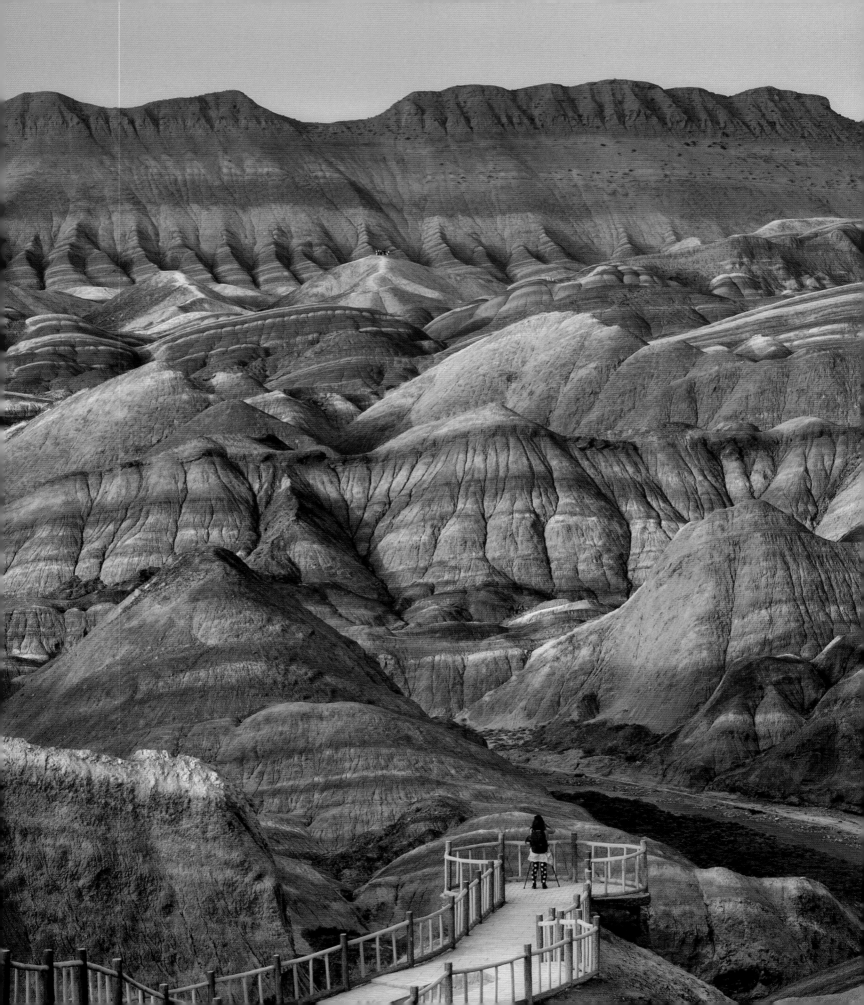

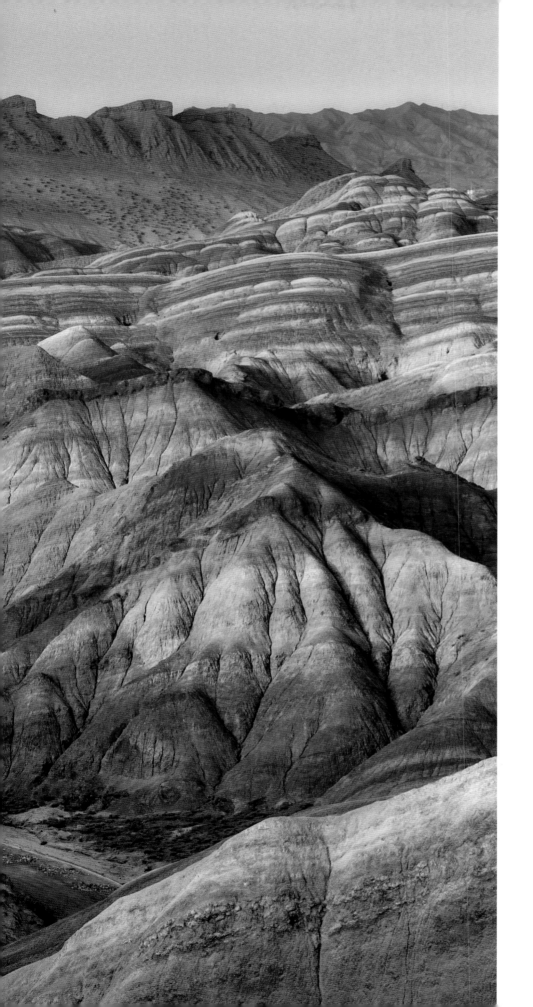

NATURE'S LAYER CAKE

Striking red sandstone combines with multihued mineral deposits to form a colorful layer cake in Zhangye Danxia Landform Geological Park. Uplift, weathering, and erosion shaped the land, while moving tectonic plates buckled the rock. *(Liu ChengCheng, Gansu Province, China)*

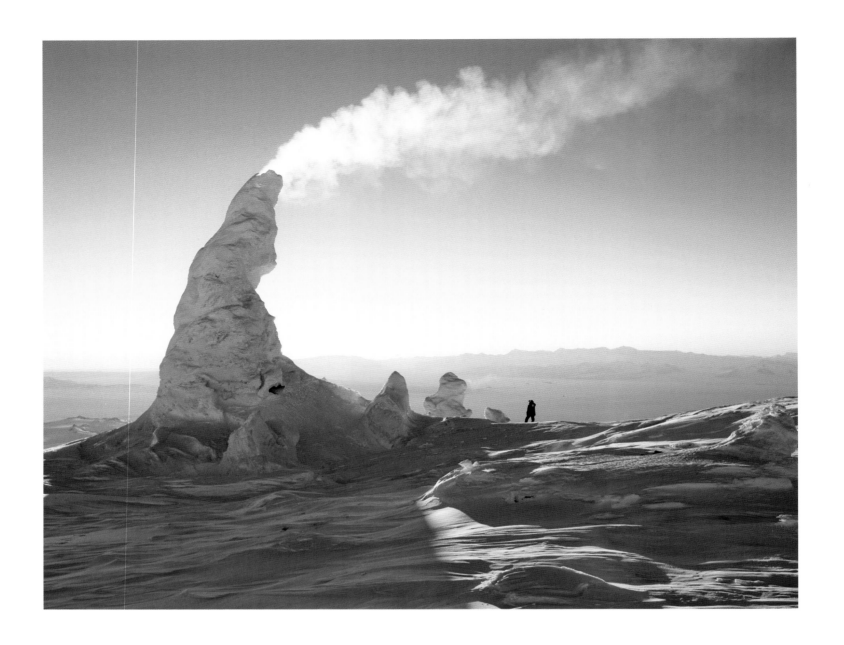

ICE FUMAROLE
An ice tower dwarfs a climber as it belches gas and smoke on the flanks of Antarctica's Mount Erebus. As heat carves out a cave on the volcano's slope, escaping steam immediately freezes in the air, building these knobby towers. *(George Steinmetz, Antarctica)*

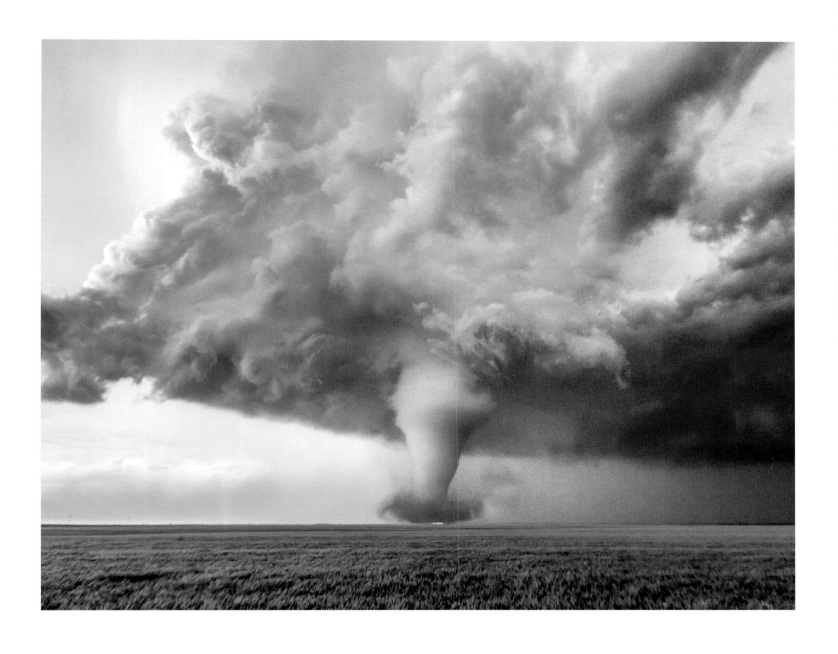

TORNADO TOUCHDOWN

An EF4, the second strongest form of tornado, touches down in central Kansas. Traveling 7 miles (11.2 km) with three-second wind gusts topping 166 miles an hour (267 km/h) once it hit the ground, this twister luckily brought only menacing beauty to the wide-open plains. *(Lorraine Mahoney, Kansas)*

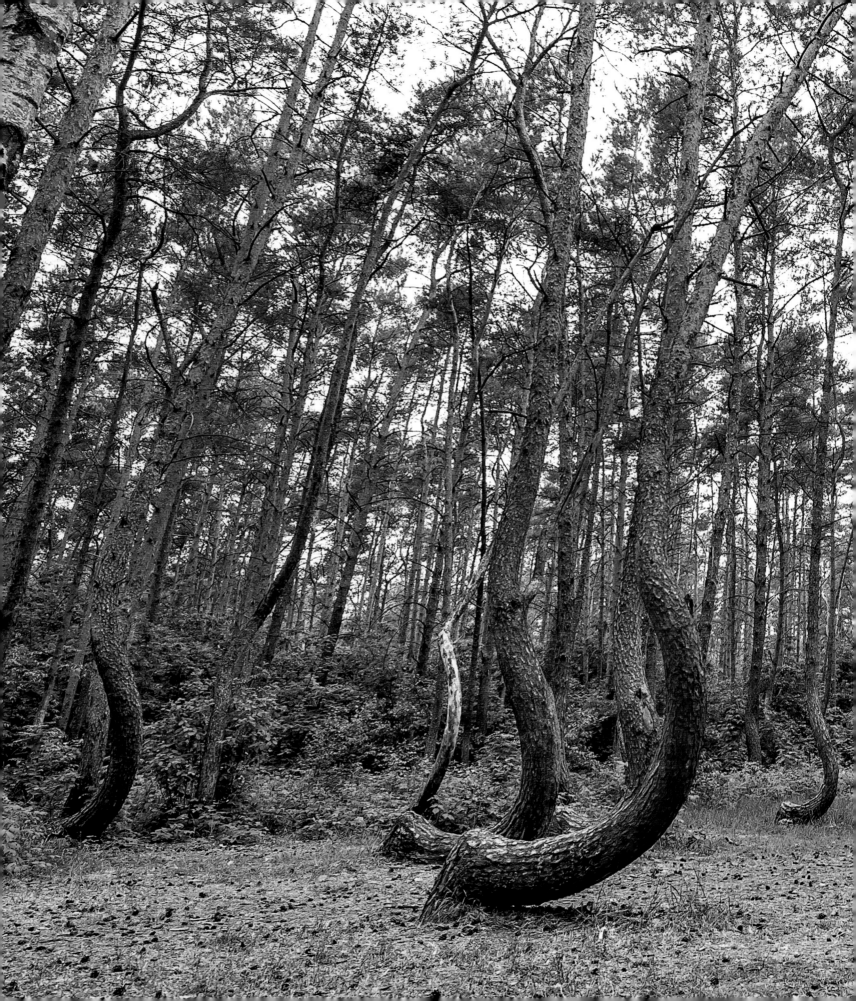

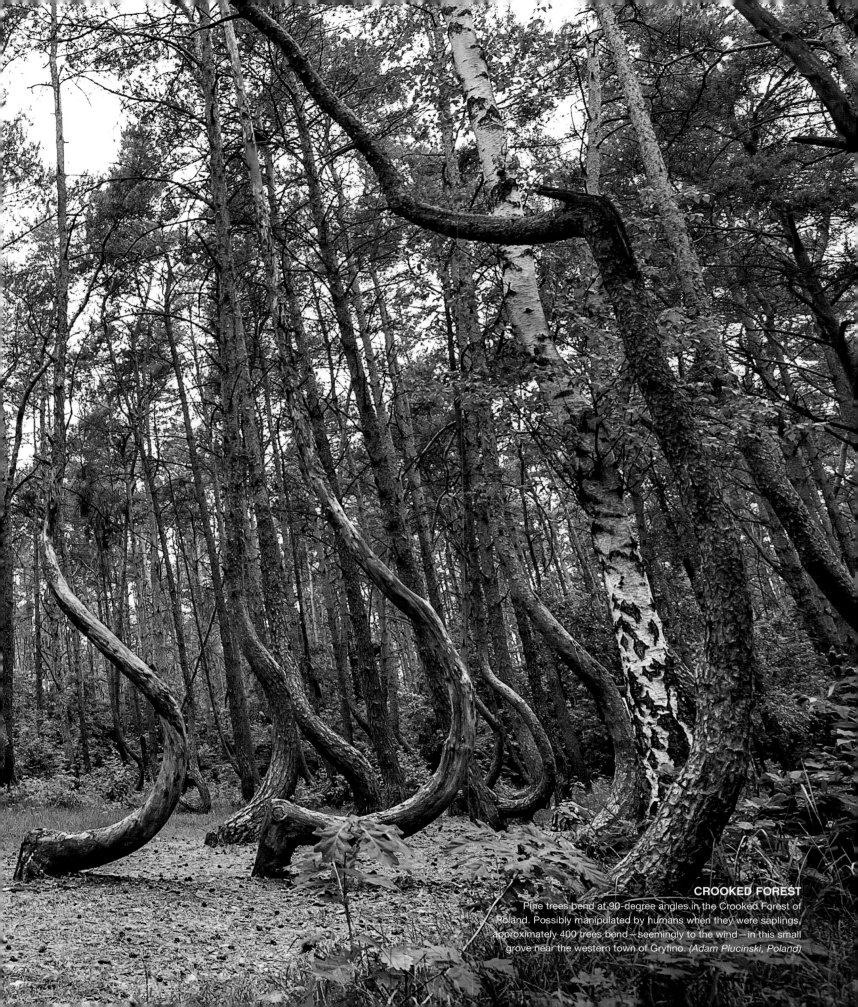

CROOKED FOREST
Pine trees bend at 90-degree angles in the Crooked Forest of Poland. Possibly manipulated by humans when they were saplings, approximately 400 trees bend—seemingly to the wind—in this small grove near the western town of Gryfino. *(Adam Plucinski, Poland)*

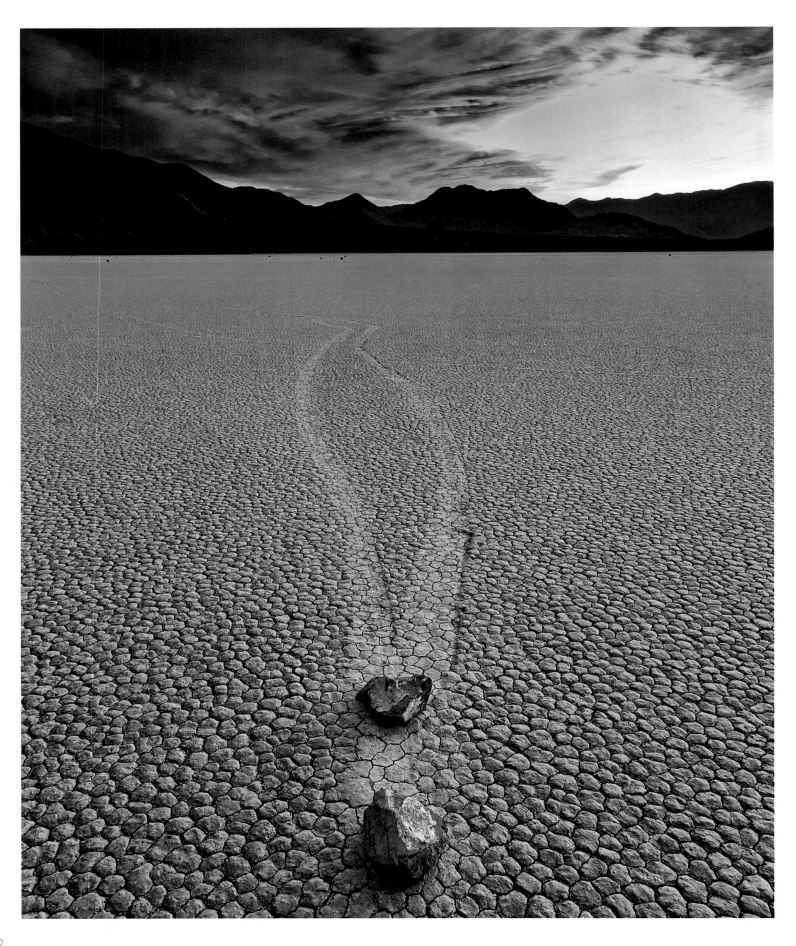

"In a remote part of Death Valley National Park, the Racetrack is the only place I know of where you can see the trails of boulders that have moved across the playa. It takes a special blend of wet, cold, and a gale for this to occur. Sadly, though, this pair is no more. I returned two years later and discovered that someone had stolen these stones and others. Take only photos. Leave only footprints."

ERIK HARRISON

OPPOSITE: **SAILING STONES**
Sailing stones leave trails in the cracked mud of Racetrack Playa in Death Valley National Park. Moved by small pools of water formed by ice melted in the morning sun, these "sailing" stones have confounded viewers for years. *(Erik Harrison, Death Valley, California)*

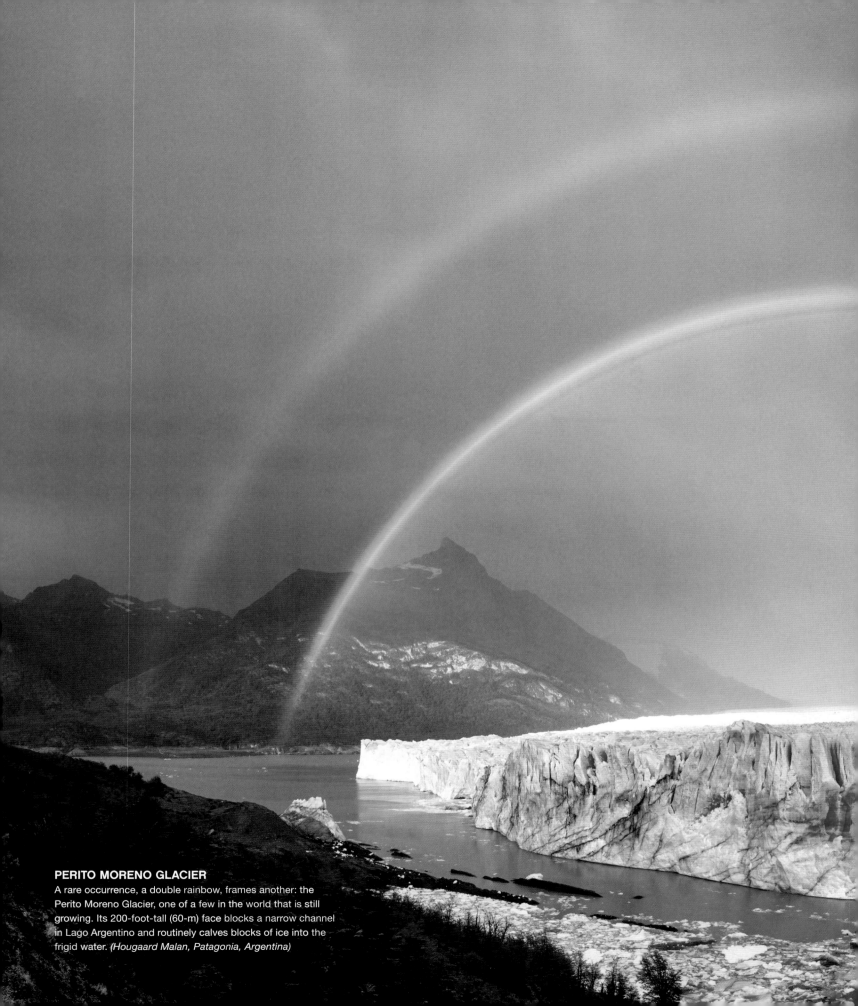

PERITO MORENO GLACIER

A rare occurrence, a double rainbow, frames another: the Perito Moreno Glacier, one of a few in the world that is still growing. Its 200-foot-tall (60-m) face blocks a narrow channel in Lago Argentino and routinely calves blocks of ice into the frigid water. *(Hougaard Malan, Patagonia, Argentina)*

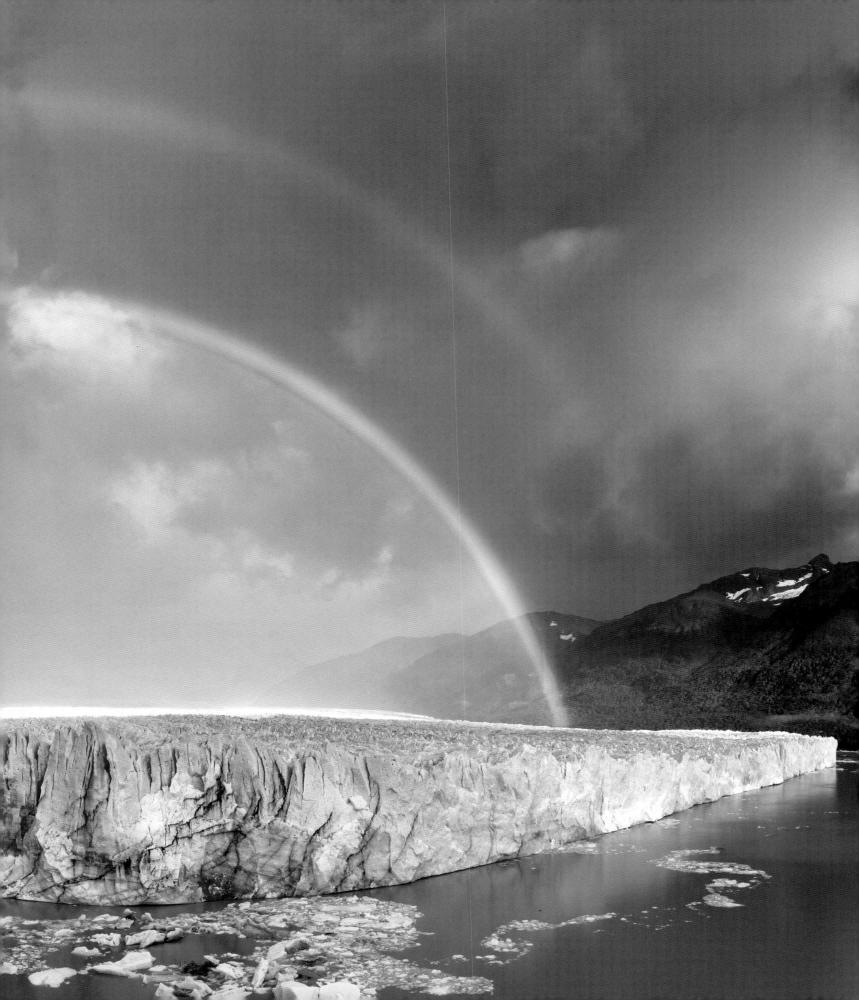

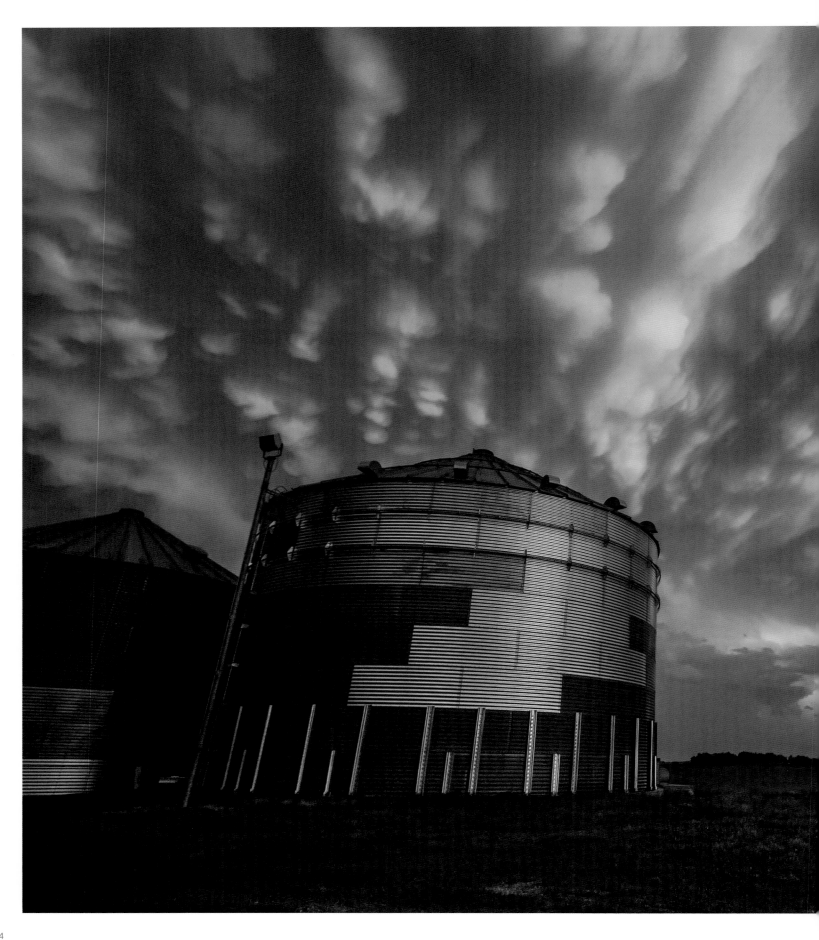

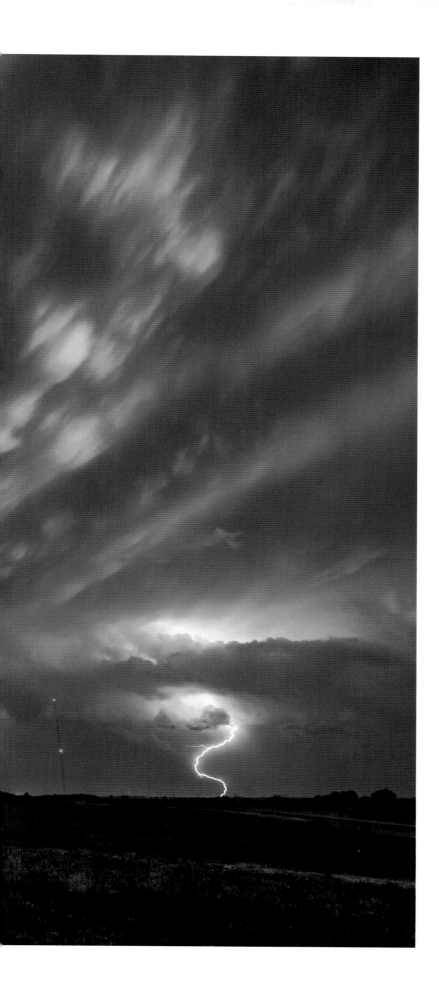

MAMMATUS CLOUDS

Soft, rounded mammatus clouds seem to drape themselves above a silo in central Nebraska. The distant lightning strike provides a clue to their formation, which often follows severe thunderstorms. Mammatus clouds form when heavy, saturated air starts to sink toward the ground and, being cooler than the surrounding air, forms these pouch-like puffs. *(Mike Hollingshead, Nebraska)*

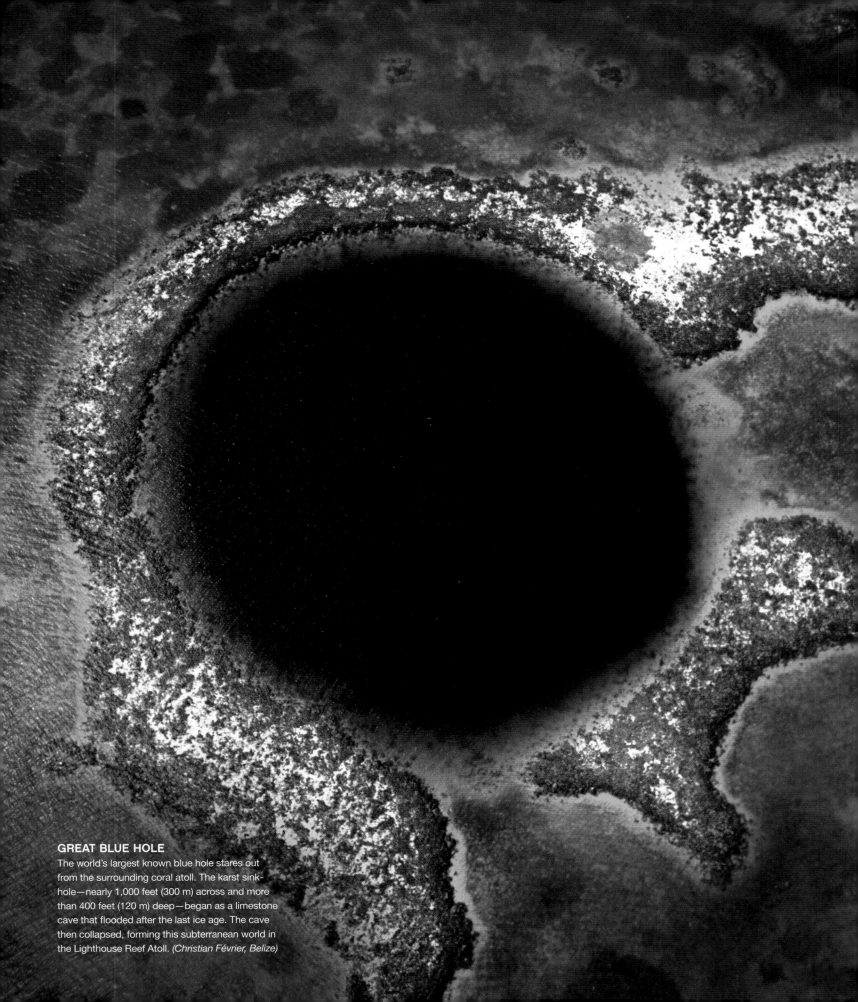

GREAT BLUE HOLE
The world's largest known blue hole stares out from the surrounding coral atoll. The karst sink-hole—nearly 1,000 feet (300 m) across and more than 400 feet (120 m) deep—began as a limestone cave that flooded after the last ice age. The cave then collapsed, forming this subterranean world in the Lighthouse Reef Atoll. *(Christian Février, Belize)*

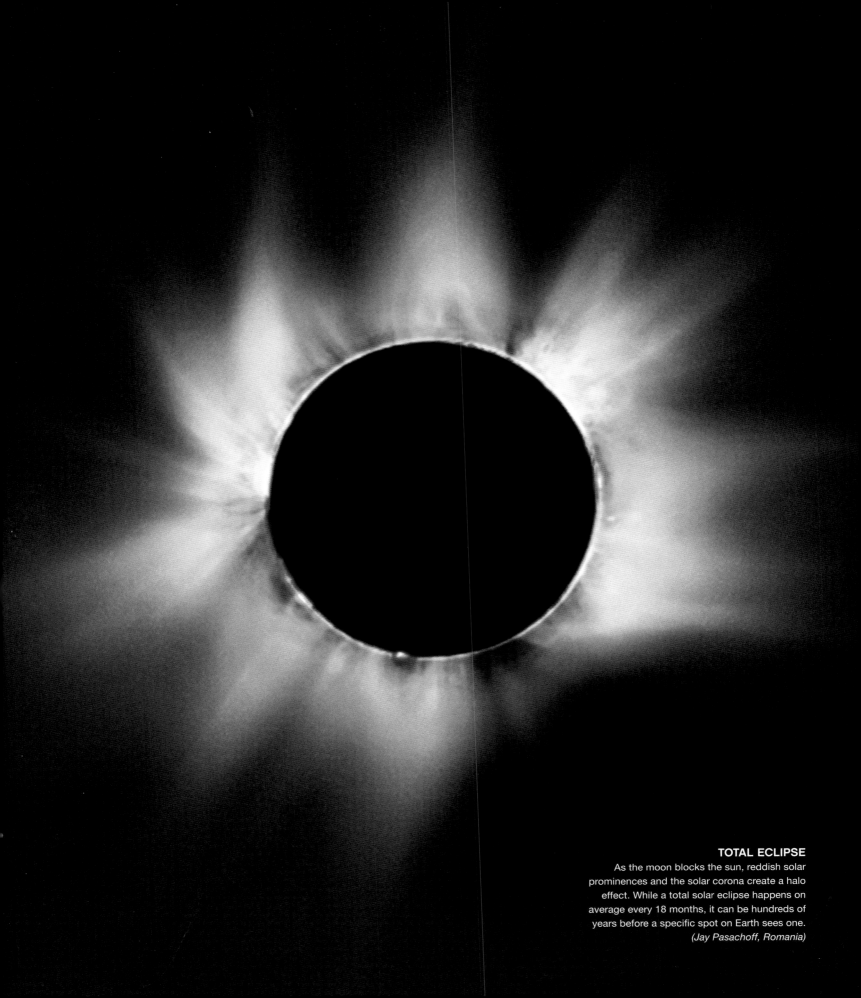

TOTAL ECLIPSE
As the moon blocks the sun, reddish solar prominences and the solar corona create a halo effect. While a total solar eclipse happens on average every 18 months, it can be hundreds of years before a specific spot on Earth sees one.
(Jay Pasachoff, Romania)

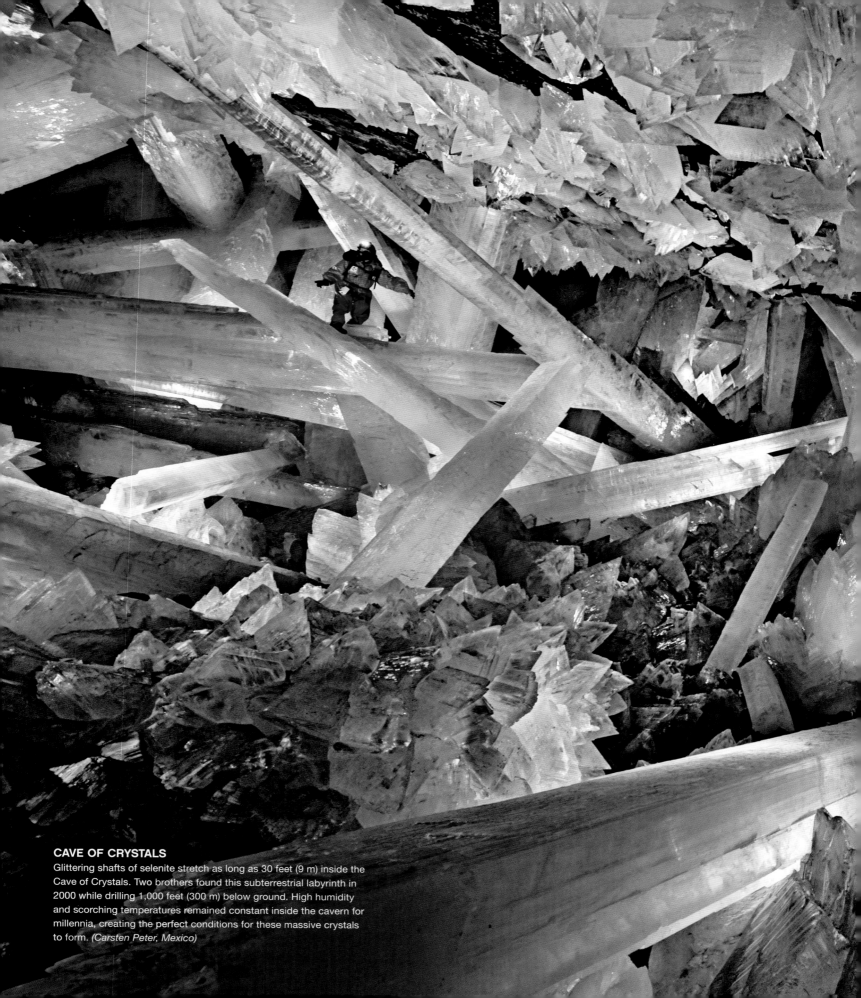

CAVE OF CRYSTALS

Glittering shafts of selenite stretch as long as 30 feet (9 m) inside the Cave of Crystals. Two brothers found this subterrestrial labyrinth in 2000 while drilling 1,000 feet (300 m) below ground. High humidity and scorching temperatures remained constant inside the cavern for millennia, creating the perfect conditions for these massive crystals to form. *(Carsten Peter, Mexico)*

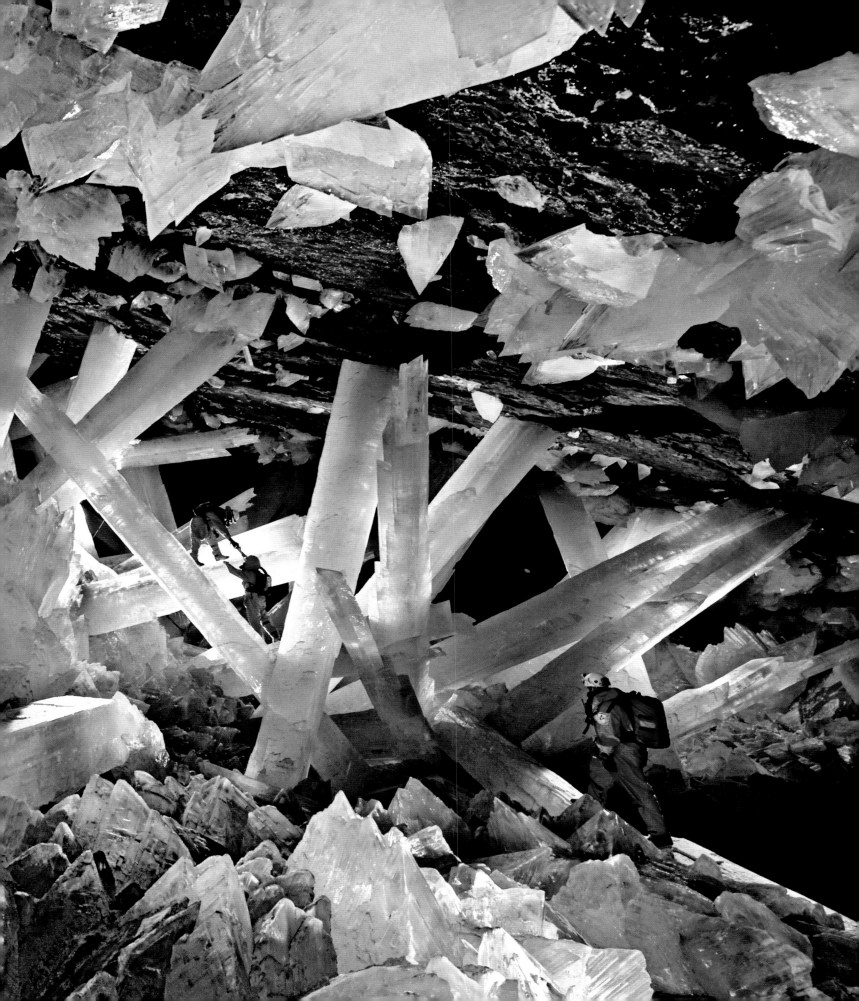

"That winter's [2011] weather was particularly favorable to creating these dramatic ice cracks. Extreme temperature variations caused the lake to repeatedly thaw and refreeze, creating a spiderweb of cracks in various sizes and depths. The temperature was well below zero degrees Fahrenheit while I was shooting this sunrise."

CHIP PHILLIPS

OPPOSITE: **ICE FORMATIONS**
Winter's dance with the cold can be seen in cracks stretching toward the horizon on a lake in Canada's Rocky Mountains.
Repeated freezing and thawing create striking geometric patterns on the surface ice. *(Chip Phillips, Canadian Rockies)*

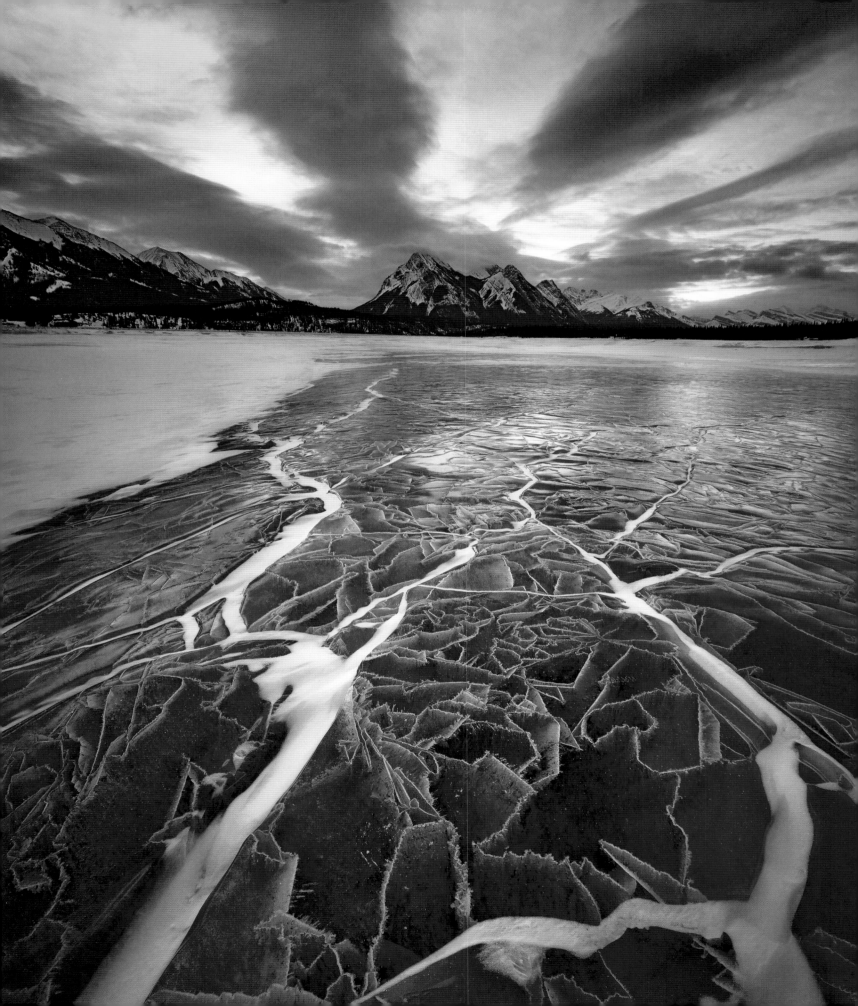

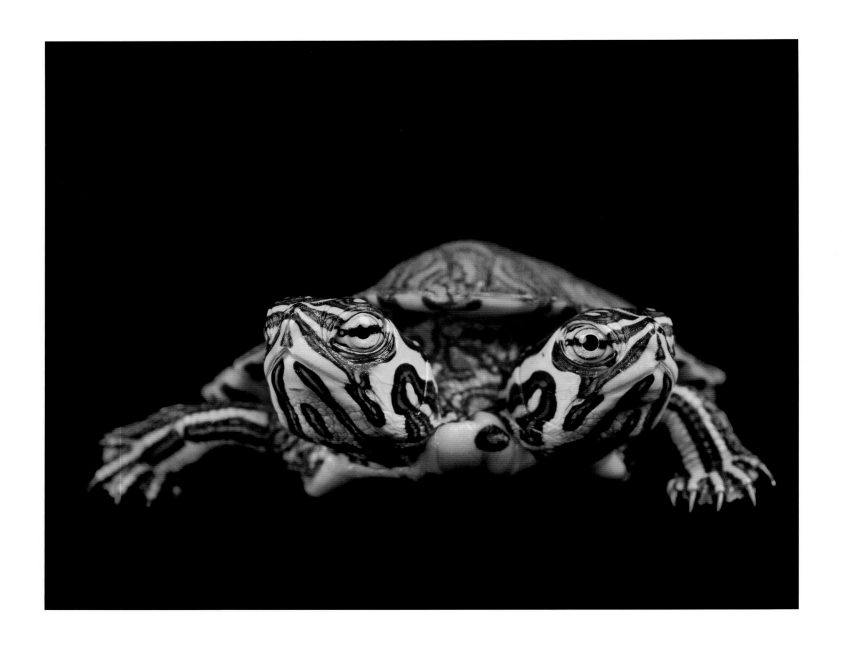

TWO HEADS ARE BETTER THAN ONE

Four eyes peer out from a yellow-striped shell, but it's no optical illusion—this turtle has two heads. Native to the central and eastern United States, the yellow-bellied slider turtle is threatened by habitat loss, pesticides, and heavy metal pollution. This one-in-a-million birth makes this turtle unusual. *(Joel Sartore)*

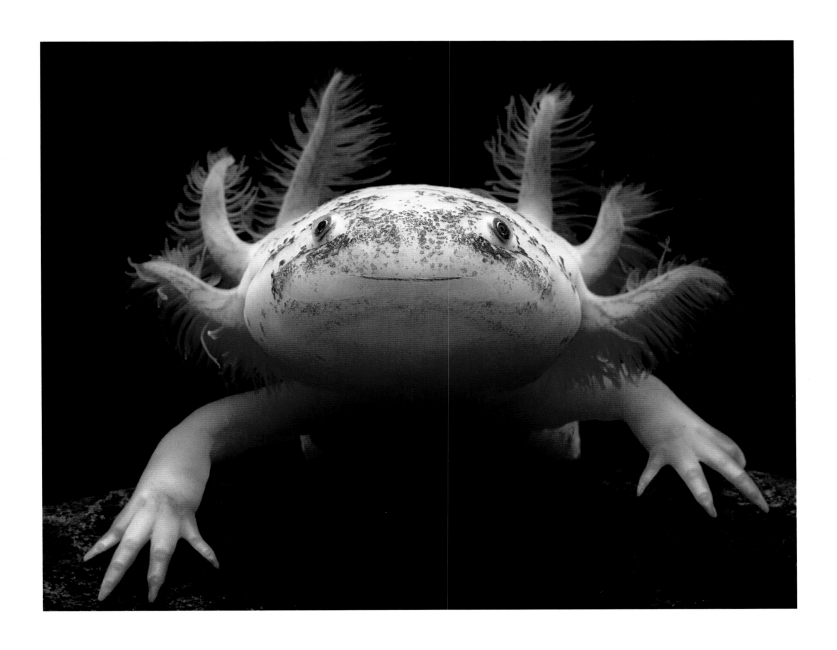

FOREVER YOUNG

Sporting feathery, frilled gills that emanate from its expansive head, the Mexican axolotl salamander retains its larval features throughout its adulthood. Axolotls live in the lakes of Xochimilco near Mexico City, Mexico. Popularity as both a pet and a delicacy has led to its critically endangered status. *(Stephen Dalton)*

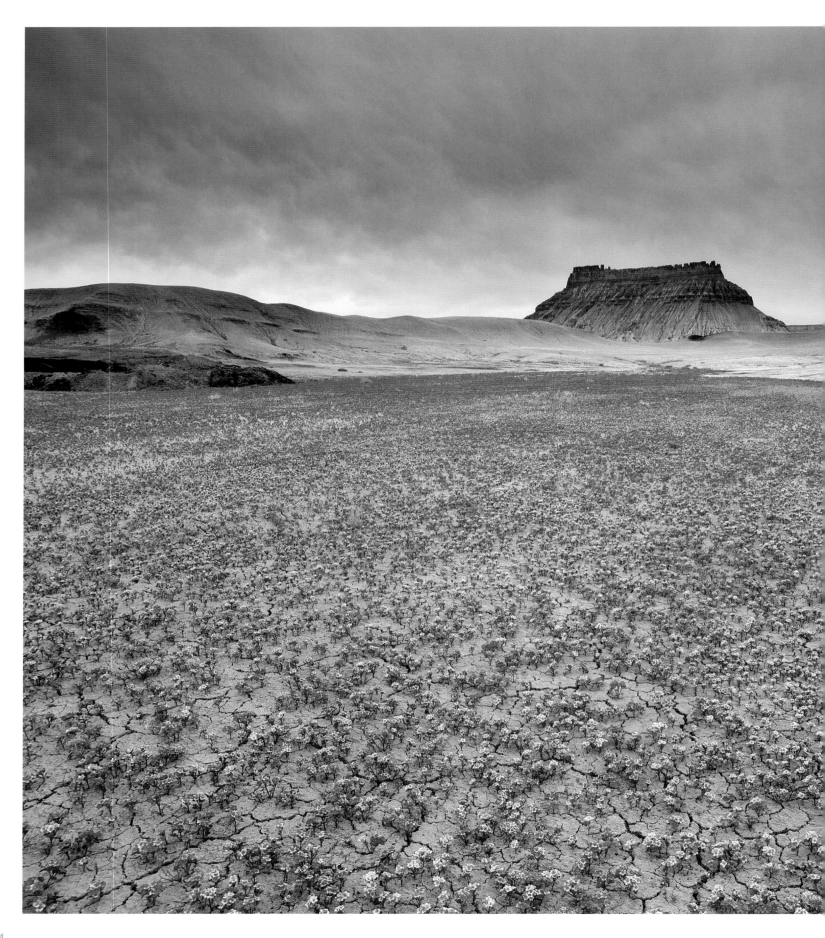

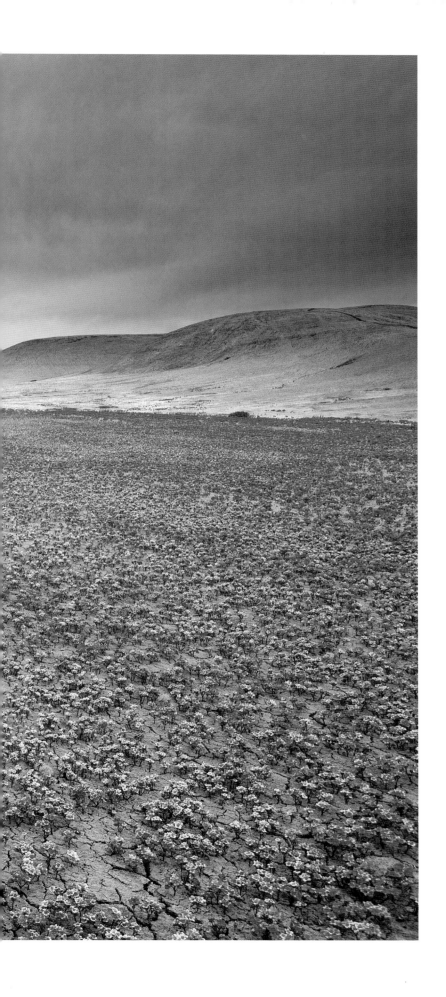

PURPLE HAZE

A rare carpet of purple flowers spreads toward a distant butte. Every few years, when winter snows and spring warmth create the ideal conditions, this stretch of the Colorado Plateau bursts into color with bee plant and scorpion weed. The view is best enjoyed from a distance—bee plant has an unpleasant odor and scorpion weed is named for its bite, which can cause a reaction similar to poison ivy. *(Guy Tal, Utah)*

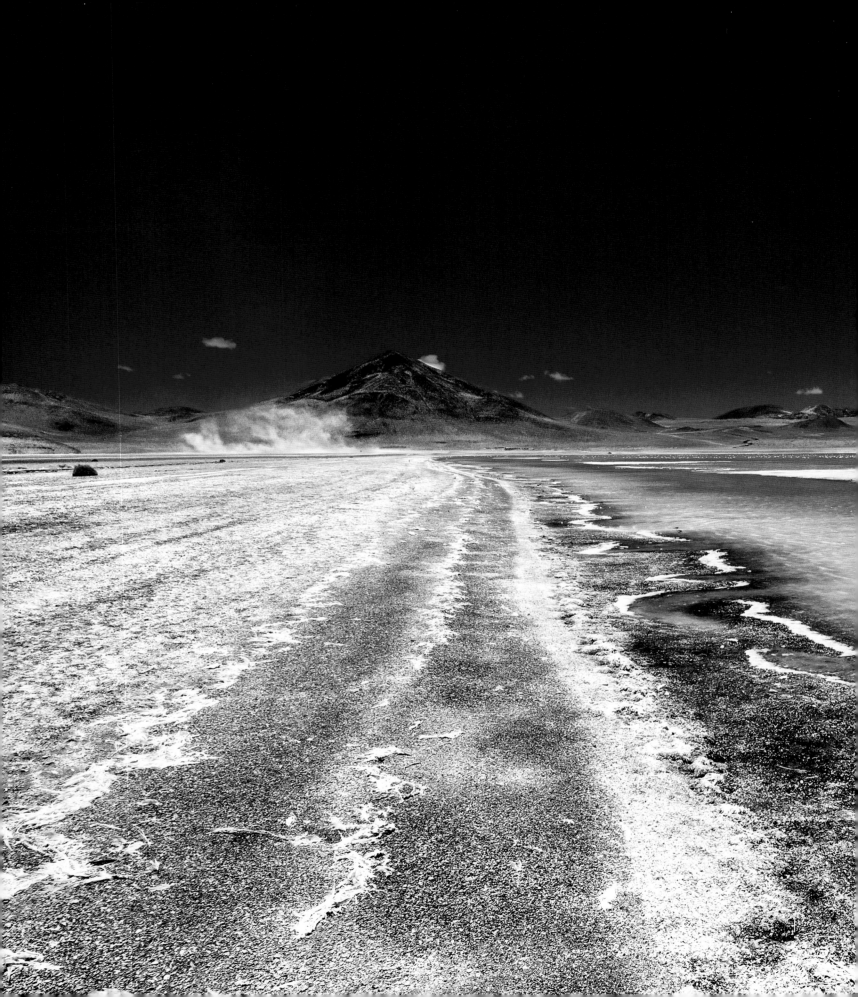

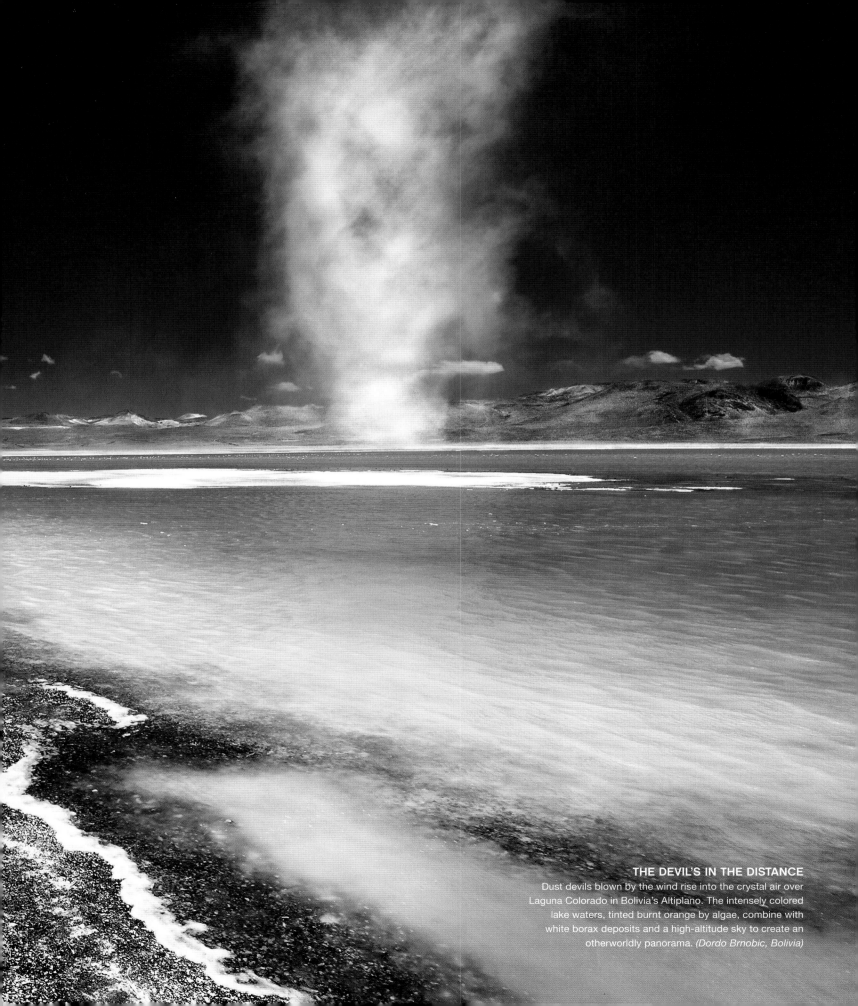

THE DEVIL'S IN THE DISTANCE
Dust devils blown by the wind rise into the crystal air over Laguna Colorado in Bolivia's Altiplano. The intensely colored lake waters, tinted burnt orange by algae, combine with white borax deposits and a high-altitude sky to create an otherworldly panorama. *(Dordo Brnobic, Bolivia)*

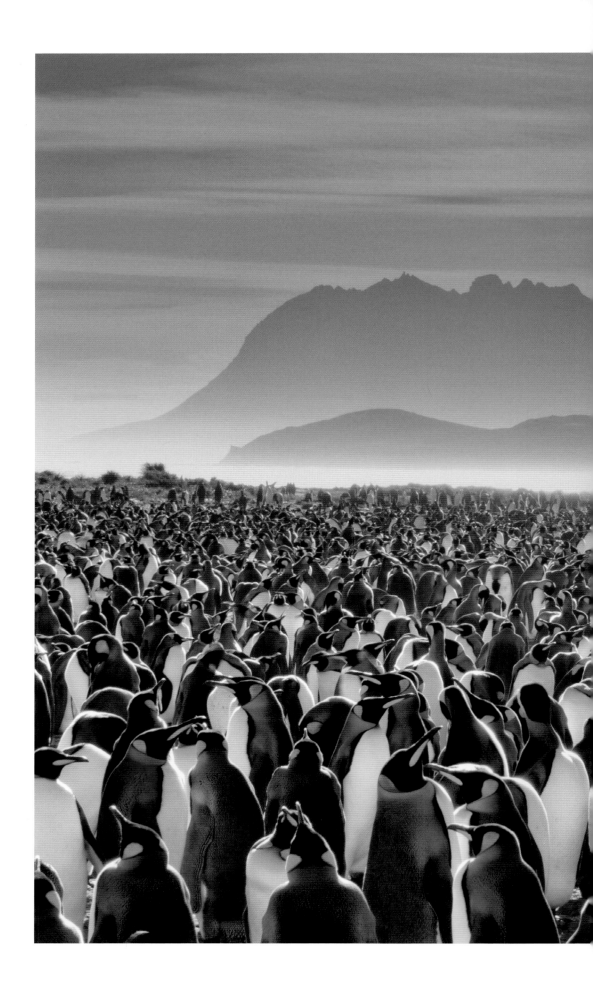

KING COLONY

A sea of king penguins *(Aptenodytes patagonicus)* stretch out to meet the hills on South Georgia Island in the southern Atlantic Ocean. King penguins, the second largest penguin species, congregate here starting in September. The aquatic birds form breeding colonies that can reach up to tens of thousands in number. *(Frans Lanting, Antarctica)*

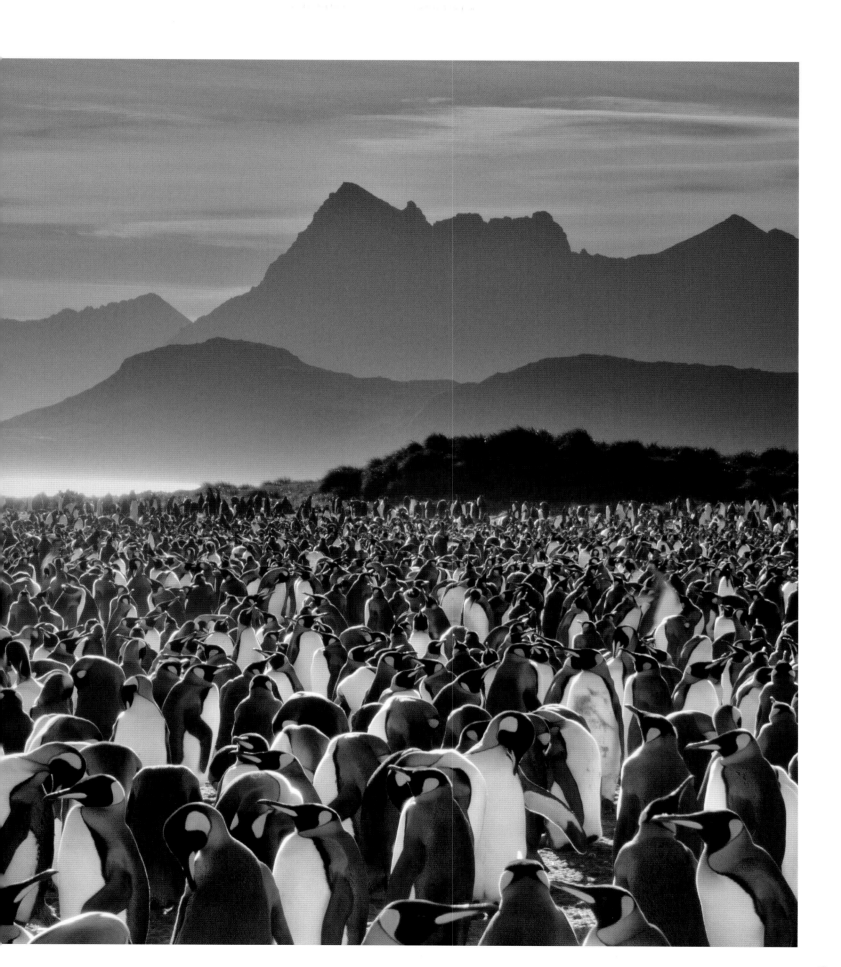

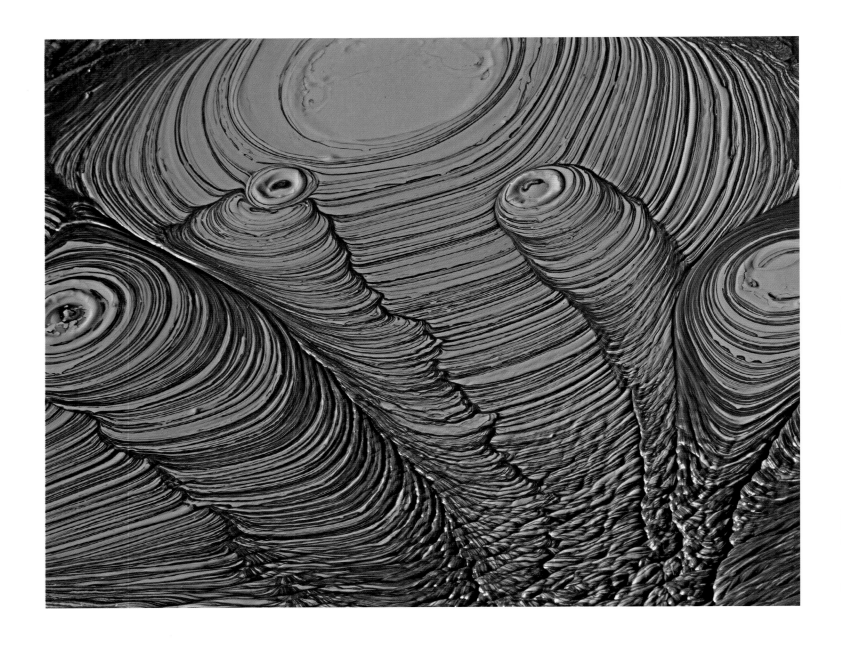

BOILING MUD

A pool of bubbling mud in Russia's Uzon Caldera forms layered patterns in Kronotsky Zapovednik (a nature reserve) on the Kamchatka Peninsula. The volcanic region has at least 500 geothermal features, including the volcanic cone that collapsed some 40,000 years ago, leaving this caldera to bubble on.
(Michael Melford, Kamchatka Peninsula)

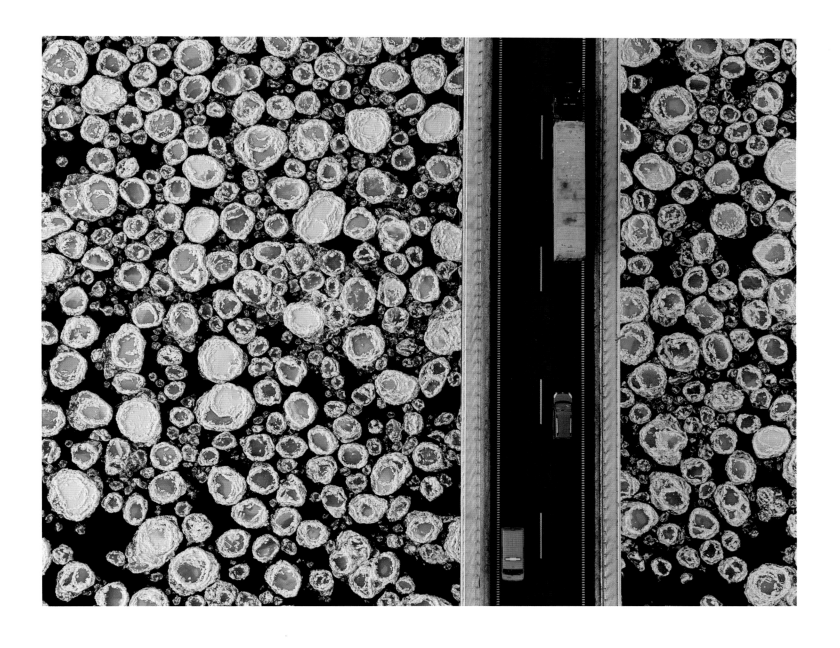

PANCAKE ICE

A road forms a black ribbon, cutting through multisize blocks of
floating ice on the Vistula River near the village of Kiezmark, Poland.
The circular shapes—known as pancake ice—that fill the nearly
frozen river form as smooth pieces of ice bump against each other
and round off their sharp edges. *(Kacper Kowalski, Poland)*

CRIES OF NATURE

Lava, lightning, and ash make for a crucible of destruction at southern Japan's Sakurajima volcano. One of the most active on Earth, the volcano erupts in Kyushu with regular frequency. Some scientists think the phenomenon of volcanic lightning bolts serves to quench opposite electric charges. *(Martin Rietze, Japan)*

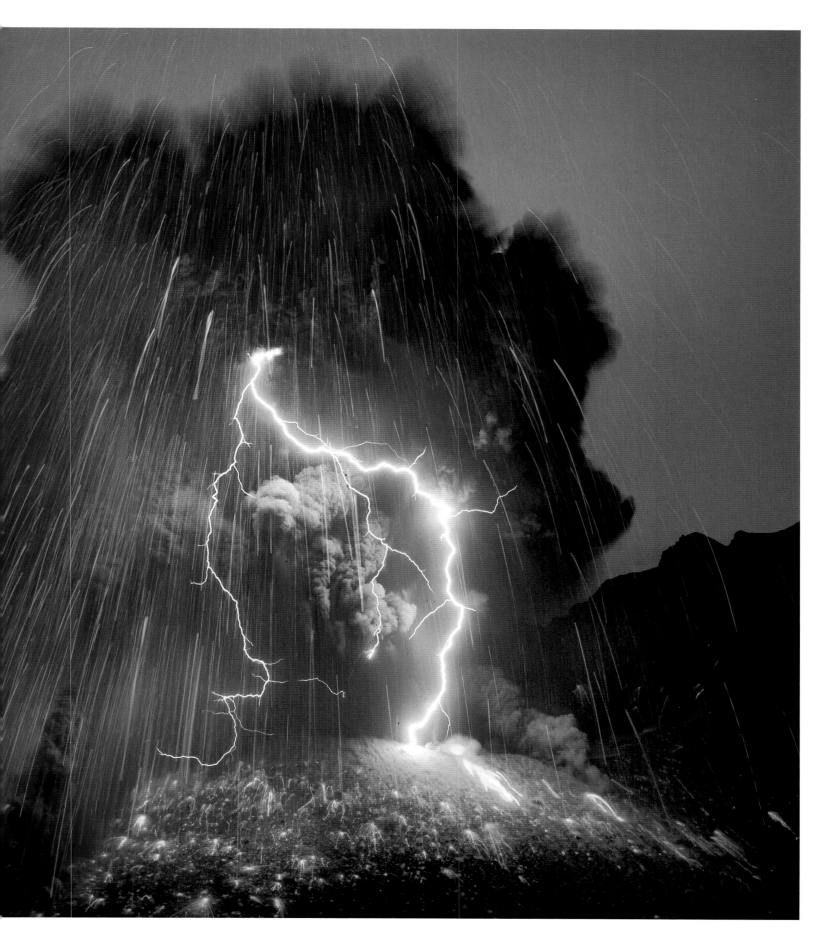

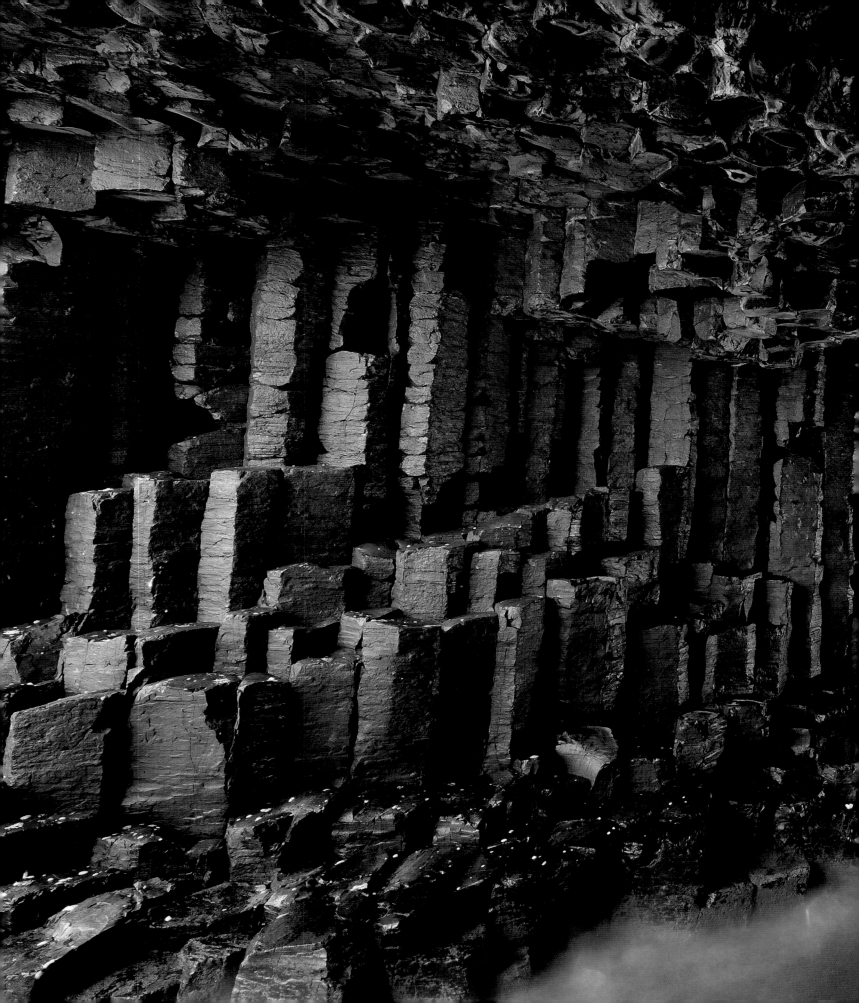

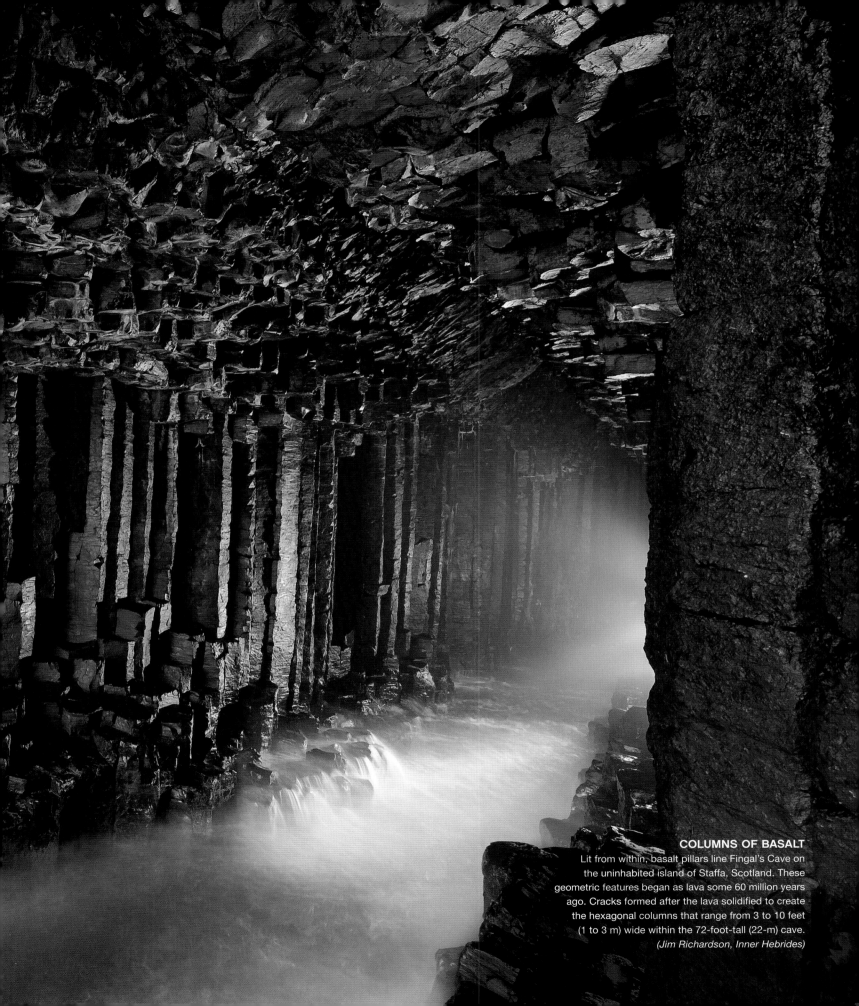

COLUMNS OF BASALT
Lit from within, basalt pillars line Fingal's Cave on
the uninhabited island of Staffa, Scotland. These
geometric features began as lava some 60 million years
ago. Cracks formed after the lava solidified to create
the hexagonal columns that range from 3 to 10 feet
(1 to 3 m) wide within the 72-foot-tall (22-m) cave.
(Jim Richardson, Inner Hebrides)

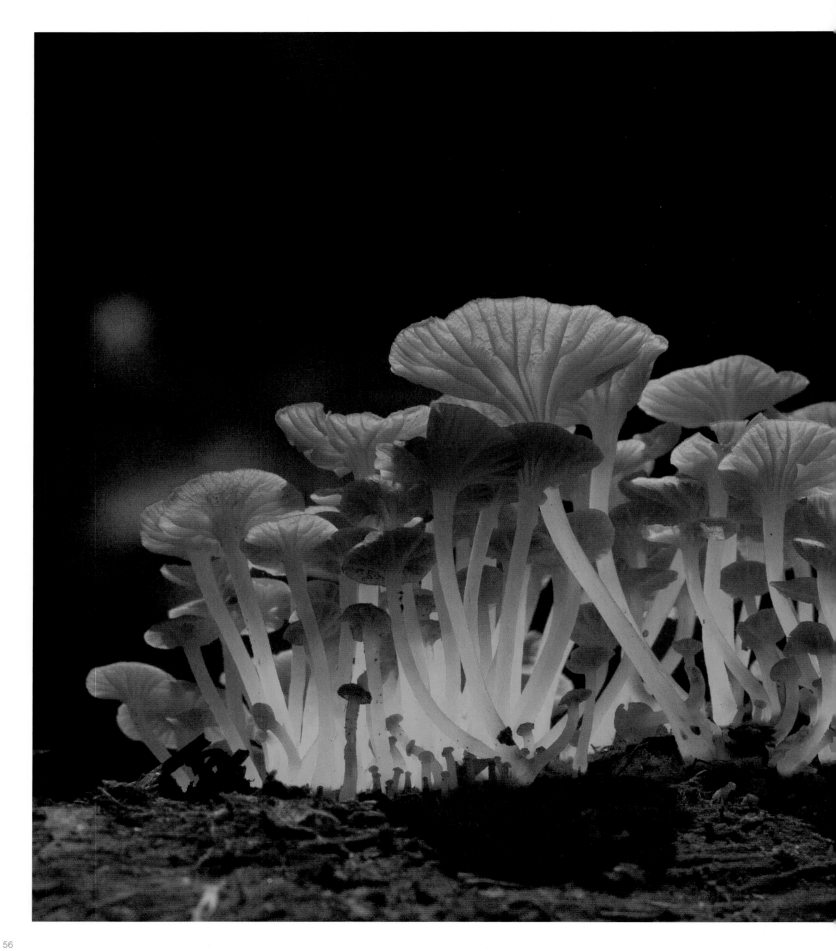

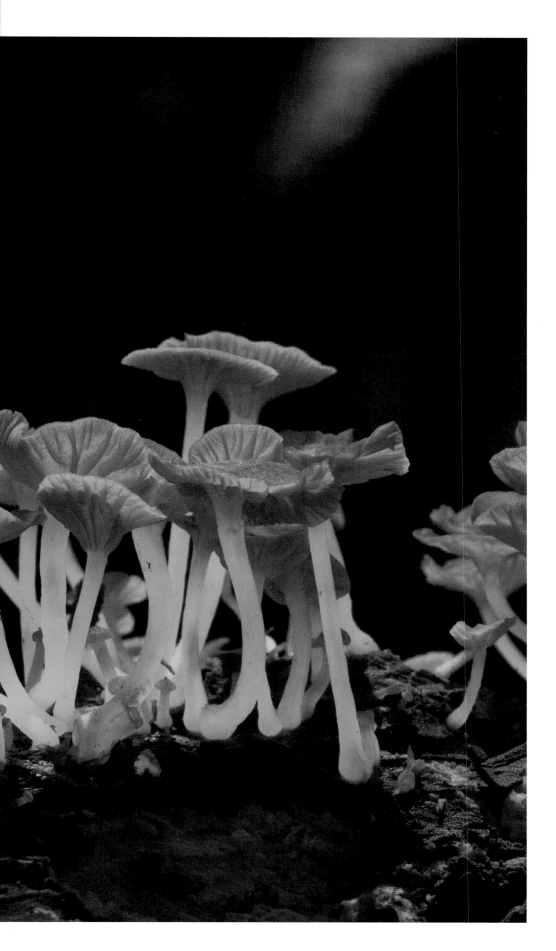

GLOWING MUSHROOMS

Bioluminescent mushrooms stretch their glowing
green stems away from the brown matter of a rotting
log. A chemical reaction in the fungi produces this
cold light. Although they are "on" all day, the show
starts when they light up the night. Bioluminescence
on land is rarer than at sea because most bio-
luminescent organisms call the oceans their home.
(Taylor F. Lockwood, Brazil)

"The Fly Geyser is an unlikely encounter
in an arid area near Nevada's Black Rock Desert,
resembling some strange feature on an alien
planet. I had the opportunity to study it at all
times of the day; as the wind shifted the steam
concealed and moistened some parts of the
formation, while others temporarily dried up,
constantly changing the appearance of the
incredibly colorful algae-covered travertine.
It is also so intriguing that it was people
and a well drill that started the creation
of this natural wonder."

INGE JOHNSSON

OPPOSITE: **FLY GEYSER**
When an energy company drilled a well on this site some 40 years ago, the seal didn't hold and Fly Geyser has been active ever since.
Geothermal energy feeds the thermophilic algae to create this desert oasis. *(Inge Johnsson, Nevada)*

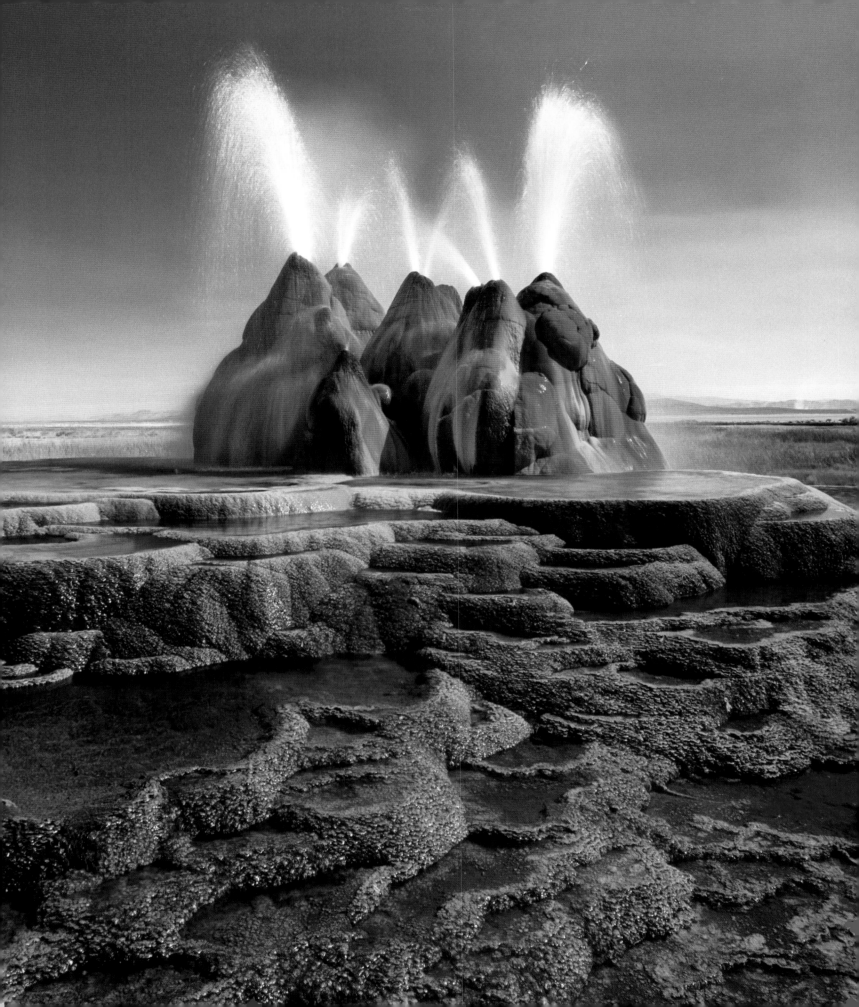

FAIRY CIRCLES
Barren land sprouts within these circles dotting the ground of NamibRand Nature Reserve. Found along a 1,200-mile (1,900-km) stretch of land from Angola to Namibia, the structures are an enigma for scientists. One theory holds that as plants compete for water in these desert conditions, they self-organize into circular patterns. Others say condensation is the cause. *(Frans Lanting, Namibia)*

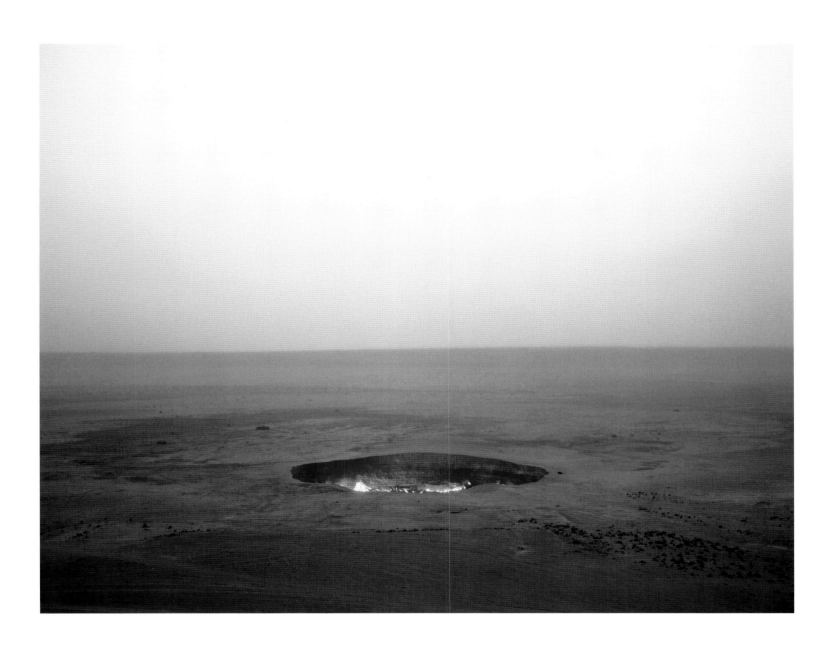

DOOR TO HELL

Burning like a solitary eye from the center of the Earth, it's thought that the 225-foot-wide (69-m) Darvaza Crater has been burning for more than 40 years. The story goes that this crater opened up and then at some point scientists lit the noxious gas. (Or at least, that's what the devil wants you to think.) *(Carolyn Drake, Turkmenistan)*

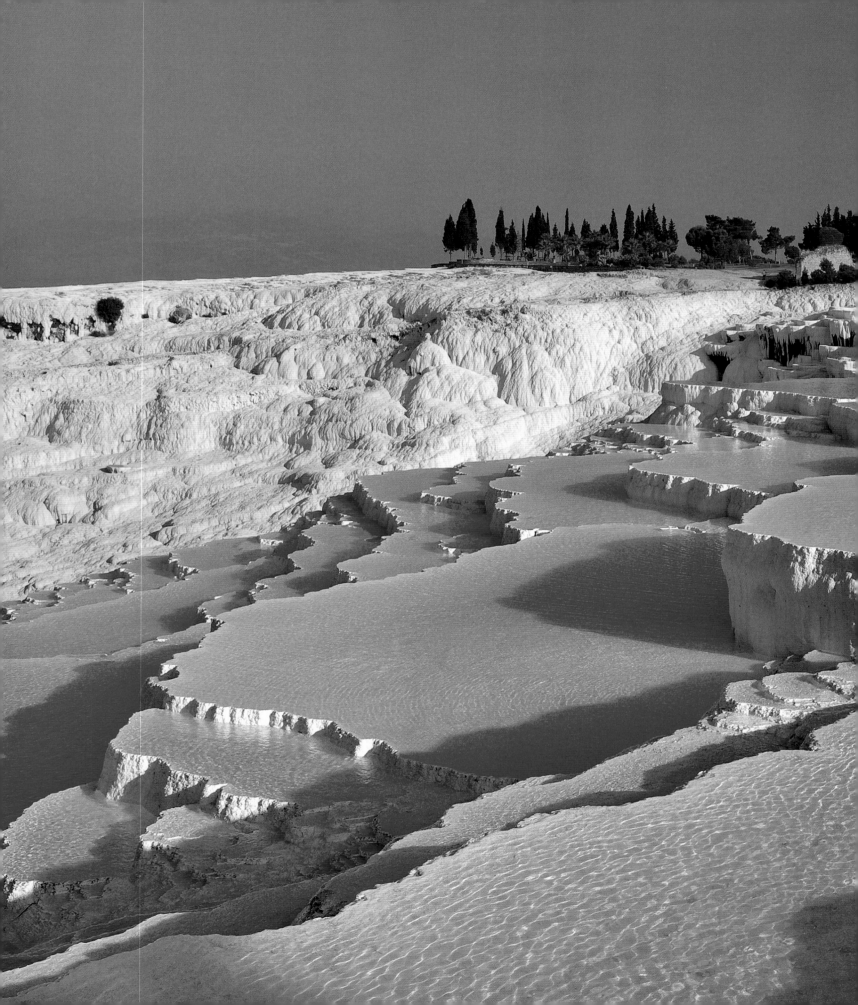

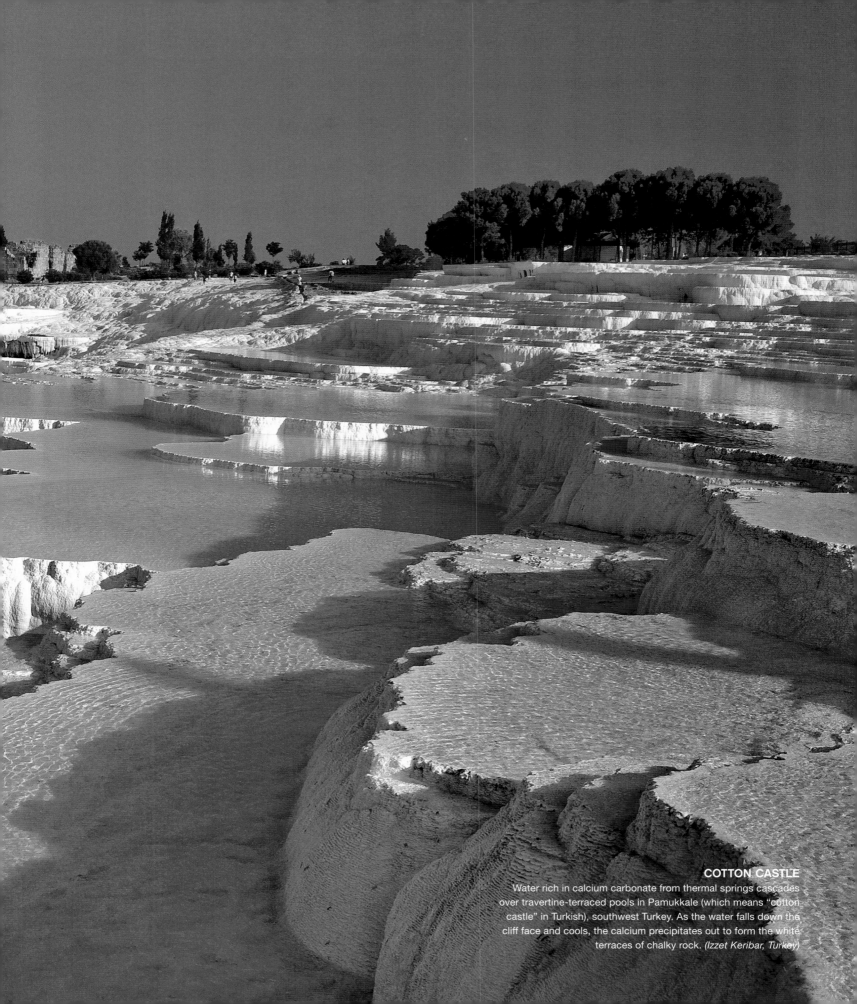

COTTON CASTLE
Water rich in calcium carbonate from thermal springs cascades over travertine-terraced pools in Pamukkale (which means "cotton castle" in Turkish), southwest Turkey. As the water falls down the cliff face and cools, the calcium precipitates out to form the white terraces of chalky rock. *(Izzet Keribar, Turkey)*

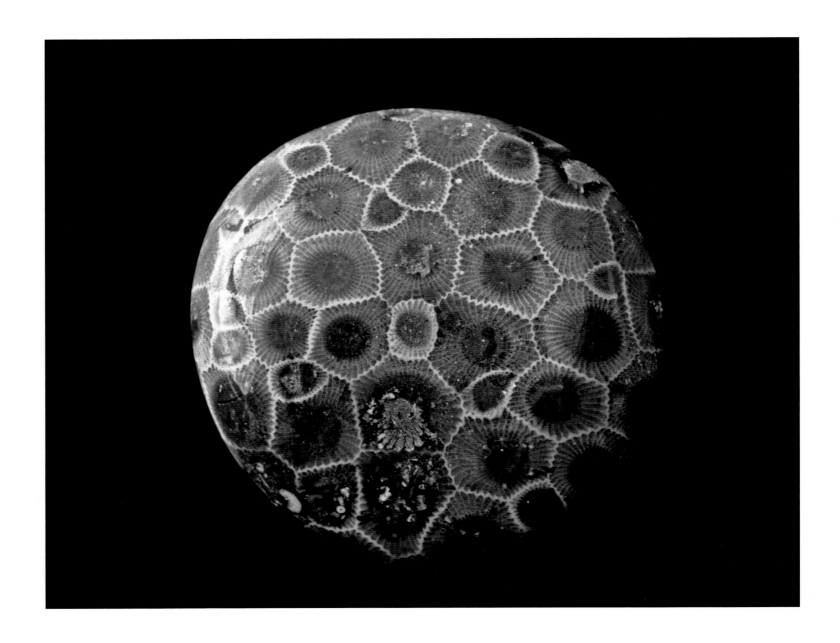

PETOSKEY STONE

A fossil of a coral colony has been polished to highlight its internal structure and outer shine. Petoskey stones began life as corals in a warm, saltwater sea, during the Devonian period some 400 million years ago. Their elaborate hexagonal, calcium carbonate skeletons provide fascinating geometric designs. Often found along the shorelines of Michigan, the fossil is the state stone. *(Ed Reschke)*

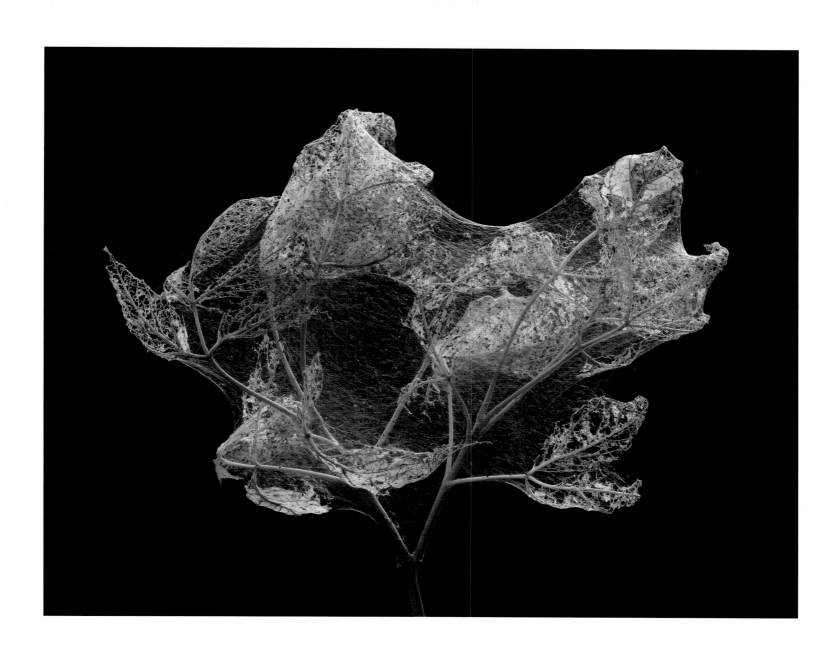

WRAPPED UP

A gossamer cocoon surrounds the delicate
structure of tree branches. The larvae of the buff tip moth
spin a protective web around the delicate branches
in order to have a safe place to feed. *(Ingo Arndt)*

"I camped out, backpacking the Yukon's Ogilvie mountain range for more than two weeks to make this capture in early winter as the lakes were freezing. For this image, I waited by the shore of the lake for three days hoping that these delicate ice formations would not crack or melt. Fortunately my luck held just long enough to make a unique capture of one of the area's high cliffs."

MARC ADAMUS

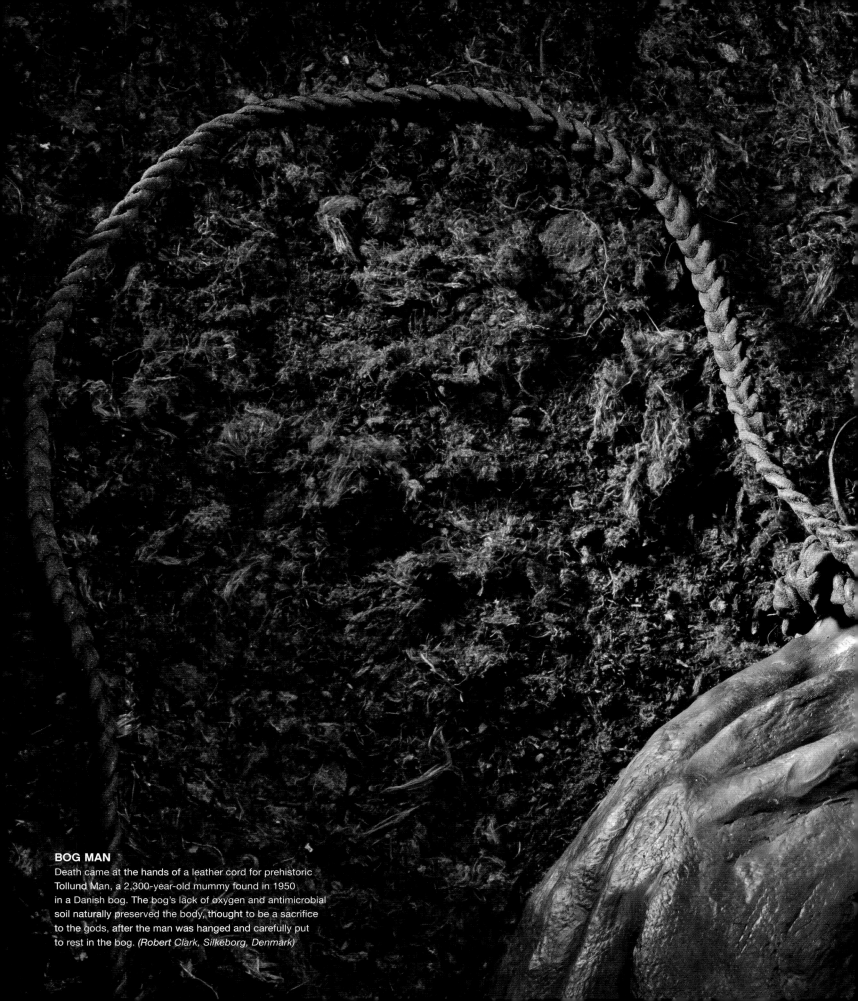

BOG MAN
Death came at the hands of a leather cord for prehistoric
Tollund Man, a 2,300-year-old mummy found in 1950
in a Danish bog. The bog's lack of oxygen and antimicrobial
soil naturally preserved the body, thought to be a sacrifice
to the gods, after the man was hanged and carefully put
to rest in the bog. *(Robert Clark, Silkeborg, Denmark)*

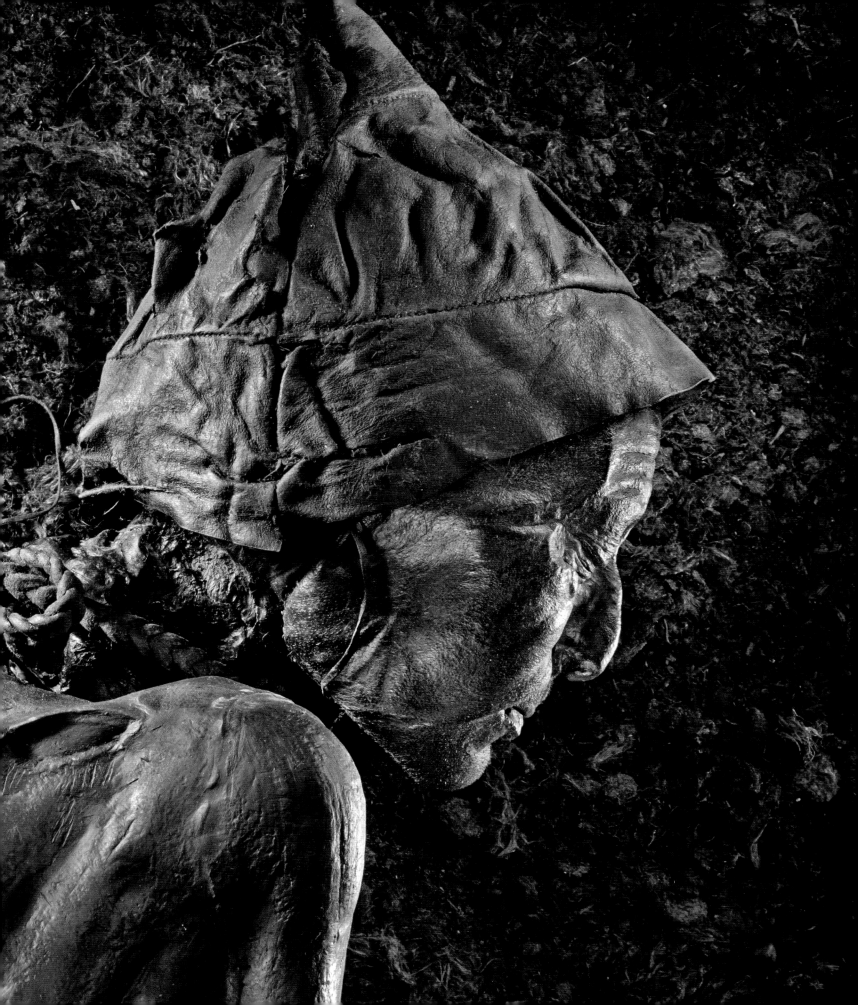

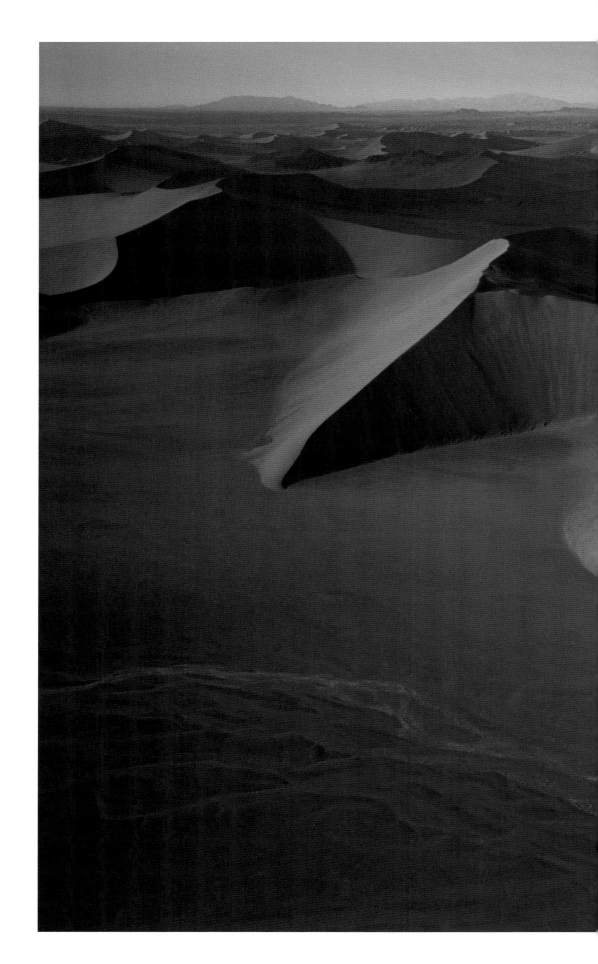

DANCING DUNES

The undulating sand dunes of Sossusvlei
in the Namib Desert tower hundreds of feet
above the ground below. Sossusvlei, which
comes from a combination of Afrikaans and
native Nama words meaning "dead-end
marsh," derives from its having no natural
outlet for rains. The sands here have been
sculpted by the wind for thousands of years.
(George Steinmetz, Namibia)

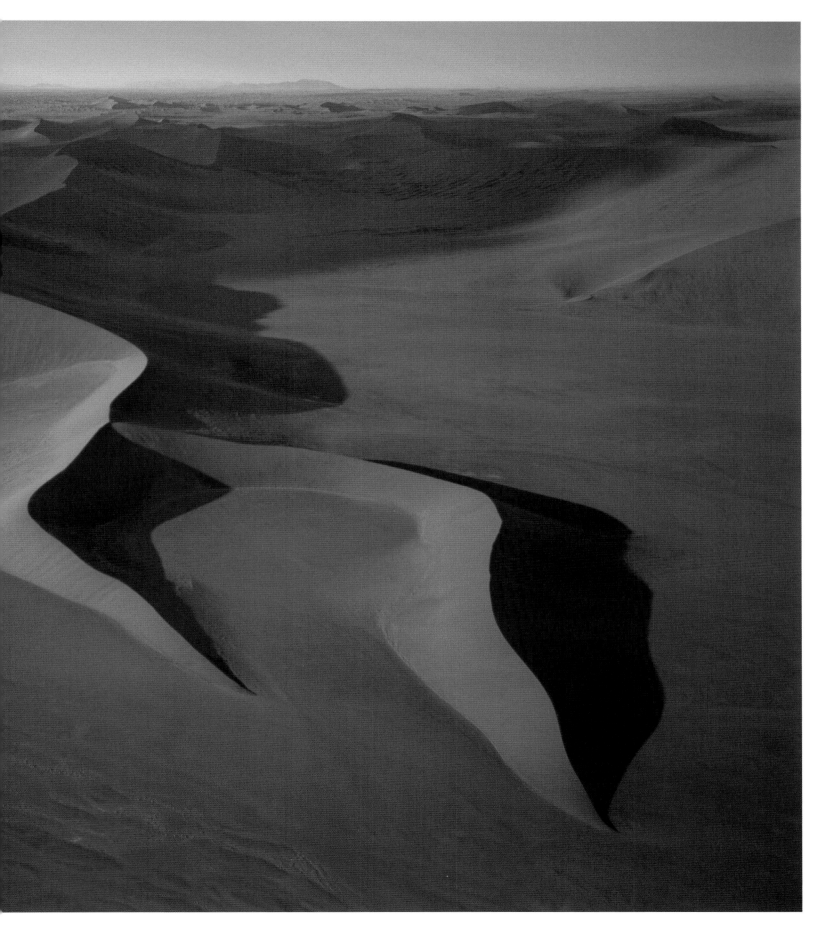

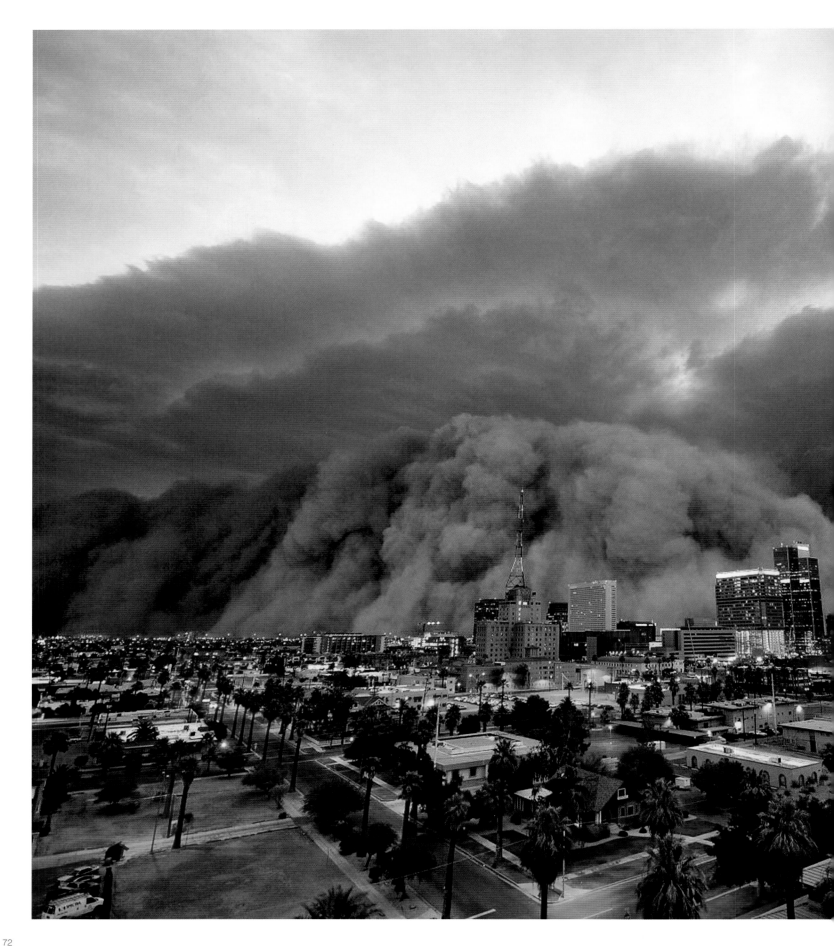

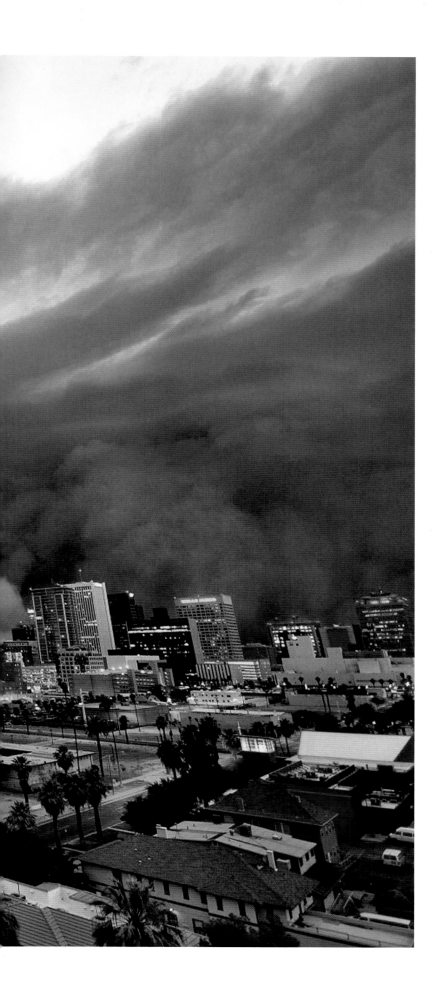

DUST STORM

The lights of Phoenix shine bright against an impending wall of dust and sand. In July 2011, this ominous storm reduced visibility to nil as a mile-high (1.6-km) wall of dust and sand enveloped the metro area. These severe sandstorms are also known as haboobs, from the Arabic word for "wind" or "blow." As cool air from a severe thunderstorm collapses, its momentum kicks up loose sand into sandstorms. *(Daniel Bryant, Arizona)*

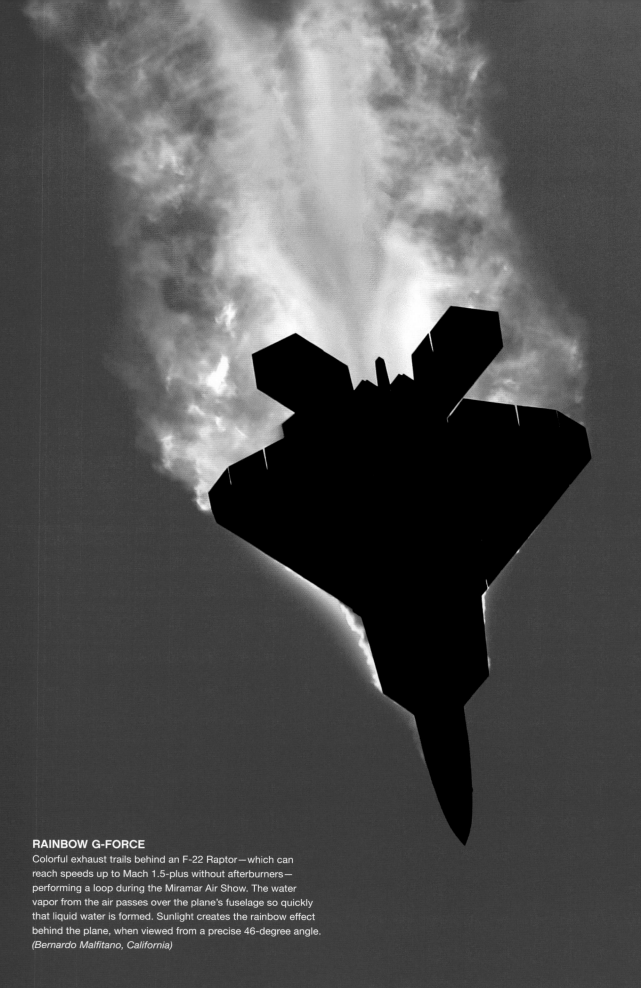

RAINBOW G-FORCE
Colorful exhaust trails behind an F-22 Raptor—which can reach speeds up to Mach 1.5-plus without afterburners— performing a loop during the Miramar Air Show. The water vapor from the air passes over the plane's fuselage so quickly that liquid water is formed. Sunlight creates the rainbow effect behind the plane, when viewed from a precise 46-degree angle.
(Bernardo Malfitano, California)

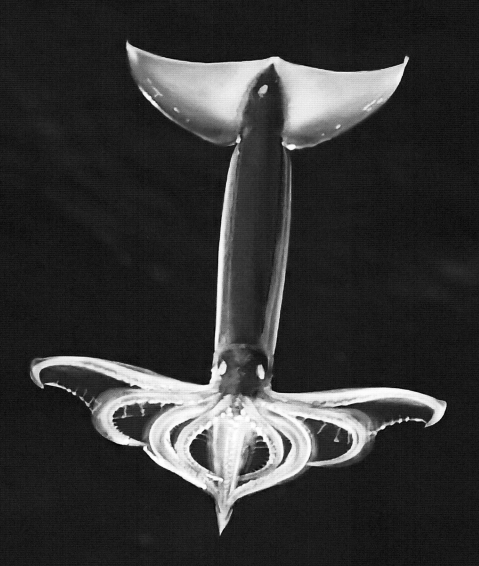

FLYING SQUID

A squid takes flight over the waters of the South Atlantic Ocean. The red flying squid *(Ommastrephes bartramii)* uses the strength of jet propulsion to take to the air. Filling its mantle with water, the squid uses a siphon below its head to propel itself, changing directions via the siphon's position. The squid migrates between feeding grounds in cooler northern waters and warmer spawning grounds, flying along the way. *(Anthony Pierce, South Atlantic Ocean)*

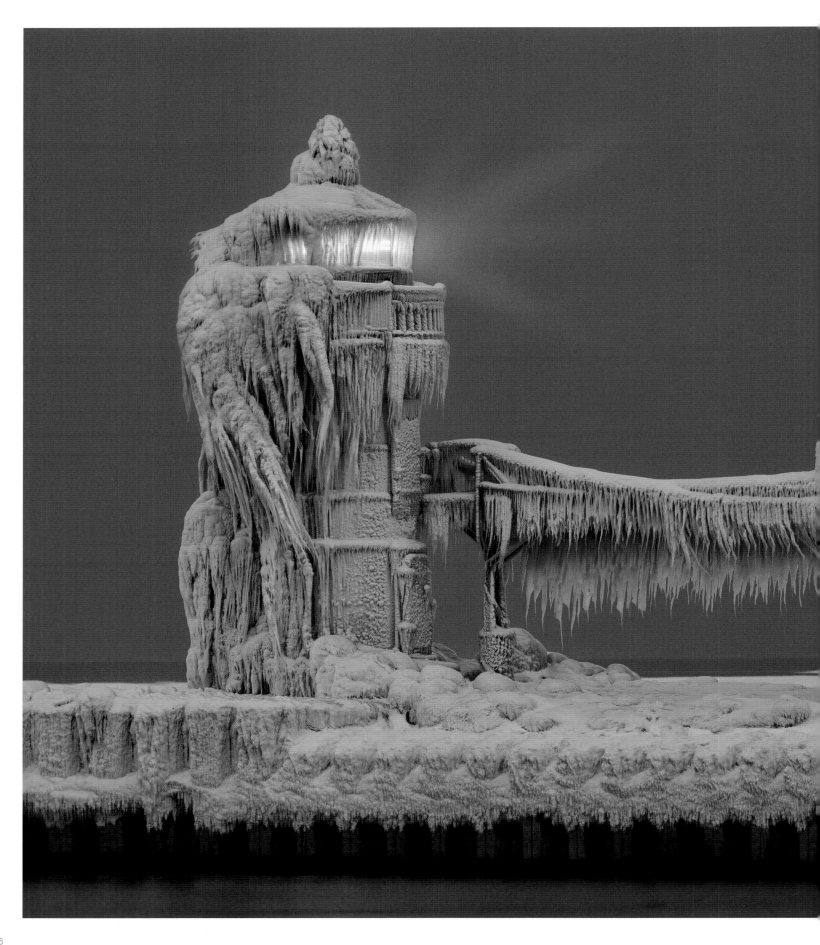

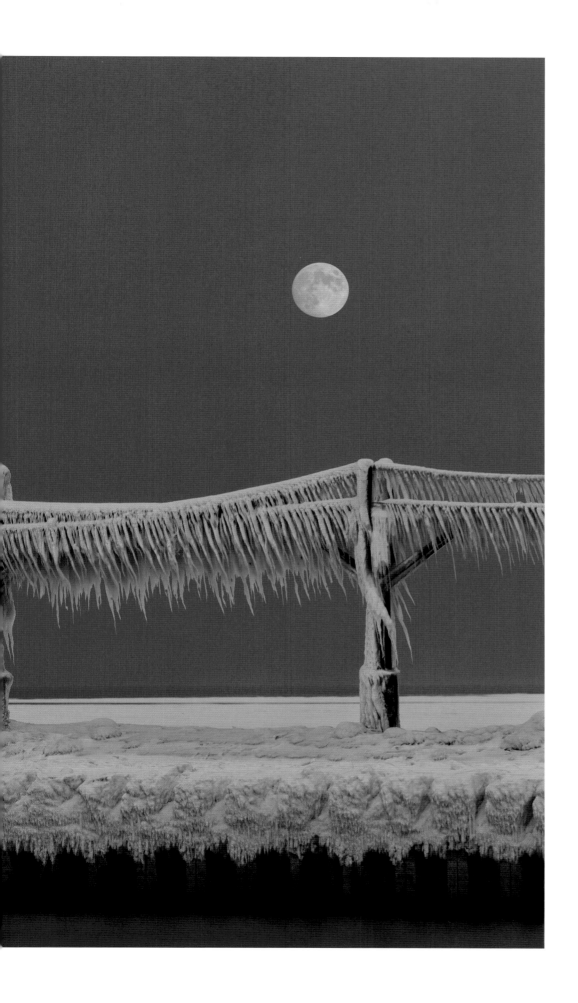

FROZEN ICE

A full moon stands guard over the St. Joseph North Pier Lighthouse in St. Joseph, Michigan. Crashing waves against the pier during the cold winter of 2013 built up layers of ice and created a frozen dreamscape on the shore of Lake Michigan. *(Glenn Nagel, Michigan)*

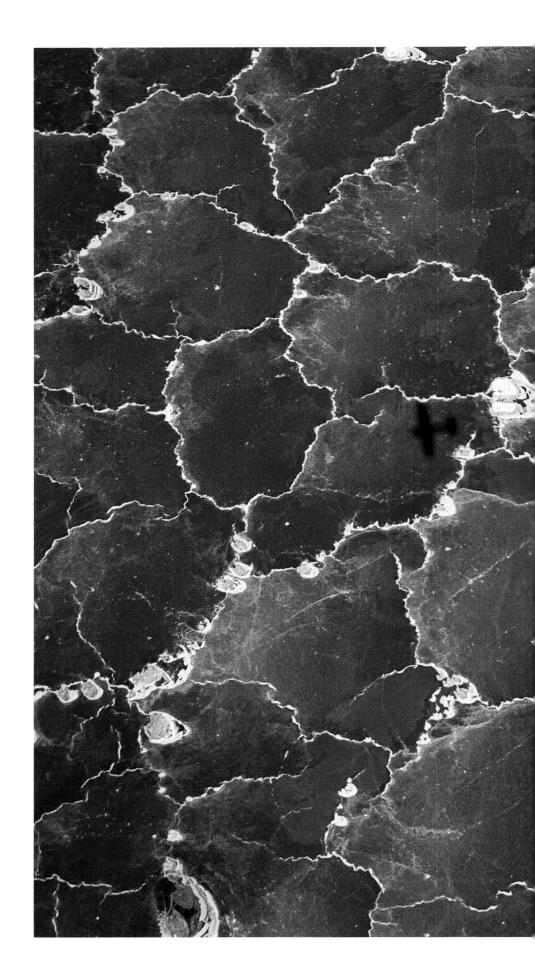

LAKE NATRON

The shadow of a plane shows the monumental scale of Lake Natron in Africa's Great Rift Valley, northern Tanzania. The salt lake—14 miles (22 km) wide—has an unusually high mineral content and extremely high alkalinity. During the dry season when the water begins to evaporate, salt-loving microorganisms thrive and a red-pigmented alkali salt crust forms on the surface. *(George Steinmetz, Tanzania)*

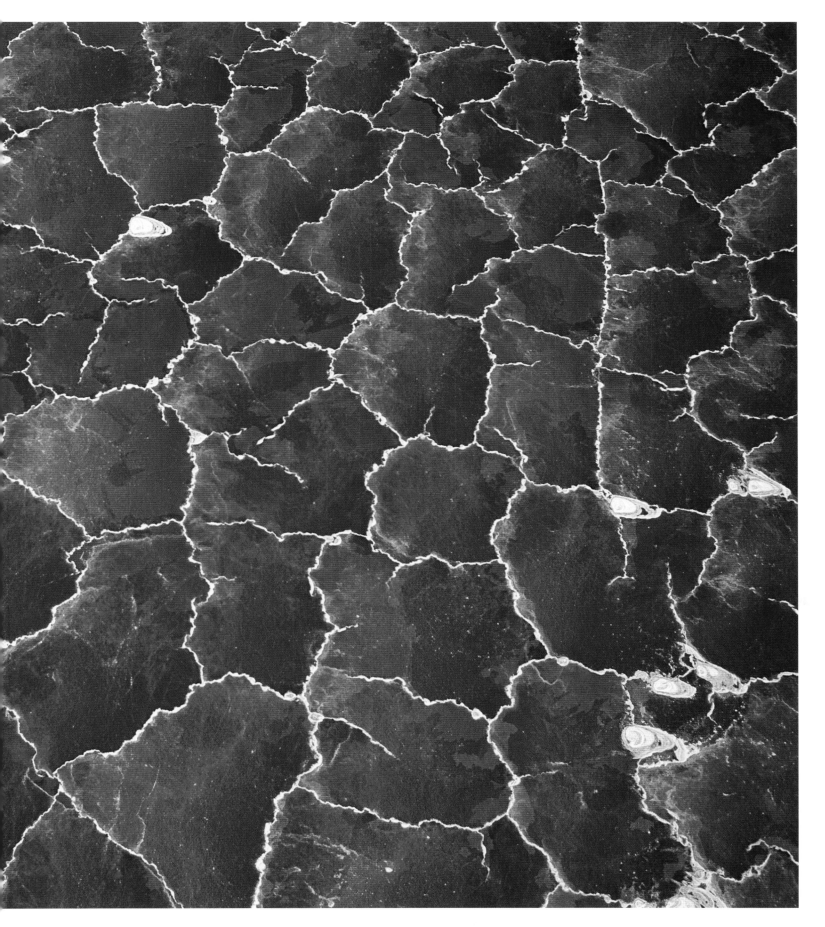

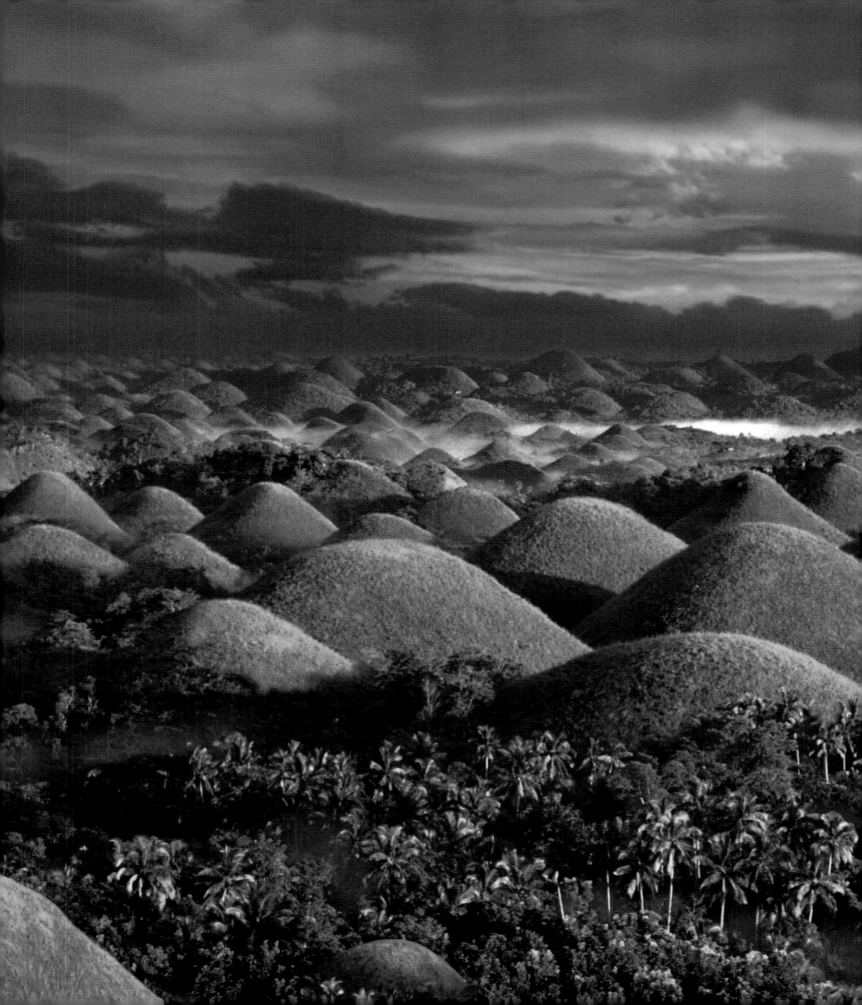

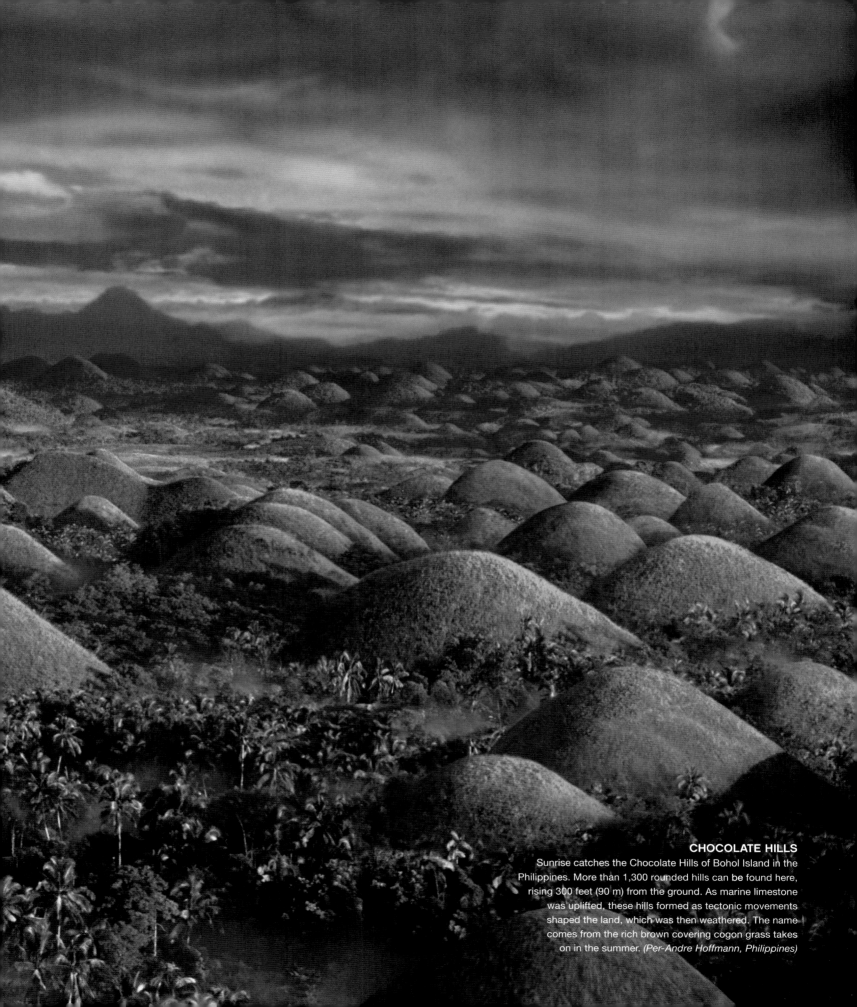

CHOCOLATE HILLS
Sunrise catches the Chocolate Hills of Bohol Island in the Philippines. More than 1,300 rounded hills can be found here, rising 300 feet (90 m) from the ground. As marine limestone was uplifted, these hills formed as tectonic movements shaped the land, which was then weathered. The name comes from the rich brown covering cogon grass takes on in the summer. *(Per-Andre Hoffmann, Philippines)*

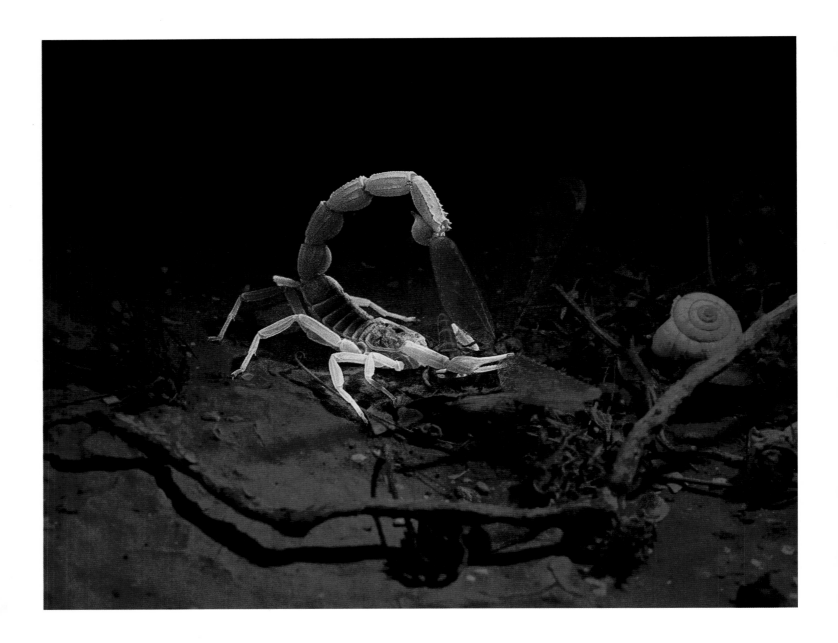

FRIGHT NIGHT

A yellow scorpion (also known as a deathstalker) glows green under a black light as it eats its dragonfly prey in the Negev desert of Israel. Although the scorpion is just a few inches long, its highly dangerous venom makes humans take notice. Scientists are not sure if the glow is an evolutionary adaptation or just an accidental occurrence with no evolutionary advantage. *(Uriel Sinai, Israel)*

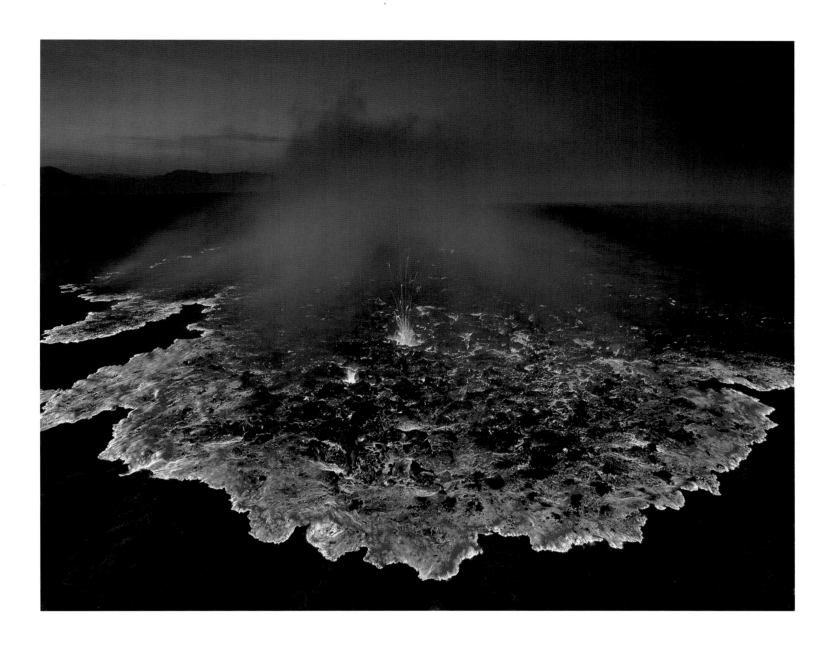

BLUE LAVA

A center eye of red lava shines against blue flames from Ethiopia's Danakil Depression. As superheated sulfur gas escapes from the vent, it goes down one of two paths: hit oxygen and burst into flame or cool in the air and condense into liquid. In liquid form, the sulfur ignites with the other gases and creates an otherworldly blue glow. *(Olivier Grunewald, Ethiopia)*

LENTICULAR SUNRISE

As sunrise sets swaths of purple and orange alive over Mount Rainier in Washington State, a lenticular cloud perches on the summit. Lenticular clouds develop when high-altitude, fast-moving winds meet a topographic barrier and there is sufficient moisture in the air. Although the clouds appear to be stationary, winds are actually swiftly moving throughout them. *(Dustin Penman, Washington)*

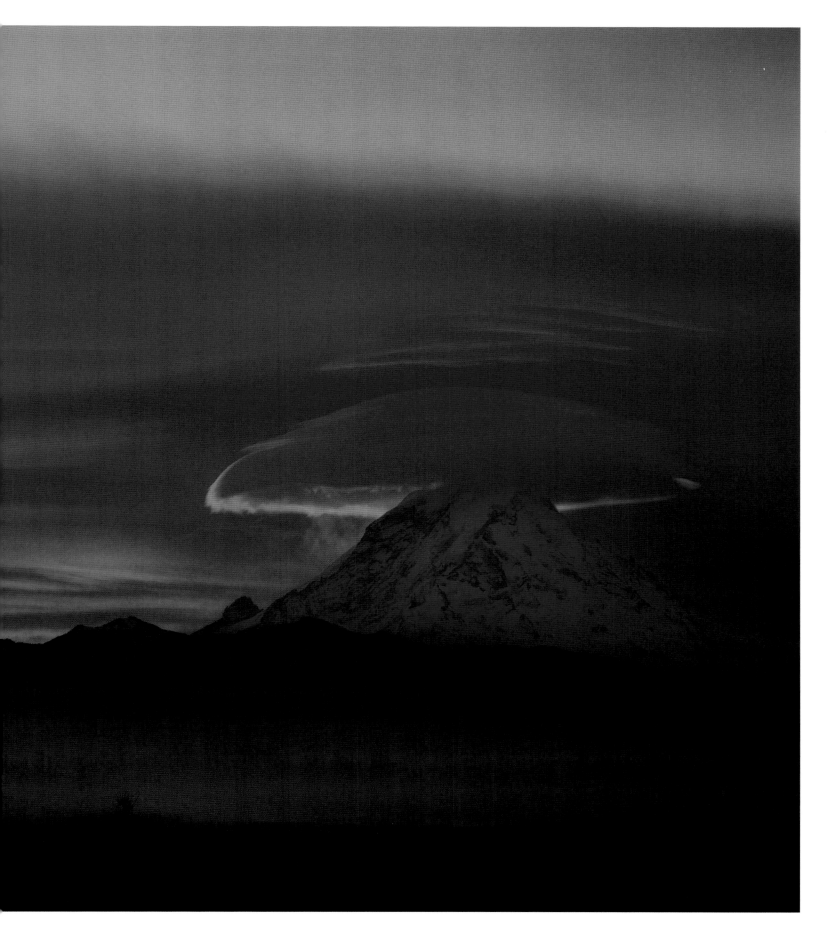

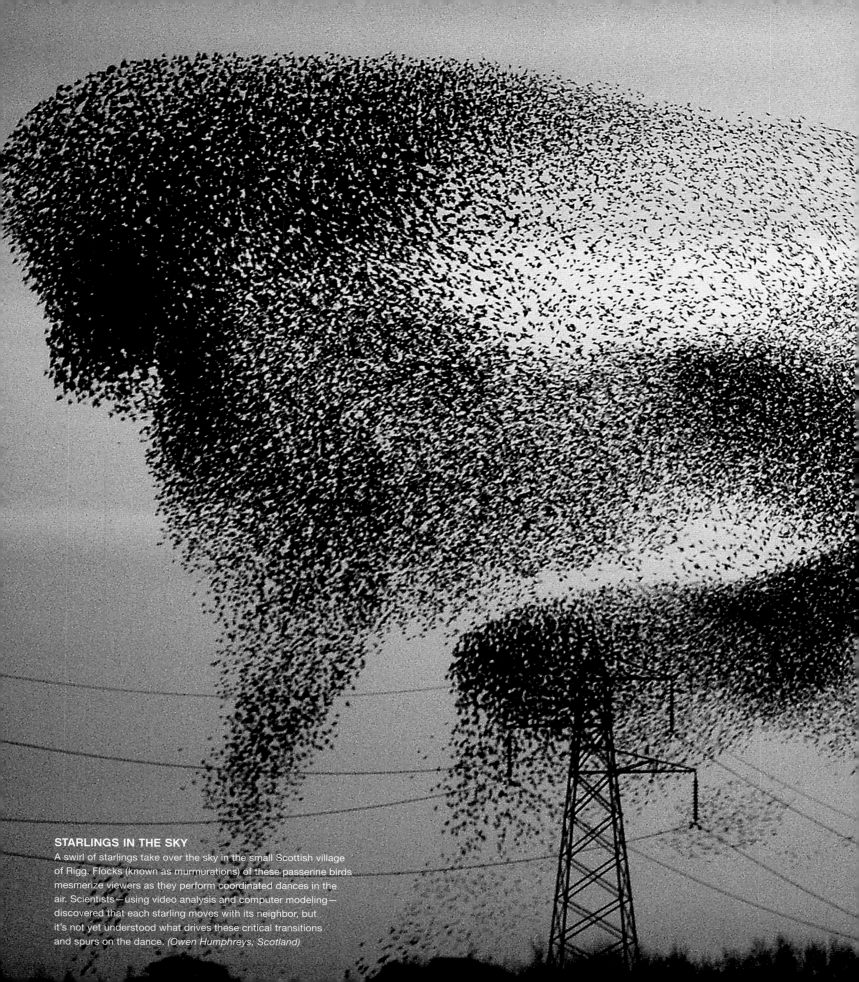

STARLINGS IN THE SKY

A swirl of starlings take over the sky in the small Scottish village of Rigg. Flocks (known as murmurations) of these passerine birds mesmerize viewers as they perform coordinated dances in the air. Scientists—using video analysis and computer modeling—discovered that each starling moves with its neighbor, but it's not yet understood what drives these critical transitions and spurs on the dance. *(Owen Humphreys, Scotland)*

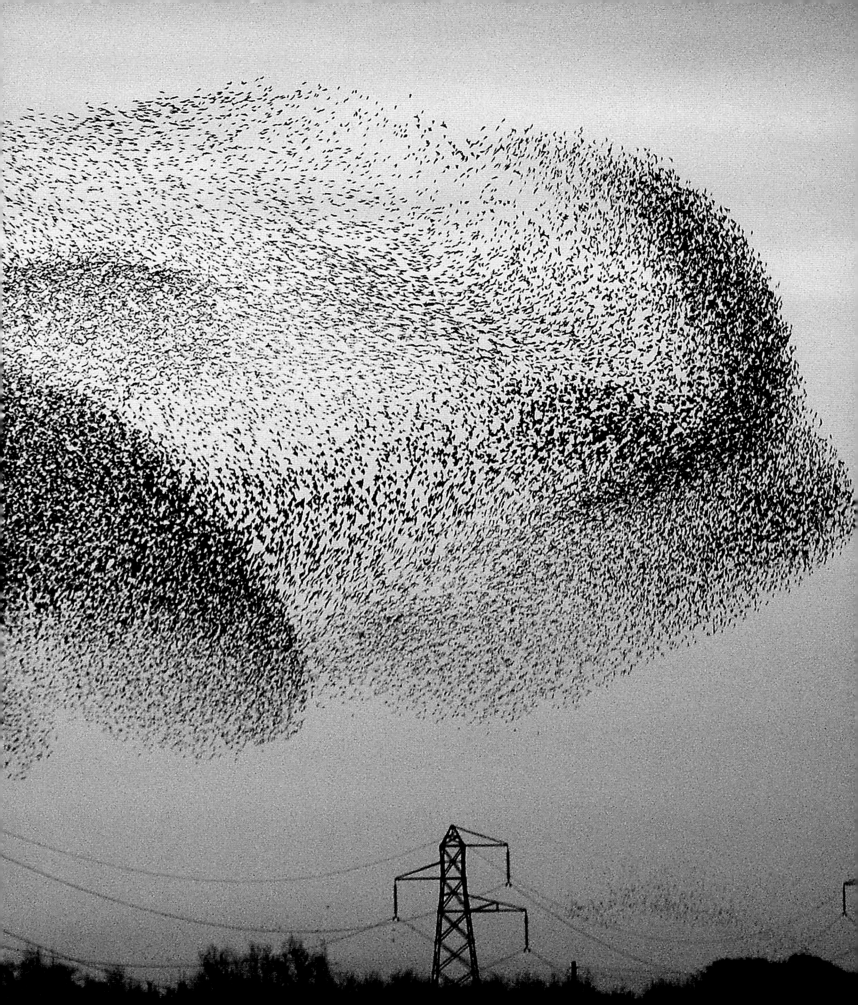

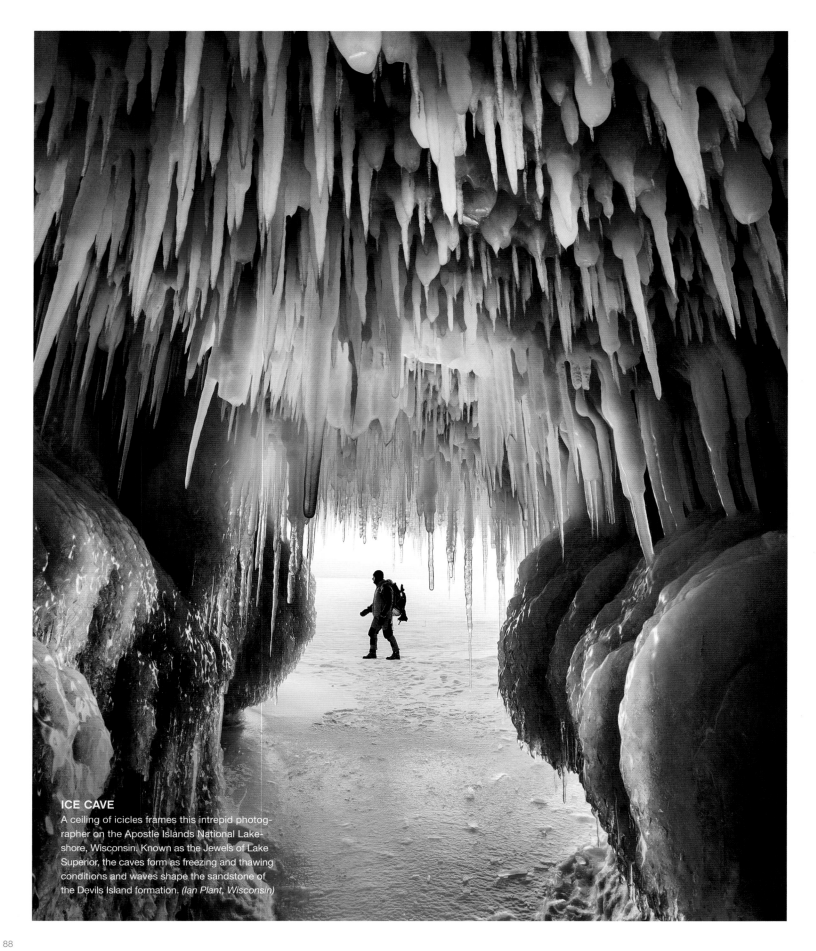

ICE CAVE

A ceiling of icicles frames this intrepid photographer on the Apostle Islands National Lakeshore, Wisconsin. Known as the Jewels of Lake Superior, the caves form as freezing and thawing conditions and waves shape the sandstone of the Devils Island formation. *(Ian Plant, Wisconsin)*

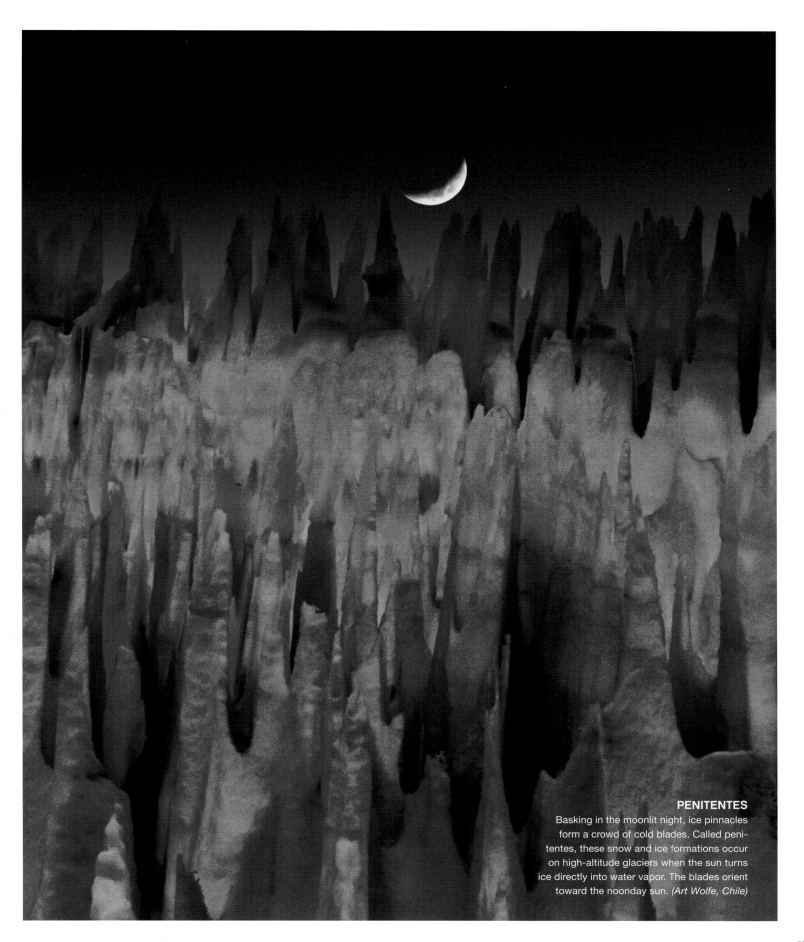

PENITENTES

Basking in the moonlit night, ice pinnacles form a crowd of cold blades. Called penitentes, these snow and ice formations occur on high-altitude glaciers when the sun turns ice directly into water vapor. The blades orient toward the noonday sun. *(Art Wolfe, Chile)*

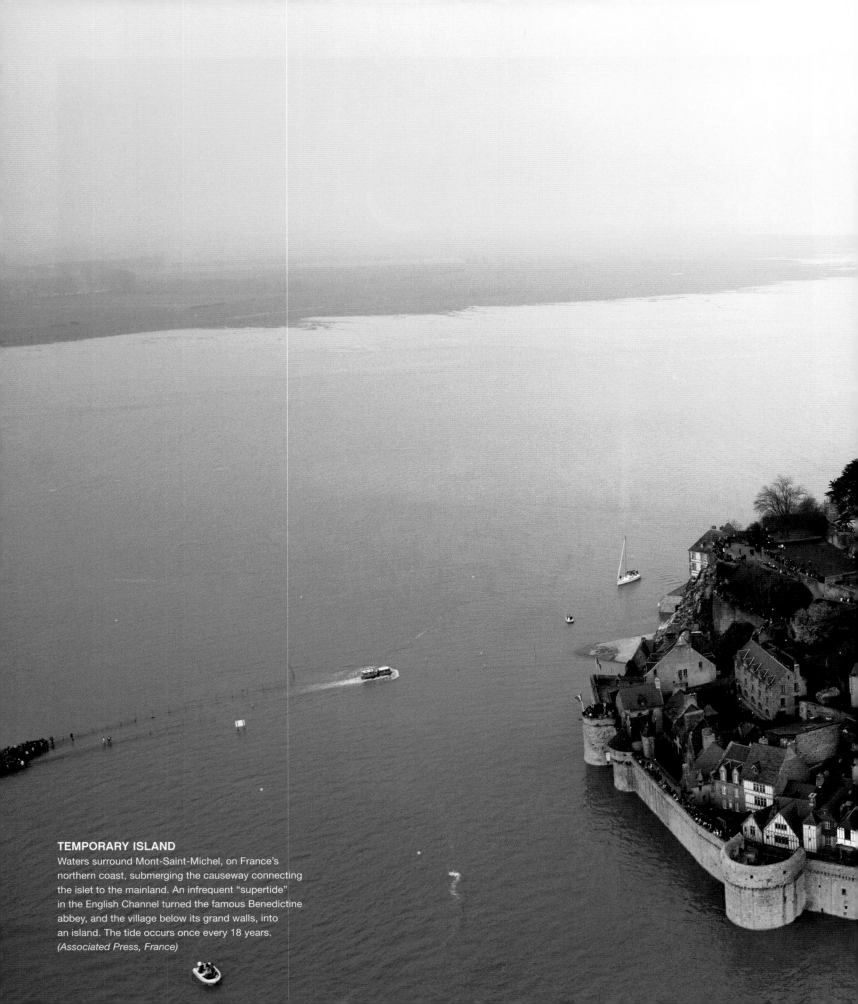

TEMPORARY ISLAND
Waters surround Mont-Saint-Michel, on France's
northern coast, submerging the causeway connecting
the islet to the mainland. An infrequent "supertide"
in the English Channel turned the famous Benedictine
abbey, and the village below its grand walls, into
an island. The tide occurs once every 18 years.
(Associated Press, France)

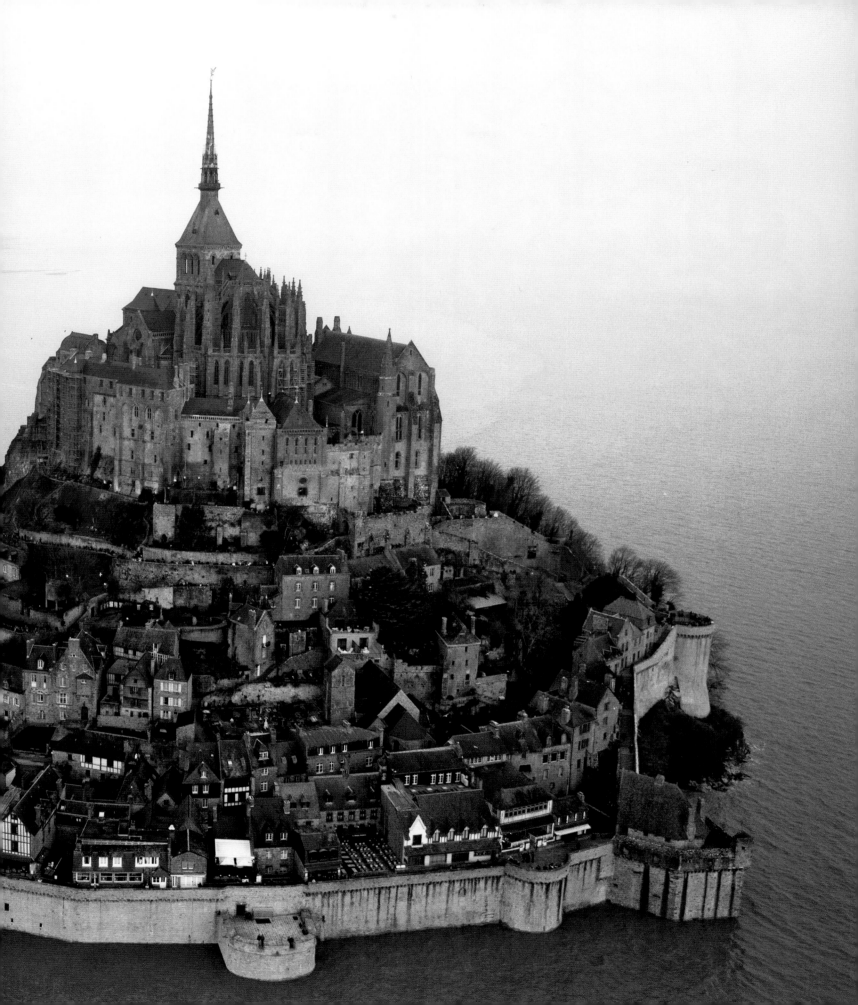

LIFE

MAN-OF-WAR
A close-up view of a Portuguese man-of-war *(Physalia physalis)* becomes an abstract scene. After this jellyfish-like creature washed up on a beach, it was placed on a light table to capture this stunning image—then returned to sea. Man-of-wars are made up of a collection of organisms. Their venomous stings, while painful, are rarely deadly. *(Aaron Ansarov, Florida)*

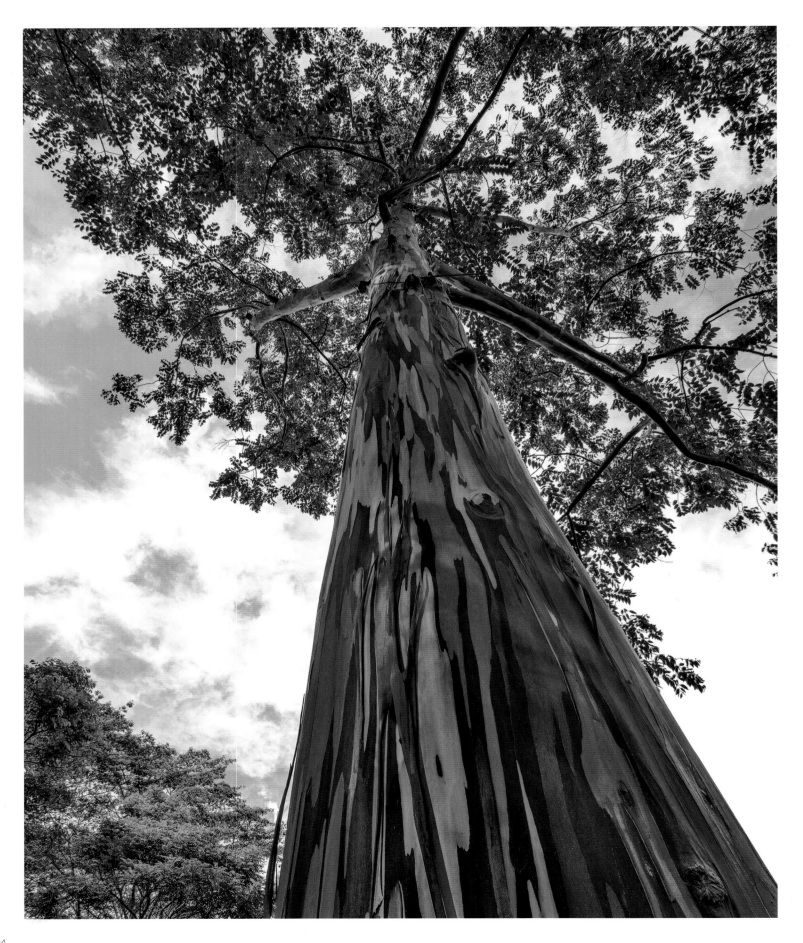

LIFE

From a single cell, from a tiny seed, from the meeting of minuscule bits of being, life blossoms into its many shapes and colors, many lives and many deaths.

We look one time and find order and symmetry. In this species, always six petals, always six stamens, always one pistil in the center of the flower, receptive and ready to make the next generation of seed. The arctic fox, always snow-white. The mountain gorilla, always umber eyes like its mother's.

We look again and find randomness, even disorder. The chance albino. A congress of crabs, each orange body a copy of the next, yet their slow crawls and superimpositions a chaos with no symmetry.

It is human nature to take delight in this tension between order and idiosyncrasy. Life is like that. A festival of lanterns, a skydivers' circle, a trained eagle, or prayer papers tossed to the wind. In all these life-forms, we revel in that conflict.

Photographers show us the beauty that hovers in between: the peak wisteria bloom so rarely seen, here today and gone tomorrow, year after year, past, present, future, ever different and always the same.

OPPOSITE: **RAINBOW RISING**
As the outer layer of the bark of this eucalyptus tree *(Eucalyptous deglupta)* peels off, the inner bright-green layer is exposed, weathering and darkening at different times, leading to this striking, multicolored bark. *(Laurence Norton, Hawaii)*

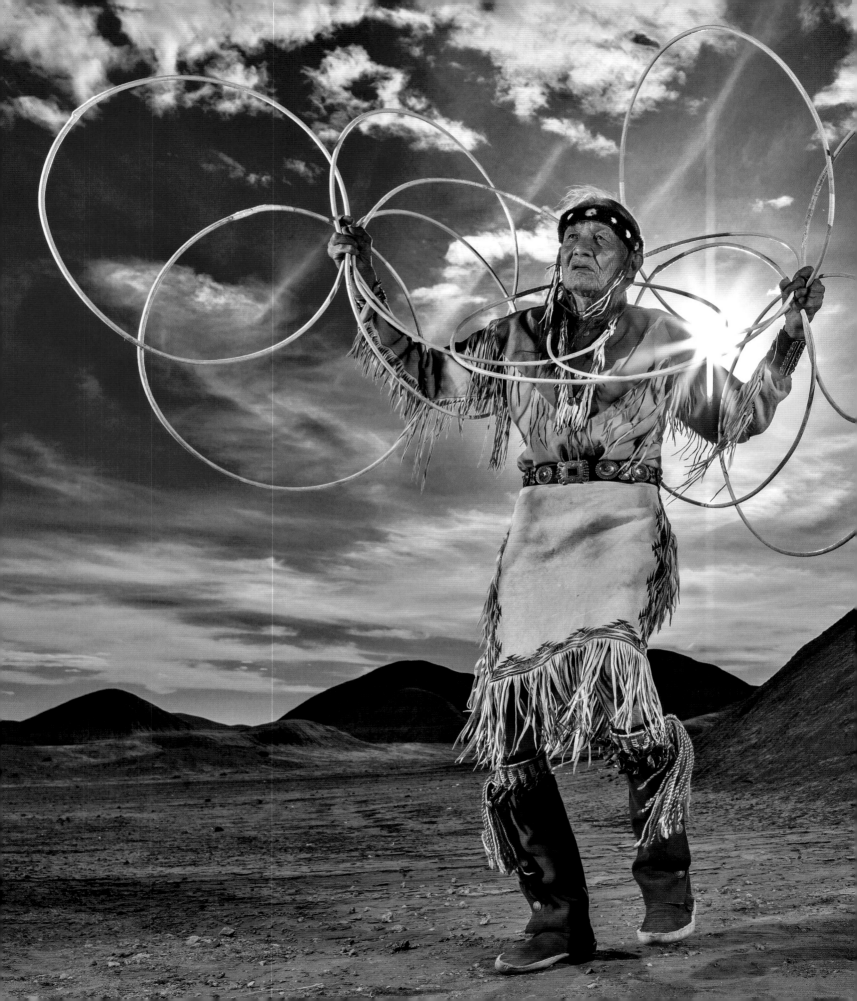

HOOP DREAMS
Sunlight catches the hoops of Navajo dancer and medicine man Jones Benally as his footfalls echo in a small canyon in the badlands of Cameron, Arizona. Traditionally performed at the end of a nine-day ceremony, the hoop dance tells a story: The hoops represent threads in the web of life, and the dance symbolizes life's never ending journey. *(Brent Stirton, Arizona)*

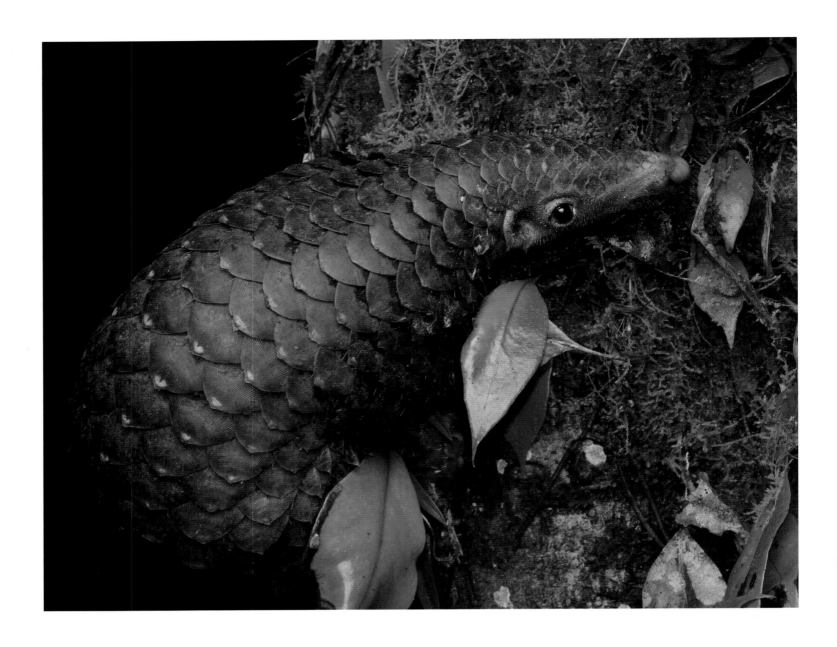

PANGOLIN

As this pangolin forages for termites and ants, its tough, overlapping scales (made of keratin) contrast against soft, green moss. While widely distributed throughout Southeast Asia, the Malayan pangolin *(Manis javanica)*, a critically endangered species, faces an uncertain future. *(Ch'ien Lee, Borneo, Malaysia)*

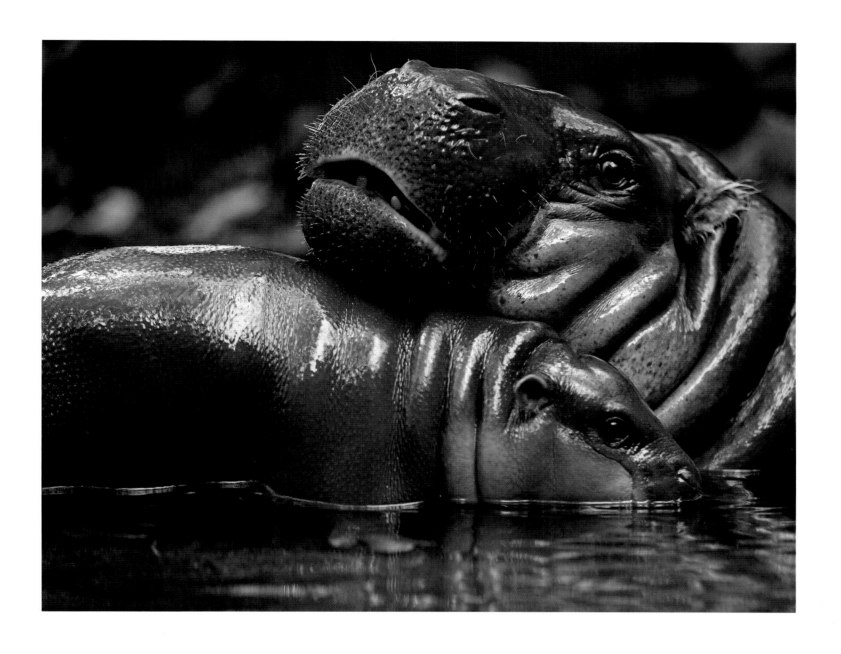

PYGMY HIPPO

A pygmy hippo *(Choeropsis liberiensis)* mother and calf share a tender moment in shallow water. The hippo's thin, greenish gray skin keeps them cool in their rain forest homes. These endangered animals are native to just four West African countries, and not much is known about the habits of this nocturnal vegetarian. *(Cyril Ruoso, West Africa)*

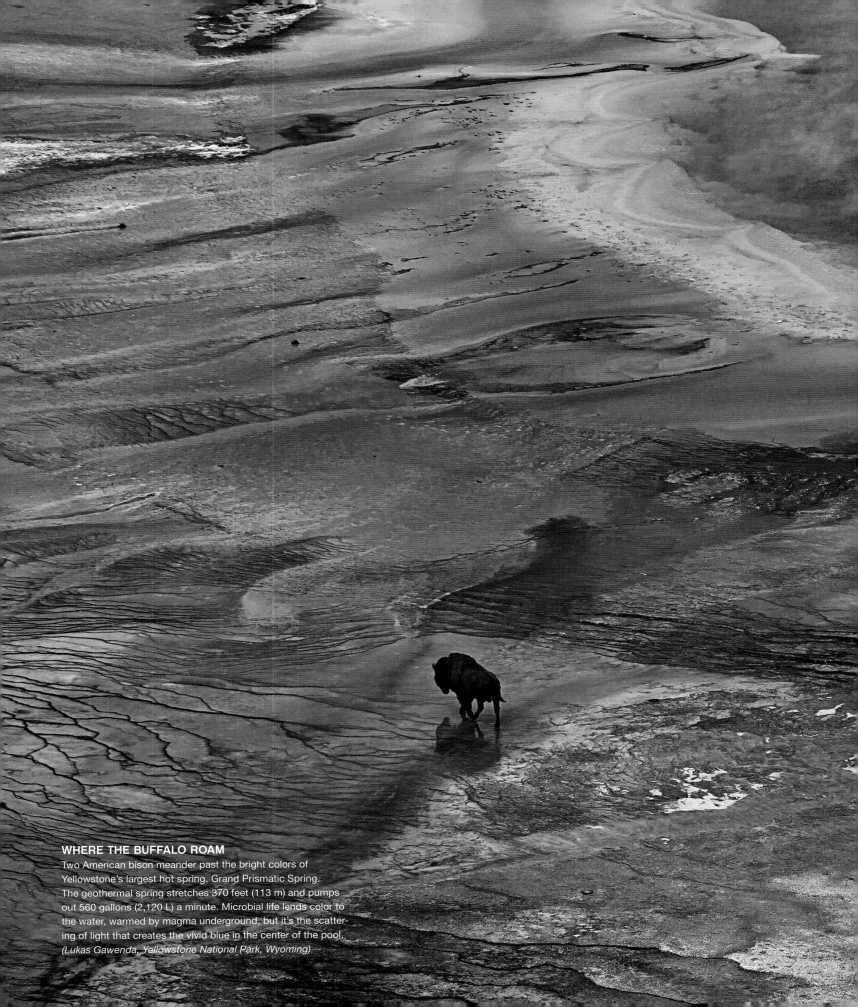

WHERE THE BUFFALO ROAM

Two American bison meander past the bright colors of Yellowstone's largest hot spring, Grand Prismatic Spring. The geothermal spring stretches 370 feet (113 m) and pumps out 560 gallons (2,120 L) a minute. Microbial life lends color to the water, warmed by magma underground, but it's the scattering of light that creates the vivid blue in the center of the pool. *(Lukas Gawenda, Yellowstone National Park, Wyoming)*

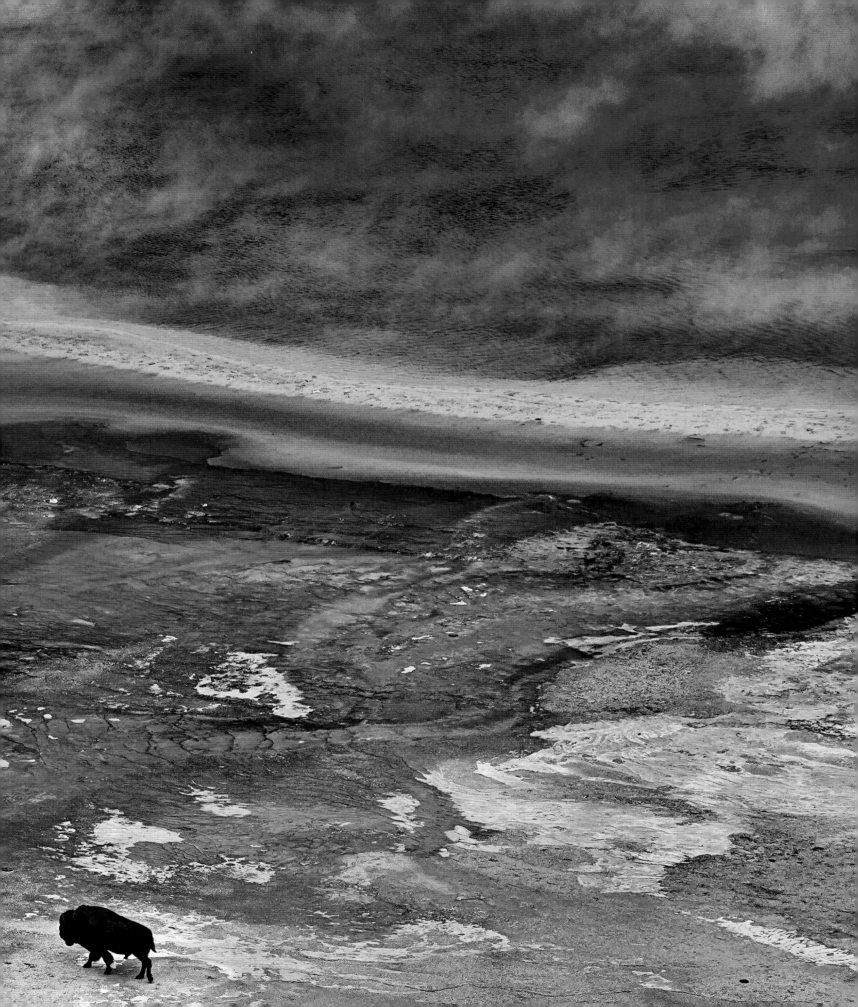

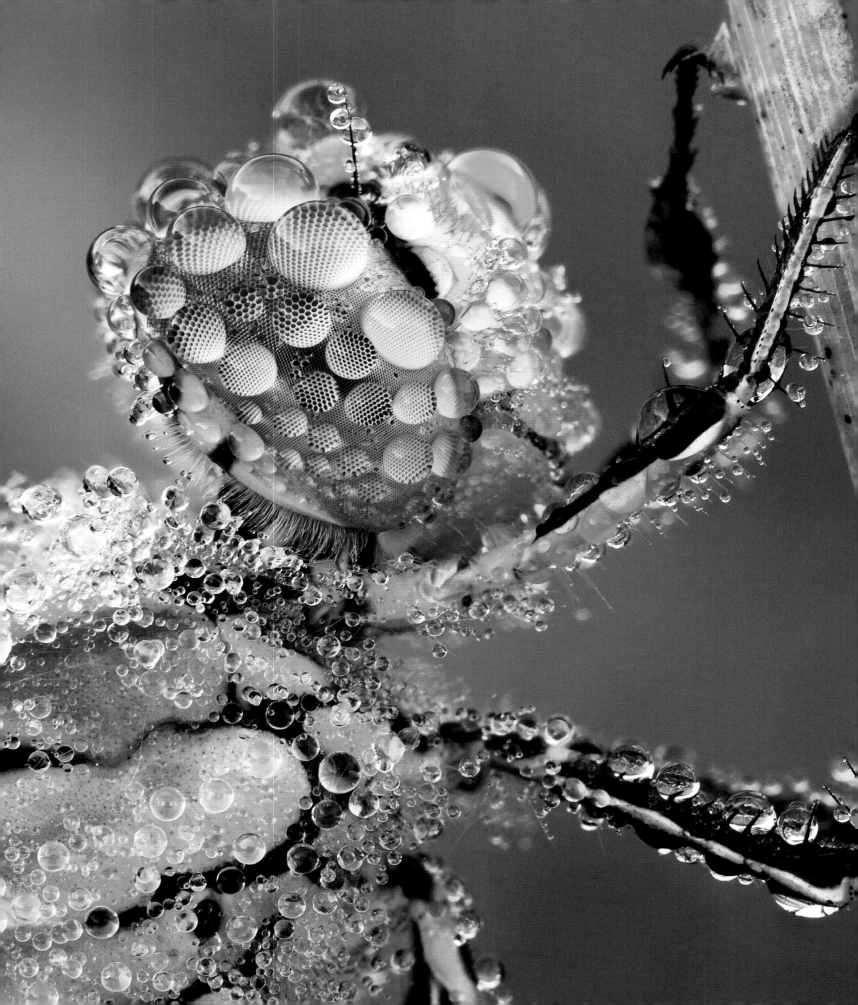

"This dragonfly, covered by millions of dewdrops that look like tiny glass pearls, makes this image something special for me. Particularly the drops, which act as little magnifiers to show the hexagonal structure of the insect's complex eye. The effect lasted until the dragonfly woke up from the torpor. Then it started wiping off the drops from its eyes."

MARTIN AMM

OPPOSITE: **DEWEY DRAGONFLY**
This close-up of dew covering a red-veined darter dragonfly makes the multicolored creature appear alien.
(Martin Amm, Kronach, Germany)

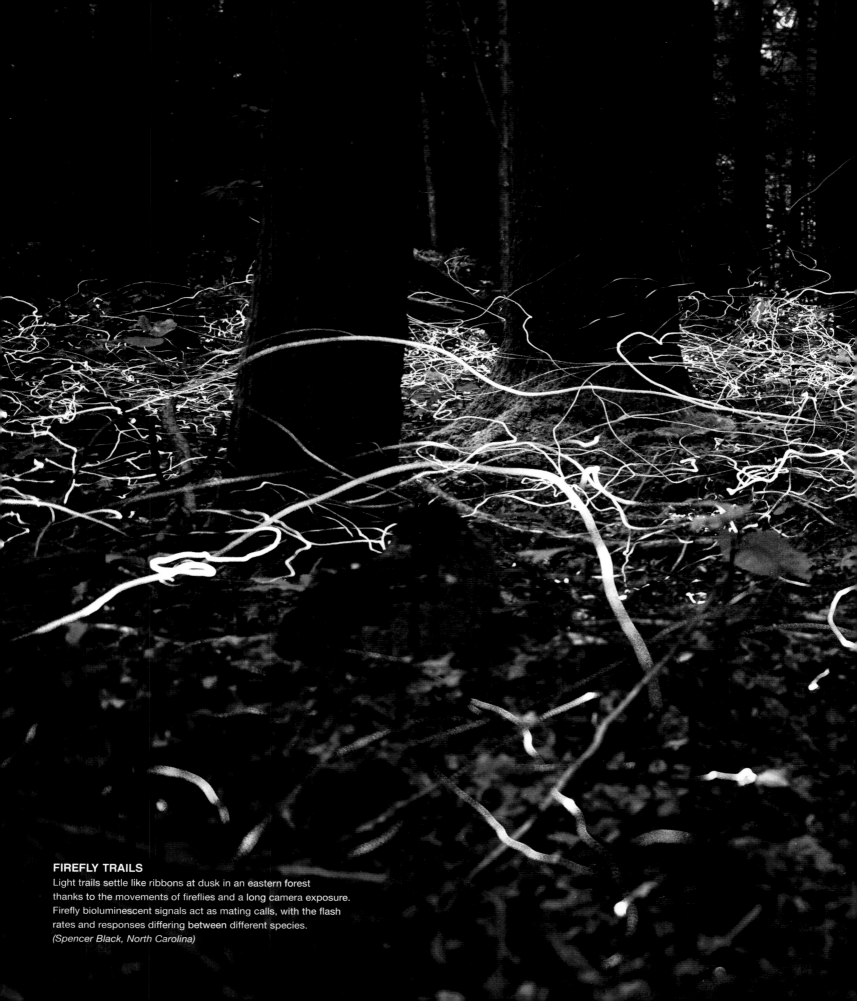

FIREFLY TRAILS

Light trails settle like ribbons at dusk in an eastern forest
thanks to the movements of fireflies and a long camera exposure.
Firefly bioluminescent signals act as mating calls, with the flash
rates and responses differing between different species.
(Spencer Black, North Carolina)

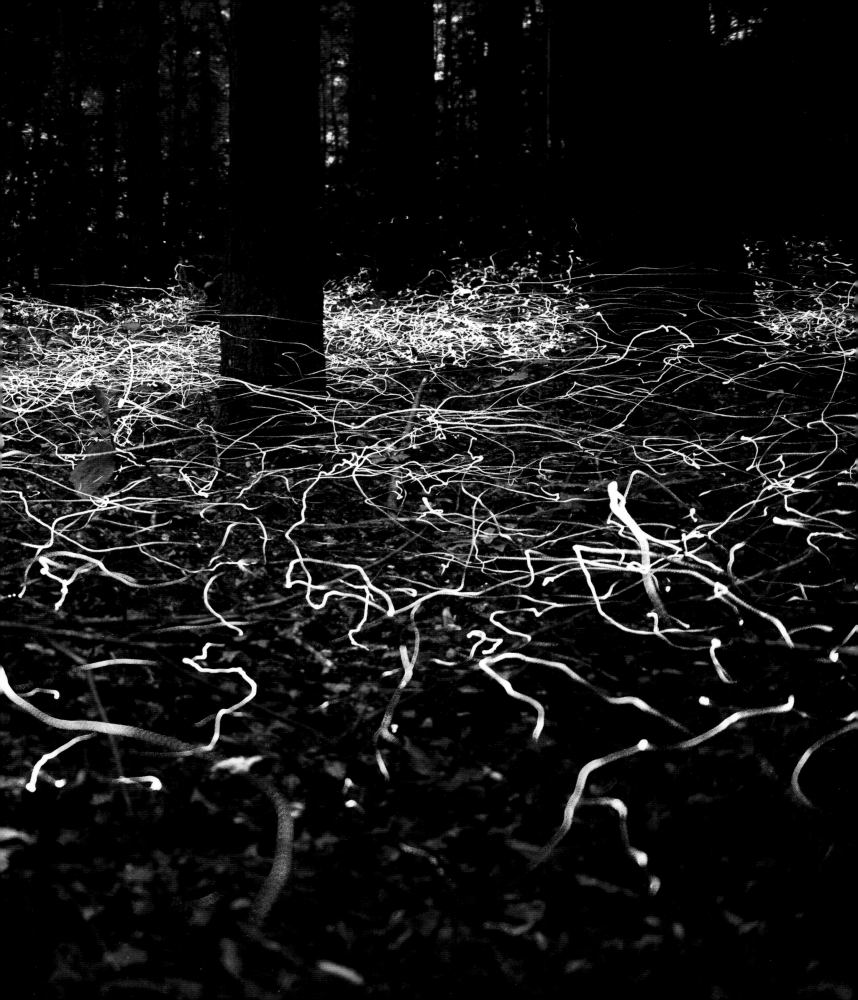

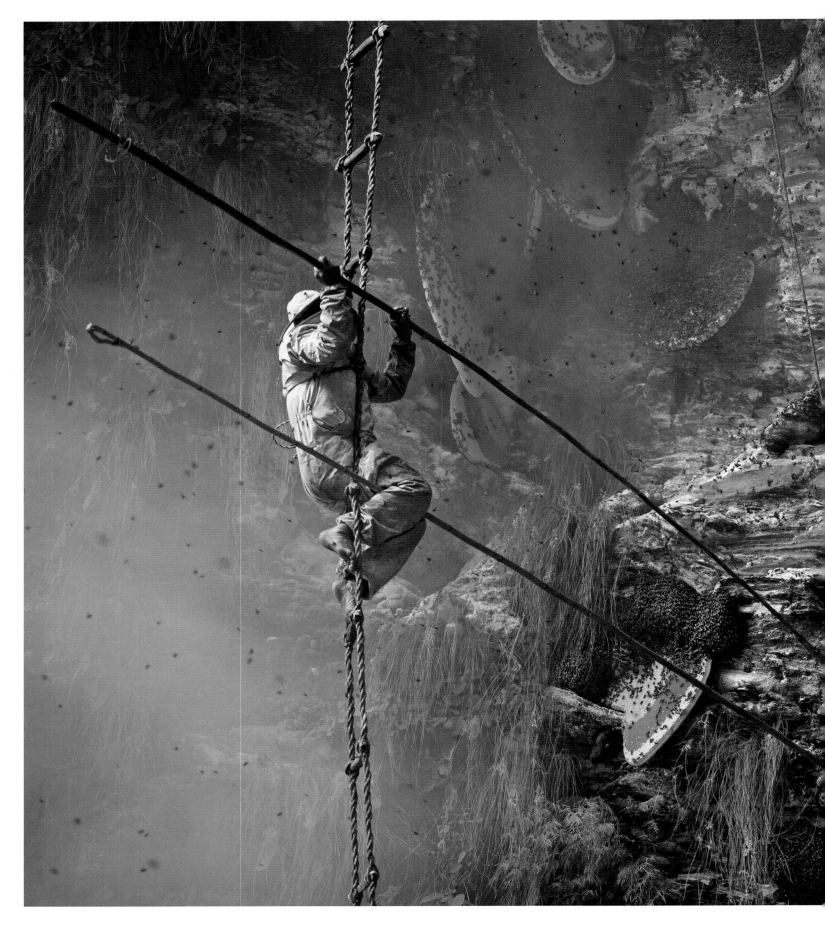

HONEY HUNTERS

Hanging hundreds of feet high on a rope ladder, a Gurung tribesman works to collect the nests of the largest honeybee in the world, *Apis laboriosa*. These Nepalese hunters practice eco-harvesting, making sure to leave enough nests for the next year. But attention from tourists and a medicinal market in Asia threaten the practice. *(Andrew Newey, Nepal)*

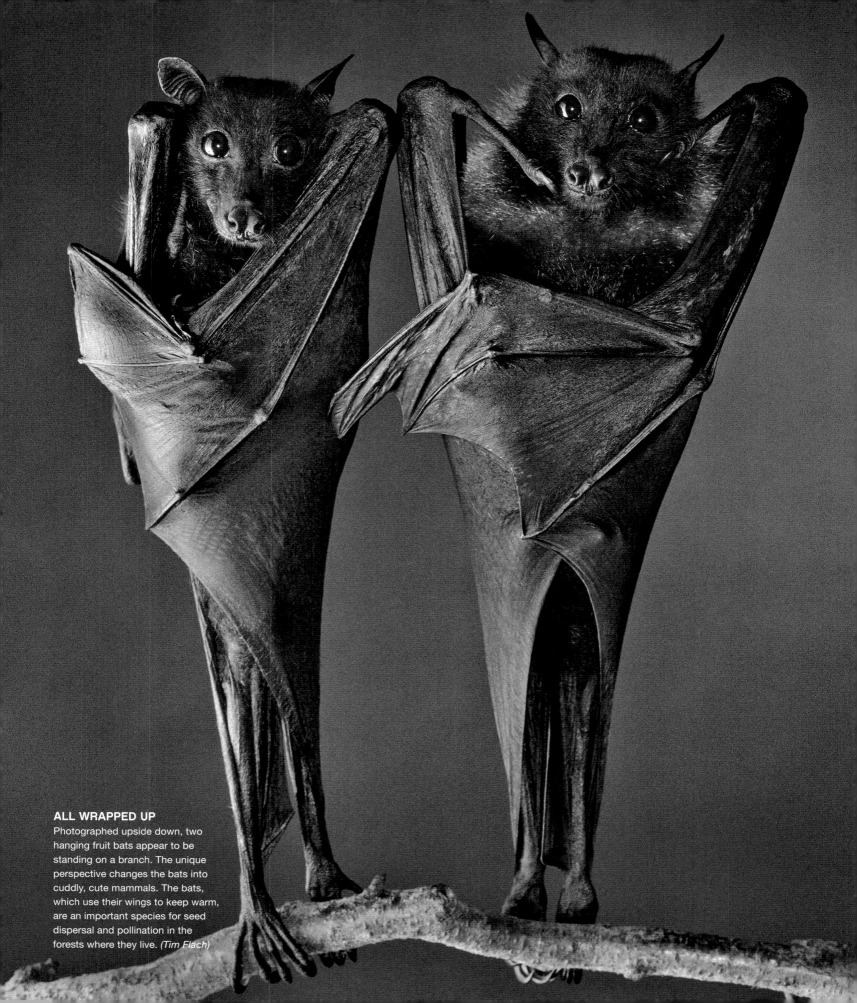

ALL WRAPPED UP
Photographed upside down, two hanging fruit bats appear to be standing on a branch. The unique perspective changes the bats into cuddly, cute mammals. The bats, which use their wings to keep warm, are an important species for seed dispersal and pollination in the forests where they live. *(Tim Flach)*

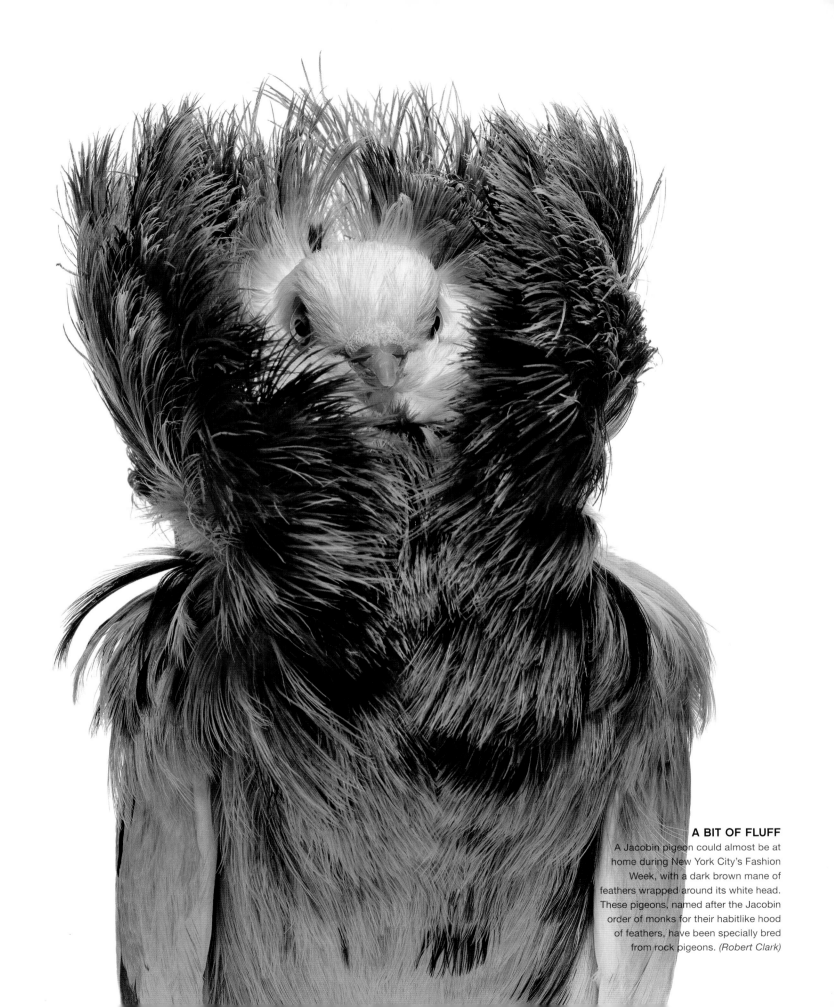

A BIT OF FLUFF

A Jacobin pigeon could almost be at home during New York City's Fashion Week, with a dark brown mane of feathers wrapped around its white head. These pigeons, named after the Jacobin order of monks for their habitlike hood of feathers, have been specially bred from rock pigeons. *(Robert Clark)*

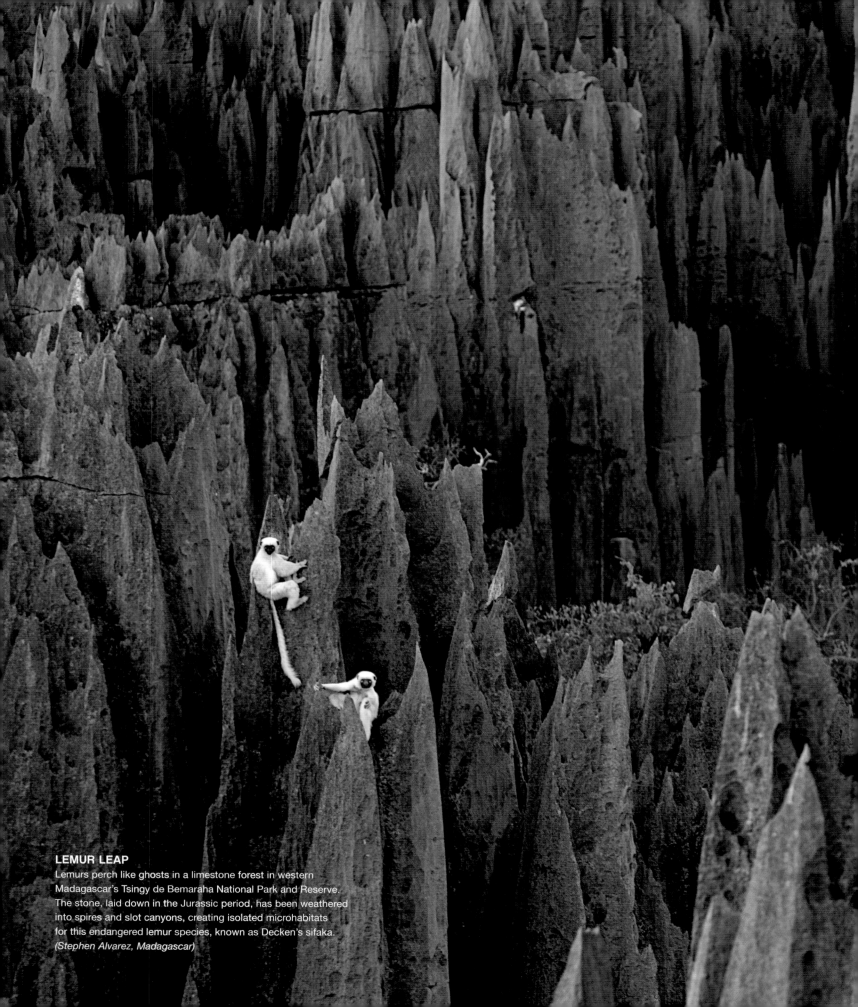

LEMUR LEAP
Lemurs perch like ghosts in a limestone forest in western
Madagascar's Tsingy de Bemaraha National Park and Reserve.
The stone, laid down in the Jurassic period, has been weathered
into spires and slot canyons, creating isolated microhabitats
for this endangered lemur species, known as Decken's sifaka.
(Stephen Alvarez, Madagascar)

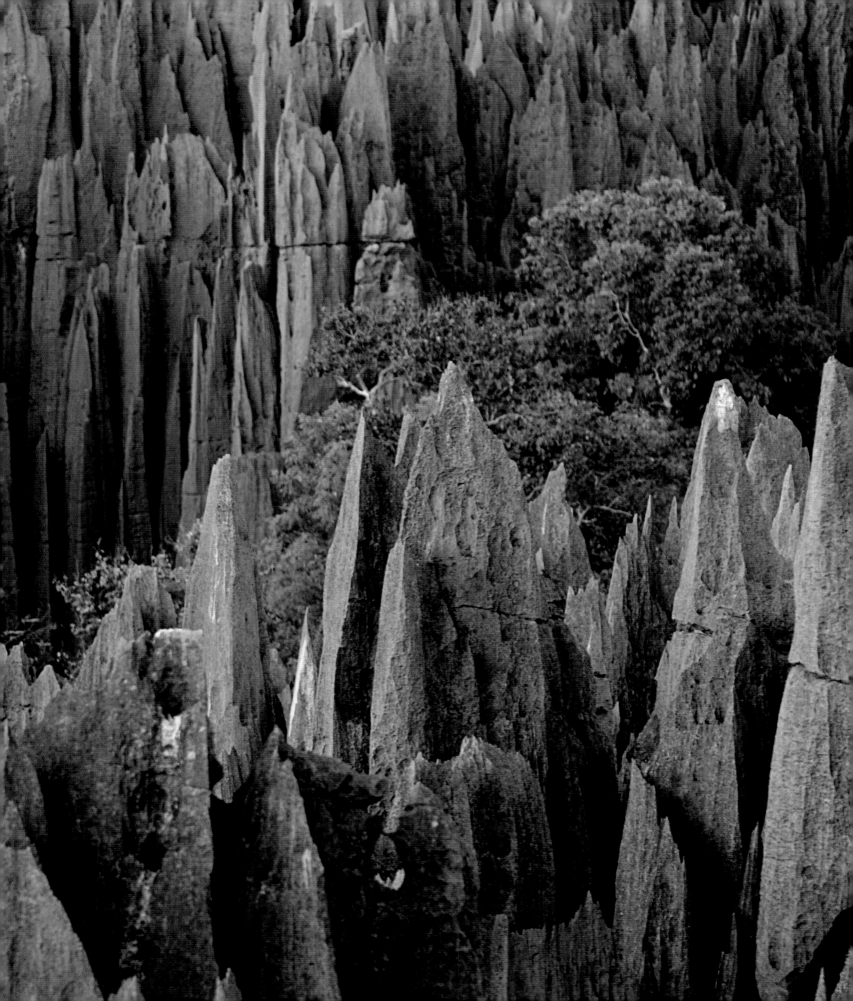

"I found this submerged tree trunk in Jiuzhaigou, China's most popular national park, famous for its translucent turquoise waters. With moss and wild flowers growing from the top, it had obviously been there a long time. I shot several frames from different angles, working to control the reflections and saturate the color of this amazing, floating mini-garden. A year later I returned after a major earthquake struck the area and it was gone, never to be photographed again."

MICHAEL S. YAMASHITA

OPPOSITE: **SPROUTING TREE**
A submerged tree wears a hat of greenery in China's Panda Lake, one of more than 100 lakes found in the Jiuzhaigou Nature Reserve. *(Michael S. Yamashita, Jiuzhaigou, China)*

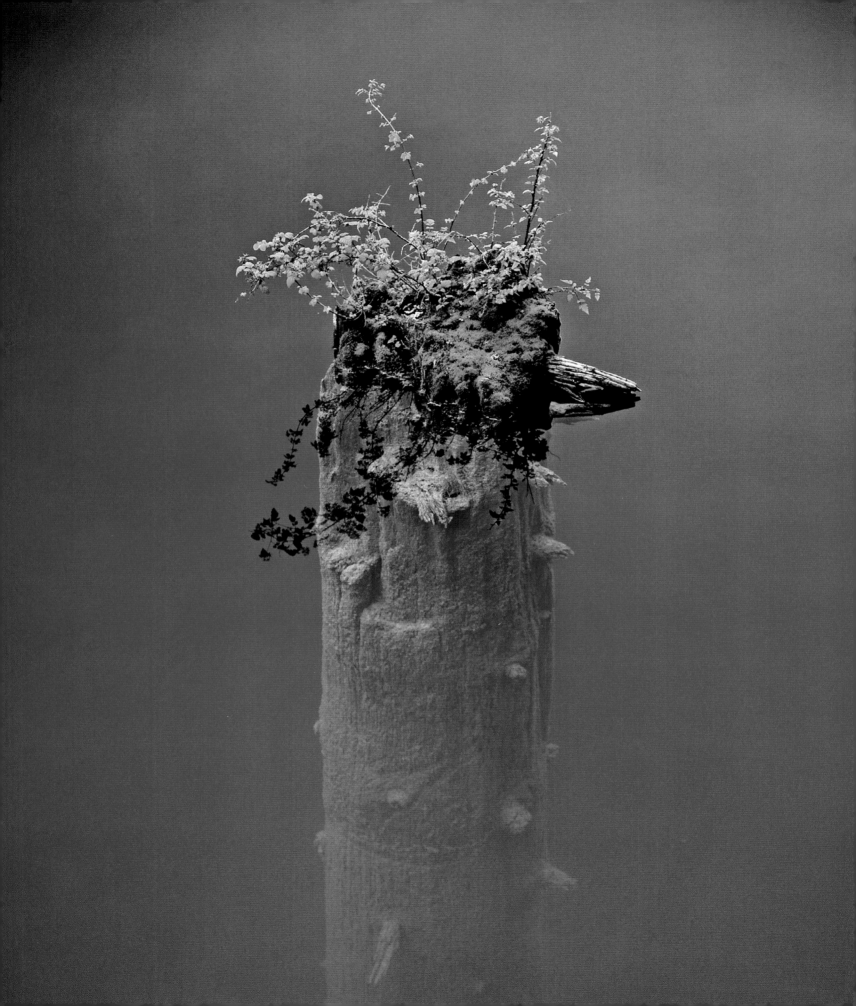

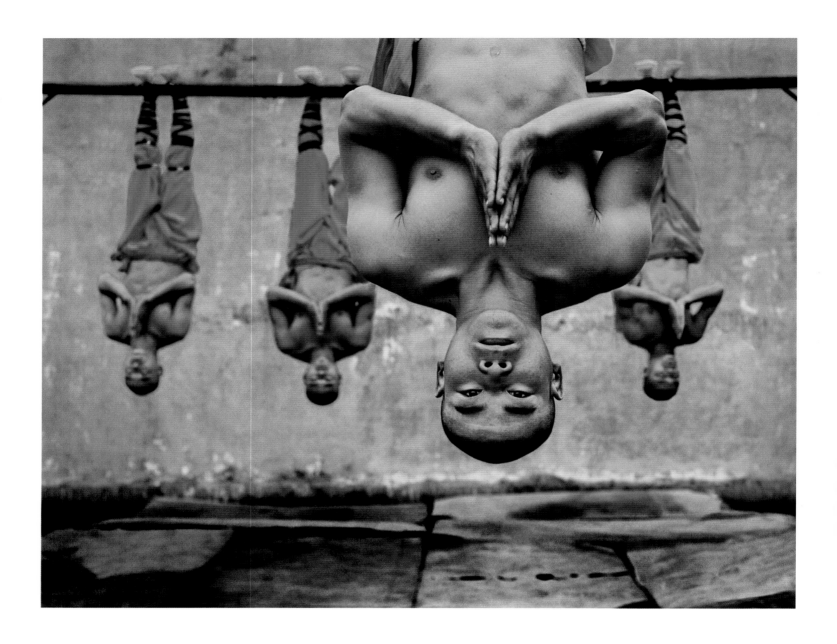

SHAOLIN MONKS

Buddhist monks in training hang upside down in Shaolin
Monastery in Zhengzhou, China. The monks practice their
faith through martial arts in a form known as Shaolin kung fu.
Used for defense, the practice is marked by self-restraint
and refined movement. *(Steve McCurry, China)*

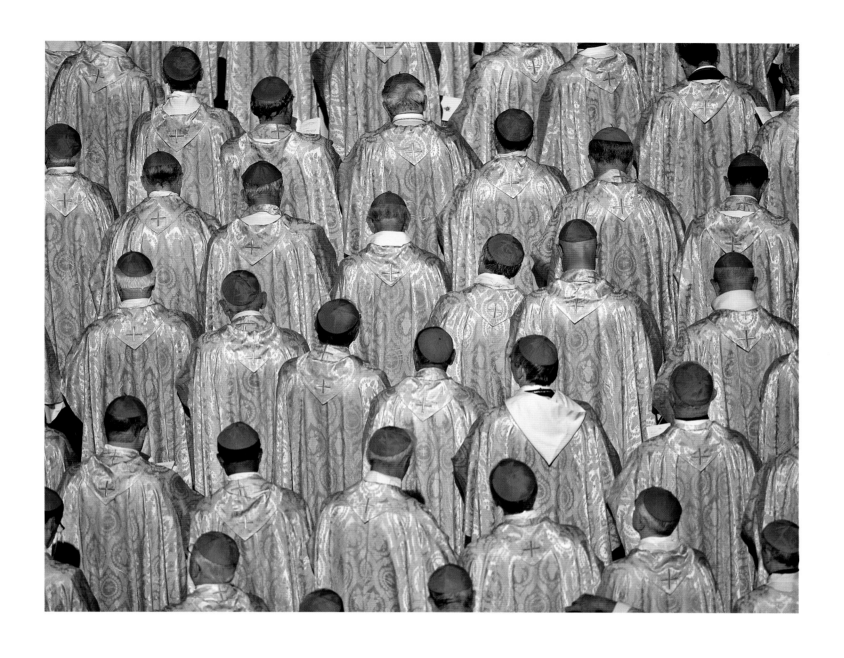

CEREMONIAL GATHERING

In October 2014, bishops in St. Peter's Square at the Vatican gathered for the beatification ceremony of Pope Paul VI and a Mass at the close of a synod, celebrated by Pope Francis. The Roman Catholic Church has about 5,000 bishops and a flock of 1.2 billion faithful. *(Andrew Medichini, Vatican City)*

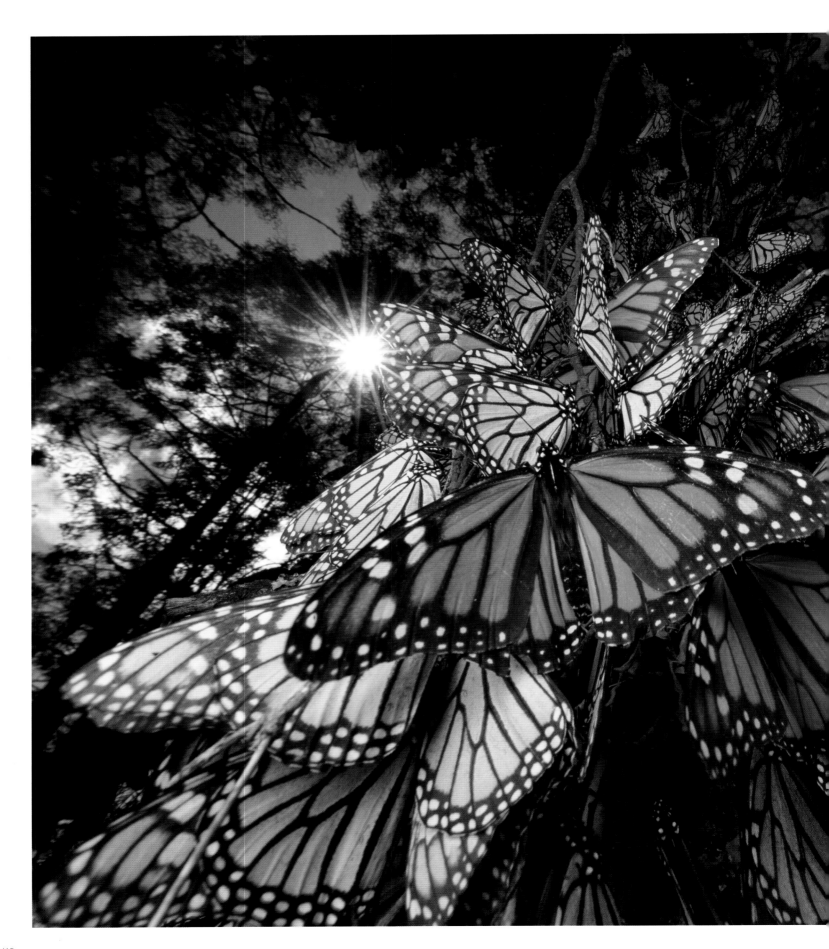

MONARCH MIGRATION

Monarch butterflies flutter toward the sun in a fir forest in Sierra Chincua, Mexico. Millions of the butterflies migrate—the only butterfly species to do so—to their winter roosts, which are in just a handful of locations in Mexico and California. Logging can disturb the insects, which cluster on the trees through the winter in high-elevation forests. *(Joel Sartore, Mexico)*

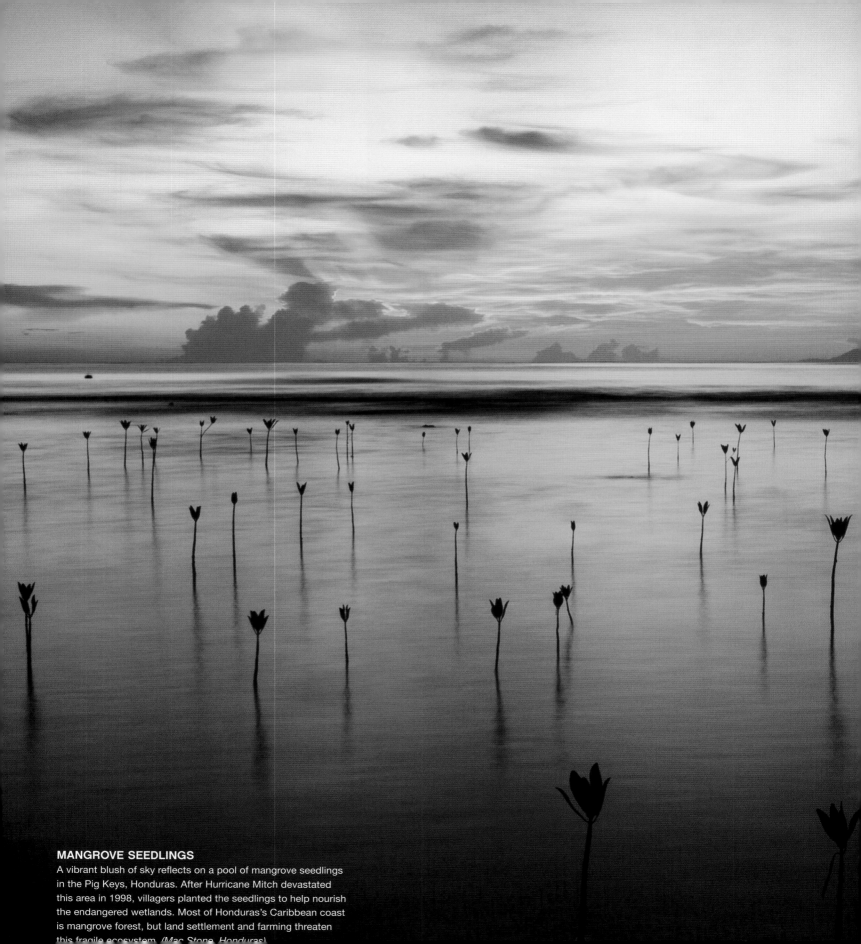

MANGROVE SEEDLINGS

A vibrant blush of sky reflects on a pool of mangrove seedlings
in the Pig Keys, Honduras. After Hurricane Mitch devastated
this area in 1998, villagers planted the seedlings to help nourish
the endangered wetlands. Most of Honduras's Caribbean coast
is mangrove forest, but land settlement and farming threaten
this fragile ecosystem. (Mac Stone, Honduras)

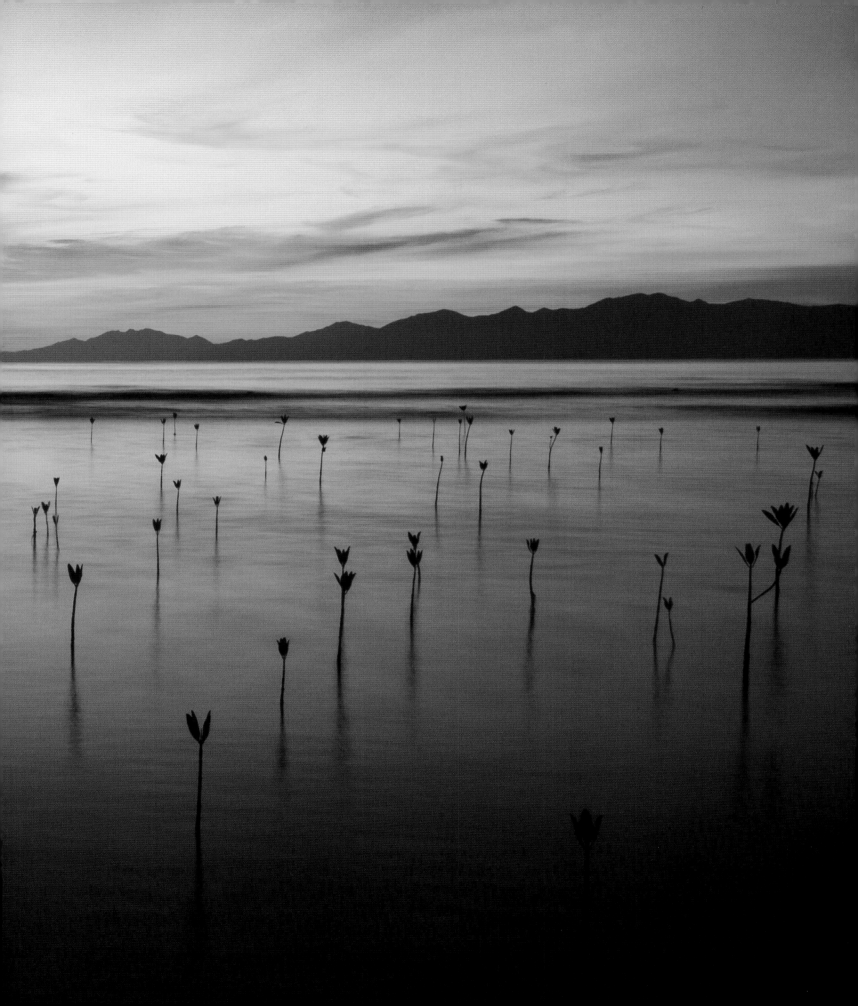

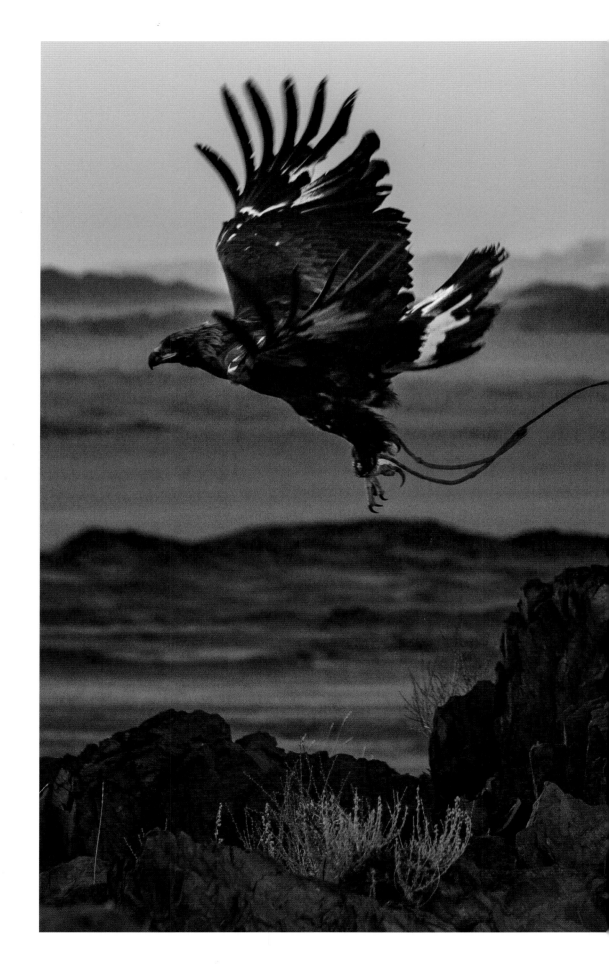

FEMALE EAGLE HUNTER

Kazakh golden eagle hunter Ashol Pan, the first girl trained in the ancient art, smiles as she joyously lets her eagle go. Her father, an experienced eagle hunter, brought her to the mountains to train after her older brother left to become an officer in the army. Families train the eagles to return with prey, then free the eagles back to the wild after a few years. *(Asher Svidensky, Mongolia)*

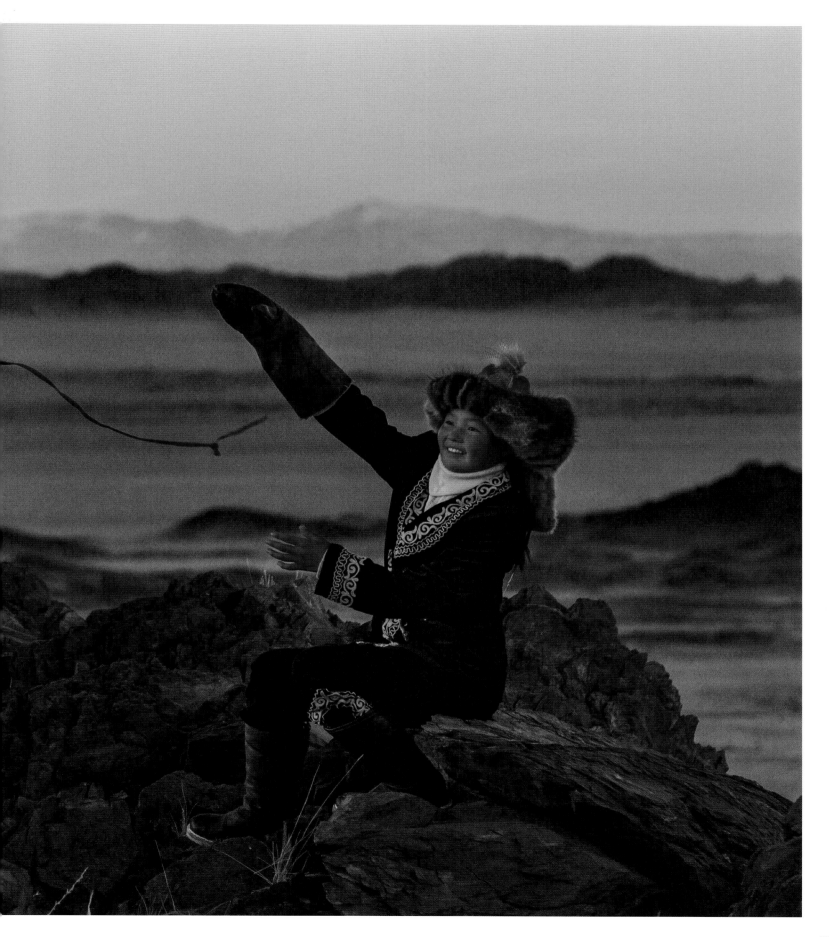

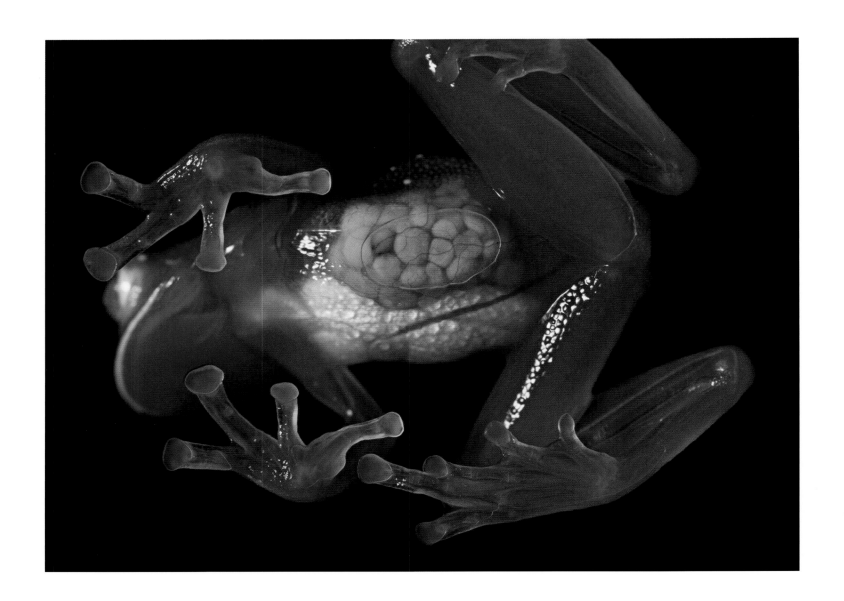

SEE-THROUGH FROG

Offering an inside look, the transparent body of a female glass frog shows her eggs. The 1-to-3-inch-long (2.5-to-7.62-cm) frogs spend their lives in trees and will lay eggs in bushes and branches over forest streams. *(Heidi and Hans-Jurgen Koch, Venezuela)*

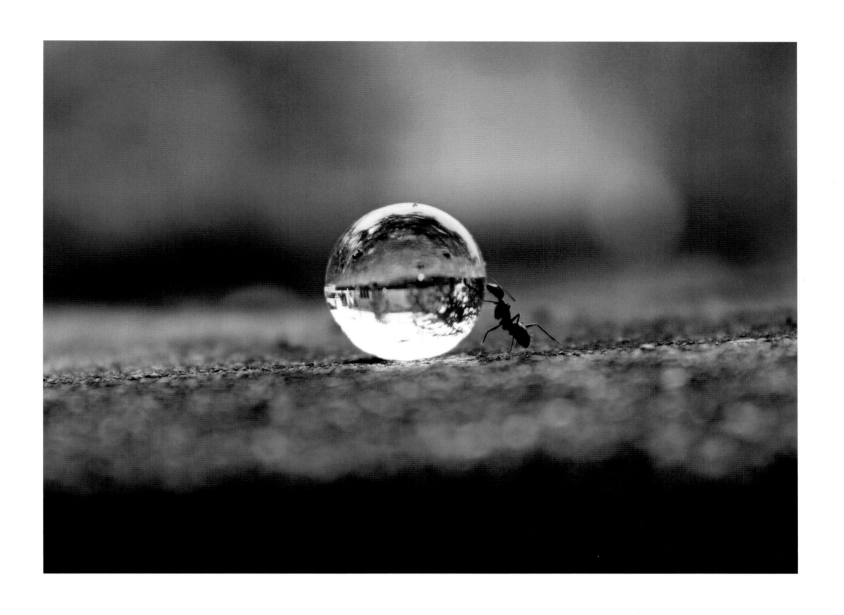

WATER WORLD

An ant pushes a spherical droplet of water down a paved path, and in the process the droplet creates a mirrored reflection of the ant's world. With more than 10,000 known ant species, these social insects play an important ecological role by aerating soils and dispersing seeds. *(Rakesh Rocky, Warangal, India)*

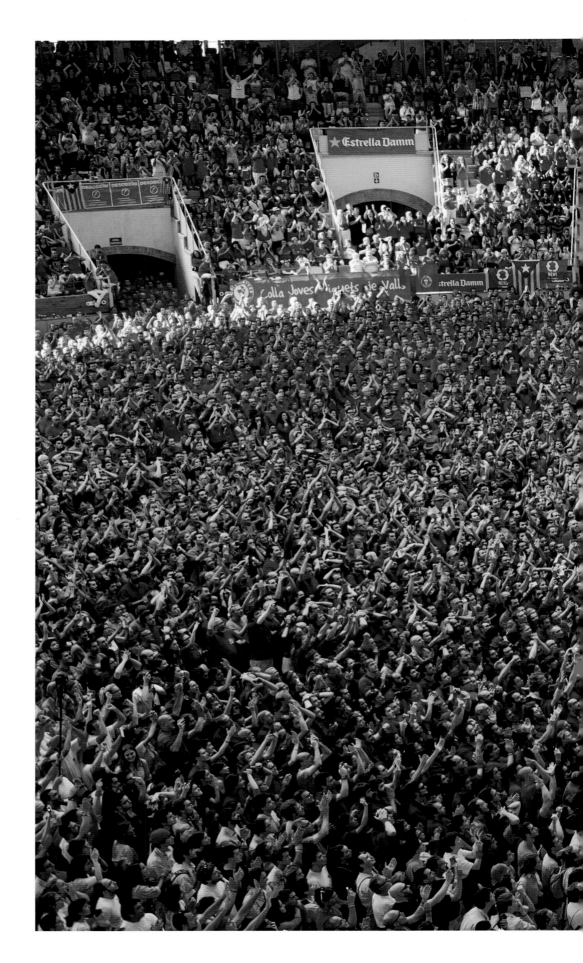

HUMAN TOWER

Purple-shirted *castellers* climb out of a sea of other competitors at the 25th Castells Competition in Tarragona, Spain. Such complex human towers are a Catalan tradition and art form. The competitions pit different groups, or *colles,* against one another to build taller and taller towers. Sometimes hundreds of people form the base—teamwork and passion bind the castellers together.
(Alex Caparros, Spain)

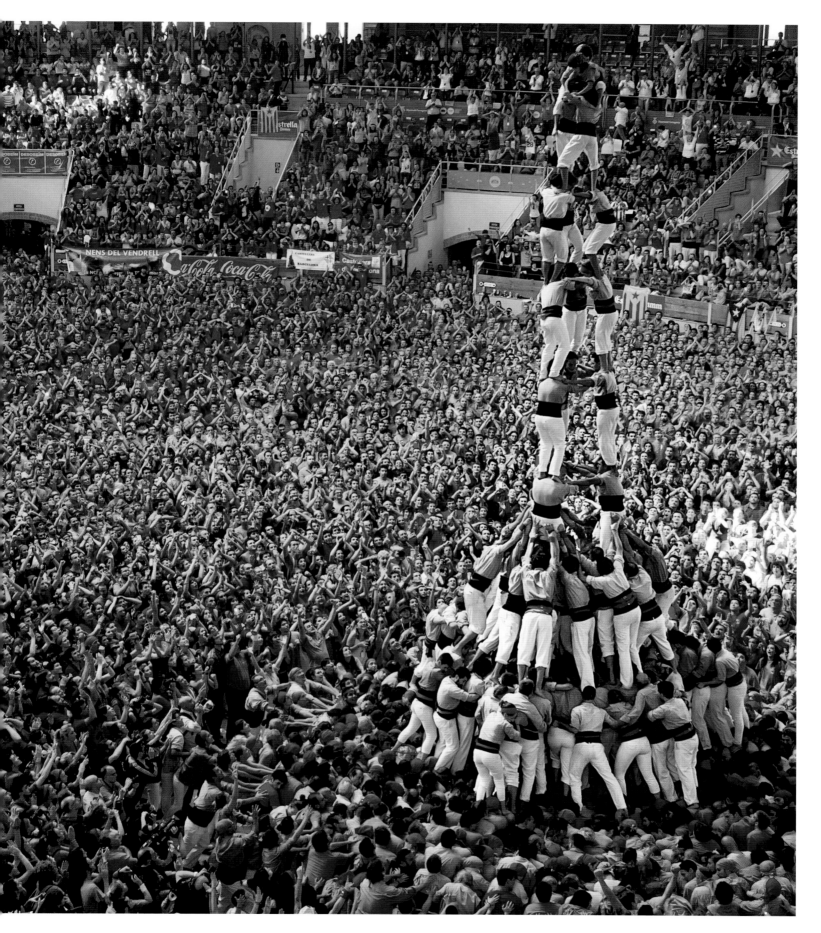

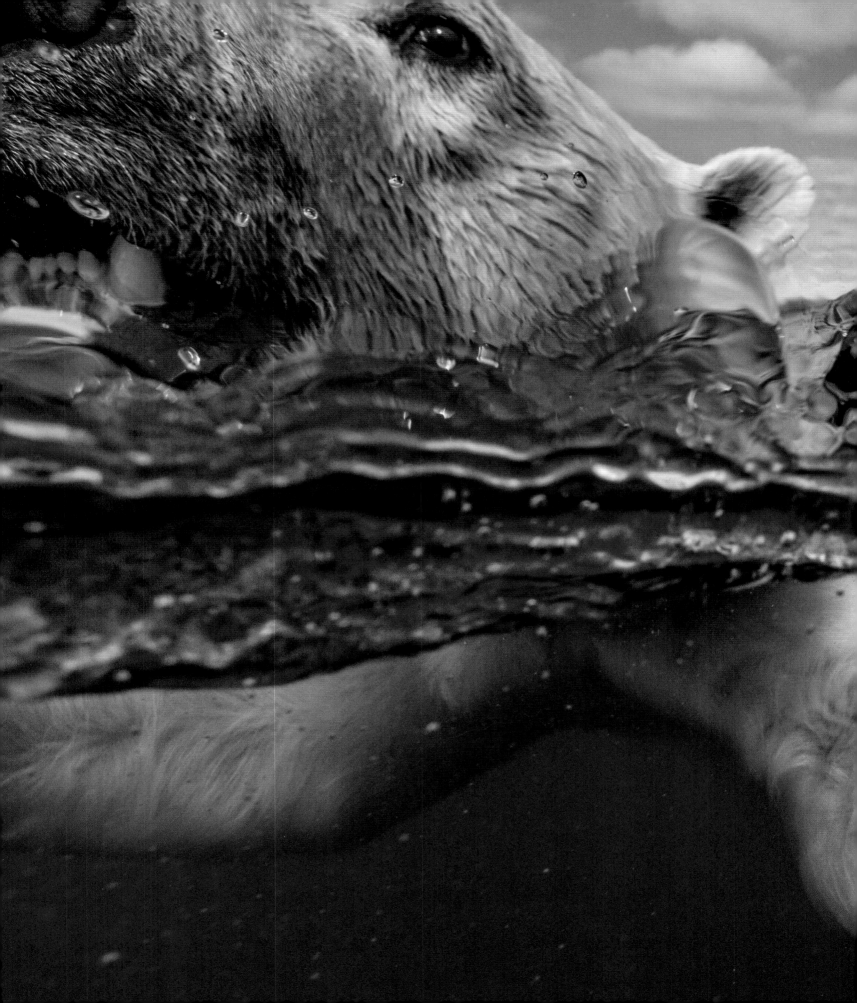

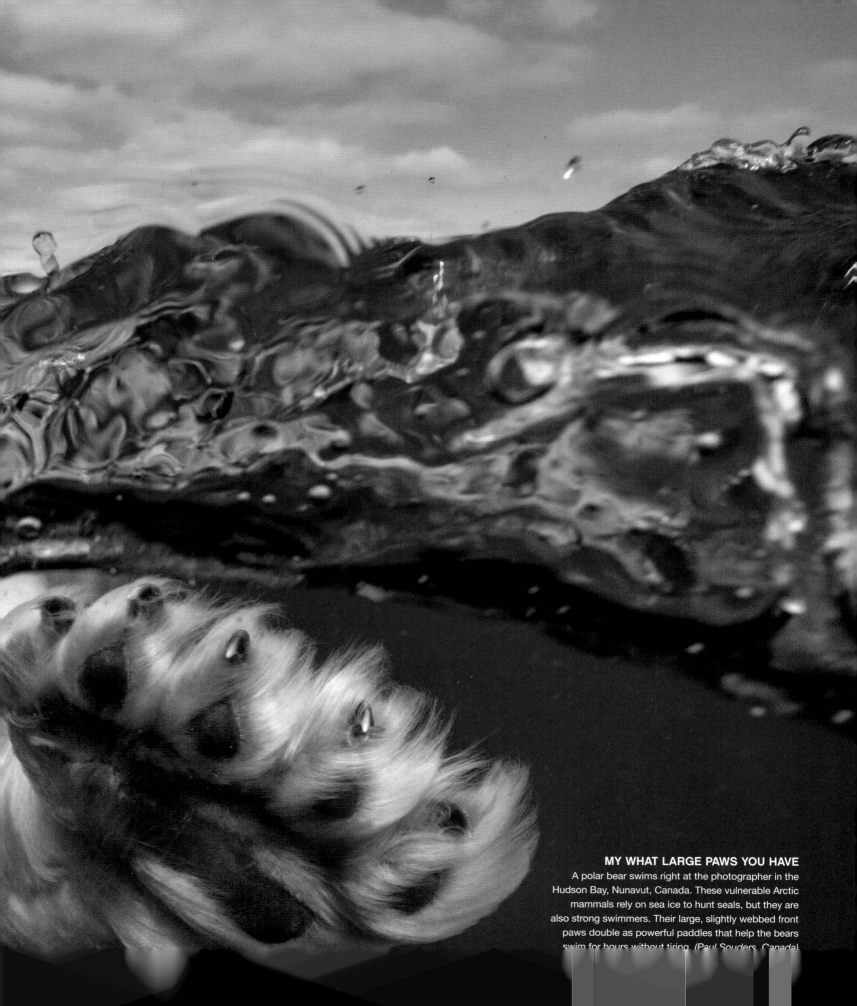

MY WHAT LARGE PAWS YOU HAVE

A polar bear swims right at the photographer in the Hudson Bay, Nunavut, Canada. These vulnerable Arctic mammals rely on sea ice to hunt seals, but they are also strong swimmers. Their large, slightly webbed front paws double as powerful paddles that help the bears swim for hours without tiring. *(Paul Souders, Canada)*

"You're looking at one of the rarest species on Earth. Australia's orange-bellied parrot is down to just 70 individuals in the wild, but don't count it out just yet. Captive breeding by Zoos Victoria [Australia] offers real hope, thanks to people who care deeply about all creatures, great and small. And that's a very good thing. After all, when we save other species, we're actually saving ourselves."

JOEL SARTORE

OPPOSITE: **ORANGE-BELLIED PARROT**
Critically endangered, the orange-bellied parrot *(Neophema chrysogaster)* breeds
at only one known site in southwest Tasmania. *(Joel Sartore, Australia)*

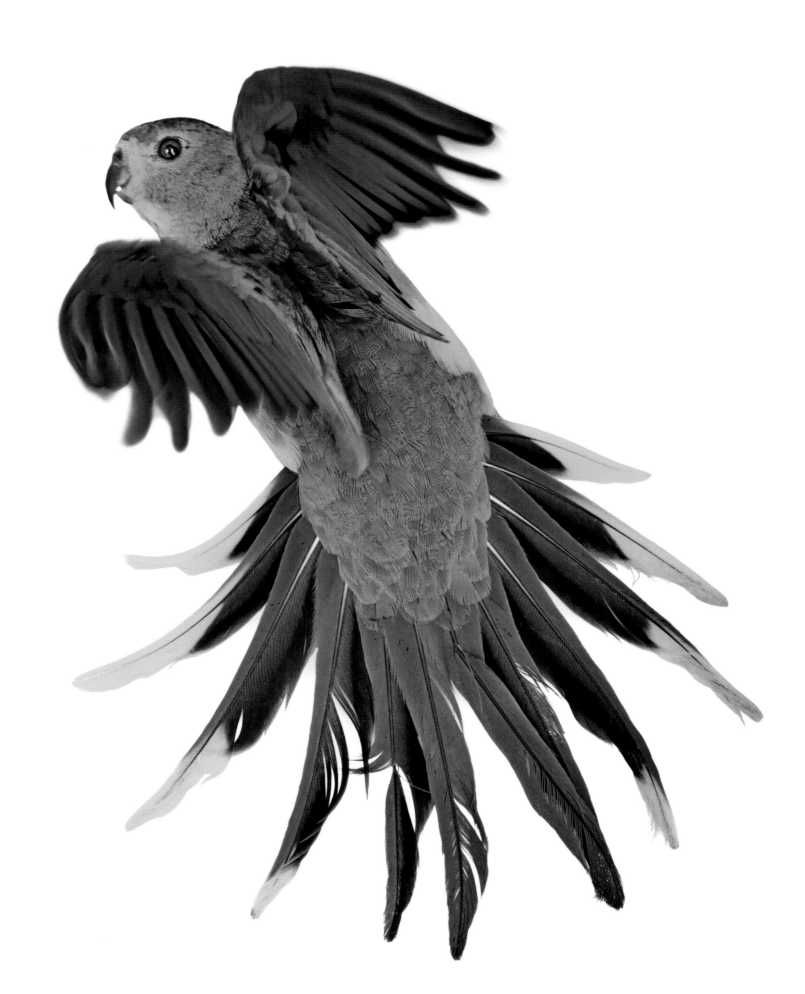

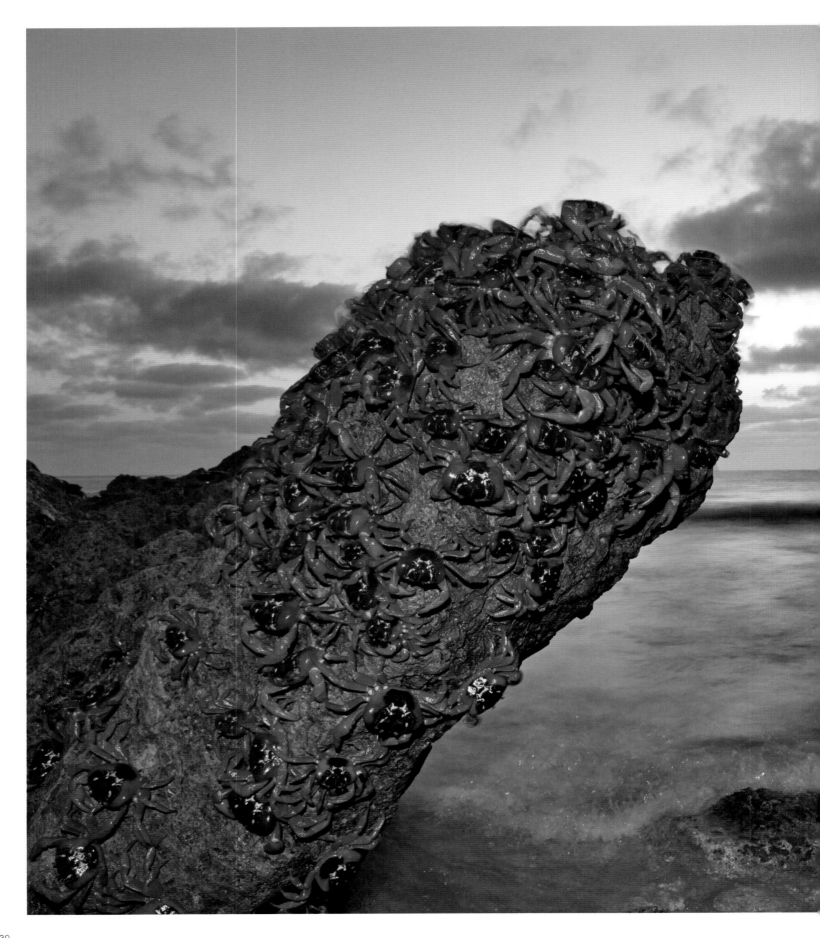

CONGRESS OF CRABS

As sunrise brightens a beach on Christmas Island, red crabs *(Gecarcoidea natalis)* swarm a rocky outpost. The crabs, which recycle nutrients, are a keystone species on this remote island. Once a year, tens of millions of crabs make their way from the forest to the sea to spawn, a timing keyed to the high tide. This annual migration is seen nowhere else on Earth.

(Ingo Arndt, Christmas Island, Indian Ocean)

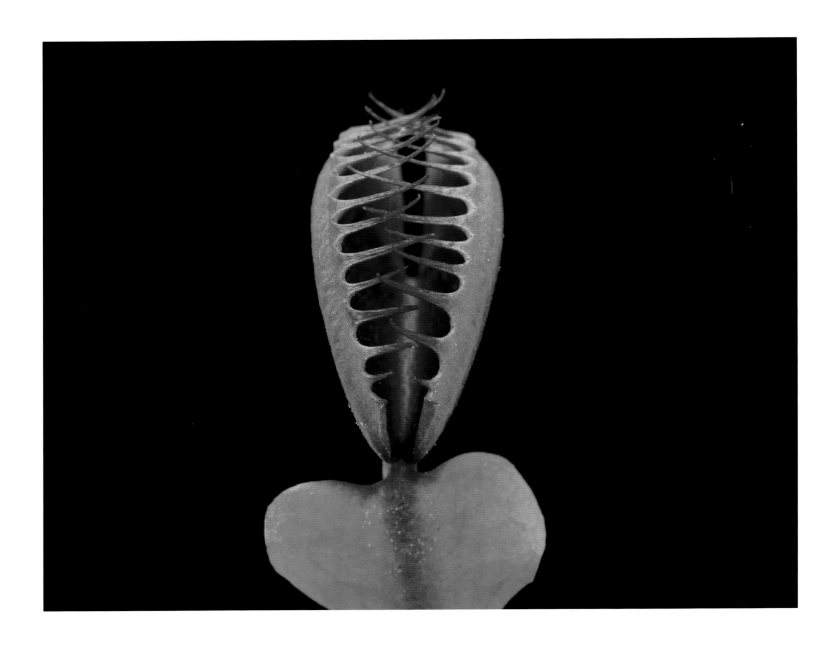

DEATH TRAP

A Venus flytrap interlaces its trigger hairs. The carnivorous
plant, native only to North and South Carolina, has adapted to
nutrient-poor soils by trapping and digesting animal matter.
If its trigger hairs detect an insect, the plant snaps shut in less
than a minute. If the trapped object isn't digestible, such as a stone,
the plant can "spit" it out. *(Helene Schmitz, Frankfurt, Germany)*

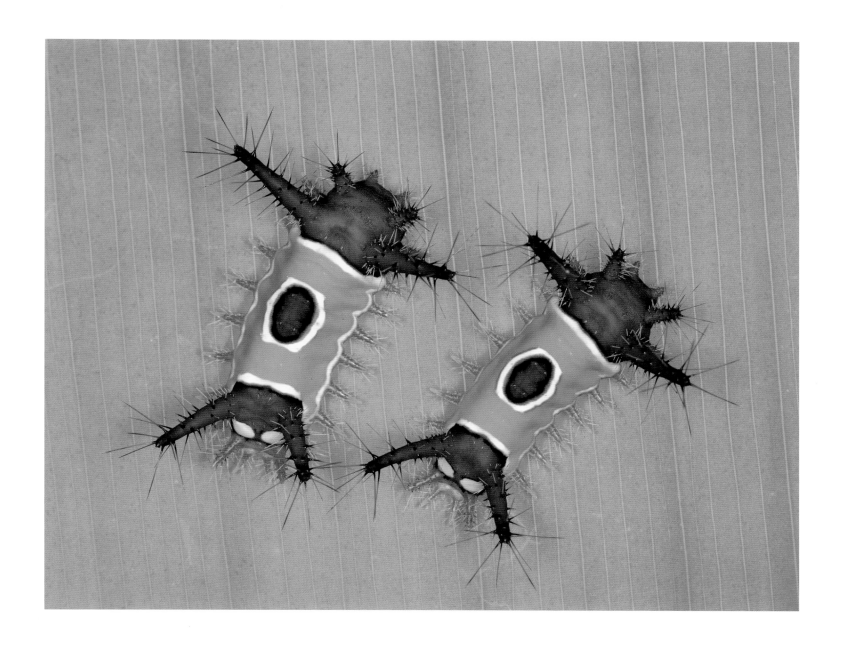

POISONOUS SPIKES

The saddleback moth caterpillar *(Sibine horrida)* looks like a spiky confectionary treat, but don't get too close. Its green "saddle" may be beautiful to look at, but these caterpillars use their poisonous hairs as a defense mechanism. They are dangerous to touch and are severely irritating to human skin. *(Ingo Arndt, Costa Rica)*

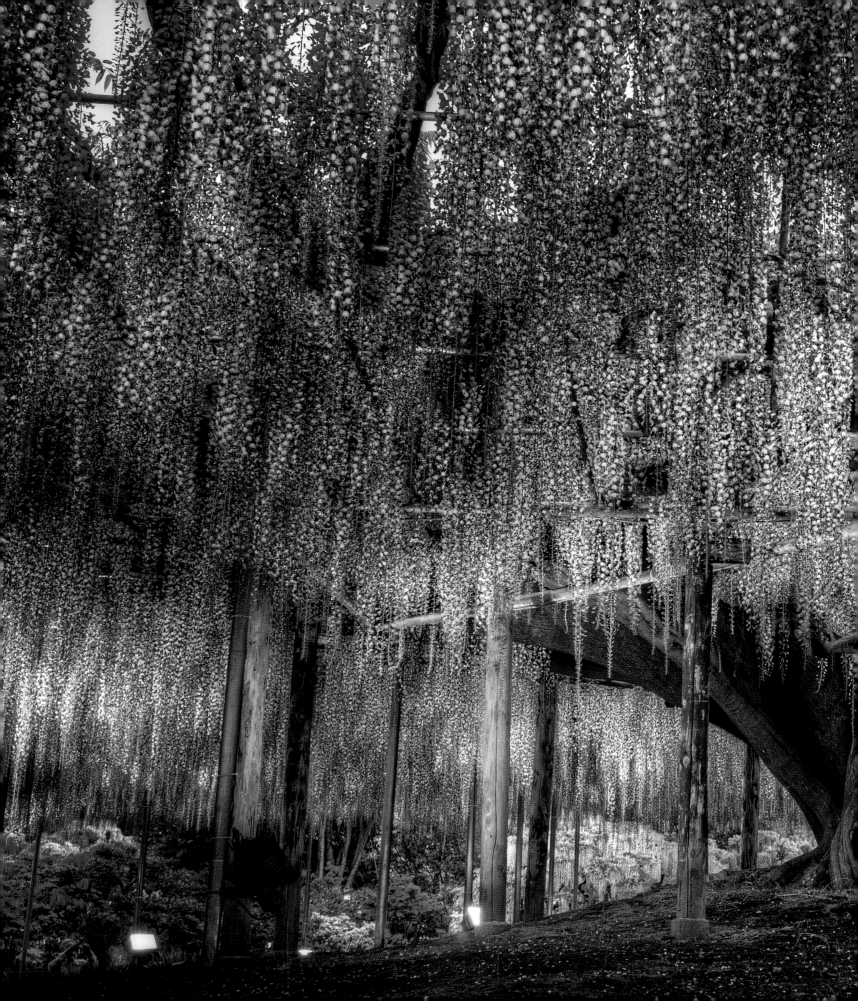

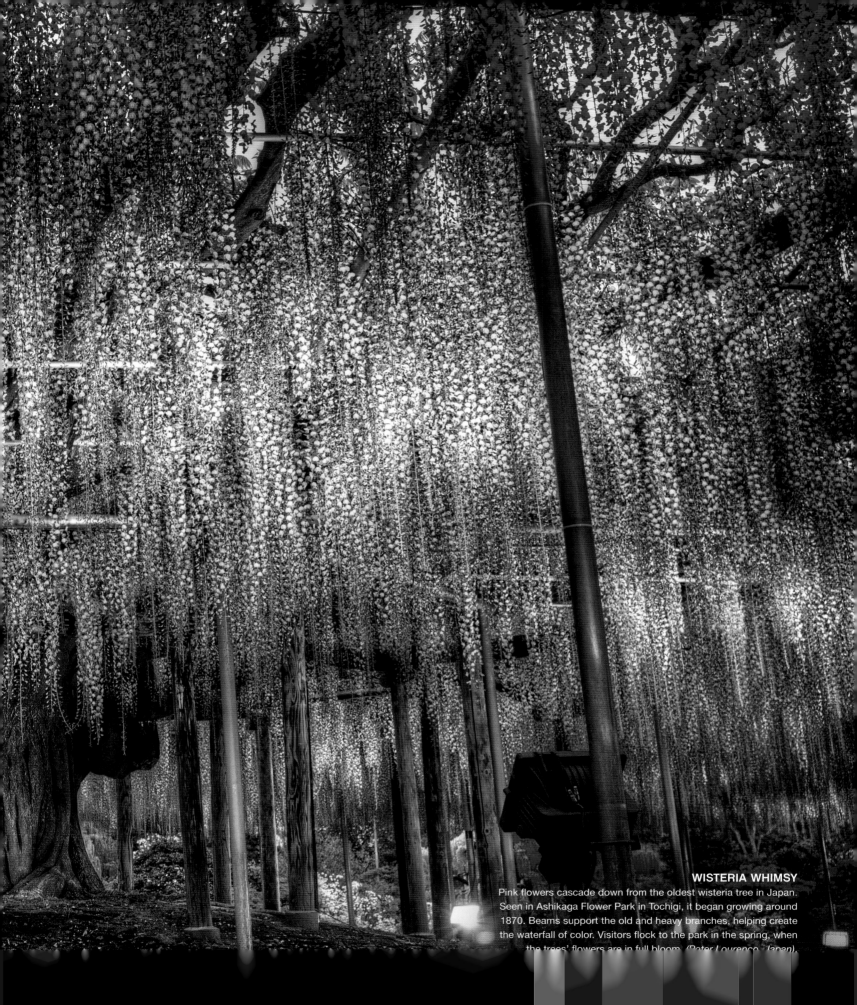

WISTERIA WHIMSY
Pink flowers cascade down from the oldest wisteria tree in Japan. Seen in Ashikaga Flower Park in Tochigi, it began growing around 1870. Beams support the old and heavy branches, helping create the waterfall of color. Visitors flock to the park in the spring, when the trees' flowers are in full bloom. (Peter Lourenco, Japan)

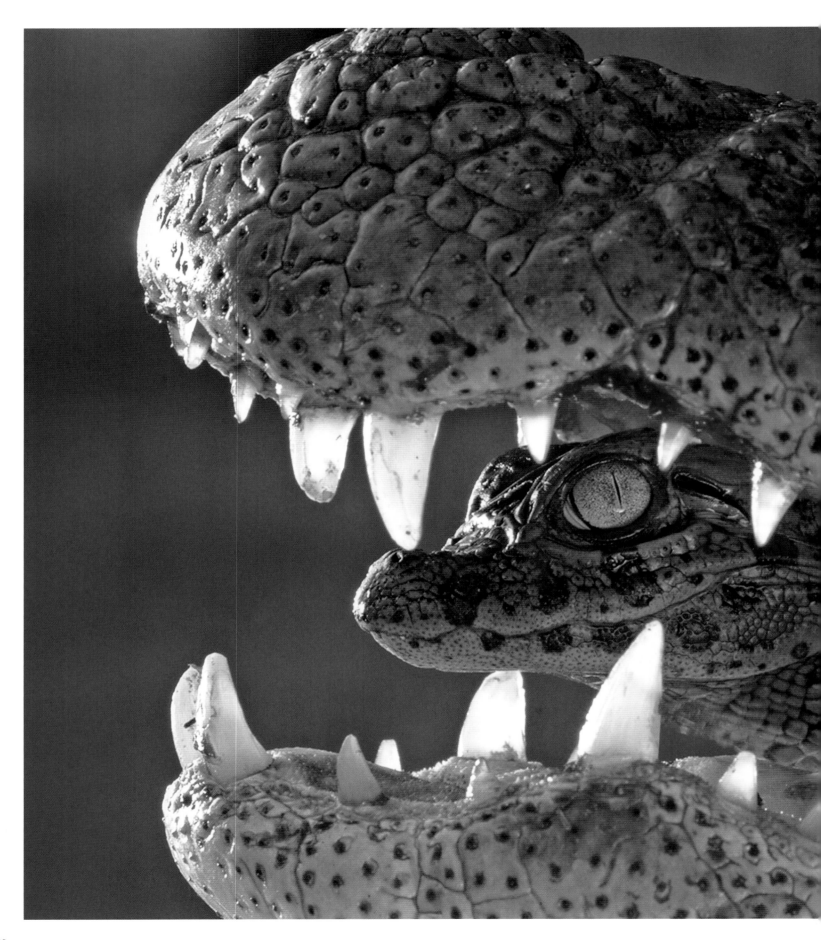

MOM'S TAXI SERVICE

Peeking out between massive teeth, a newly hatched
broad-snouted caiman *(Caiman latirostris)* goes for a ride
in its mother's mouth. Mom will care for her babies—teaching
them to swim and hunt—until they can make it on their own.
But even with all that maternal care, only about one in ten
will reach adulthood. *(Mark MacEwen, Argentina)*

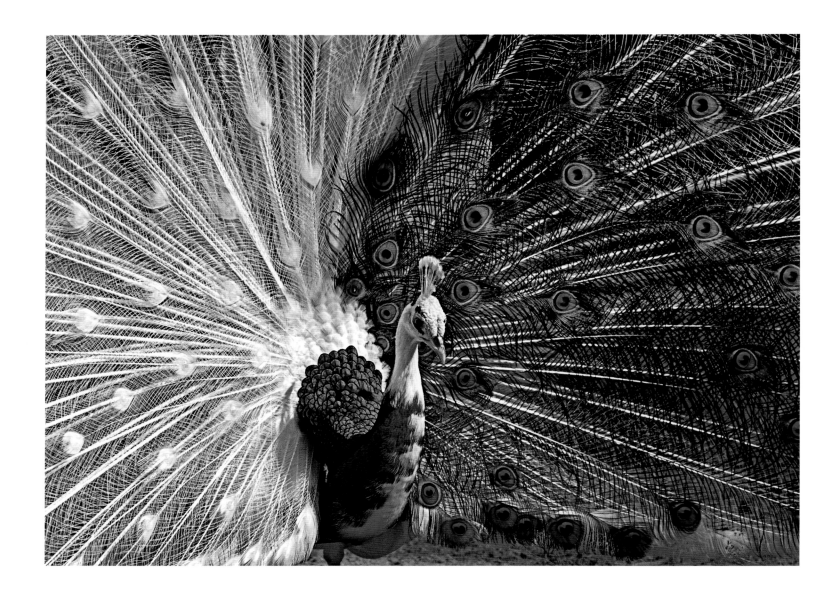

PEACOCK PARADE

This male peacock looks almost as if the artist isn't finished yet.
But that doesn't mean it can't strut its stuff. Feather structure
and pigment determine color in peacocks: the white feathers
of this peacock lack pigment, thus its piebald appearance
comes from a genetic mutation. *(Chi Liu, Australia)*

BLUE LOBSTER
This cobalt-colored crustacean is rarer than a blue moon.
Scientists estimate that only one out of two million lobsters
carry a blue shell. A rare genetic defect produces an extra
amount of a protein that colors these lobster shells blue.
(Frank Foster, Cape Cod, Massachusetts)

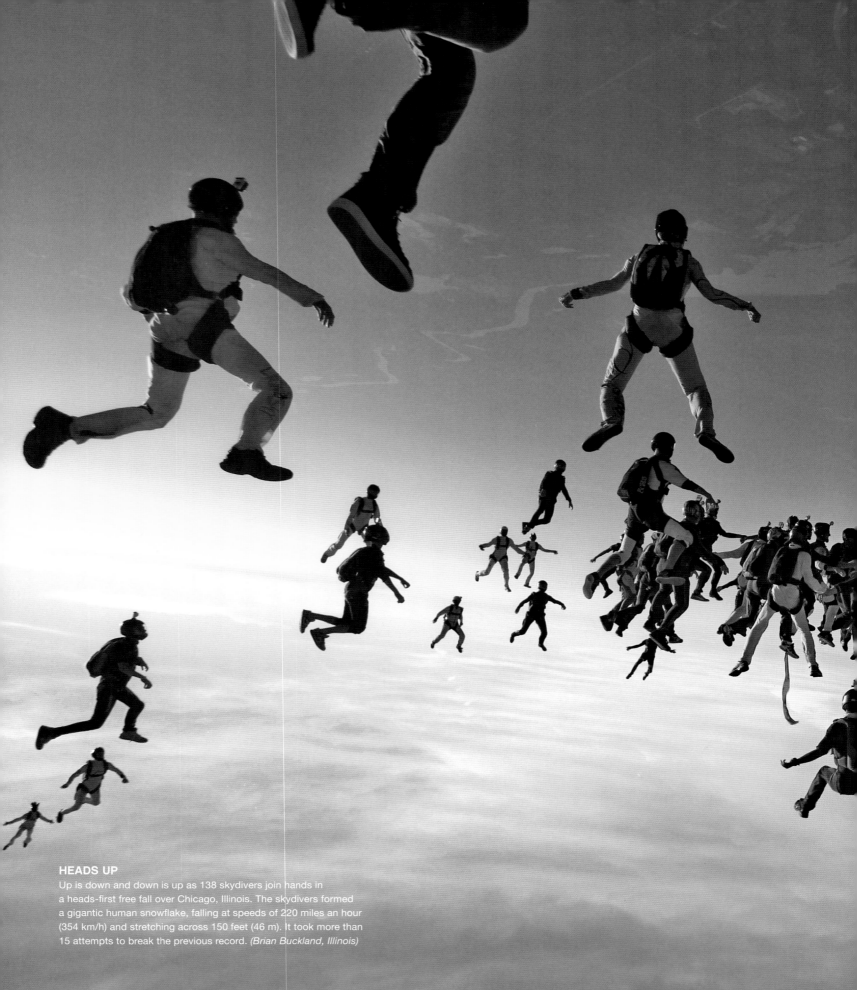

HEADS UP

Up is down and down is up as 138 skydivers join hands in a heads-first free fall over Chicago, Illinois. The skydivers formed a gigantic human snowflake, falling at speeds of 220 miles an hour (354 km/h) and stretching across 150 feet (46 m). It took more than 15 attempts to break the previous record. *(Brian Buckland, Illinois)*

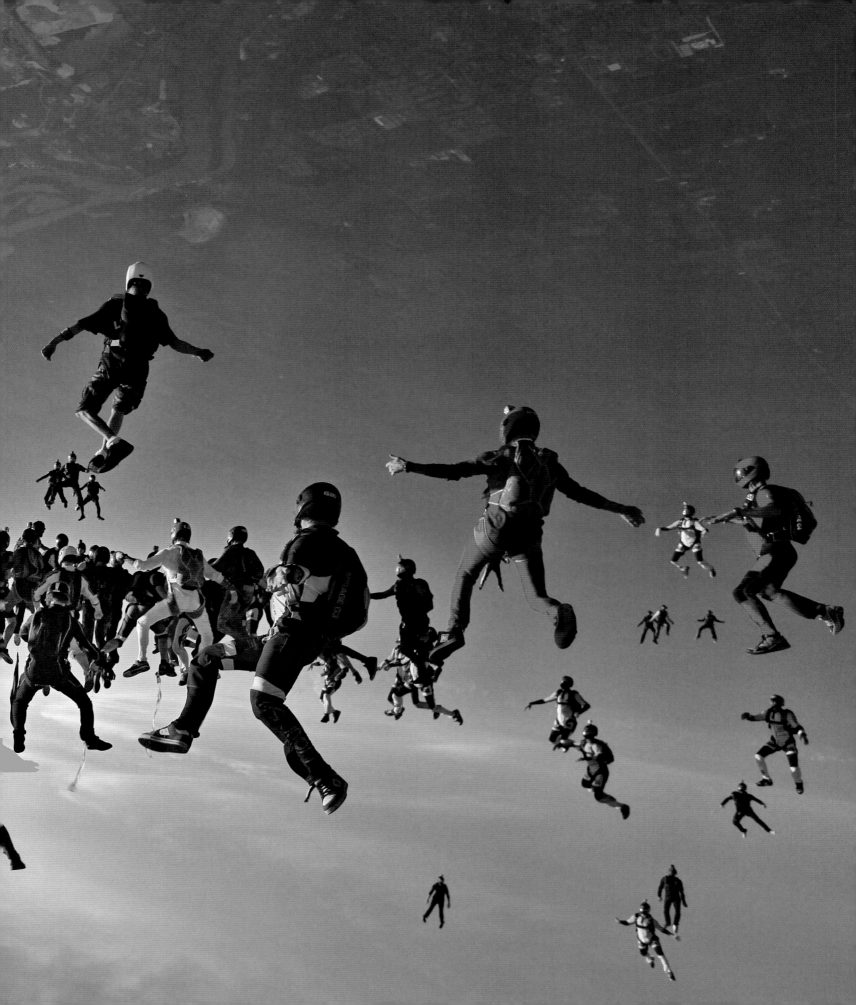

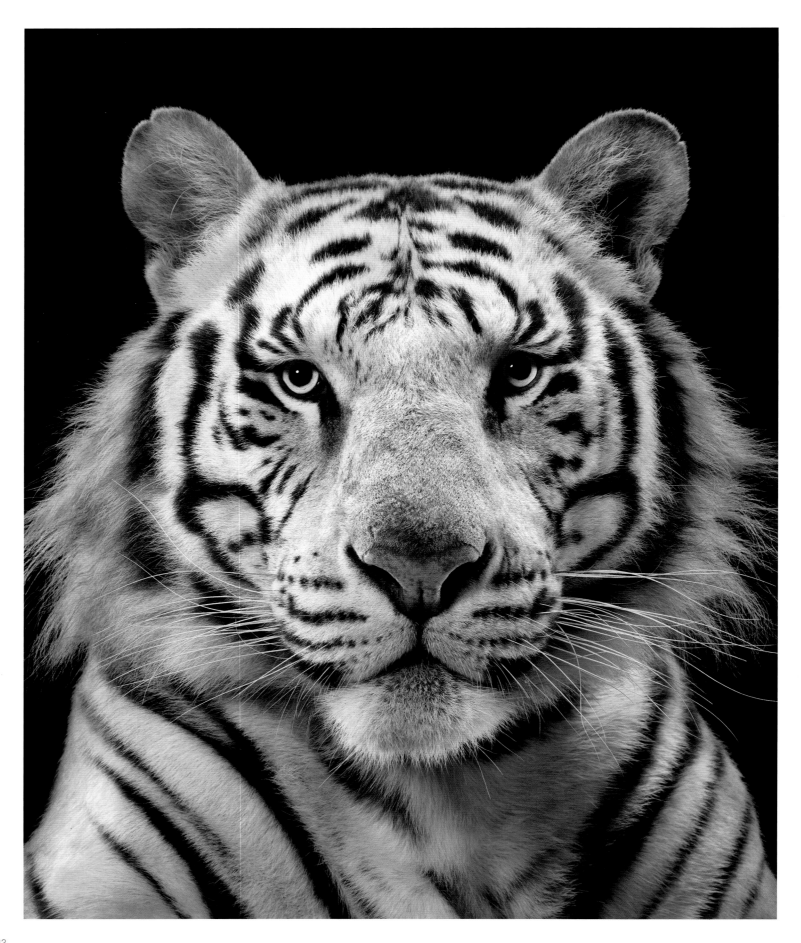

"This is a portrait of Vishnu, a seven-year-old royal white tiger male. I have mapped over a traditionally 'human' style of portraiture, taking the animals out of their natural habitat. Shot against a black background, the predator's gaze penetrates right through you, and you are compelled to stare back."

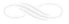

TIM FLACH

OPPOSITE: **ROYAL WHITE TIGER**
An intimate portrait captures a white tiger's quiet fierceness. Tigers are often bred
in captivity for various color variations, which rarely occur in the wild. *(Tim Flach)*

COLOR FIELD
Viewed from above, a Polish field resembles an abstract painting.
Fields of poppy weeds beginning to sprout in the spring reveal
variations of green. Brighter colors pop out in the scene as other
plants grow nearby. *(Kacper Kowalski, Poland)*

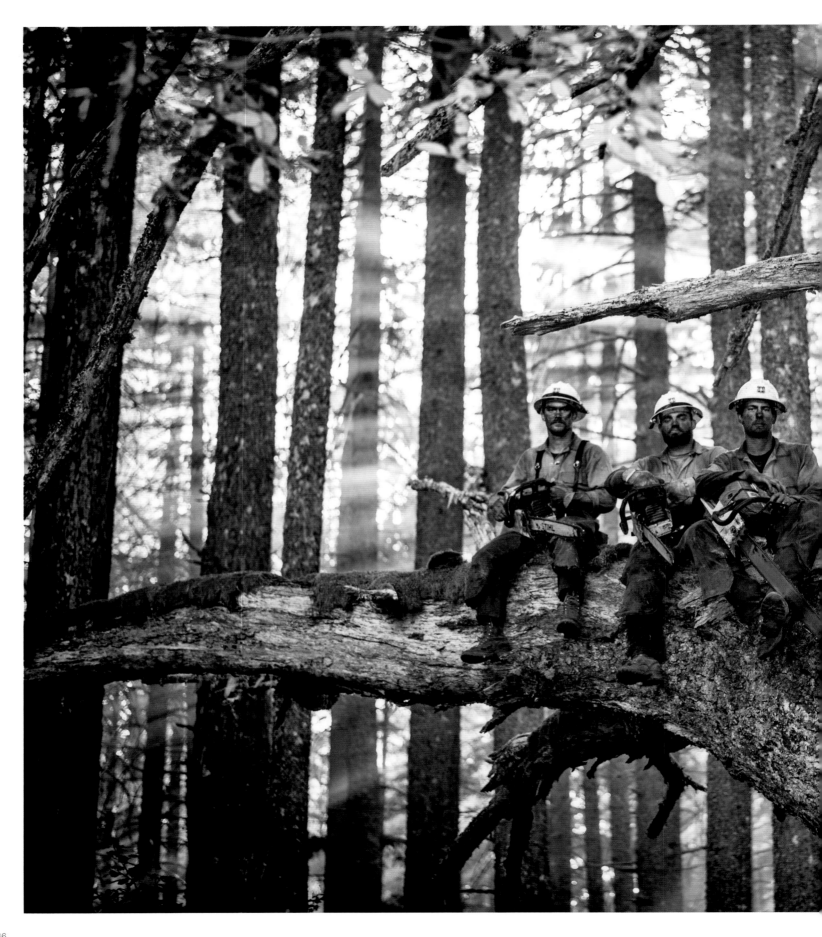

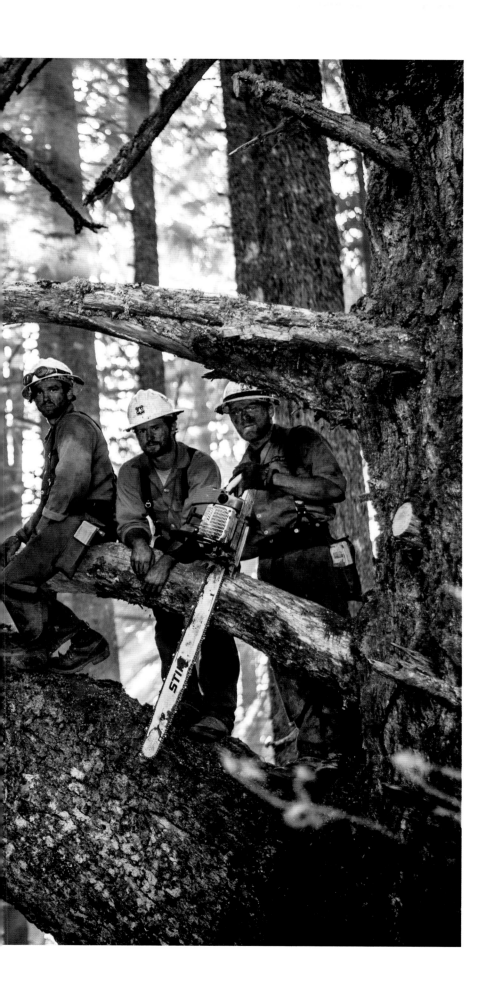

BABY, IT'S HOT OUTSIDE
Sunlight streams behind this "hot-shot" firefighting crew, resting on a massive branch of a Douglas fir tree in an Oregon forest. Saving such a massive tree can't be easy, but for these firefighters it's all in a day's work. *(Kyle Miller, Oregon)*

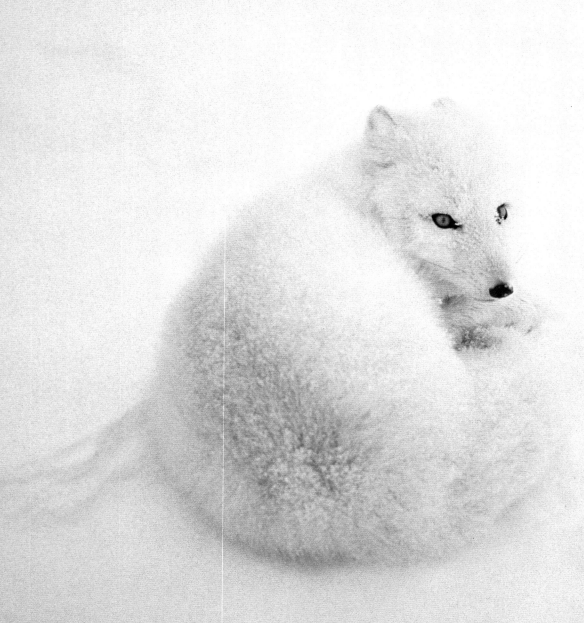

ARCTIC FOX

Effortlessly camouflaged, this arctic fox can be spotted only by its eyes and black button nose against the snowscape of Churchill, Manitoba, Canada. These hardy predators burrow into the snow to create a cozy den and follow polar bears to dine on their scraps.

(Design Pics Inc., Canada)

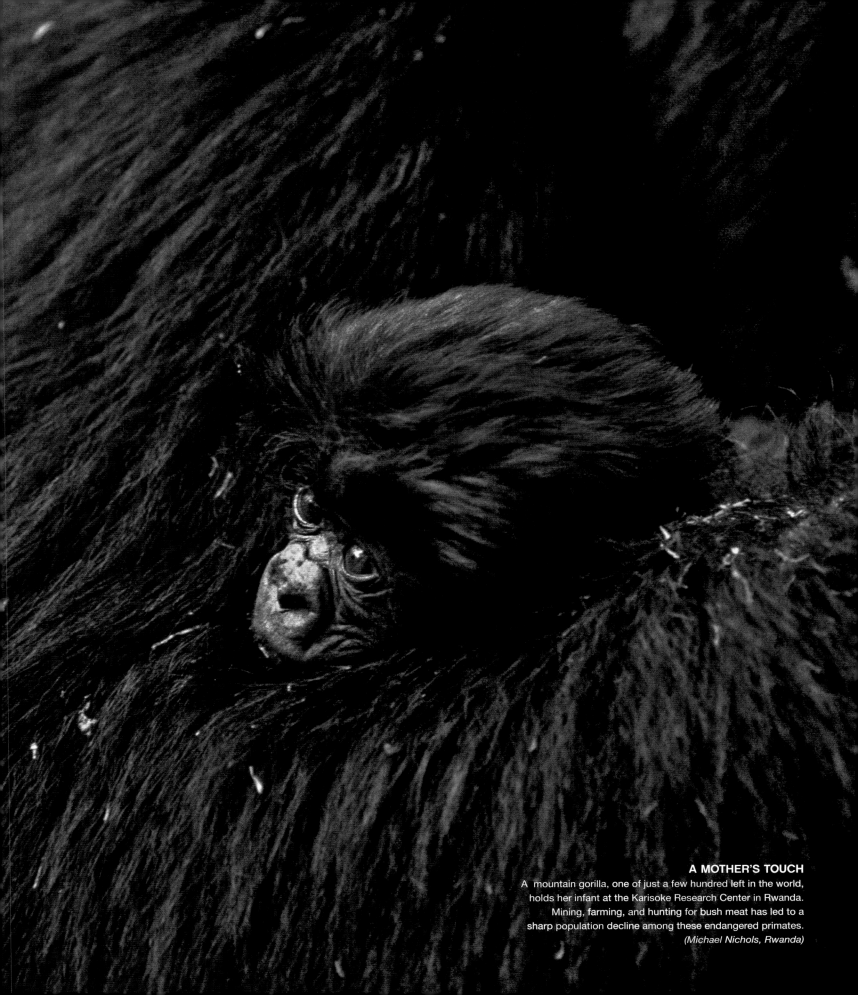

A MOTHER'S TOUCH
A mountain gorilla, one of just a few hundred left in the world, holds her infant at the Karisoke Research Center in Rwanda. Mining, farming, and hunting for bush meat has led to a sharp population decline among these endangered primates.
(Michael Nichols, Rwanda)

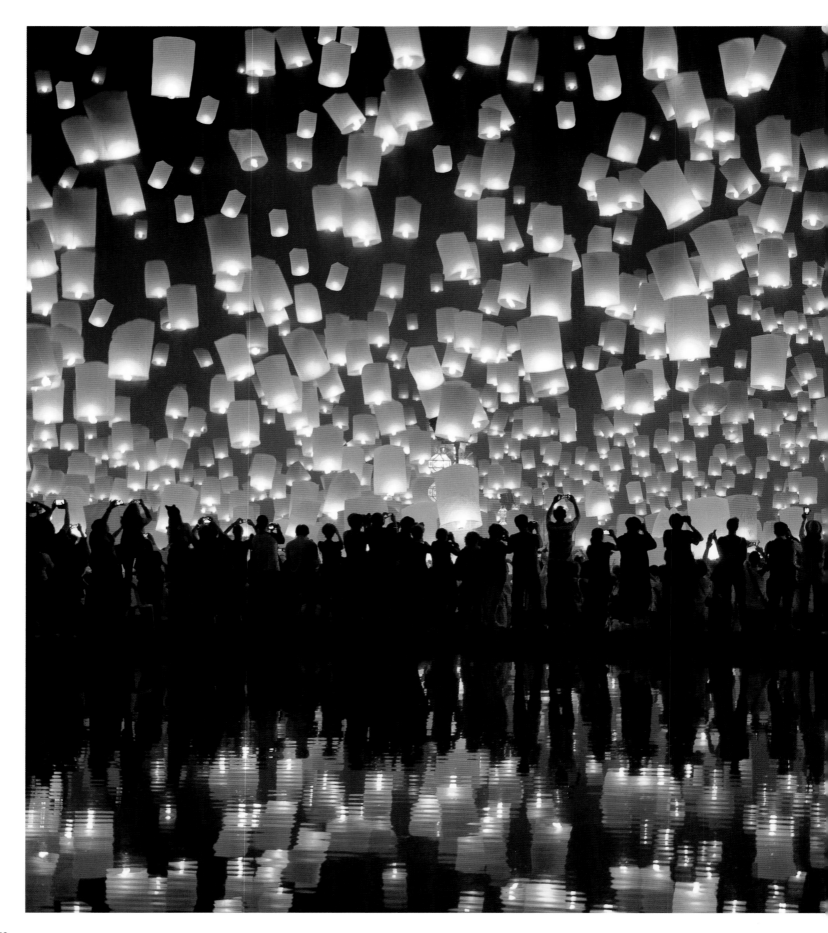

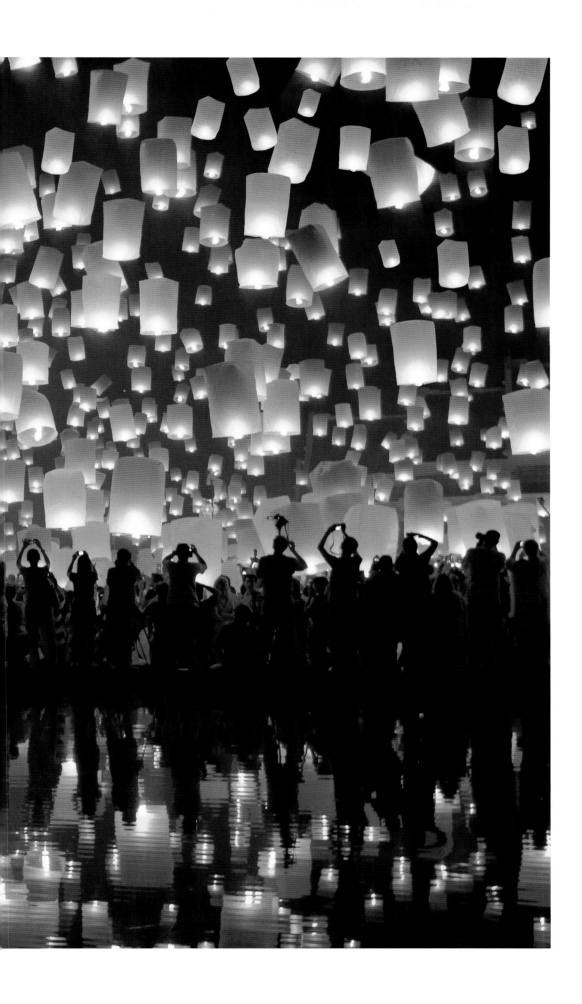

FESTIVAL OF LIGHTS
The night sky fills with light as lanterns soar and reflect a mirror image in the surrounding water. At the Loy Krathong festival, which usually takes place at the end of the rainy season in Thailand, festival-goers release lanterns to protect against bad luck. *(Nanut Bovorn, Thailand)*

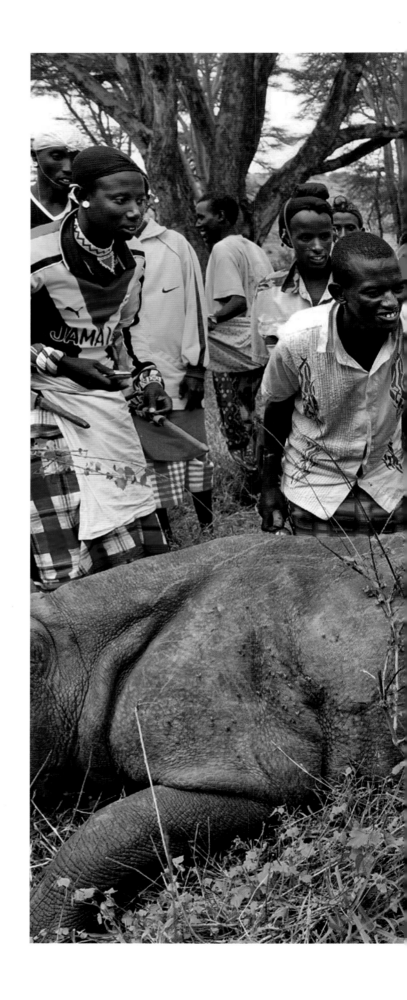

RHINO MEET AND GREET

Samburu warriors meet infant black rhinos at the Lewa Wildlife Conservancy in Kenya. These critically endangered animals have declined nearly 98 percent since 1960, which explains why these tribe members had only heard stories and never seen the animal that once thrived in their lands. *(Ami Vitale, Kenya)*

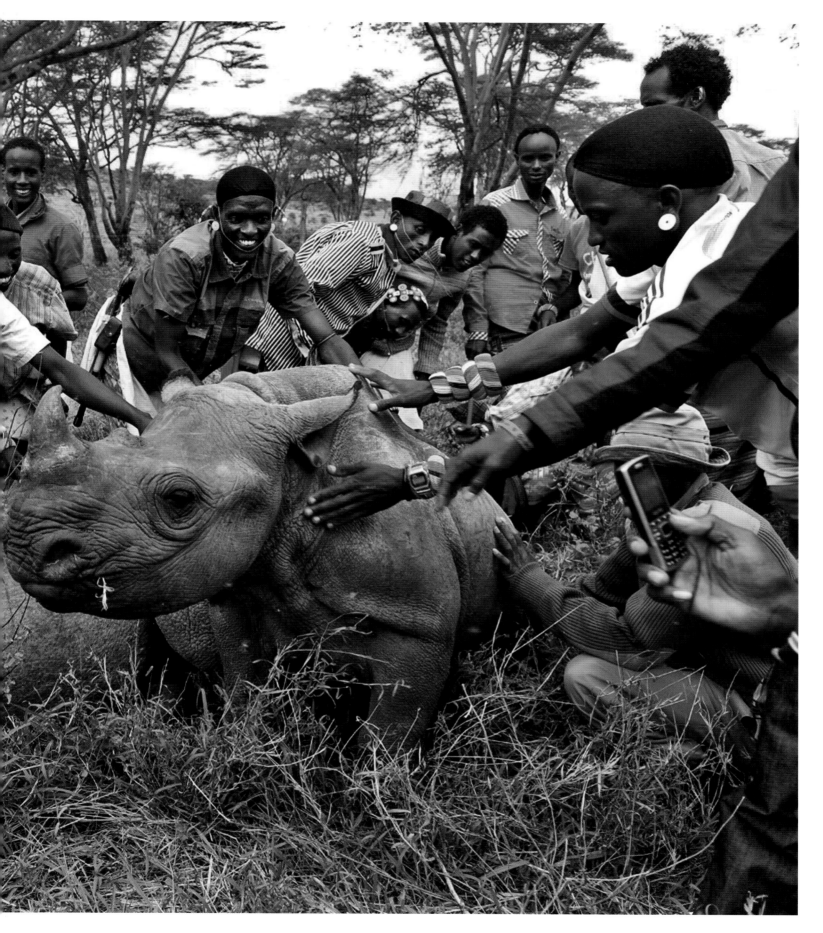

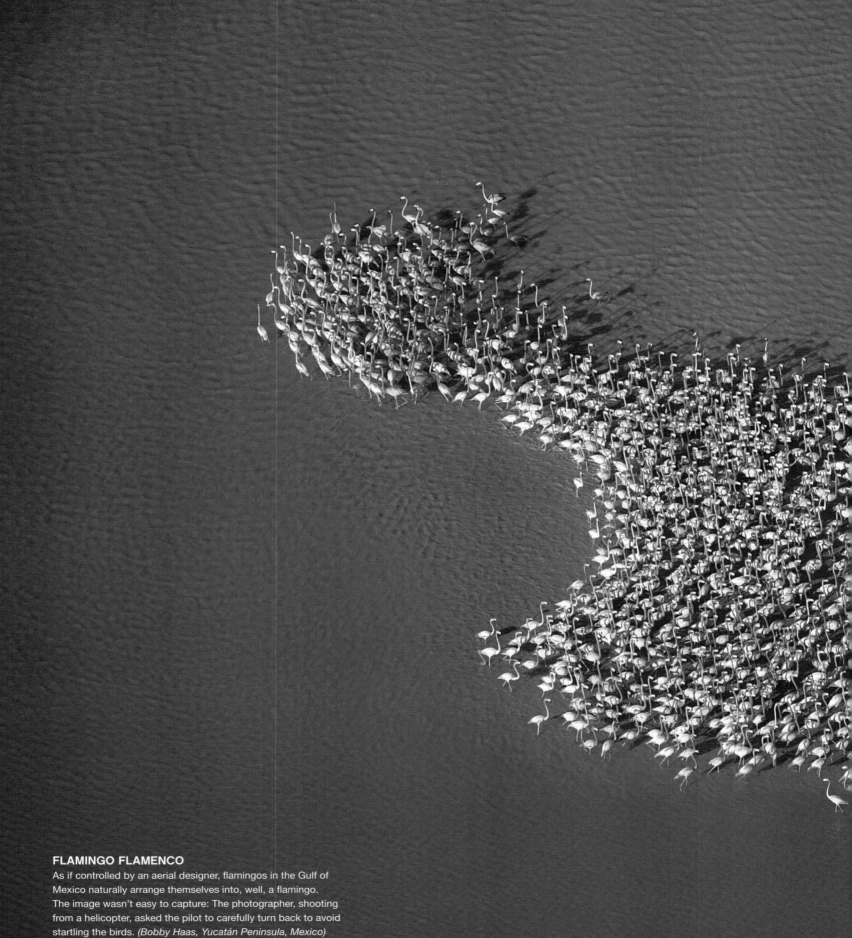

FLAMINGO FLAMENCO
As if controlled by an aerial designer, flamingos in the Gulf of
Mexico naturally arrange themselves into, well, a flamingo.
The image wasn't easy to capture: The photographer, shooting
from a helicopter, asked the pilot to carefully turn back to avoid
startling the birds. *(Bobby Haas, Yucatán Peninsula, Mexico)*

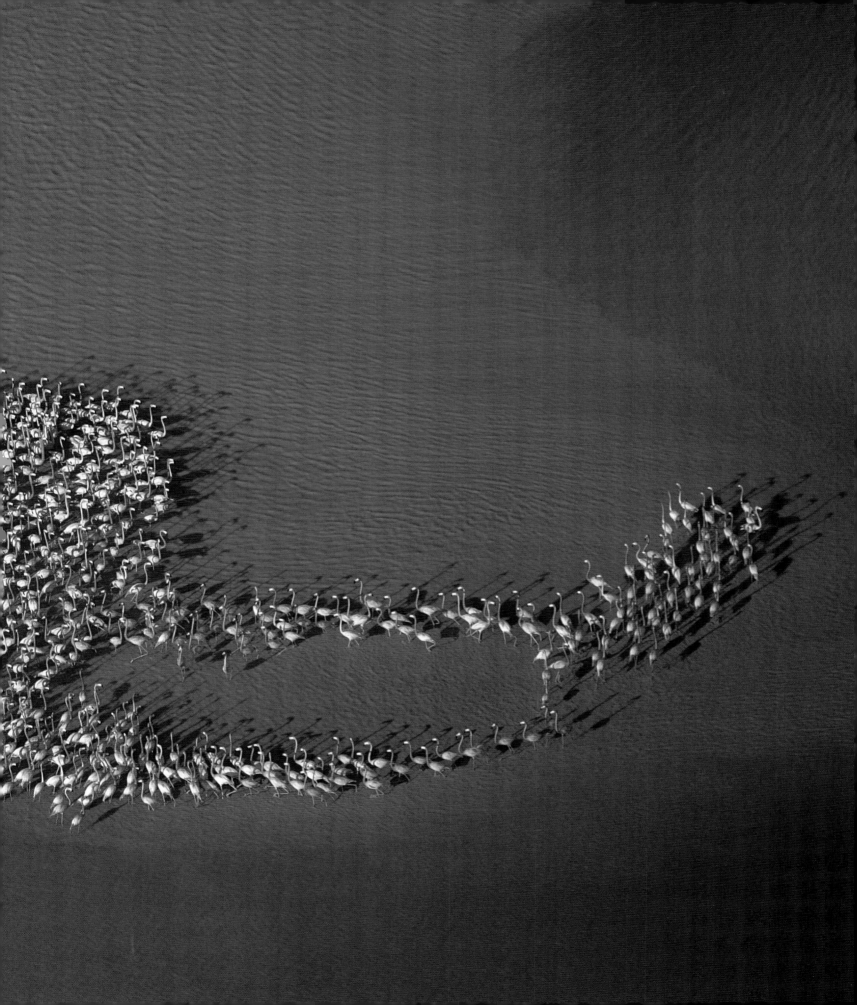

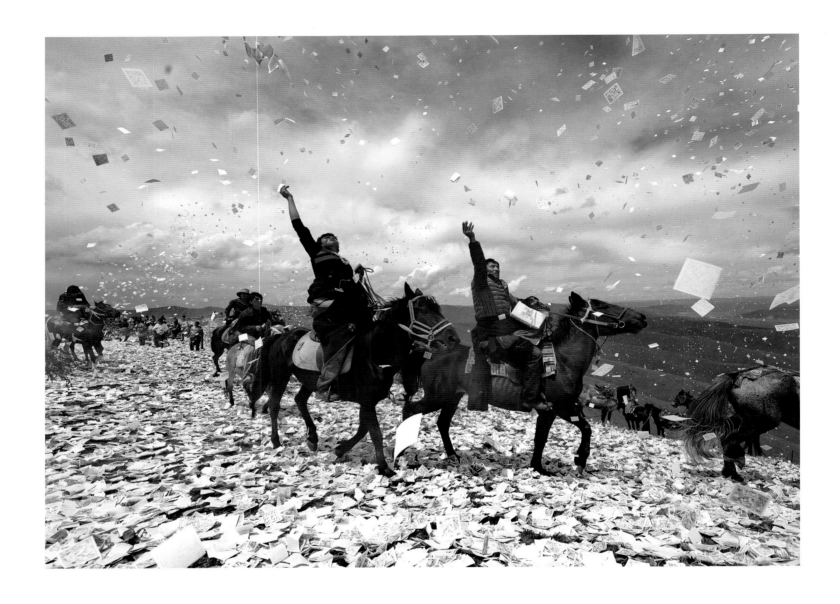

EQUINE CELEBRATION

Tibetans throw prayer papers into the air to celebrate the traditional Wei Sang festival in Sichuan Province, China. The festival, the name of which translates as "burning incense," helps ensure another year of health, a strong harvest, and peace. *(Agence France-Presse, China)*

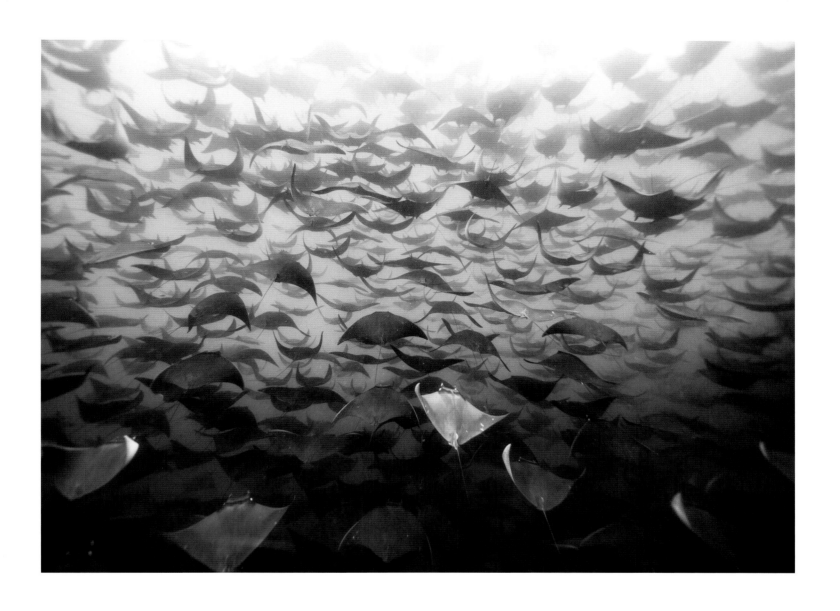

IT'S A STING
A migration of mobula stingrays clouds the ocean. Tens of
thousands of the rays will gather together and use their nearly
7-foot-wide (2-m) pectoral fins to launch themselves out
of the water. These rays have a penchant to catch big air,
which is why they are sometimes called "flying" rays.
(Eduardo Lopez Negrete, Mexico)

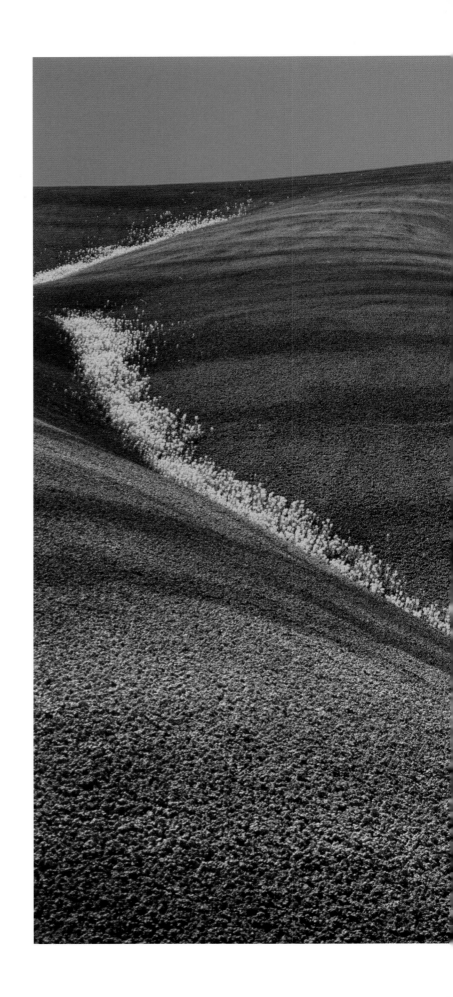

PAINTED HILLS

Golden bee plant *(Cleome platycarpa)* and John Day chaenactis
(Chaenactis nevii) flow downslope in yellow streams along the
Painted Hills of the John Day Fossil Beds National Monument.
While spring wildflowers paint the hills, its colors actually
come from different rock layers spanning multiple geological
time periods. *(Terry Donnelly, Oregon)*

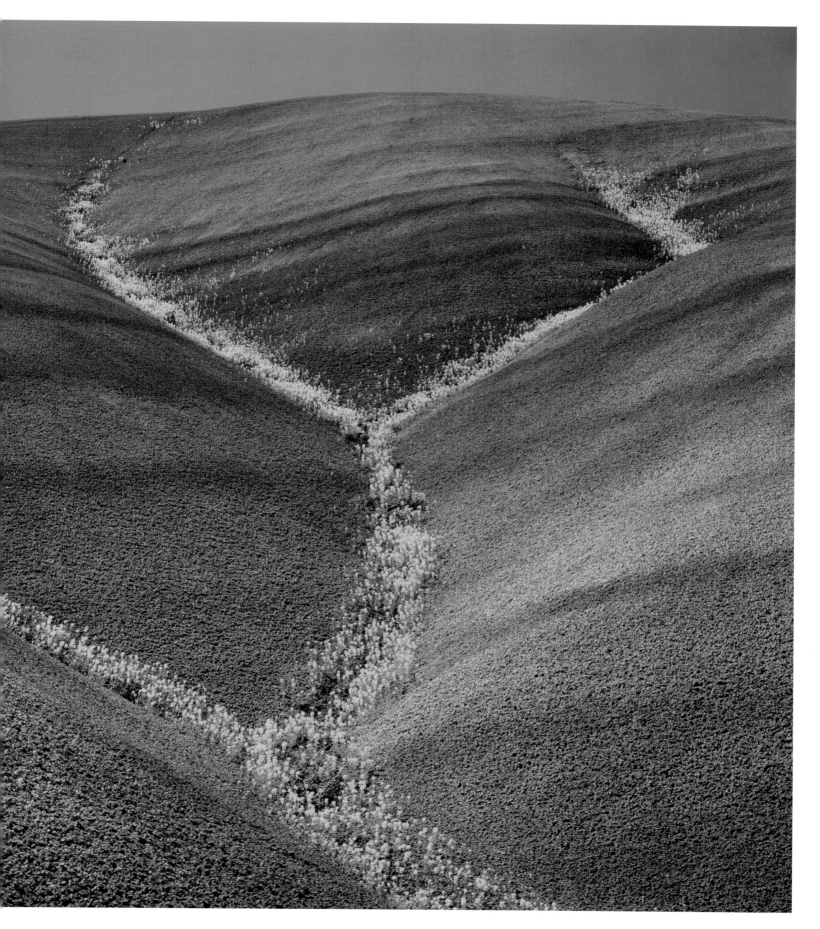

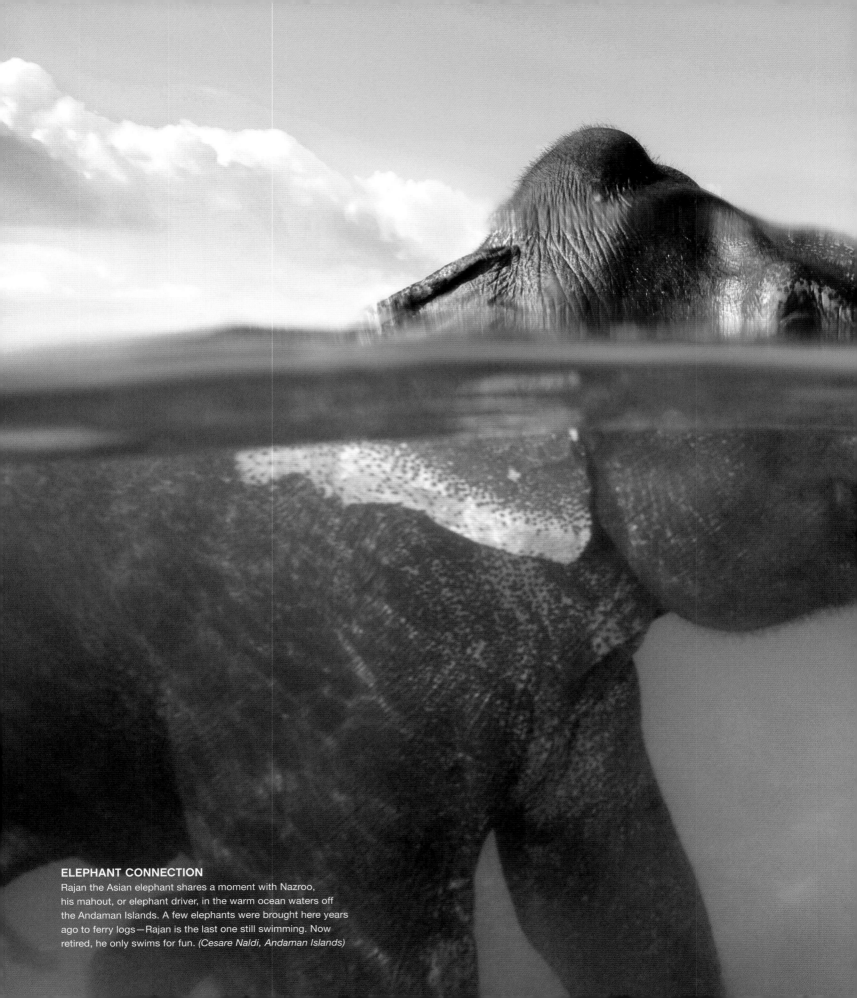

ELEPHANT CONNECTION

Rajan the Asian elephant shares a moment with Nazroo, his mahout, or elephant driver, in the warm ocean waters off the Andaman Islands. A few elephants were brought here years ago to ferry logs—Rajan is the last one still swimming. Now retired, he only swims for fun. *(Cesare Naldi, Andaman Islands)*

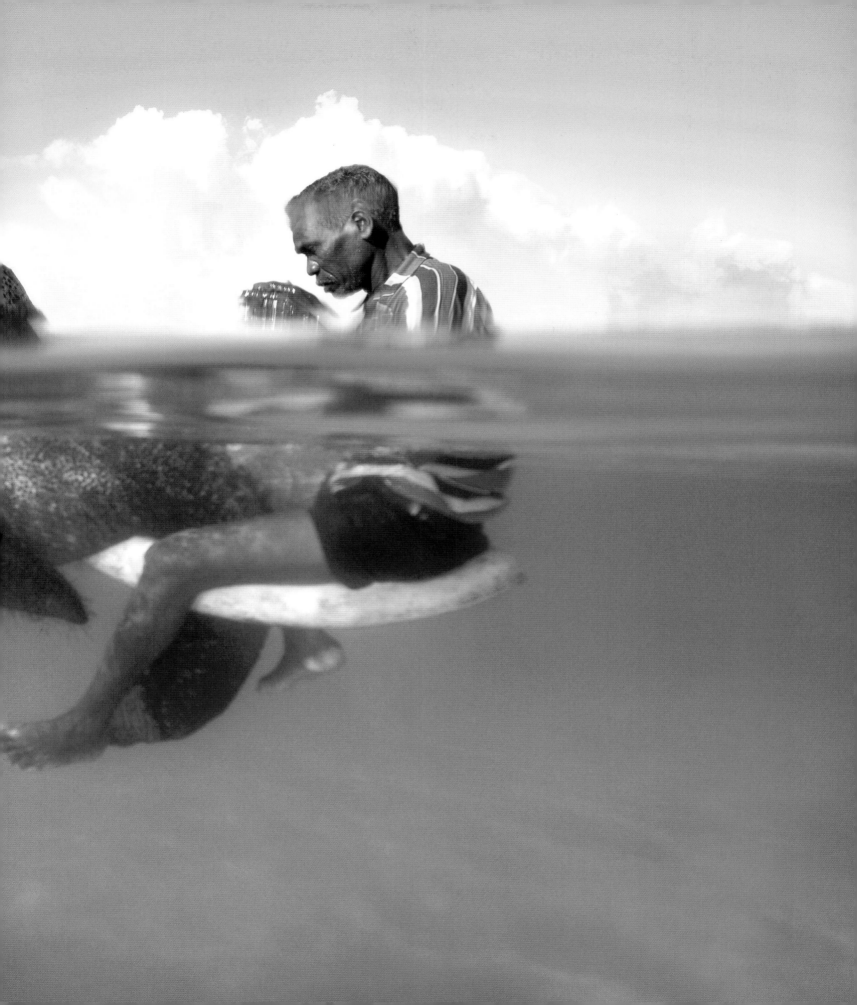

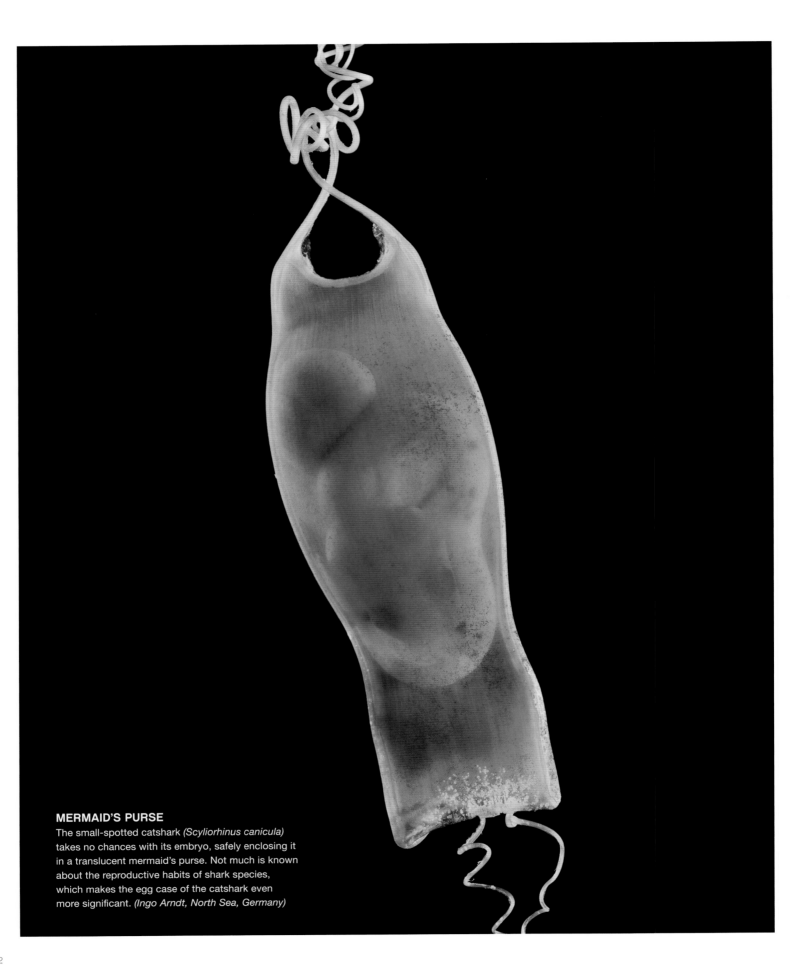

MERMAID'S PURSE
The small-spotted catshark *(Scyliorhinus canicula)* takes no chances with its embryo, safely enclosing it in a translucent mermaid's purse. Not much is known about the reproductive habits of shark species, which makes the egg case of the catshark even more significant. *(Ingo Arndt, North Sea, Germany)*

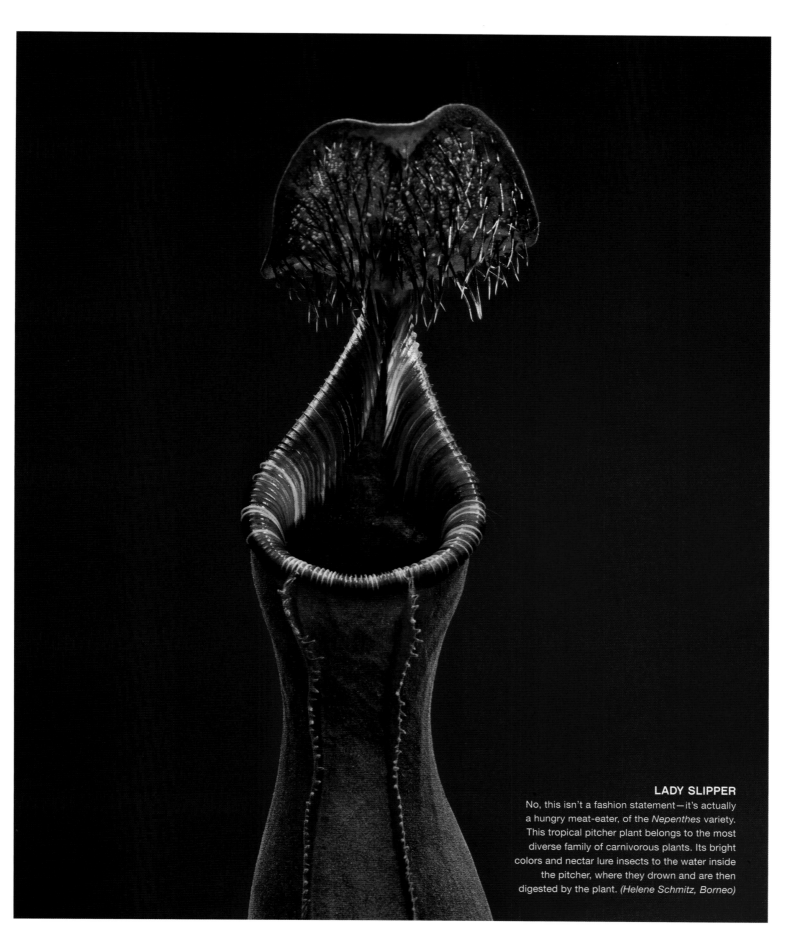

LADY SLIPPER
No, this isn't a fashion statement—it's actually a hungry meat-eater, of the *Nepenthes* variety. This tropical pitcher plant belongs to the most diverse family of carnivorous plants. Its bright colors and nectar lure insects to the water inside the pitcher, where they drown and are then digested by the plant. *(Helene Schmitz, Borneo)*

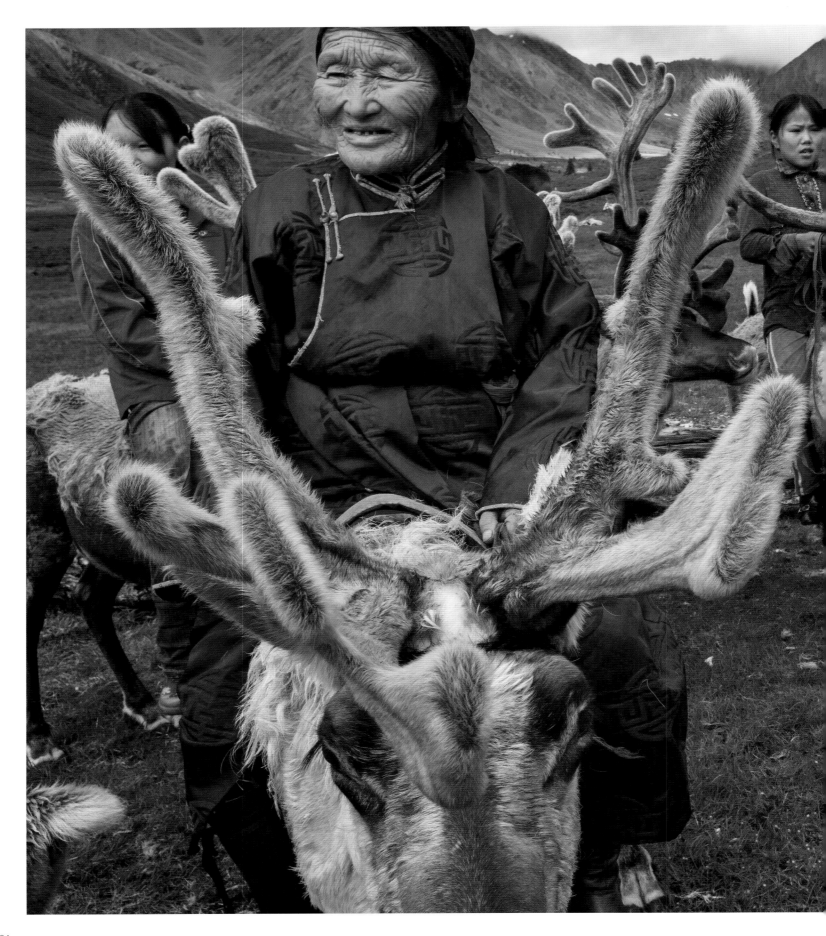

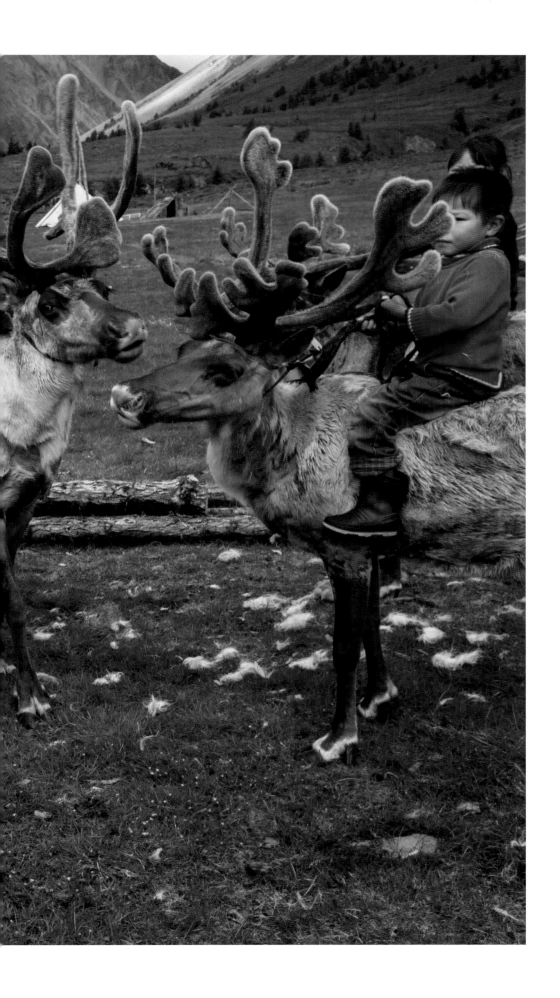

REINDEER HERDERS

The Tsaatan, or "people of the reindeer," ride their herd in a green valley in northern Mongolia. The small community of about 500 people move every few weeks to find the lichens the reindeer need to eat. The animals in turn provide clothing, milk, transportation, and only rarely meat for this marginalized community. *(Art Wolfe, Mongolia)*

"I discovered this diminutive, five-millimeter-long insect during an expedition to one of the most remote and unexplored parts of the world. Our team of biologists had to drop in by helicopter to access the forests among the inhospitable mountainous region of southern Suriname, hundreds of miles from any roads. To photograph this tiny plant-hopper, I crept closer as slowly as possible until I was able to focus with my macro lens and snap the shot, just before it leaped away with its powerful hind legs."

TROND LARSEN

OPPOSITE: **PLANT-HOPPER PERIWIG**
This 0.2-inch-long (5-mm) nymph might be small, but it packs a punch. That tuft of iridescent hair is really a secretion from the insect's abdomen. Scientists think it is possibly used as protection from predators. *(Trond Larsen, Suriname)*

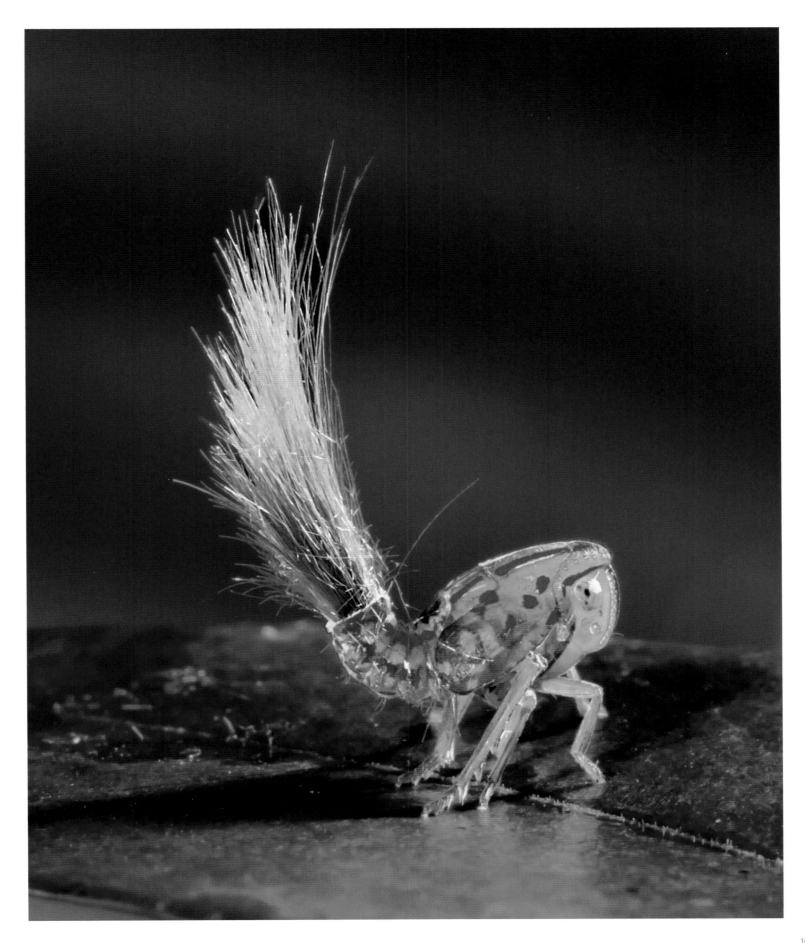

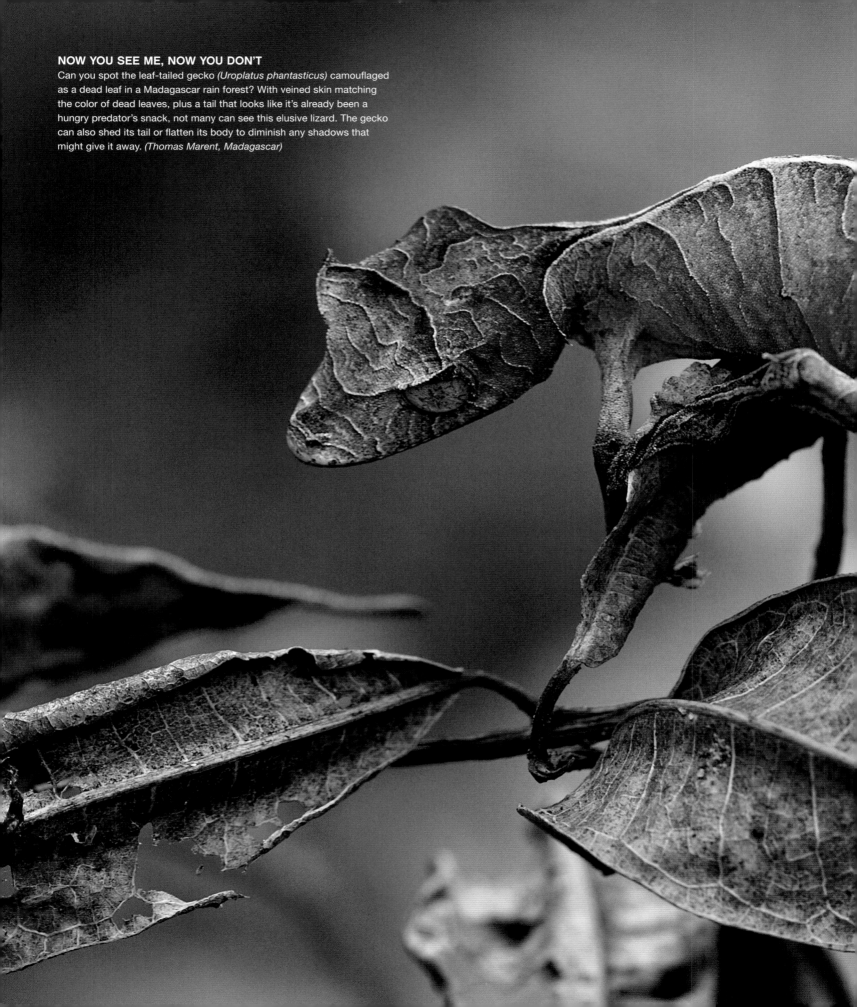

NOW YOU SEE ME, NOW YOU DON'T
Can you spot the leaf-tailed gecko *(Uroplatus phantasticus)* camouflaged as a dead leaf in a Madagascar rain forest? With veined skin matching the color of dead leaves, plus a tail that looks like it's already been a hungry predator's snack, not many can see this elusive lizard. The gecko can also shed its tail or flatten its body to diminish any shadows that might give it away. *(Thomas Marent, Madagascar)*

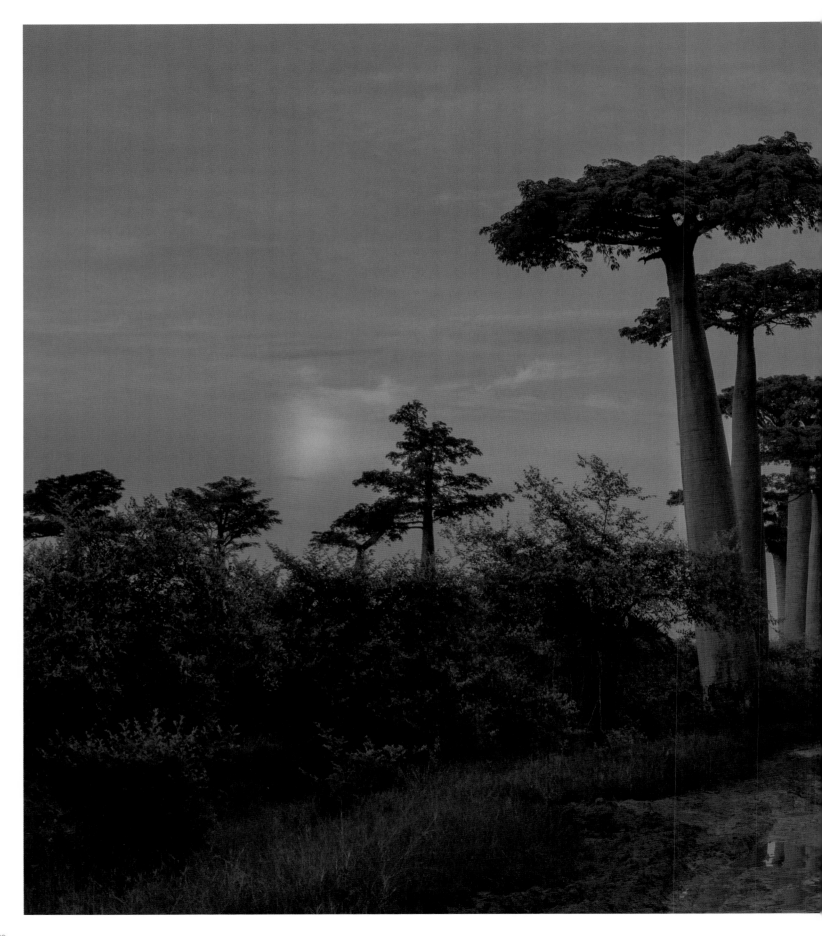

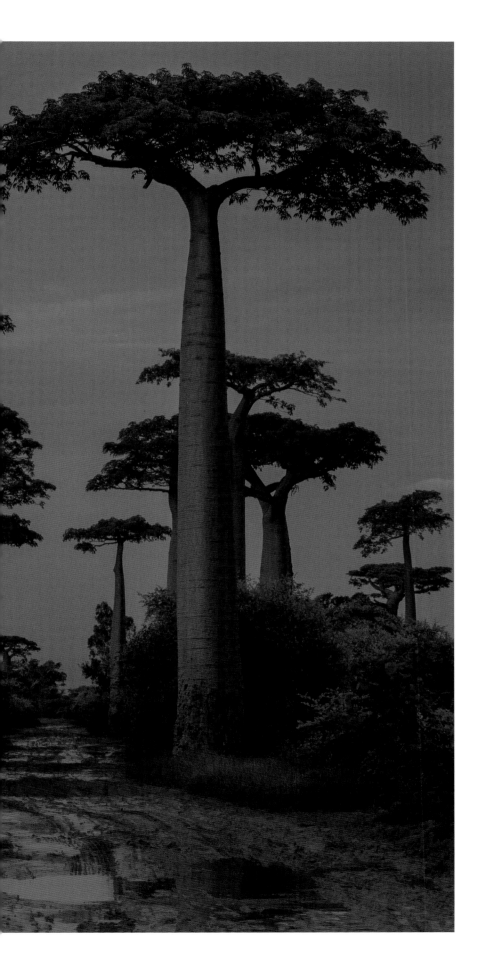

UPSIDE-DOWN TREES

A river path through majestic baobab trees seems to transgress time. With tall trunks and towering branches, these trees can live for thousands of years. Unfortunately, today they face habitat destruction. Six out of eight species make their home on the African island nation of Madagascar. *(Cristina Mittermeier, Madagascar)*

BUFFALO HERDERS

In colorful, embroidered clothing, 17-year-old Marian leads her family's caravan of water buffalo on hoof through the foothills of the Himalaya. These nomadic herders live in the forests of northern India, and the family is making its way to the summer, high-alpine meadows. *(Michael Benanav, India)*

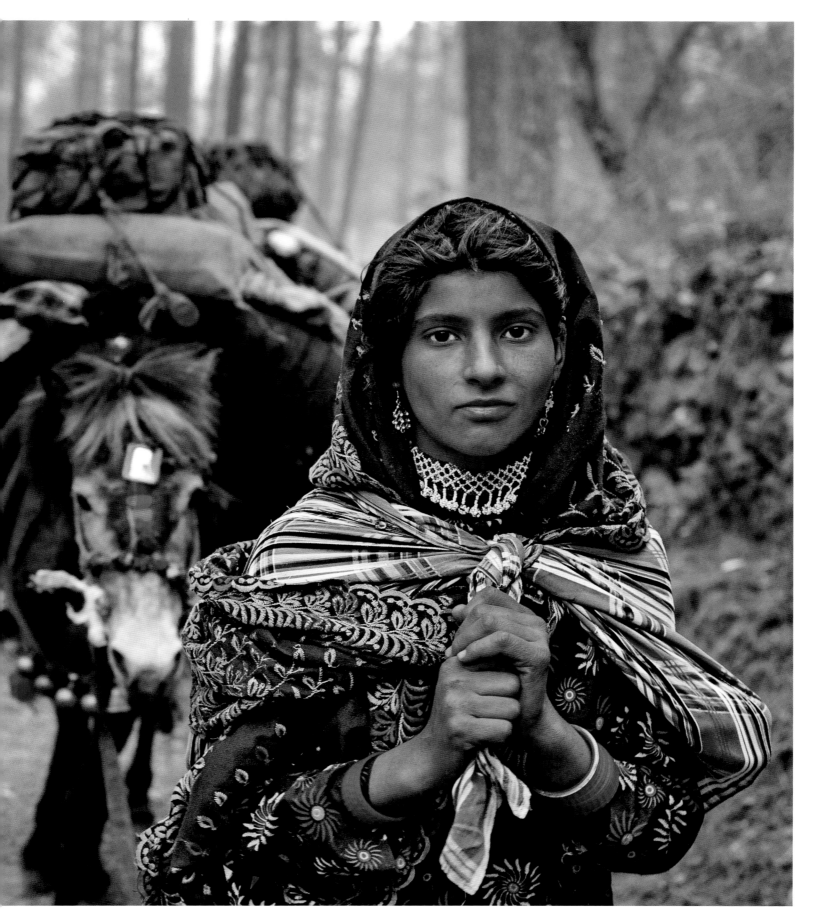

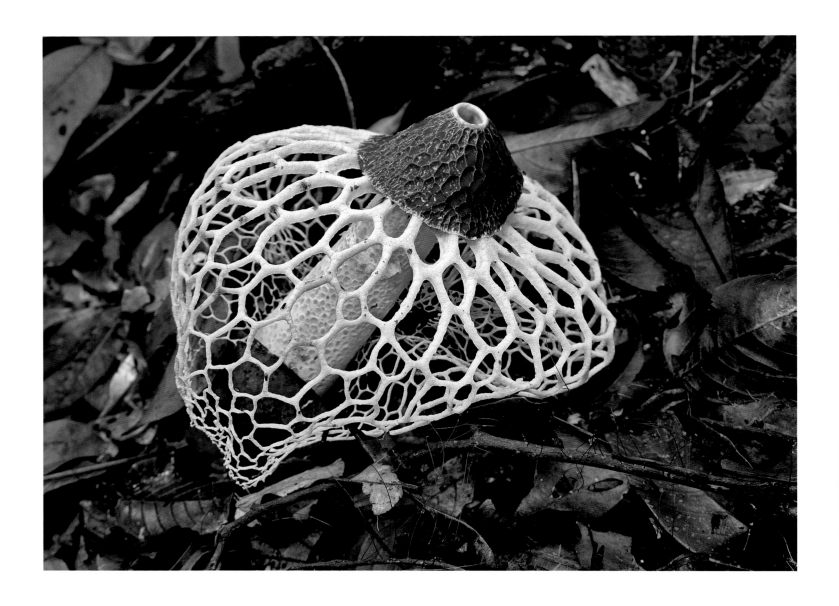

NETTED STINKHORN

The conical cap and pockmarked veil of a stinkhorn fungus
(Phallus indusiatus) thrives in the rich soil of lowland rain forests.
The fungus lives for only about 12 hours before decay sets in,
but that's long enough to disperse its spores. The dried form is
sold as a delicacy in Asian markets. *(Fletcher & Baylis, Philippines)*

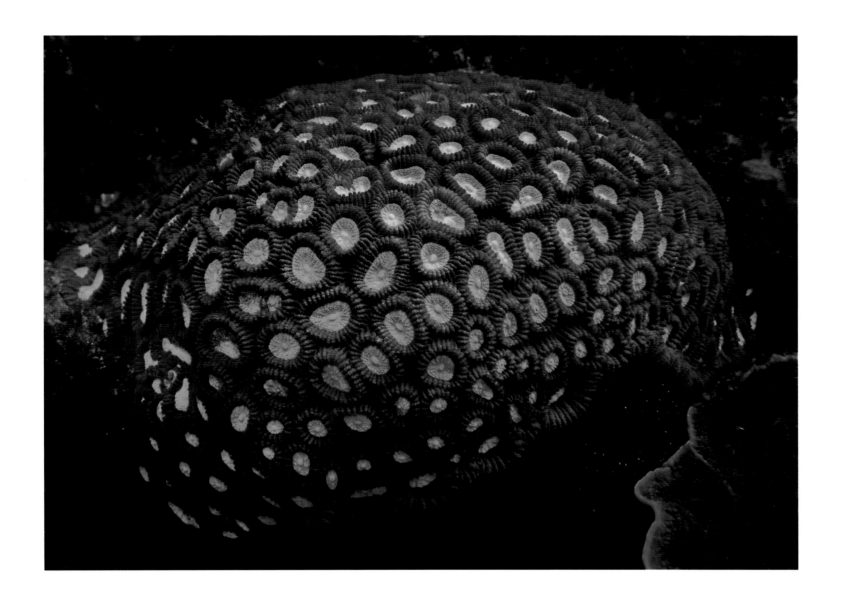

HONEYCOMB CORAL

In a hotspot of diversity, a honeycomb coral pulses with a soft, green glow in the waters off the Raja Ampat Islands, Indonesia. A quarter of all coral species in the world can be found here. These reef-building corals have green oral disks surrounded by thick-walled tentacles. *(Mark Pickford, Indonesia)*

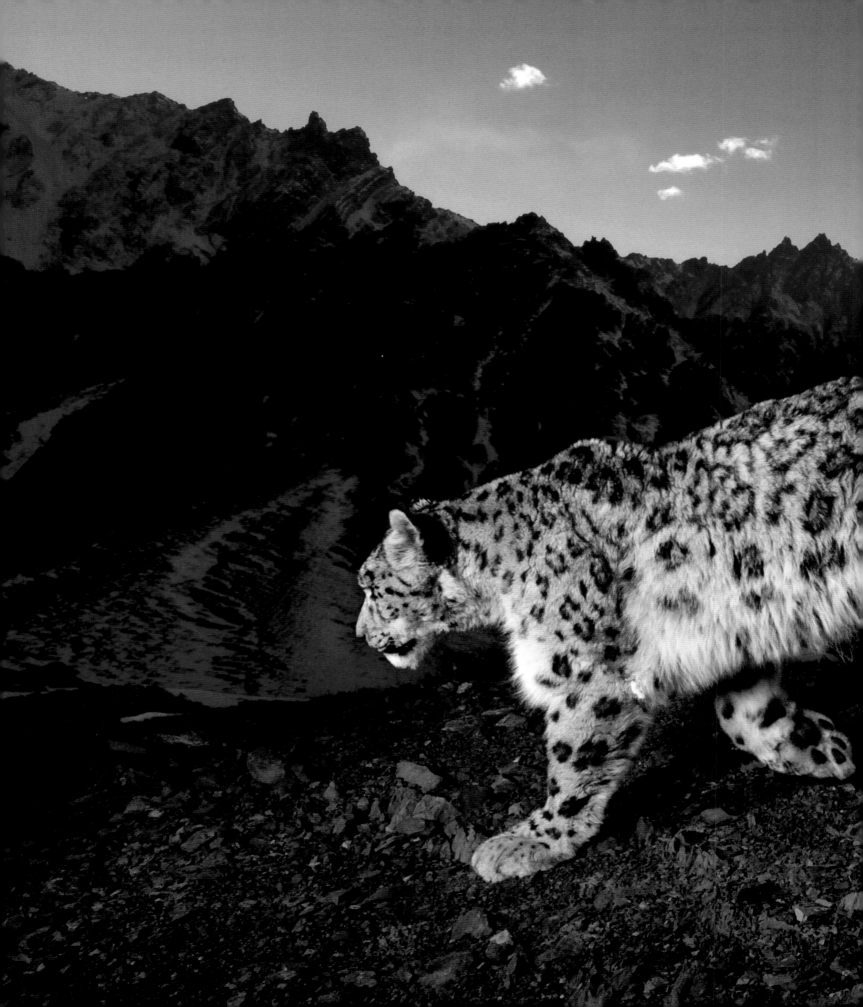

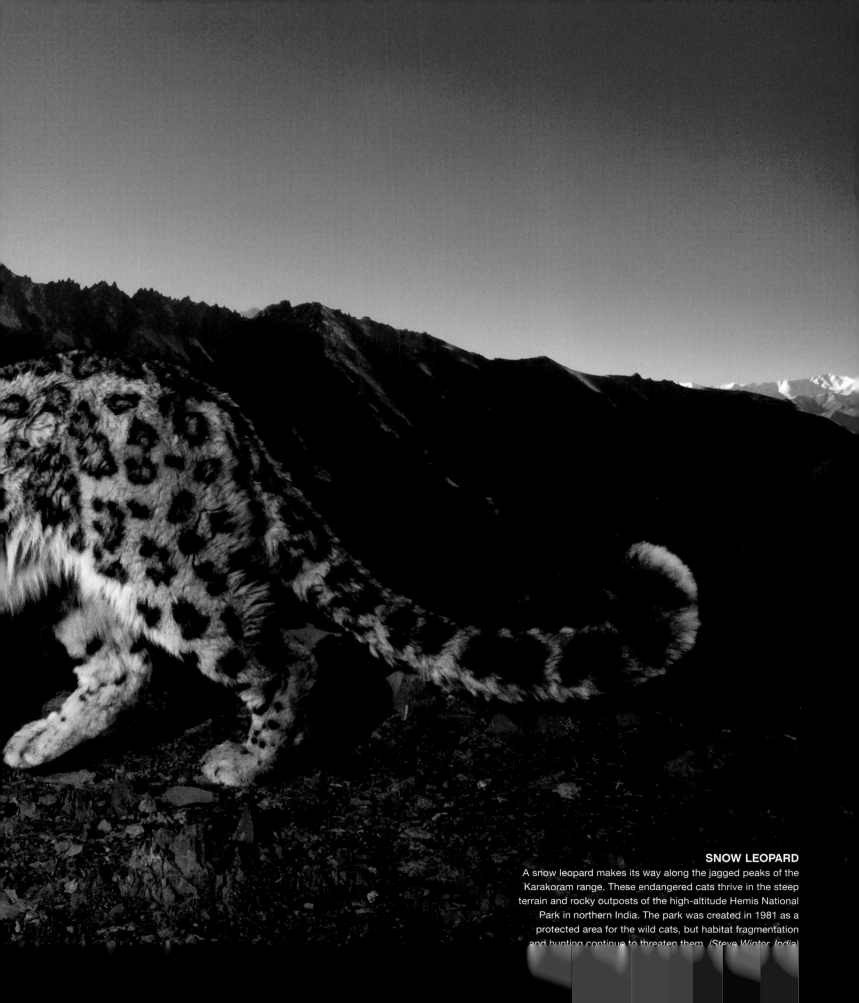

SNOW LEOPARD

A snow leopard makes its way along the jagged peaks of the Karakoram range. These endangered cats thrive in the steep terrain and rocky outposts of the high-altitude Hemis National Park in northern India. The park was created in 1981 as a protected area for the wild cats, but habitat fragmentation and hunting continue to threaten them. *(Steve Winter, India)*

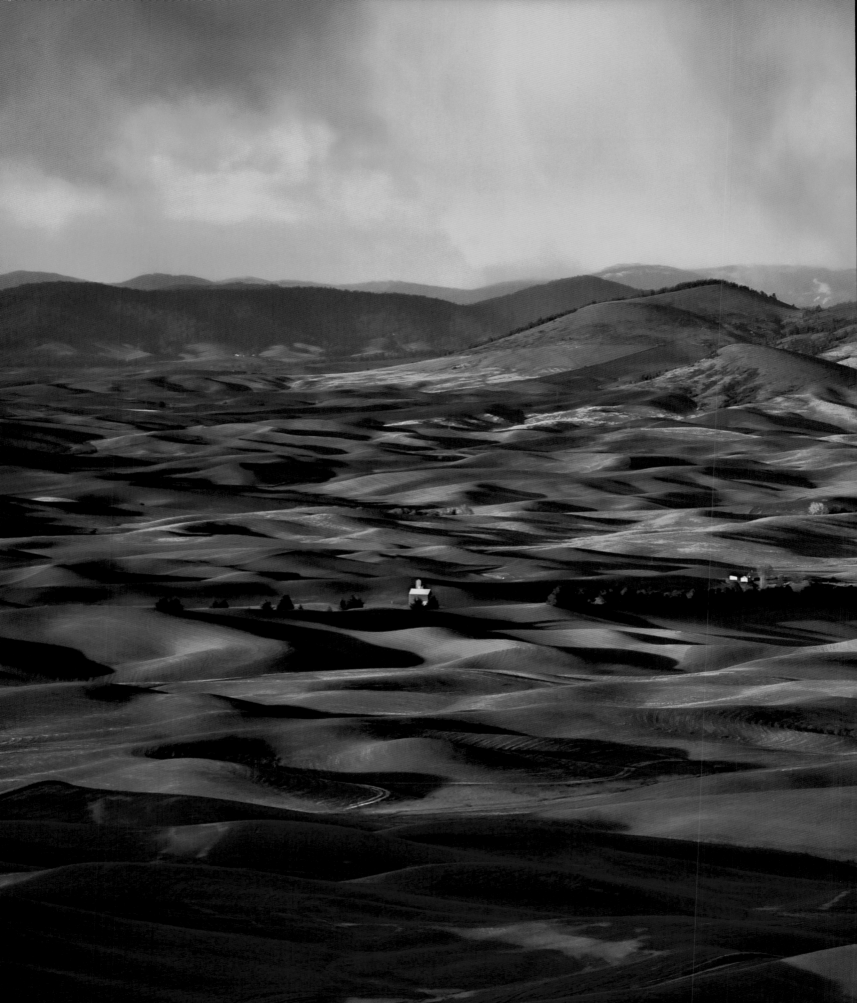

PLACES

PALOUSE HILLS

A sunset storm dapples the rolling hills of the Palouse, adding color and shadow to the rich earth. Rivers didn't form the slopes and hollows of the 4,000-square-mile (10,000-sq-km) region. Instead, geologists think that the rich soil was blown here by prehistoric dust storms during thousands of years. *(Chip Phillips, Washington)*

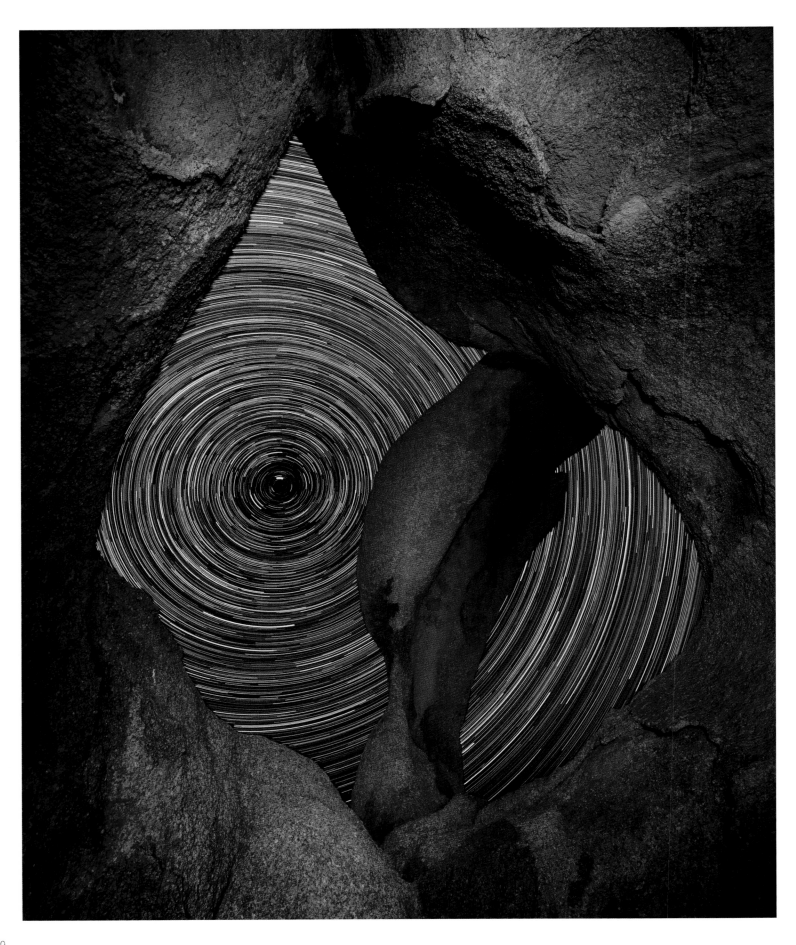

PLACES

Where shall we go today? Some place where we breathe in art—the dank smell of eons-old carvings witnessed by people who dreamed in a language unknown to us today. Or some other place where we drown in nature—where the splash and gush and current and turmoil of water erase all else from our minds.

Let's go far away, to places we would never explore on our own. Atop the skyscrapers of Hong Kong, all noise and bling and angles—or through silent, secret pathways leading to archetypal memories painted on the walls of the cave of Chauvet.

The farther we go, the more we wonder. Nature has sculpted breathtaking scenes. Rocks and trees, caverns and islands. And it's not only nature's extremes that astound us—even a common place can reveal treasure, when glimpsed, broken open at just the right moment.

It is to the intersection of time and place that we should travel. Those are the visions that satisfy us the most, whether ageless ruins half sunk in an ancient land or a momentary whir, birds taking wing against a sunset never to appear with quite those shapes and colors ever again.

OPPOSITE: **INTO THE VOID**
Captured by a long exposure, stars turn into a pinwheel in the sky, framed by a double arch in the
Alabama Hills outside of Lone Pine, California. The granite arches formed as erosion and water percolated through
the soil that covered these stones, rounding and sculpting them throughout millions of years. *(Jim Patterson, California)*

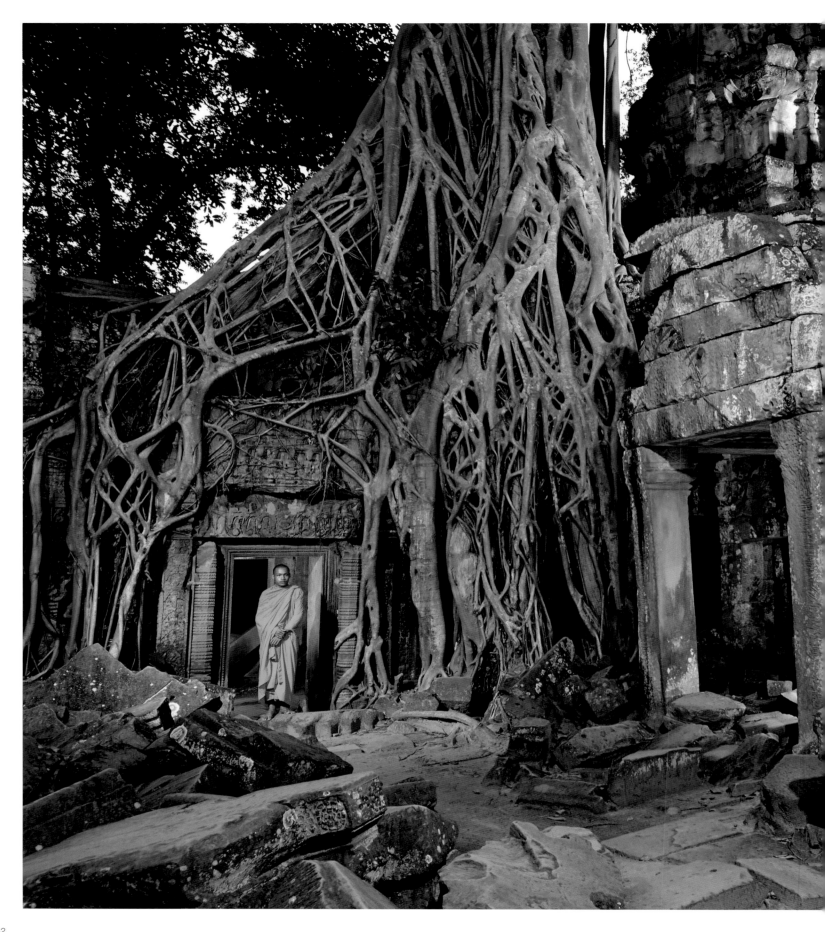

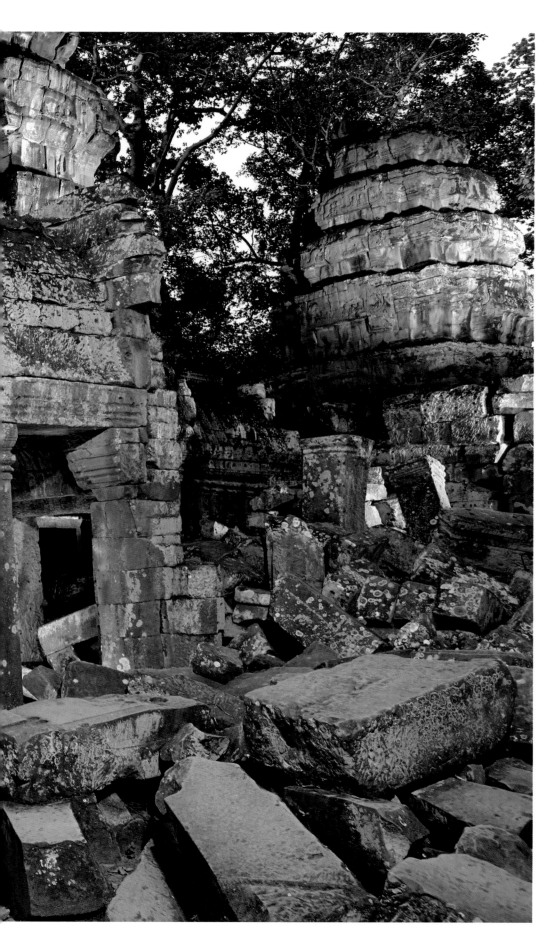

TA PROHM

A monk stands in a doorway of the root-covered temple complex Ta Prohm in Cambodia. Once abandoned, the temple, neighbor to the more famous Angkor Wat, was quickly reclaimed by the surrounding forest. Since no mortar was used when the temple was built in 1186, the roots of strangler figs and cotton trees had plenty of room to grow.
(Robert Clark, Cambodia)

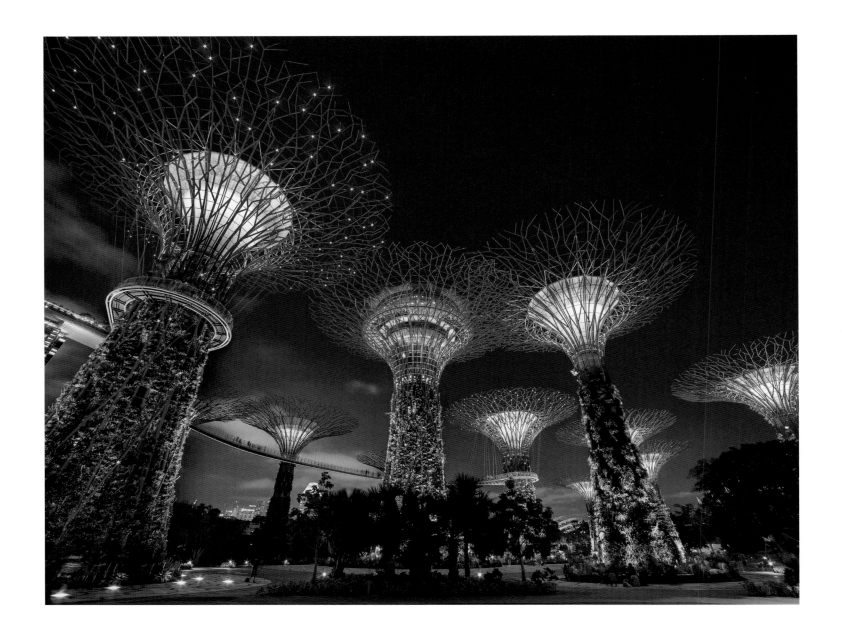

SUPERTREE GROVE

It's best to visit the supertrees in Singapore's Garden by the Bay at night. Visitors can stroll along a 420-foot-long (128-m) walkway that connects 2 of the 18 artificial trees, which stand as tall as a five-story building. The trees harvest solar energy during the day, and then come alive with a light and music show at night. *(Peter Stewart, Singapore)*

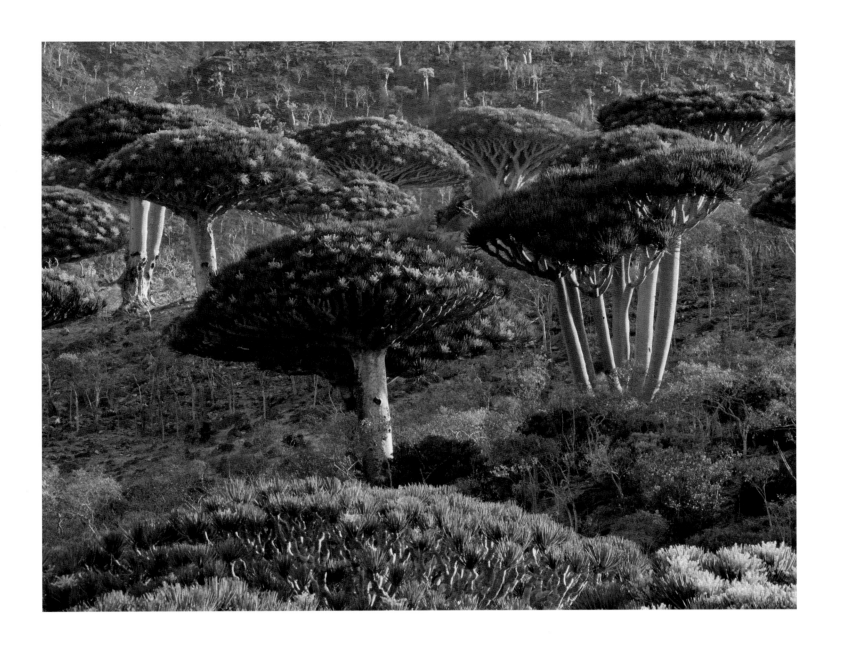

REACHING FOR THE SKY

Dragon's blood trees on Socotra, an island off the coast of Yemen, use their upstretched limbs to capture mist from the surrounding highlands. The vulnerable trees can only be found on this windswept island, and a decrease in seasonal cloud cover has created challenging conditions for young dragon's blood trees, threatening their survival. *(Michael Melford, Yemen)*

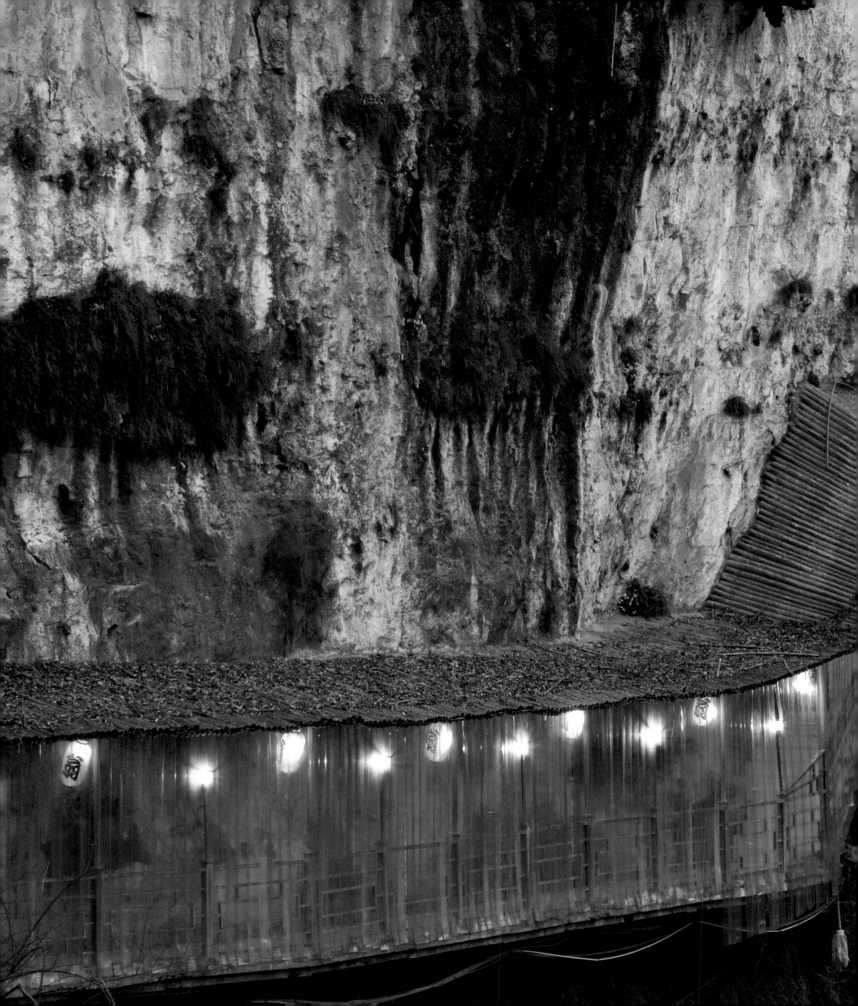

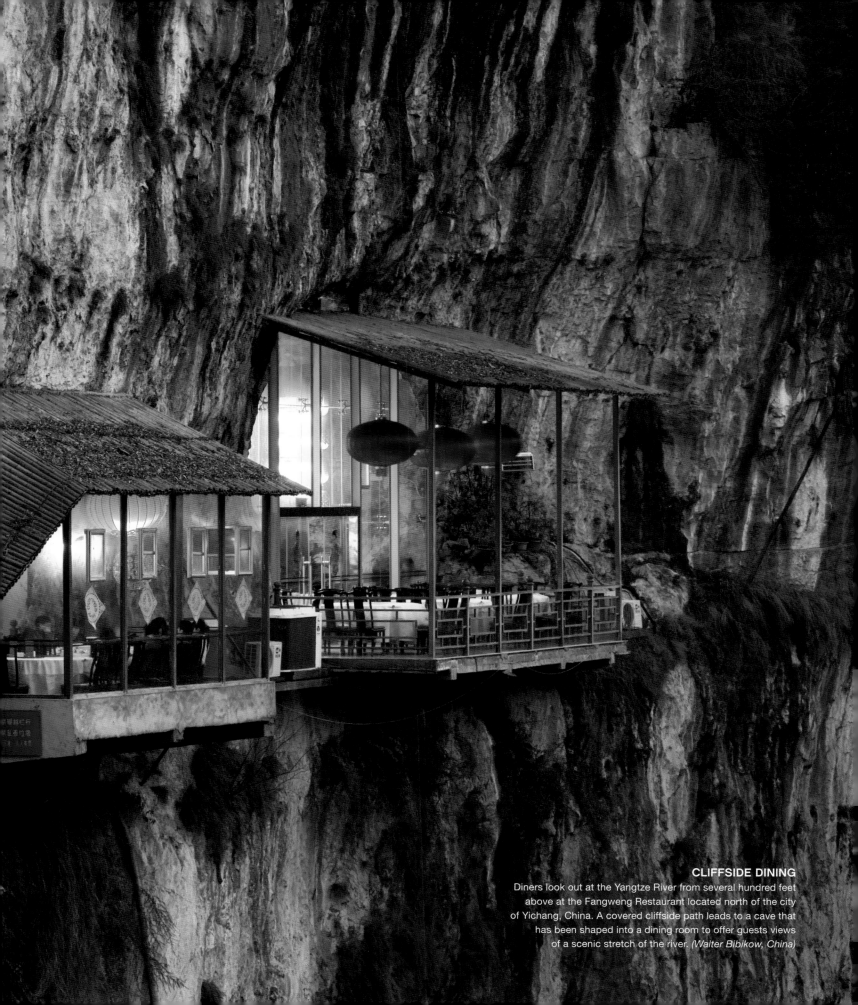

CLIFFSIDE DINING

Diners look out at the Yangtze River from several hundred feet above at the Fangweng Restaurant located north of the city of Yichang, China. A covered cliffside path leads to a cave that has been shaped into a dining room to offer guests views of a scenic stretch of the river. *(Walter Bibikow, China)*

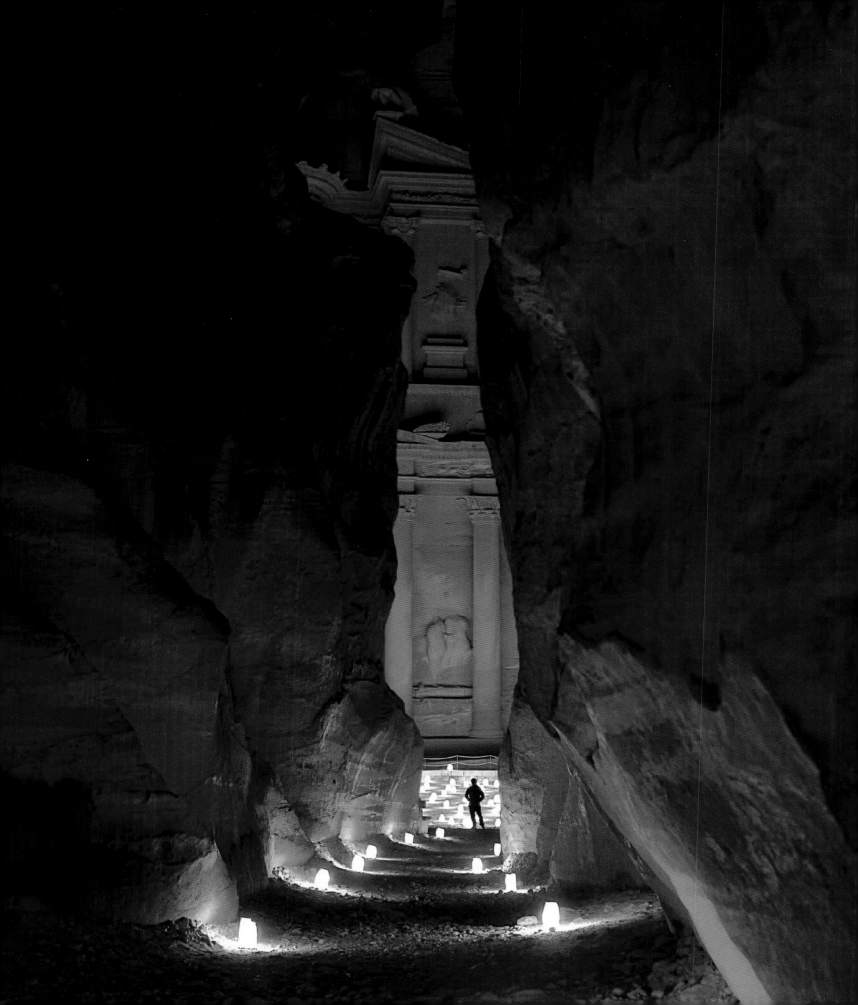

"The Treasury is the most photographed structure in all of Petra. I was there alone and early. A man who was preparing candles for a ceremony stopped to watch me. Were it not for his few seconds of perplexity, there wouldn't have been any poetic, solitary sense of scale—no true understanding of the enormous achievement this naturally carved 3,000-year-old canyon represents."

JOHN STANMEYER

OPPOSITE: **PETRA**
Candles shimmer on the pathway to the edifice of the Treasury in Petra. Nearly 3,000 years ago, the Nabateans carved the city out of solid rock. (*John Stanmeyer, Jordan*)

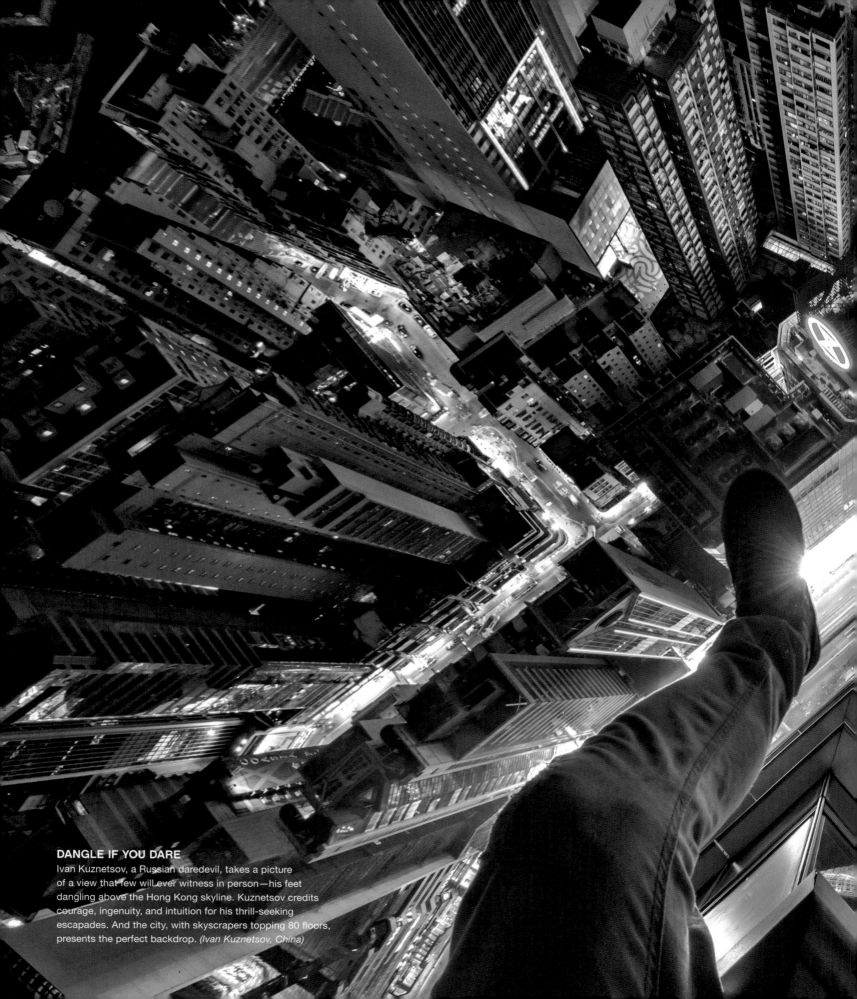

DANGLE IF YOU DARE
Ivan Kuznetsov, a Russian daredevil, takes a picture of a view that few will ever witness in person—his feet dangling above the Hong Kong skyline. Kuznetsov credits courage, ingenuity, and intuition for his thrill-seeking escapades. And the city, with skyscrapers topping 80 floors, presents the perfect backdrop. *(Ivan Kuznetsov, China)*

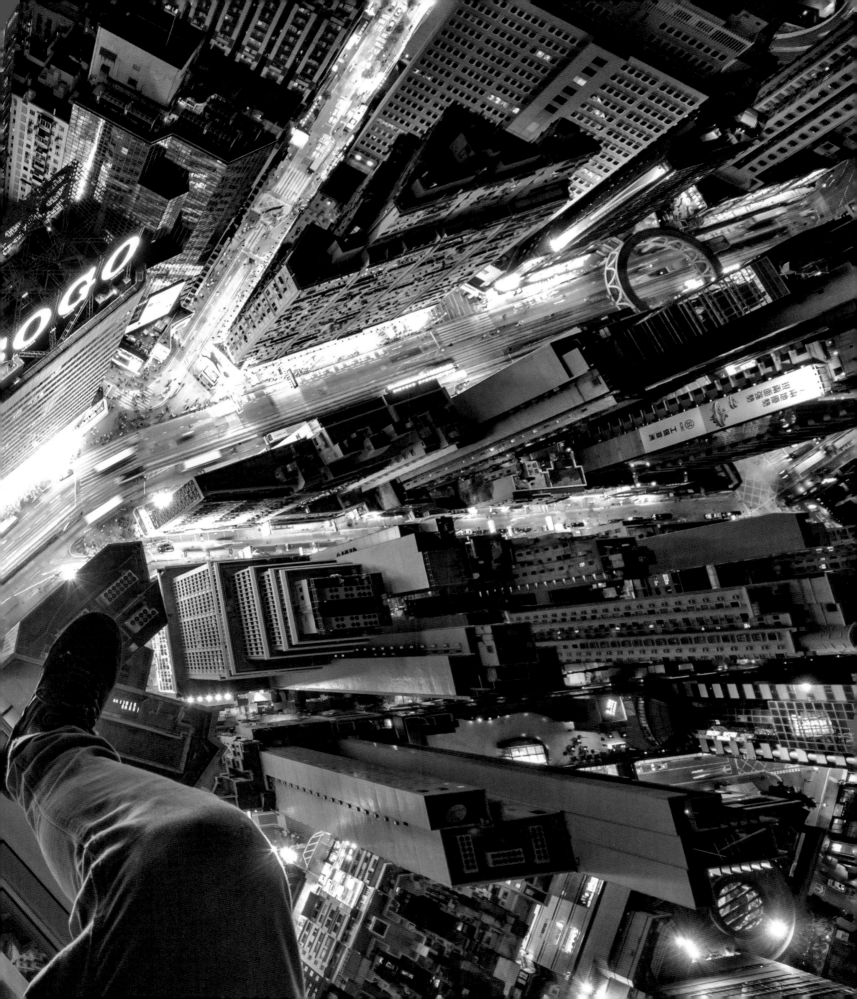

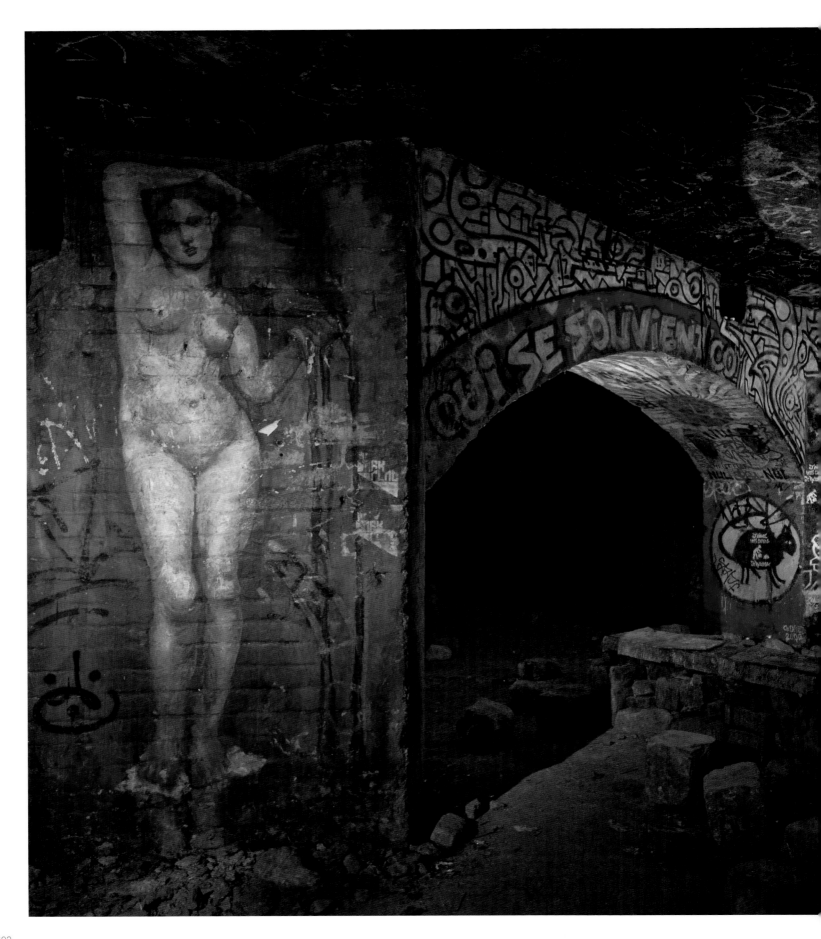

UNDERGROUND ART

Graffiti fills the tunnels under Paris, France, as if you are in an avant-garde museum. Frescoes in the abandoned Le Cellier, or "the storeroom" as tunnel aficionados call it, portray everything from a Greek-inspired nude to Keith Haring–esque geometric shapes. More than 180 miles (290 km) of these tunnels stretch below Paris. *(Stephen Alvarez, France)*

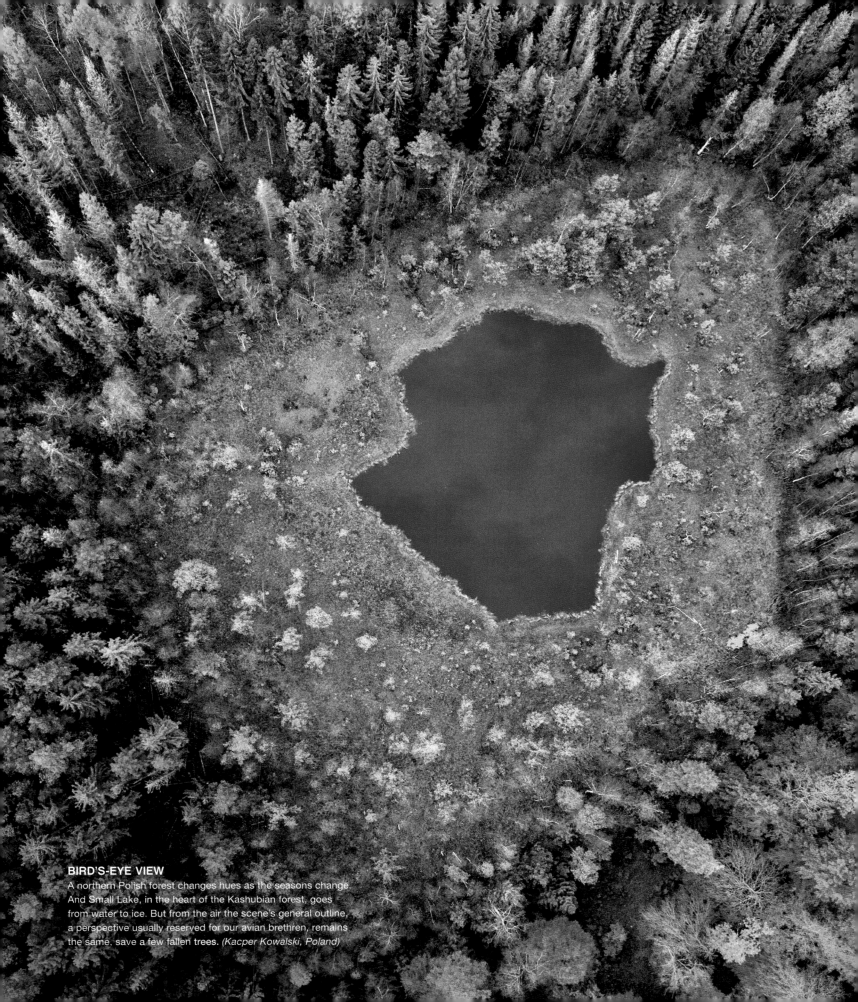

BIRD'S-EYE VIEW
A northern Polish forest changes hues as the seasons change. And Small Lake, in the heart of the Kashubian forest, goes from water to ice. But from the air the scene's general outline, a perspective usually reserved for our avian brethren, remains the same, save a few fallen trees. *(Kacper Kowalski, Poland)*

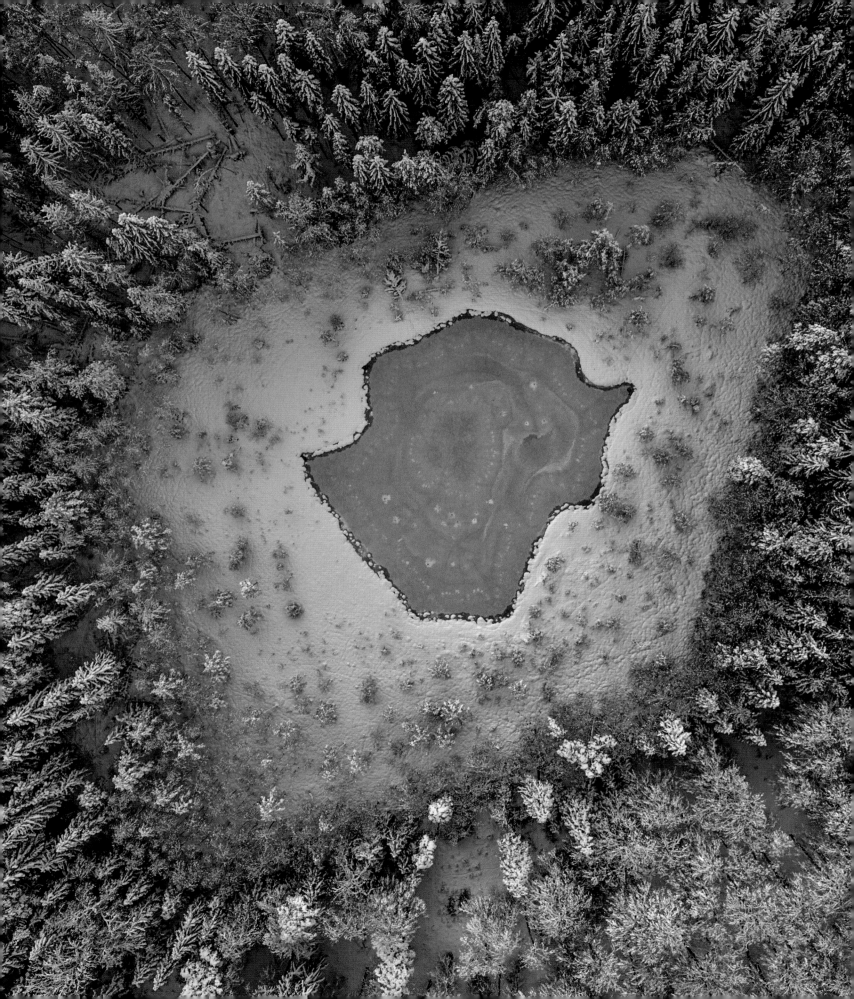

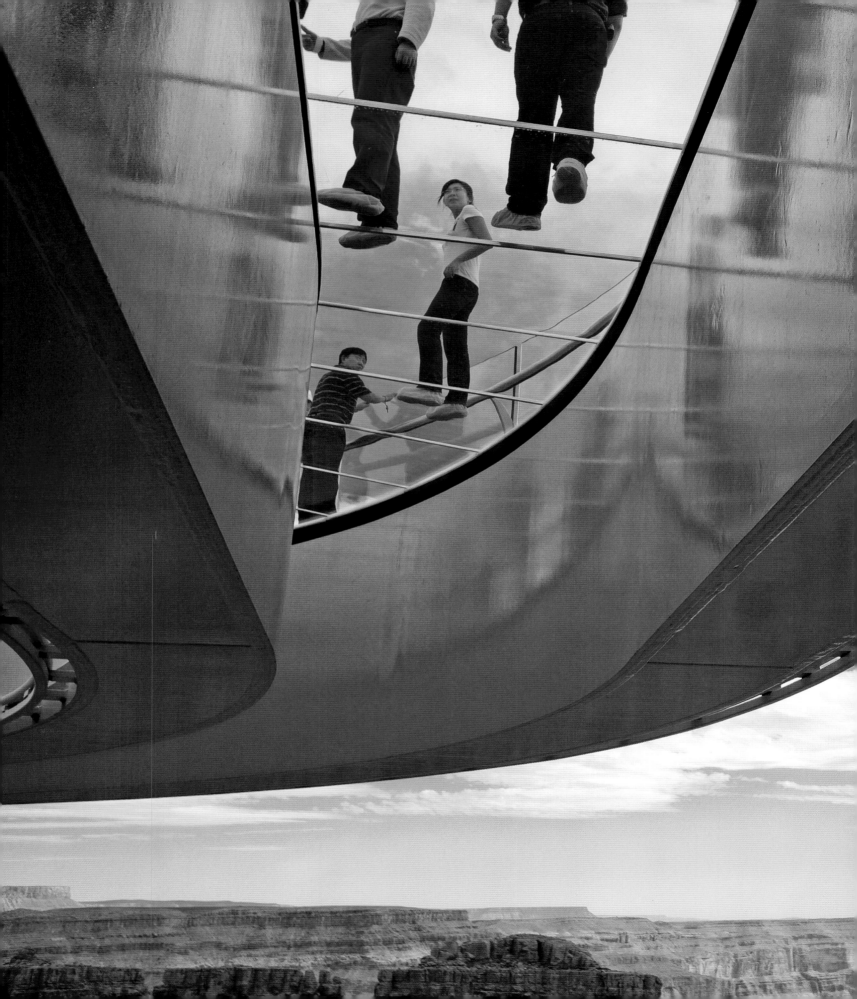

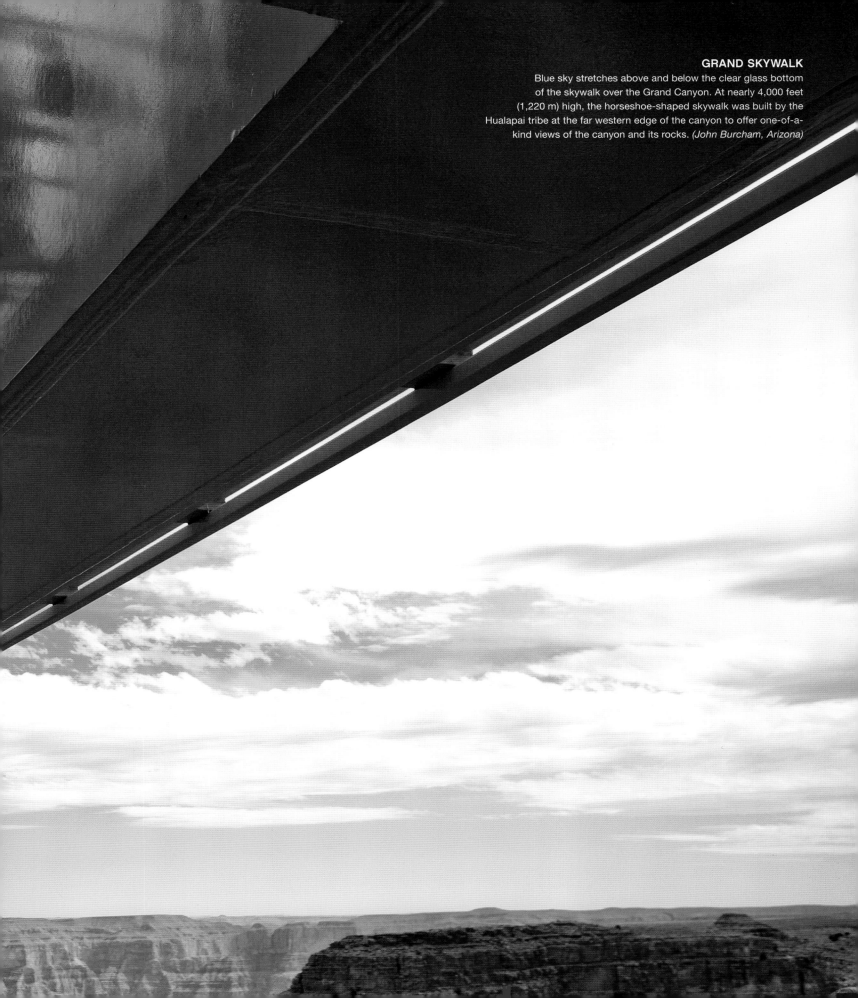

GRAND SKYWALK
Blue sky stretches above and below the clear glass bottom of the skywalk over the Grand Canyon. At nearly 4,000 feet (1,220 m) high, the horseshoe-shaped skywalk was built by the Hualapai tribe at the far western edge of the canyon to offer one-of-a-kind views of the canyon and its rocks. *(John Burcham, Arizona)*

"South of the tidal island on which Elizabeth Castle now stands is a small, rocky islet. Here, a hermit called Helier is said to have lived in a hollow in the rock in the sixth century. Pirates discovered Helier's cave, purportedly through a cloud of birds that surrounded it. They decapitated Helier, but he is said to have picked up his head and walked with it toward the shore. Helier is now the patron saint of Jersey. In the 12th century this small oratory, now known as the Hermitage of St. Helier, was built on the islet."

∞

STEVEN MORROW

OPPOSITE: **HERMITAGE ROCK**
Storm clouds gather over the Hermitage of St. Helier on a tidal islet on the south
coast of the island of Jersey in the English Channel. (*Steven Morrow, United Kingdom*)

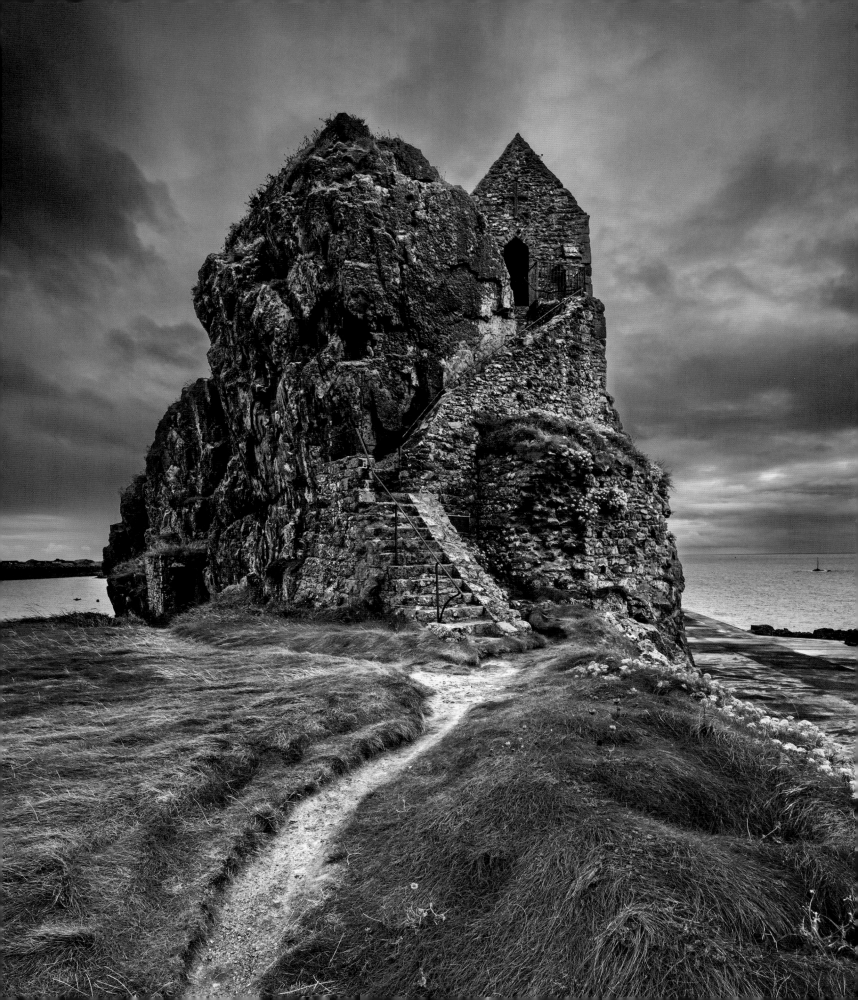

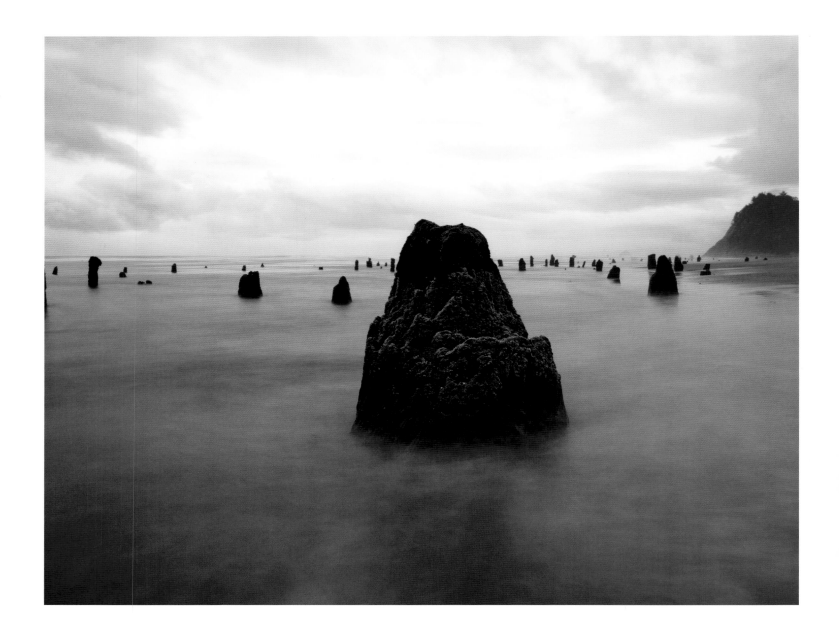

CEDAR FOREST

An ancient forest of cedar trees along a beach peek over the fog at low tide. Thought to date back 2,000 years, the stumps first became visible in 1998 after a winter storm scoured sand from the beach in Neskowin, Oregon. The trees, which had been submerged by an ancient earthquake, were preserved by the salt water. *(John Stanmeyer, Oregon)*

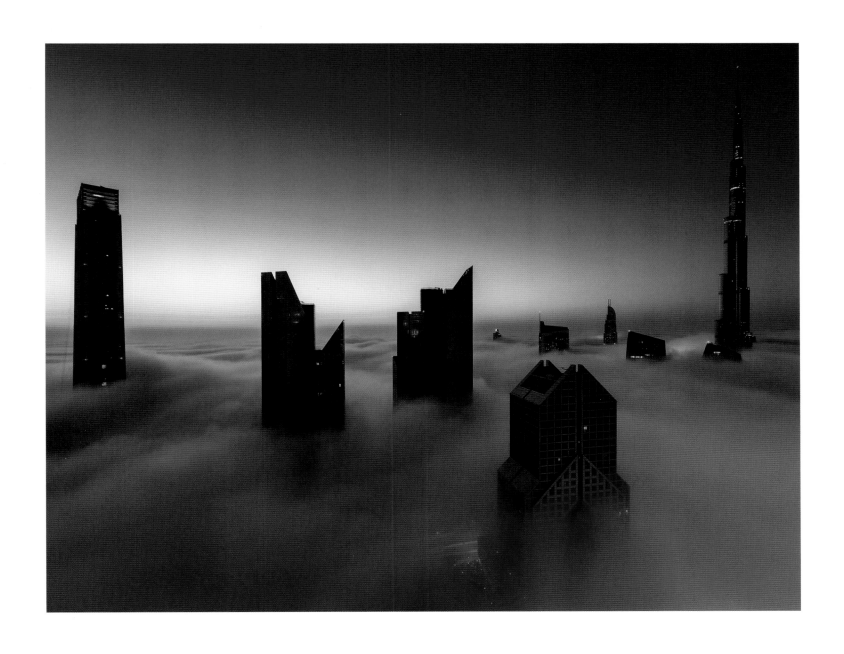

SKYSCRAPERS TOUCH THE SKY

The lights of Dubai's tallest skyscrapers sparkle at sunrise
above a dense layer of fog. A building spree in the 2000s
changed the desert skyline and created multiuse, impressively
tall buildings that have made the city a tourist destination.
(Marcelo Castro, United Arab Emirates)

WALK WITH THE FLOWERS

Inlaid flowers create a colorful tapestry as a woman walks across the 183,000-square-foot (17,000-sq-m) central courtyard of the Sheikh Zayed Mosque. The marble used in the construction came from all over the world. The mosque can hold 40,000 worshippers for prayer. *(Dave Yoder, Abu Dhabi)*

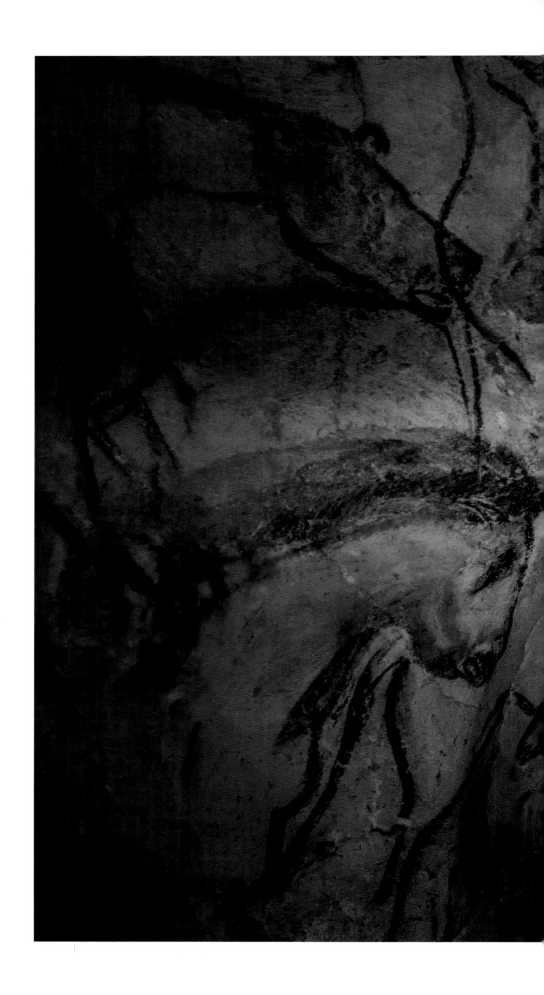

WALL ART

The walls come alive in Chauvet-Pont-d'Arc, first discovered by three friends exploring inside in 1994. The cave holds hundreds of paintings and engravings that are nearly 30,000 years old, created by our early ancestors of the Aurignacian culture. The bestiary includes lions, bears, and rhinos—animals no longer a threat in present-day France. *(Stephen Alvarez, France)*

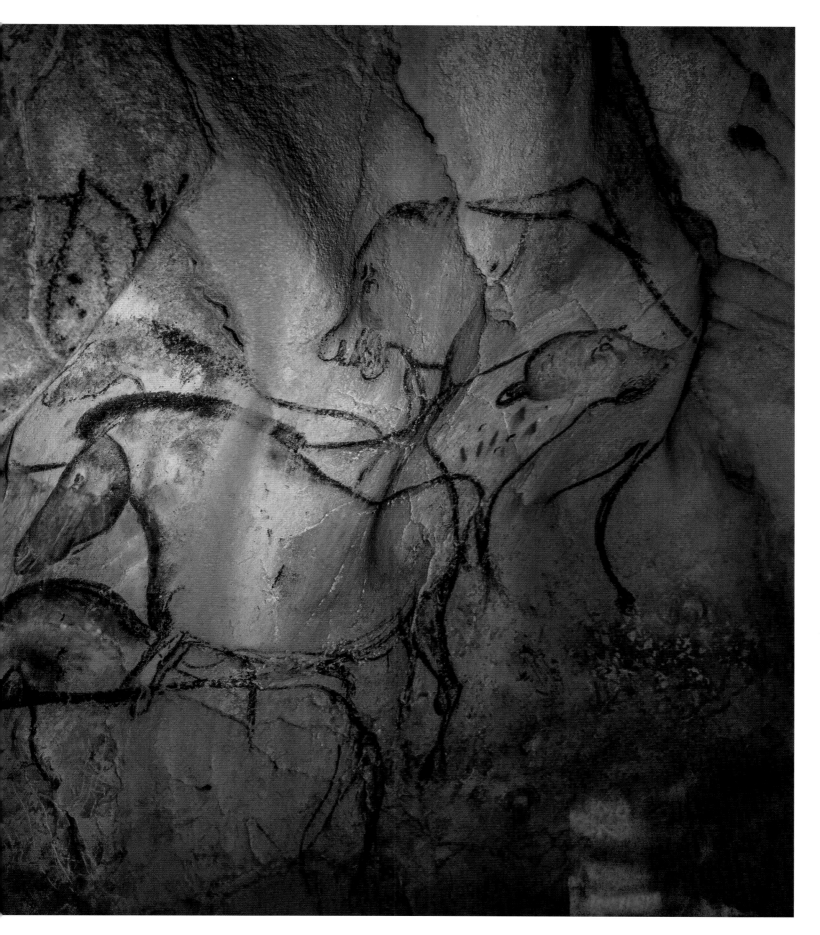

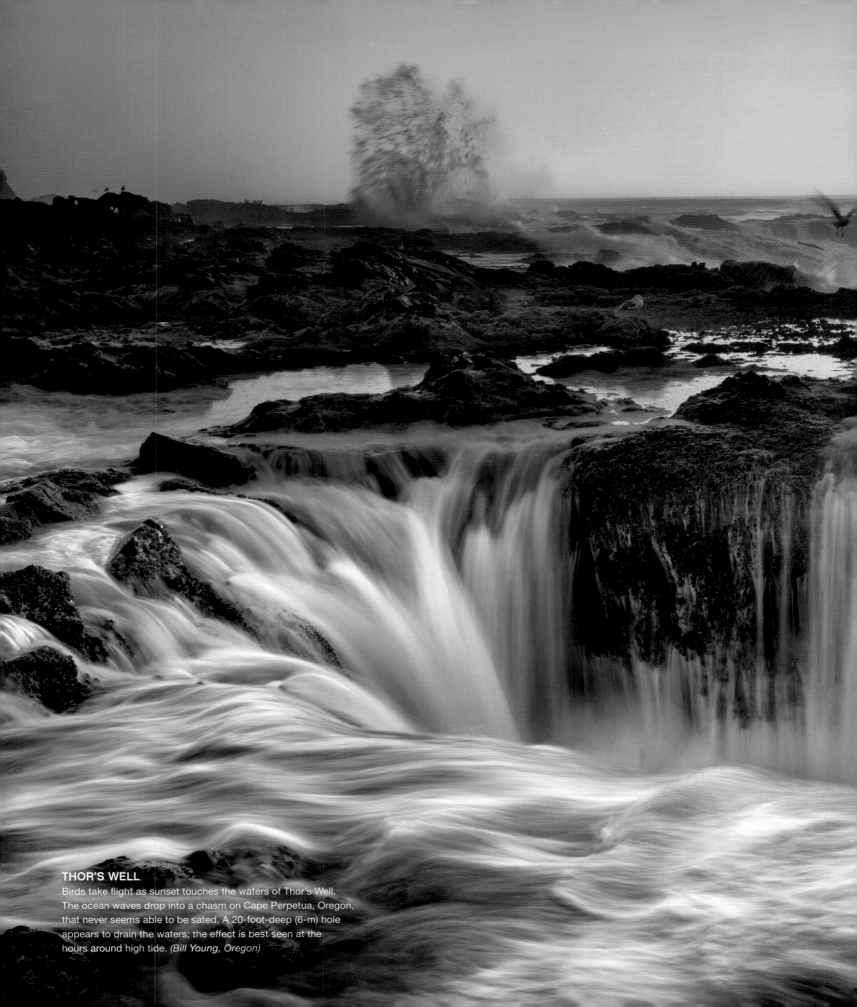

THOR'S WELL
Birds take flight as sunset touches the waters of Thor's Well.
The ocean waves drop into a chasm on Cape Perpetua, Oregon,
that never seems able to be sated. A 20-foot-deep (6-m) hole
appears to drain the waters; the effect is best seen at the
hours around high tide. *(Bill Young, Oregon)*

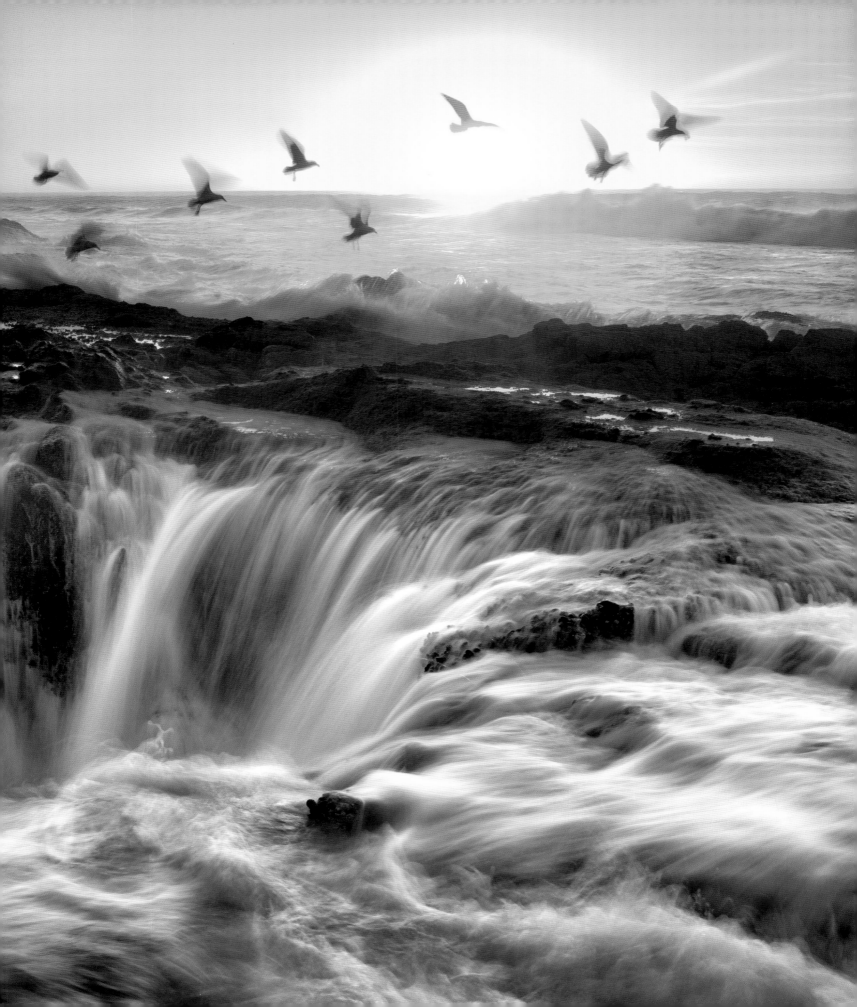

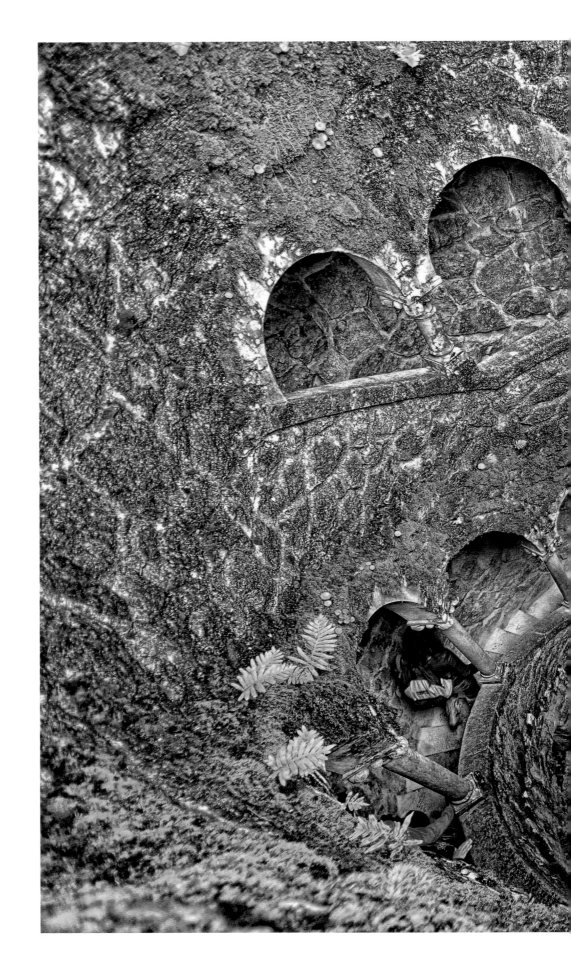

WELL OF INITIATION

A subterranean well winds down 89 feet (27 m) at the Quinta da Regaleira, a 10-acre (4-ha) estate and garden near Sintra, Portugal. The well, initially used during Tarot initiation rights, uses a series of underground walkways to link the aboveground buildings, fountains, and grottoes of the estate. Symbols of Masonry and the Knights Templar abound. *(Sagrario Gallego, Portugal)*

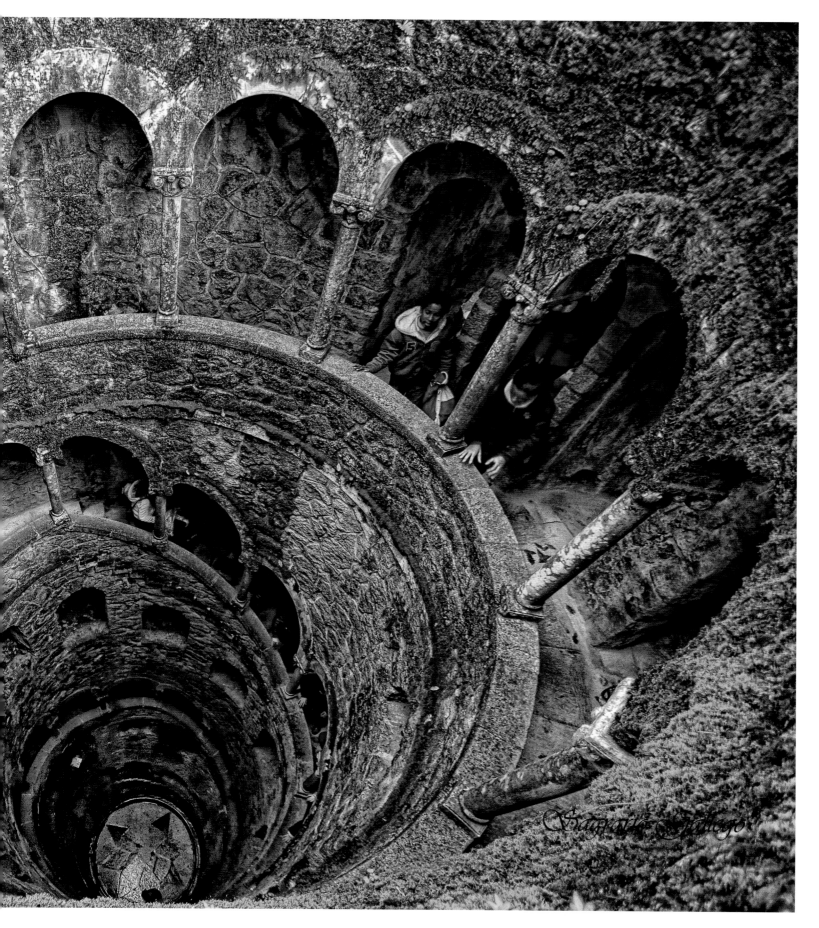

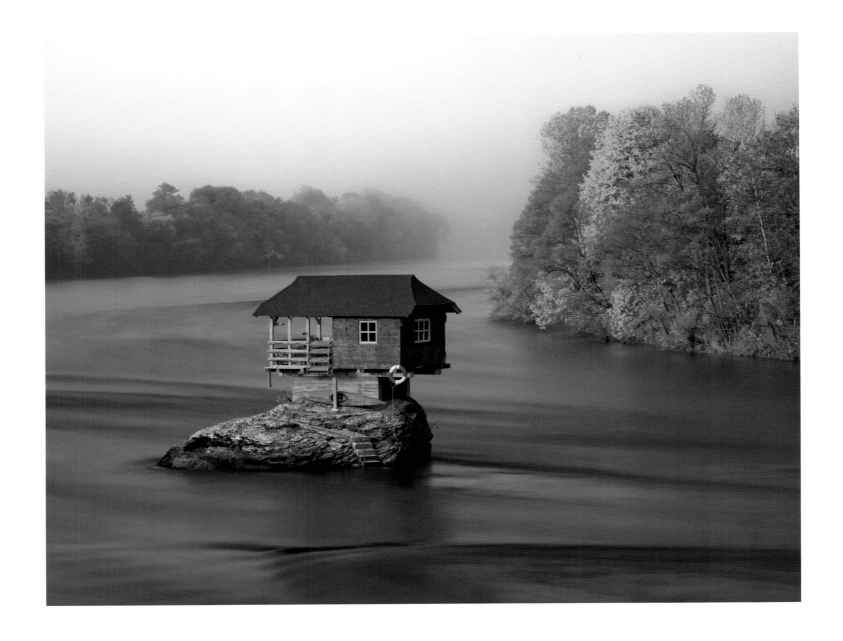

RIVER HOUSE

The lazy currents of the Drina River in Serbia surround this one-room "rock" house, which has been sitting here for more than 45 years. Materials to build this fortress in the middle of the river were carried by kayak or floated downstream. While storms and floods have led to repairs, the house has always been restored. *(Irene Becker, Serbia)*

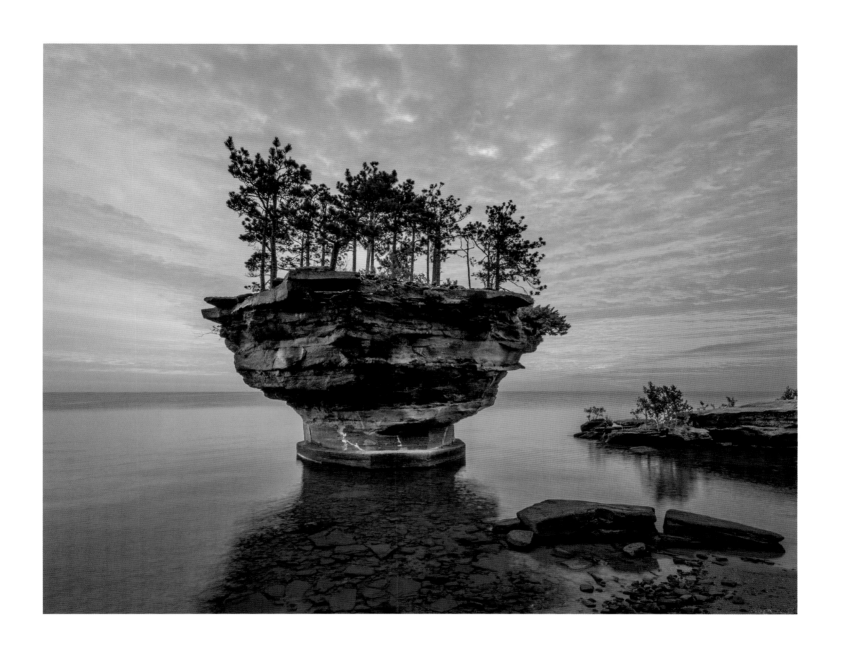

TURNIP ROCK

Sunrise creates a warm blush over Turnip Rock near Port Austin at the tip of Michigan's Lower Peninsula. At the first light of day, the photographer kayaked out into Lake Huron to capture the rock, which has been forming for thousands of years. *(David Frey, Michigan)*

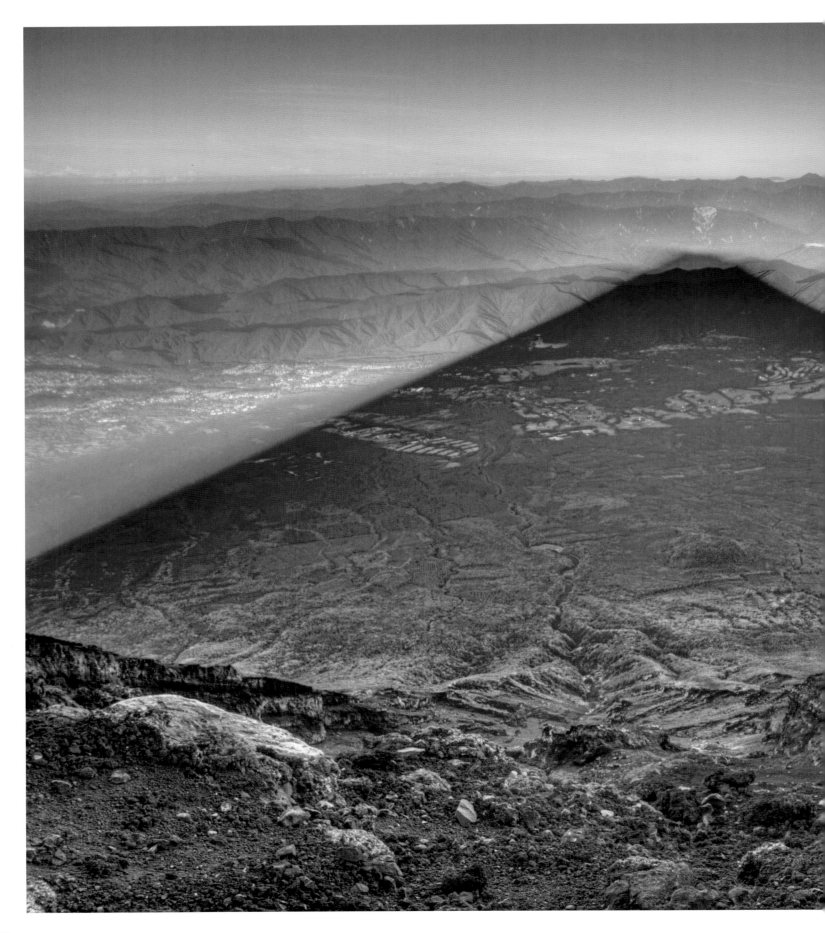

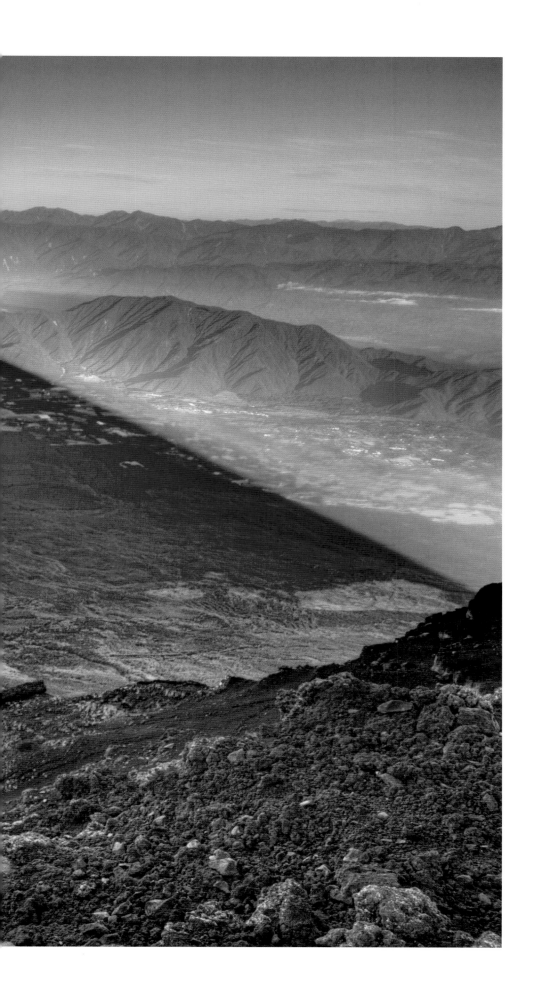

SHADOW MOUNTAIN
Mount Fuji casts a 15-mile-long (24 km) shadow over its surrounding plain. Every year some 200,000 people climb to the summit of the 12,380-foot-tall (3,776-m) volcano. The mountain is sacred for people of the Shinto faith and serves as the spiritual center of the nation. *(Kris J. Boorman, Japan)*

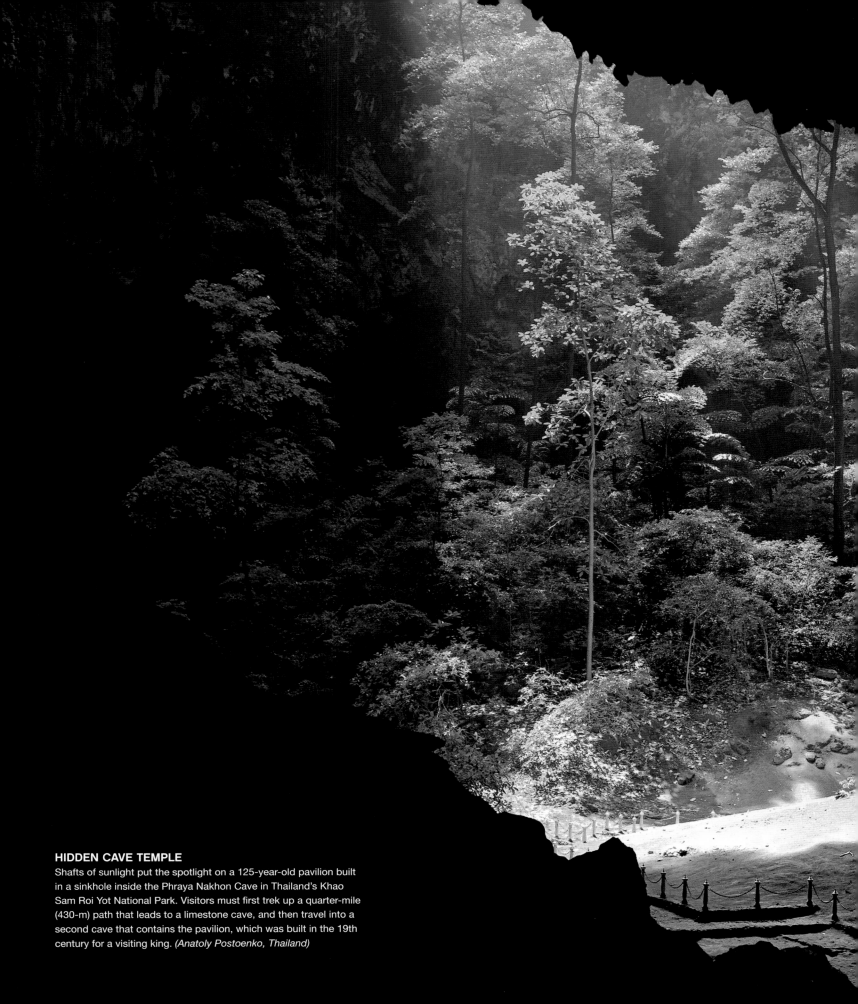

HIDDEN CAVE TEMPLE

Shafts of sunlight put the spotlight on a 125-year-old pavilion built in a sinkhole inside the Phraya Nakhon Cave in Thailand's Khao Sam Roi Yot National Park. Visitors must first trek up a quarter-mile (430-m) path that leads to a limestone cave, and then travel into a second cave that contains the pavilion, which was built in the 19th century for a visiting king. *(Anatoly Postoenko, Thailand)*

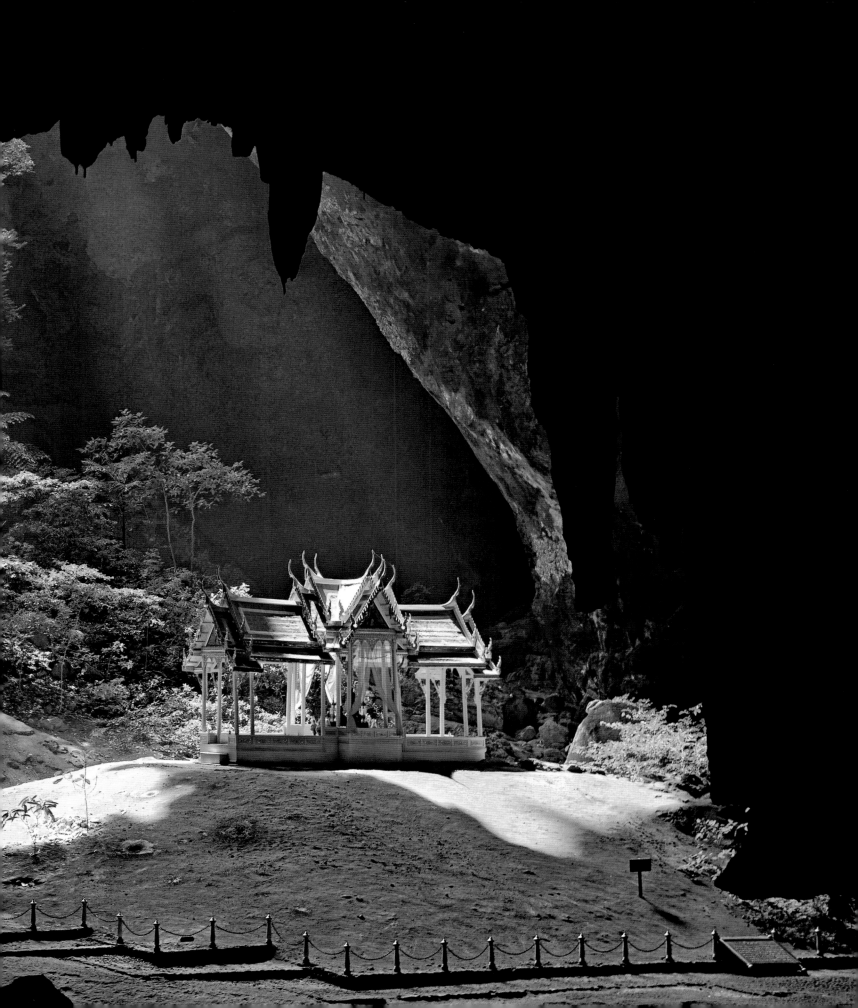

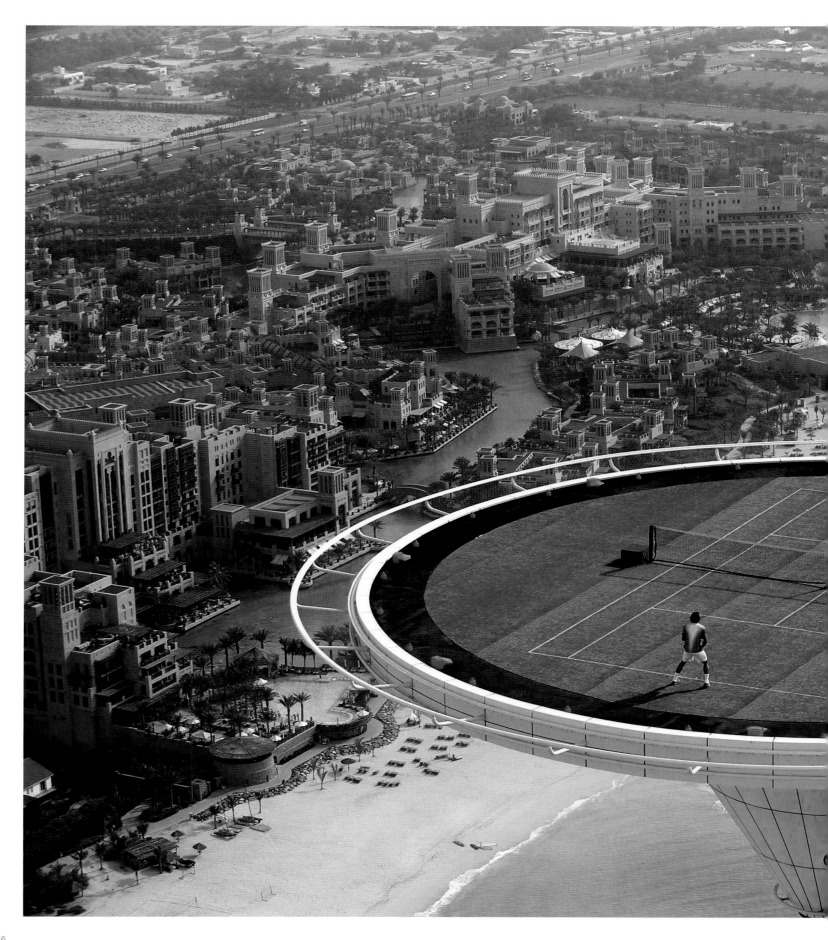

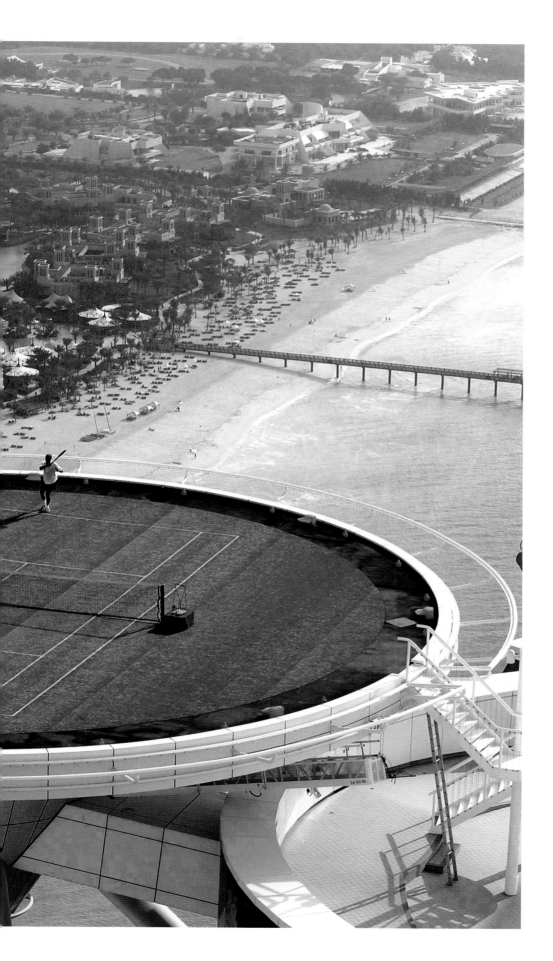

MATCH POINT

Tennis legends Andre Agassi and Roger Federer play a friendly match on the helipad of the Burj Al Arab hotel in Dubai. Serving on a court 690 feet (211 m) aboveground doesn't faze these champions. But they're not the only soaring sportsmen—table tennis and golf have also been played from these heights. *(european pressphoto agency, Dubai)*

"The Galápagos Islands provide
a window on time. In a geologic sense,
the islands are young,
yet they appear ancient."

FRANS LANTING

OPPOSITE: **PAHOEHOE LAVA FORMATIONS**
Pahoehoe lava forms swirls and ropes alongside Sullivan Bay in the Galápagos Islands. This kind of lava
moves over land as a thick liquid and forms intricate patterns as it encounters uneven terrain. *(Frans Lanting, Ecuador)*

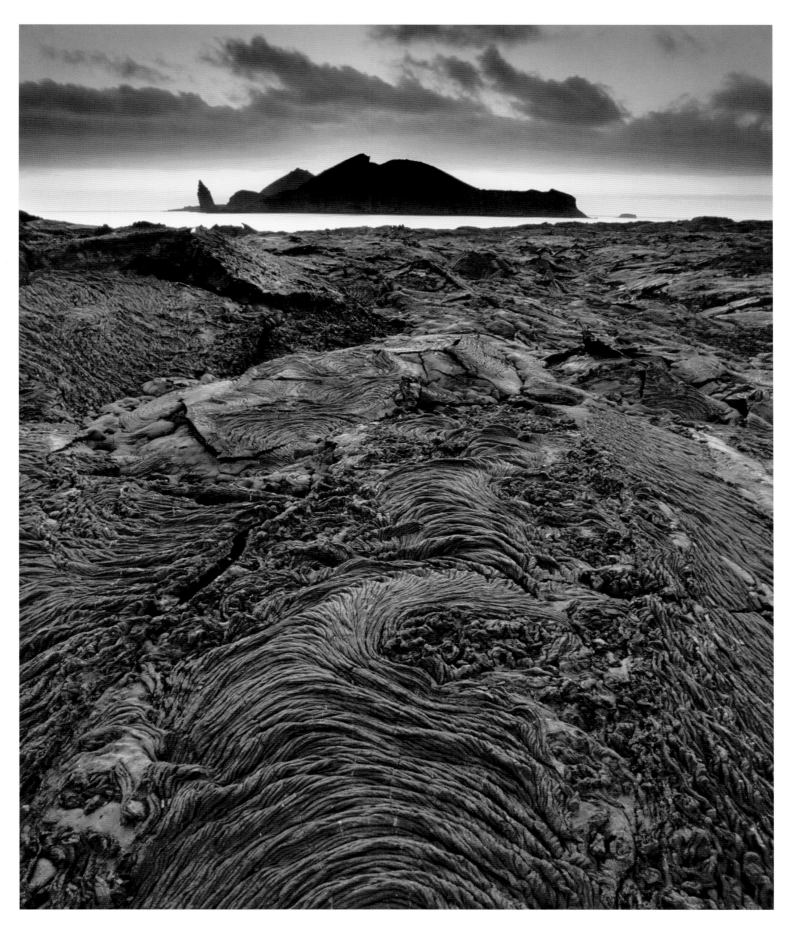

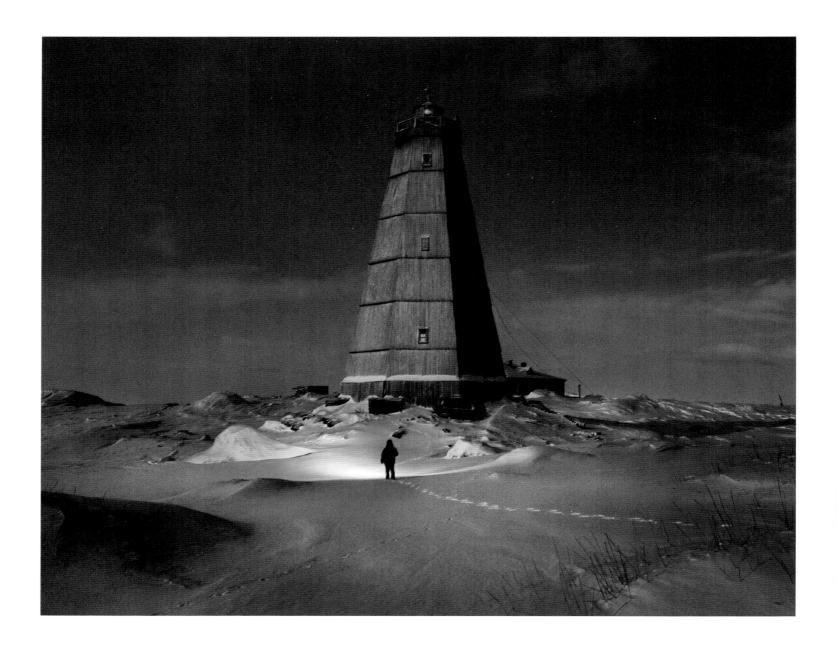

REMOTE WEATHER

A flashlight and the full moon light this abandoned lighthouse in Khodovarikha, a remote spot on the shore of the Barents Sea. Previously, the lighthouse served ships using the Northern Sea Route. Now a lone weatherman from a nearby weather station visits it to measure the temperature, the wind, and, of course, the snow in the Arctic area. *(Evgenia Arbugaeva, Russia)*

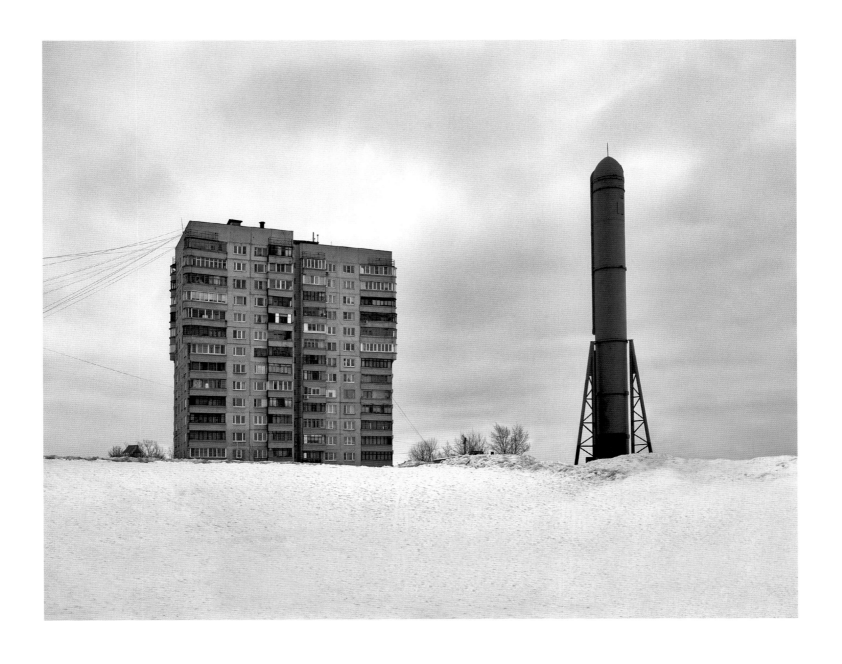

ABANDONED MISSILE

"Build it and they will abandon it" should be the motto of this empty Siberian missile-making town. These restricted areas and secret cities of the U.S.S.R. aren't easy to get to but tell of the deep military history of the Soviet past and a different age. *(Danila Tkachenko, Russia)*

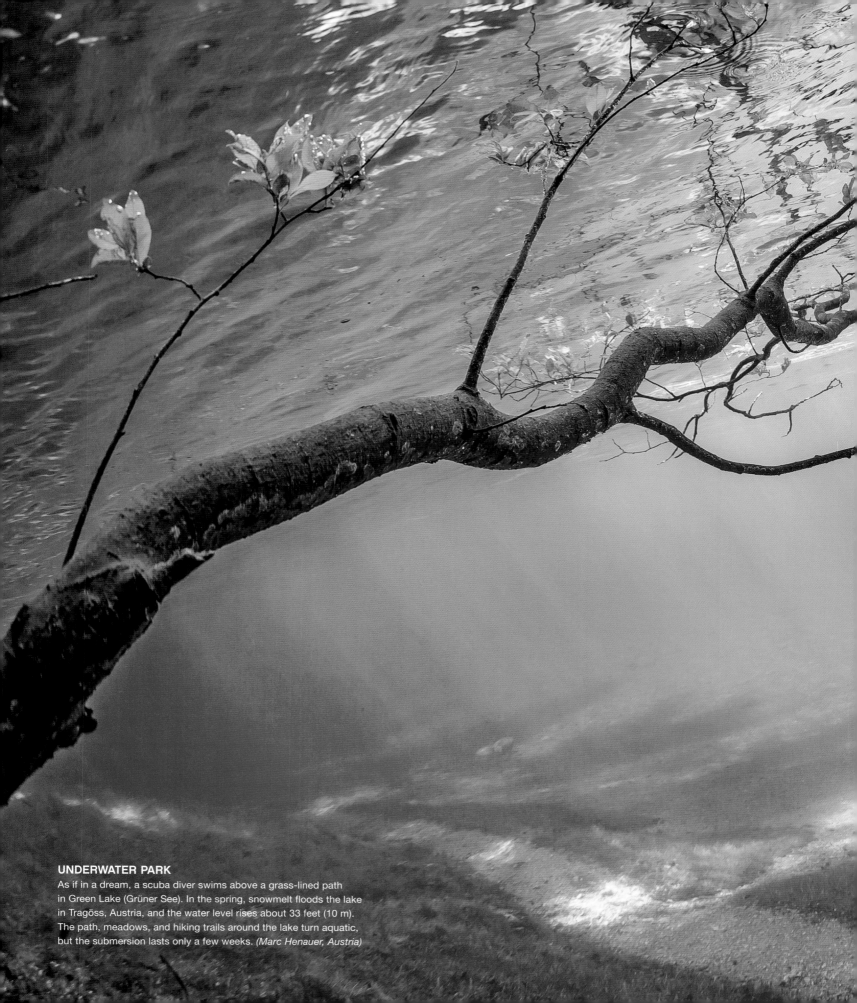

UNDERWATER PARK

As if in a dream, a scuba diver swims above a grass-lined path
in Green Lake (Grüner See). In the spring, snowmelt floods the lake
in Tragöss, Austria, and the water level rises about 33 feet (10 m).
The path, meadows, and hiking trails around the lake turn aquatic,
but the submersion lasts only a few weeks. *(Marc Henauer, Austria)*

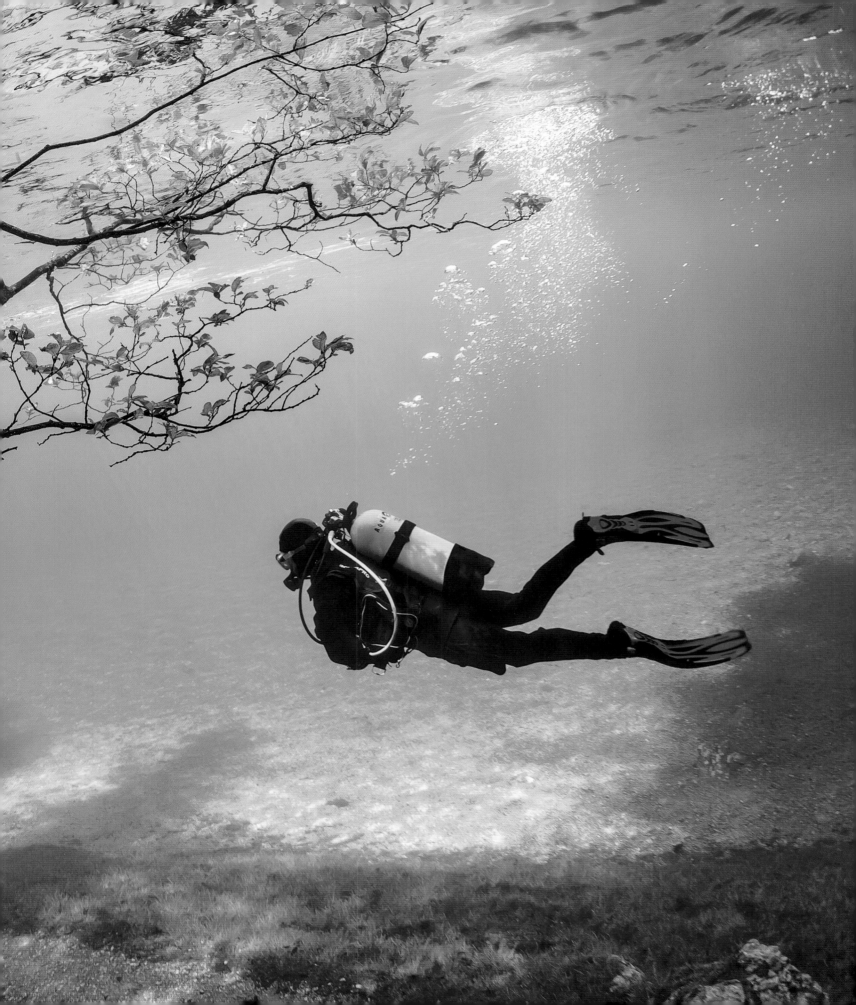

INSIDE THE VATICAN

The Renaissance murals and gilded ceiling surround visitors of the Sala Regia, the state hall in the Apostolic Palace in the Vatican. Painted in the 16th century, the frescoes depict important events in the history of the church. Although it's the world's least populous country, Vatican City does not want for splendor. *(Victor Boswell, Vatican City)*

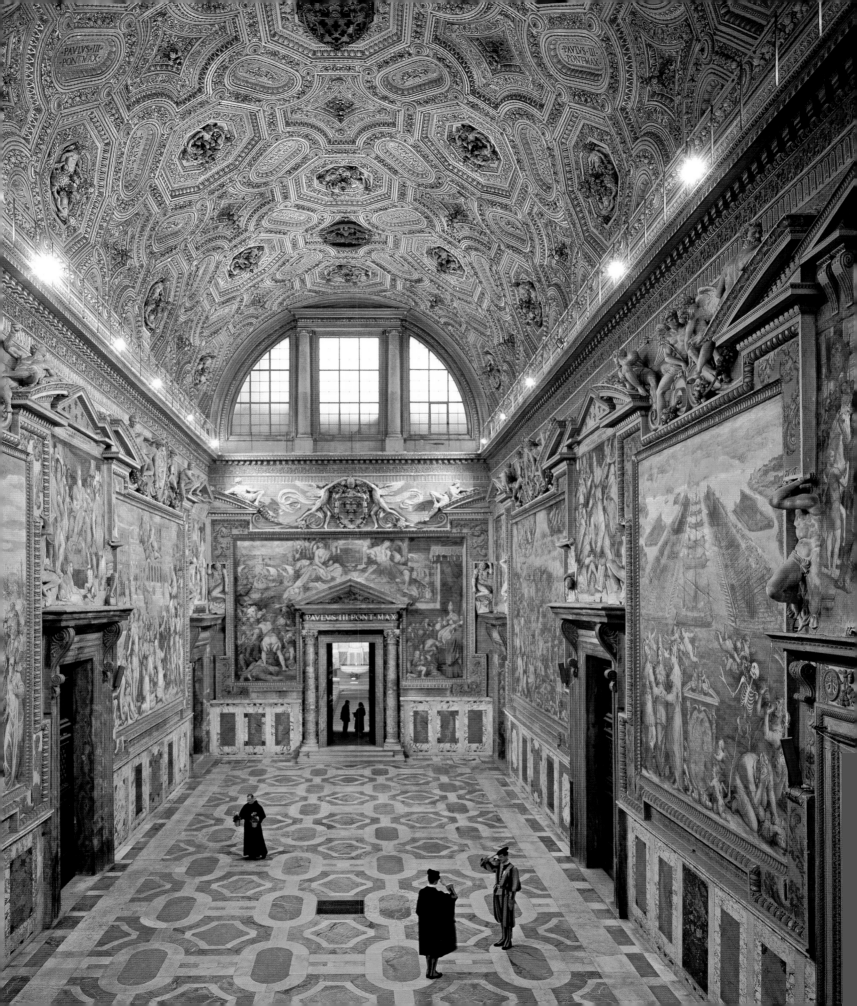

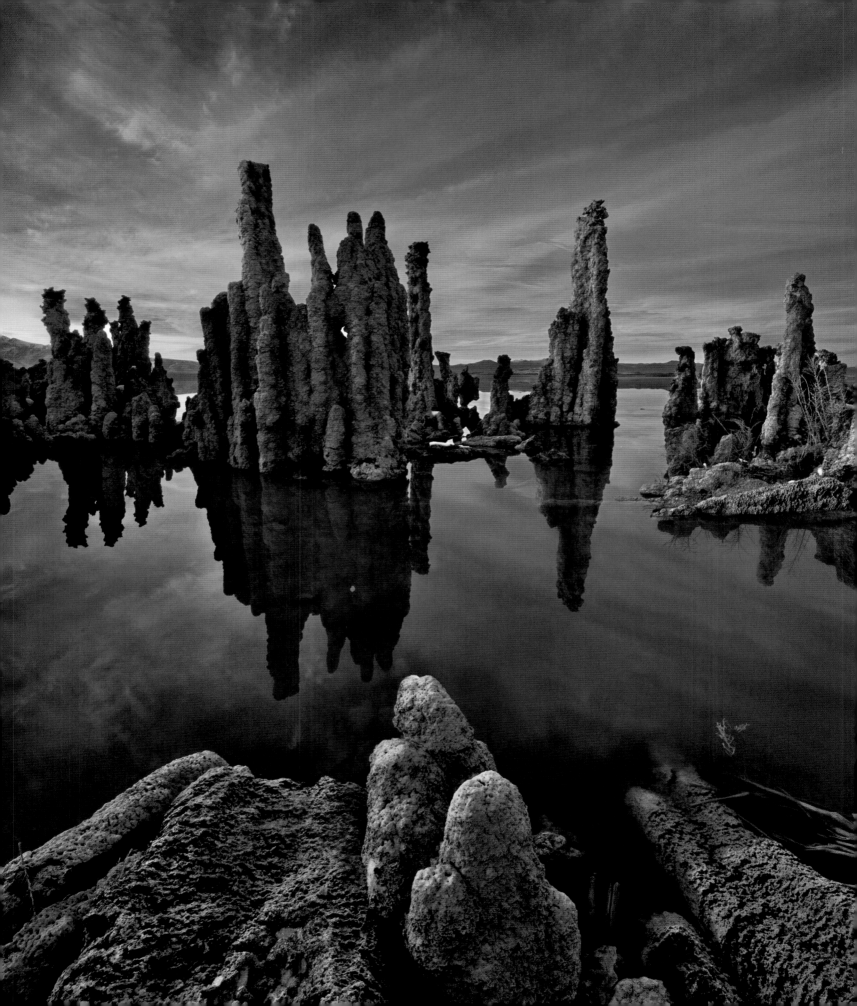

"On this evening I happened to catch one of the most colorful sunsets I have seen at Mono Lake in California. These reflections of the unique tufa formations, in my mind, represent more than just natural beauty. This photograph depicts the end of an era at Mono. With California continuing to dry up, Mono Lake has gone with it. Today the water level is lower than ever—no shots like this are possible anymore and no one knows if they ever will be again."

MARC ADAMUS

OPPOSITE: **MONO FIRE**
Tufa towers in Mono Lake were formed underwater by a chemical reaction between calcium-rich springs and lake waters full of carbonates. Receding lake waters have revealed the towers. *(Marc Adamus, California)*

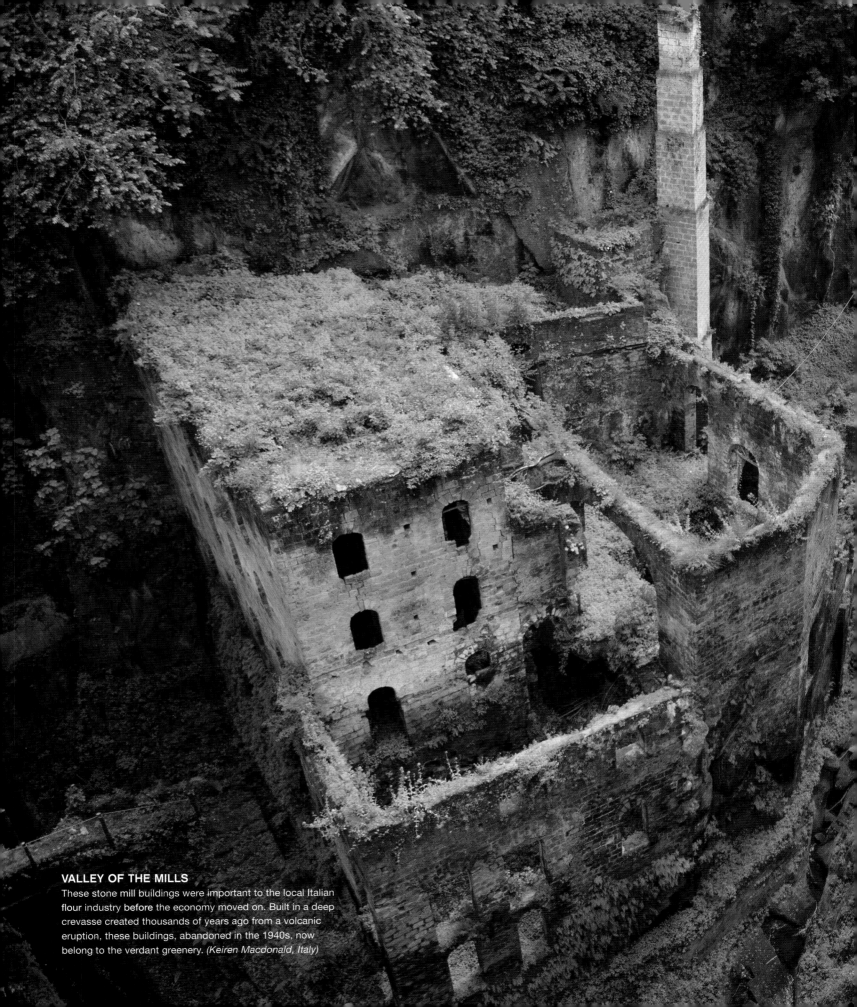

VALLEY OF THE MILLS
These stone mill buildings were important to the local Italian flour industry before the economy moved on. Built in a deep crevasse created thousands of years ago from a volcanic eruption, these buildings, abandoned in the 1940s, now belong to the verdant greenery. *(Keiren Macdonald, Italy)*

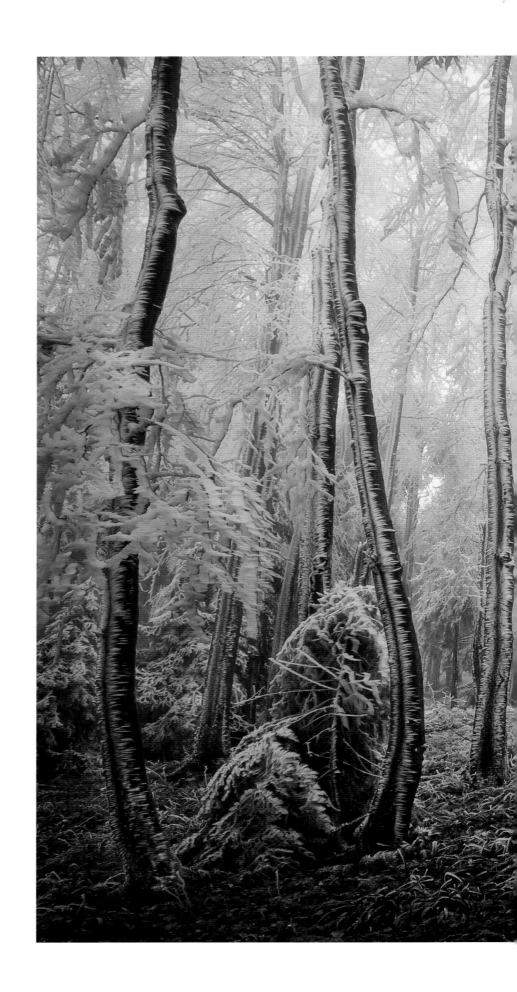

FROST IN THE TREES

A combination of low temperatures, high winds, and precipitation created a frozen masterpiece in the Beskidy Mountains on the border between the Czech Republic and Slovakia. The directional pattern of the ice appeared just long enough to be captured on camera.
(Jan Bainar, Czech Republic)

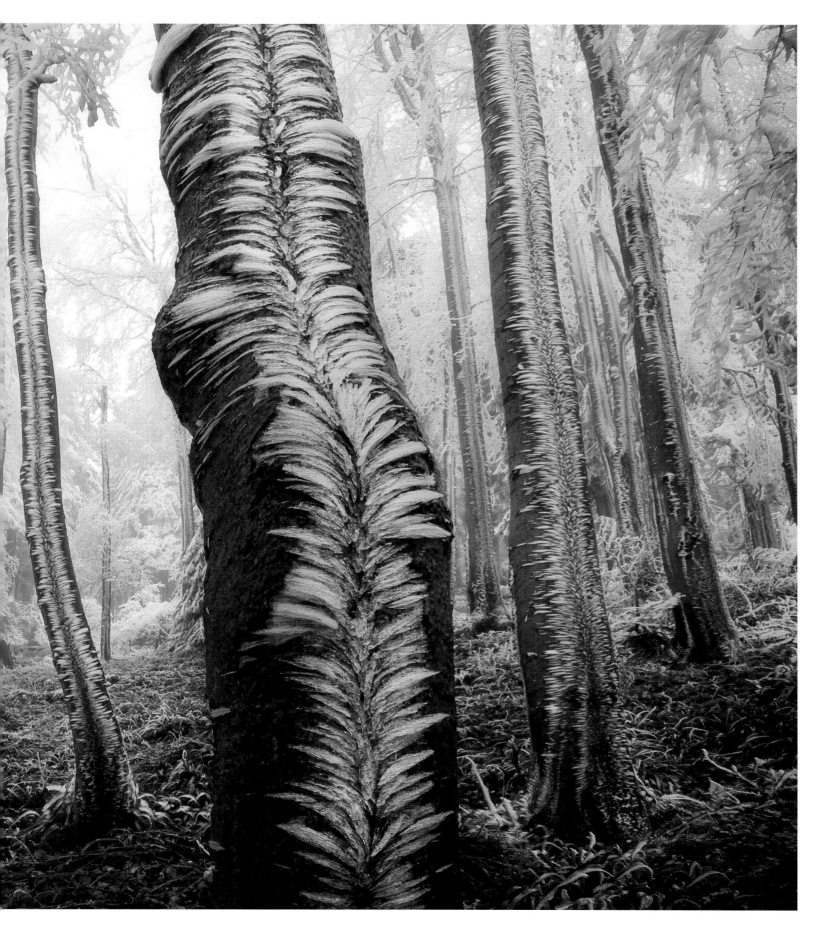

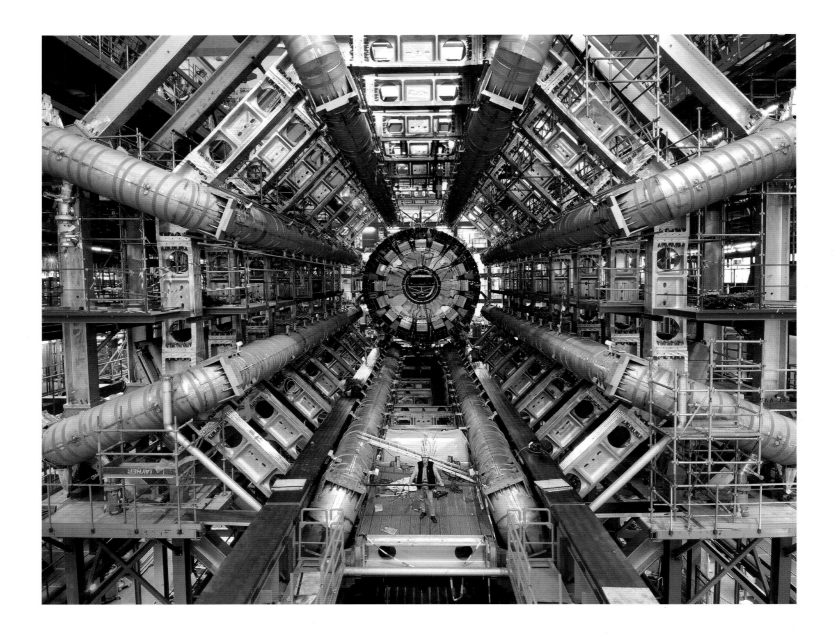

CERN COLLIDER

The limits of technology intersect with this six-story building at the Large Hadron Collider at the European Organization for Nuclear Research (CERN). This high-tech physics experiment accelerates two particle beams to nearly the speed of light before they collide—enabling scientists to study clues about what the universe was like at the very beginning, right after the big bang. *(Maximilien Brice, Switzerland)*

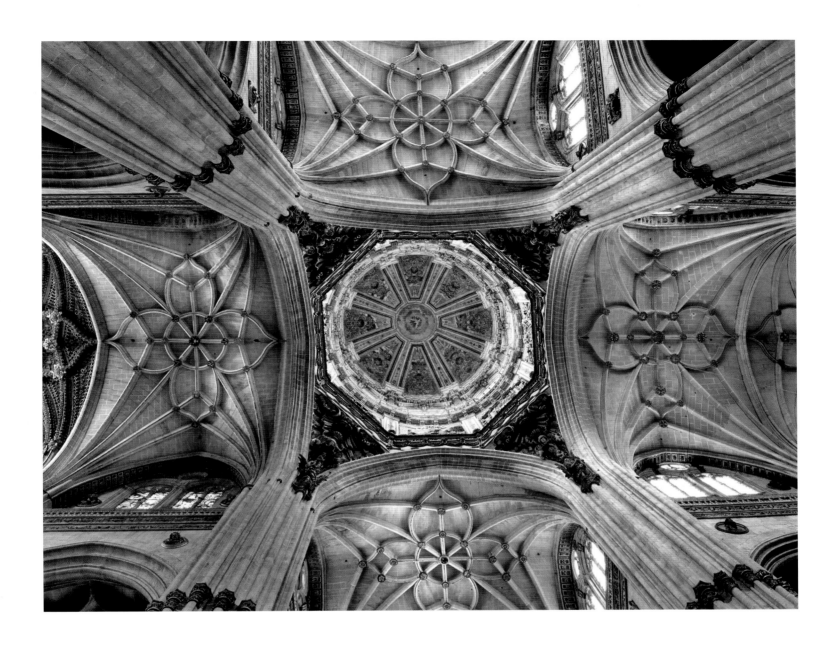

CATHEDRAL CEILING
The decorated ceiling and cupola of the New Cathedral
in Salamanca, Spain, creates a geometric puzzle. Construction
of the Roman Catholic cathedral began in the Gothic style,
to match the adjoining 12th-century cathedral. The baroque
cupola wasn't added until the 18th century. *(Manuel Cohen, Spain)*

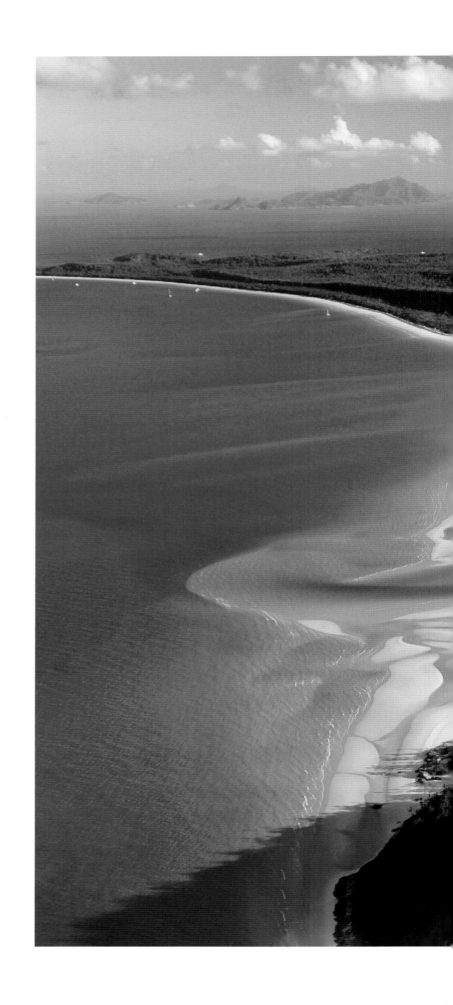

WHITEHAVEN BEACH

Shifting tides create new patterns of white silica sand in the clear, turquoise water of Australia's Whitsunday Island, the largest of the 74 islands in the Whitsundays. More than 4 miles (7 km) long, the cove at the northern end of the island creates shifting scenes as the tide changes. *(Gerhard Zwerger-Schoner, Australia)*

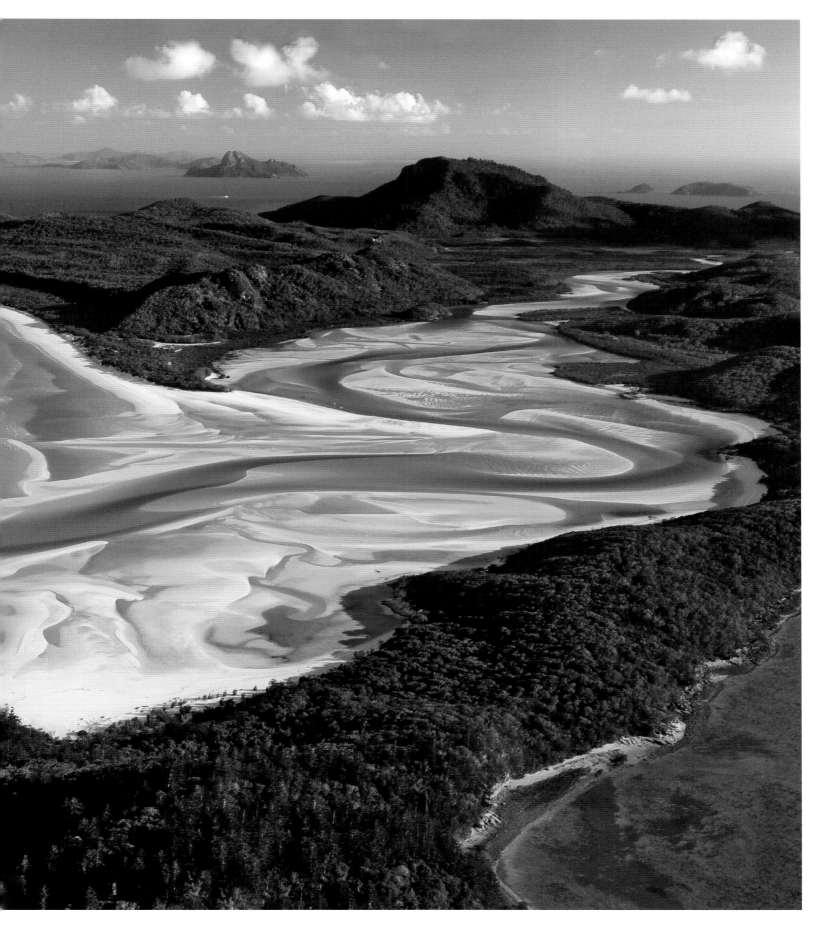

UNDERWATER BALLROOM

Socialite Whitaker Wright built this room under an artificial lake at his Witley Park estate in the late 19th century. Wright's elaborate mansion in Surrey, England, included this subterranean room with its 30-foot-tall (9-m) aquarium ceiling, but after his death the estate was left to decay. Access to the former smoking room is now locked. *(Marc Roberts, United Kingdom)*

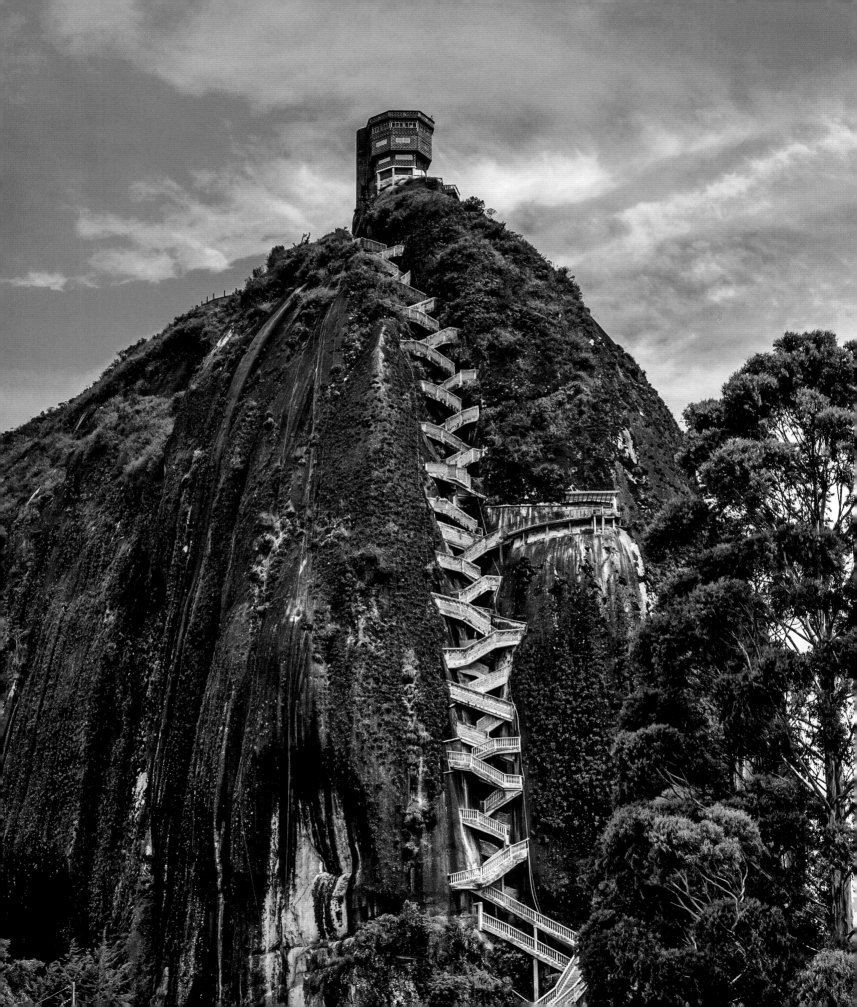

"Climbing up the zigzagging stone steps of this ten-million-ton rock took some effort, but the views from the top were worth it. The staircases are like a zipper stitching the rock together. Perched at the top, above the Colombian countryside, you see miles of clear lakes, mountains, and small tree-covered islands."

GAME OF LIGHT

OPPOSITE: **THE ROCK OF GUATAPÉ**
It takes some 650 steps to reach the top of the massive rock known as the Rock of Guatapé
or the Rock of Peñol, which is visible for miles from the surrounding plain. *(Game Of Light, Colombia)*

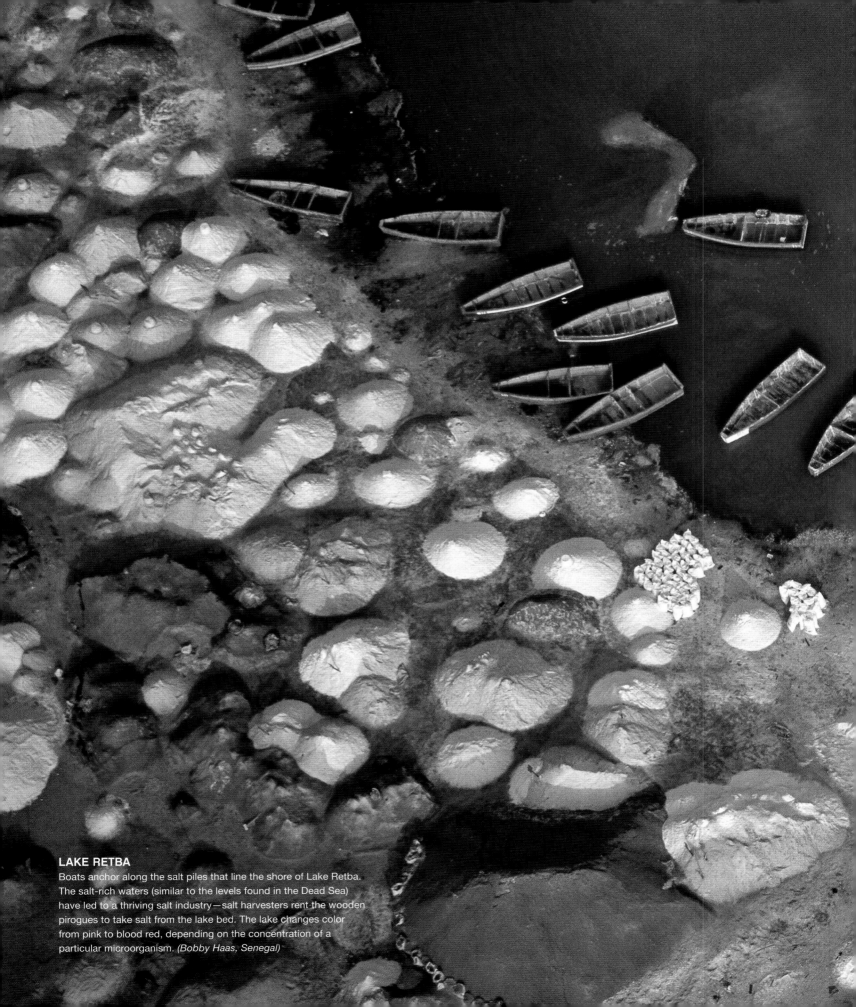

LAKE RETBA

Boats anchor along the salt piles that line the shore of Lake Retba. The salt-rich waters (similar to the levels found in the Dead Sea) have led to a thriving salt industry—salt harvesters rent the wooden pirogues to take salt from the lake bed. The lake changes color from pink to blood red, depending on the concentration of a particular microorganism. *(Bobby Haas, Senegal)*

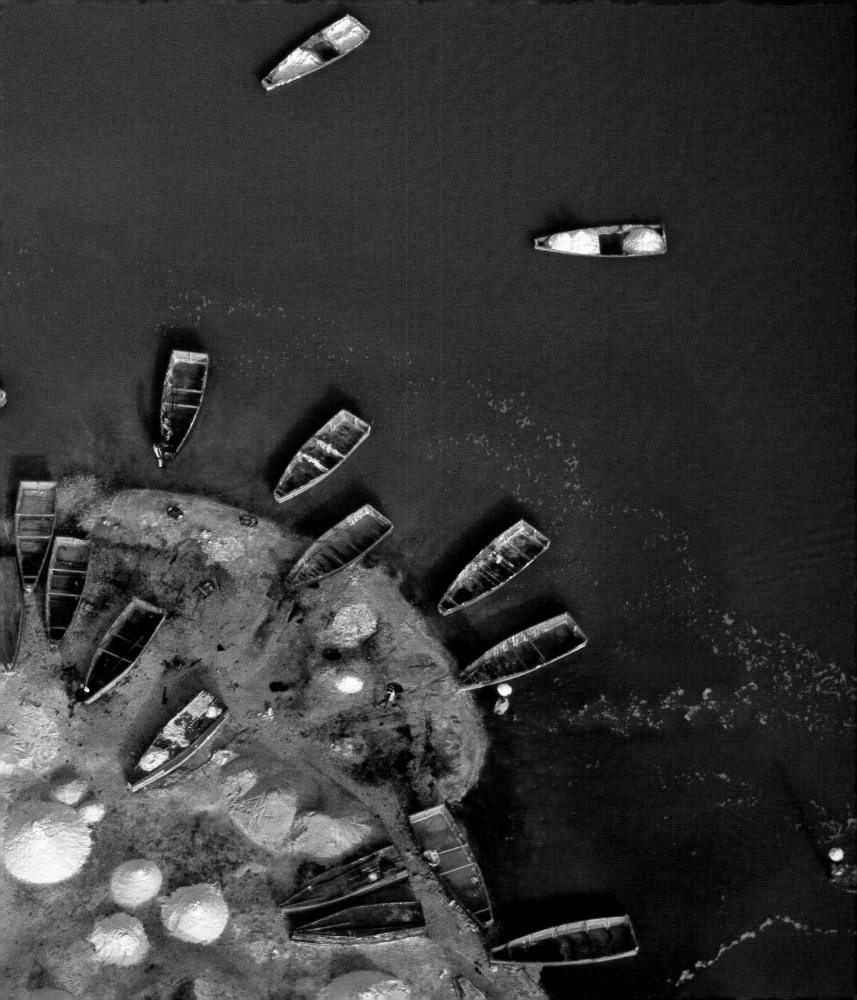

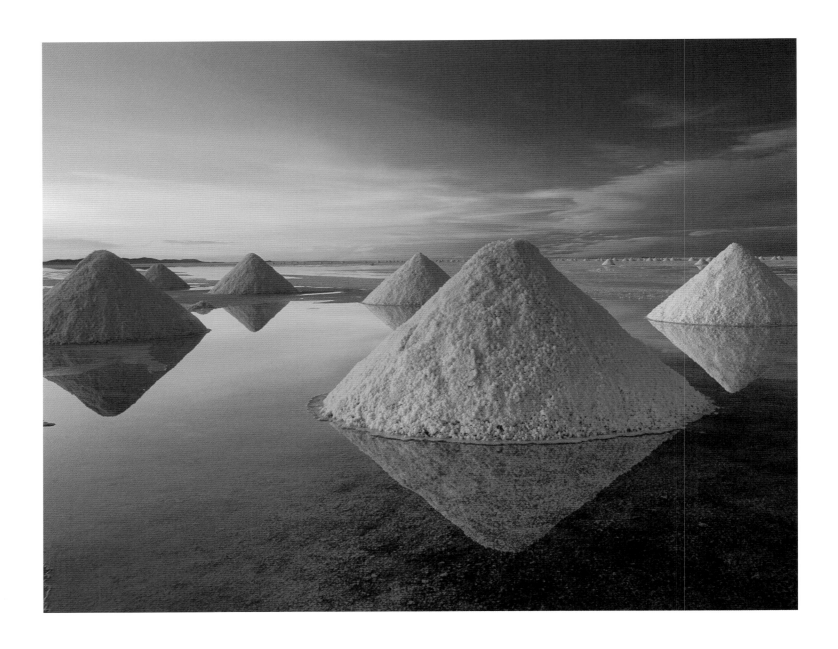

SALT FLATS

Pyramids of salt in Salar de Uyuni, the world's largest salt flat, mirror the colors of the predawn sky. Located at nearly 12,000 feet (3,660 m) in Bolivia's Altiplano, the salt pans hold water during the wet season and create scenes of reflective beauty. *(Art Wolfe, Bolivia)*

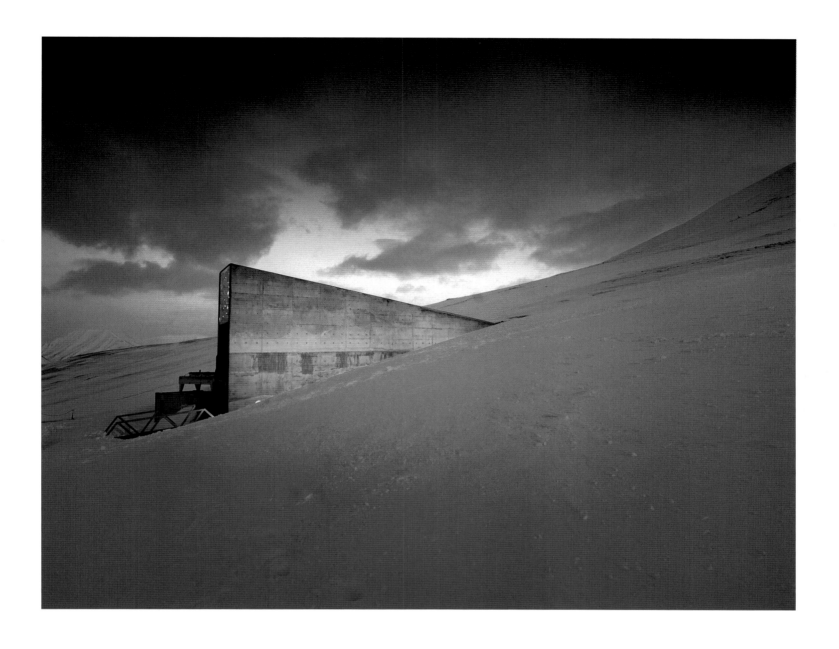

SEED BANK

The Svalbard Global Seed Bank on Spitsbergen, an Arctic island off Norway's coast, dives into the ground like an arrow. The bank can hold up to 2.25 billion seeds, ensuring seed diversity for future generations and plant survival in case of global disasters. The seeds are kept in a cold-storage vault that also protects them from earthquakes. *(Jim Richardson, Norway)*

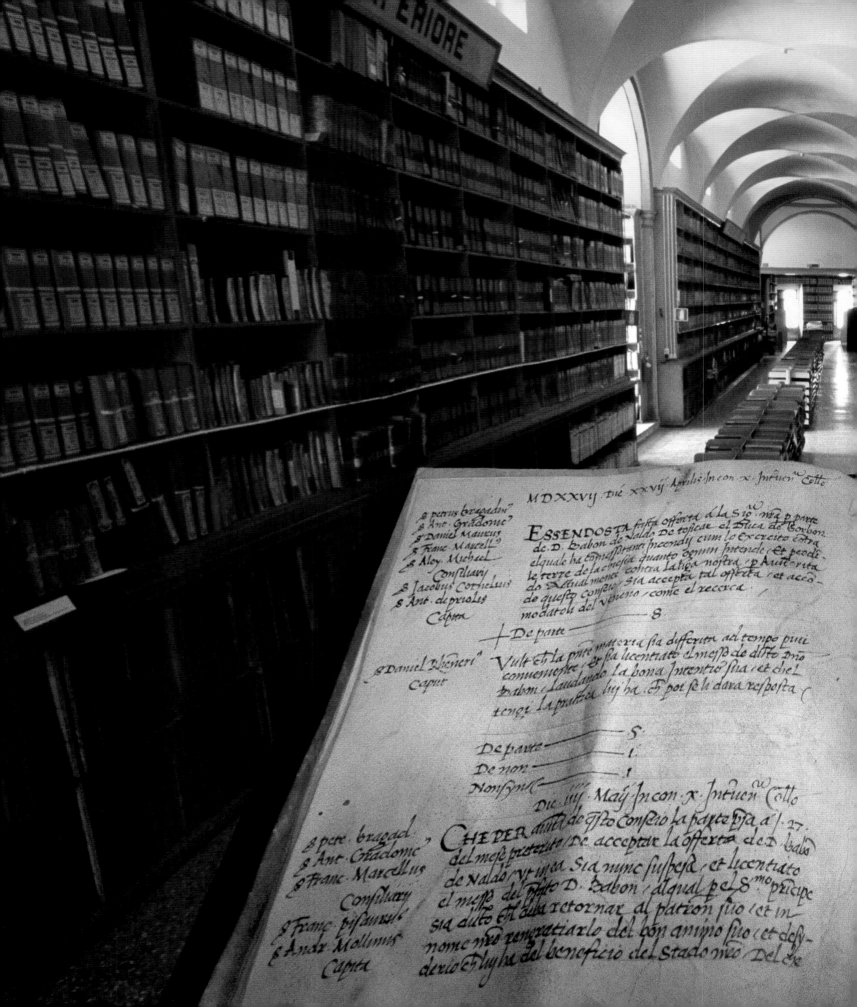

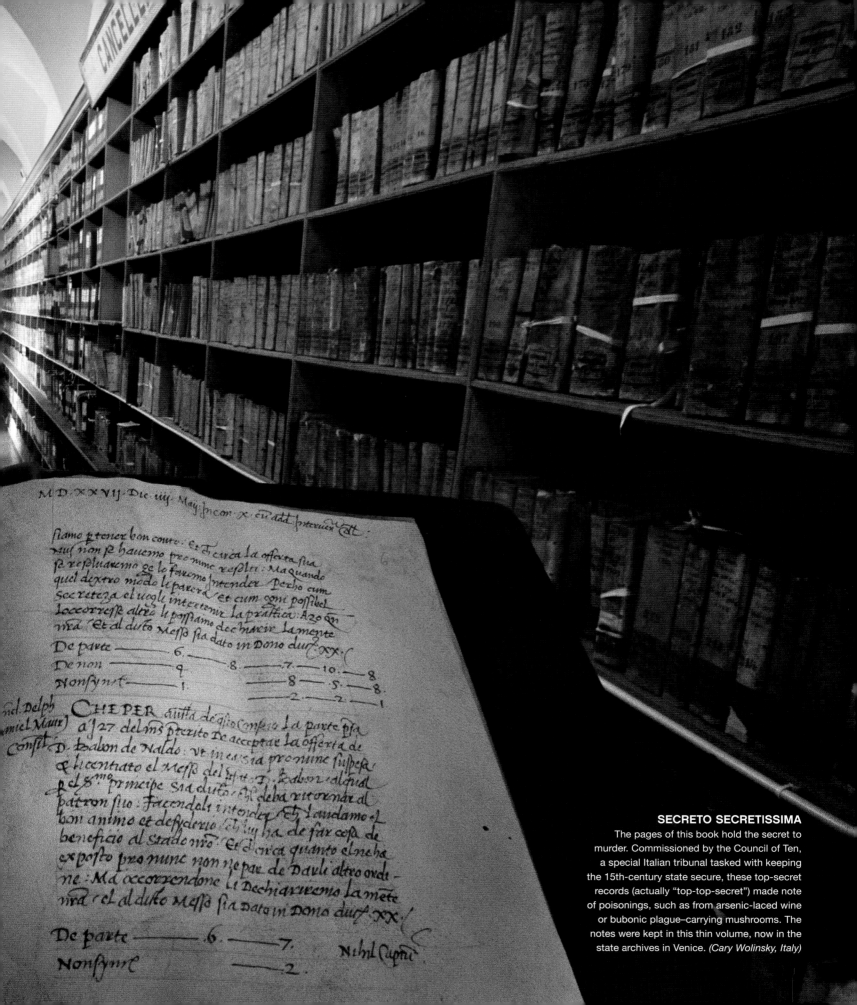

SECRETO SECRETISSIMA
The pages of this book hold the secret to murder. Commissioned by the Council of Ten, a special Italian tribunal tasked with keeping the 15th-century state secure, these top-secret records (actually "top-top-secret") made note of poisonings, such as from arsenic-laced wine or bubonic plague–carrying mushrooms. The notes were kept in this thin volume, now in the state archives in Venice. *(Cary Wolinsky, Italy)*

SECRET GARDEN

Quiet spaces and hidden sculptures take their place among the ferns in Australia's Dandenong Ranges. William Ricketts, a 20th-century sculptor, worked in clay to build statues into the glade that celebrate our connection to nature and reflect his interest in Aboriginal people. He wrote: "Each one of us is a transformer of Divine Power." *(Andrew Leckie, Australia)*

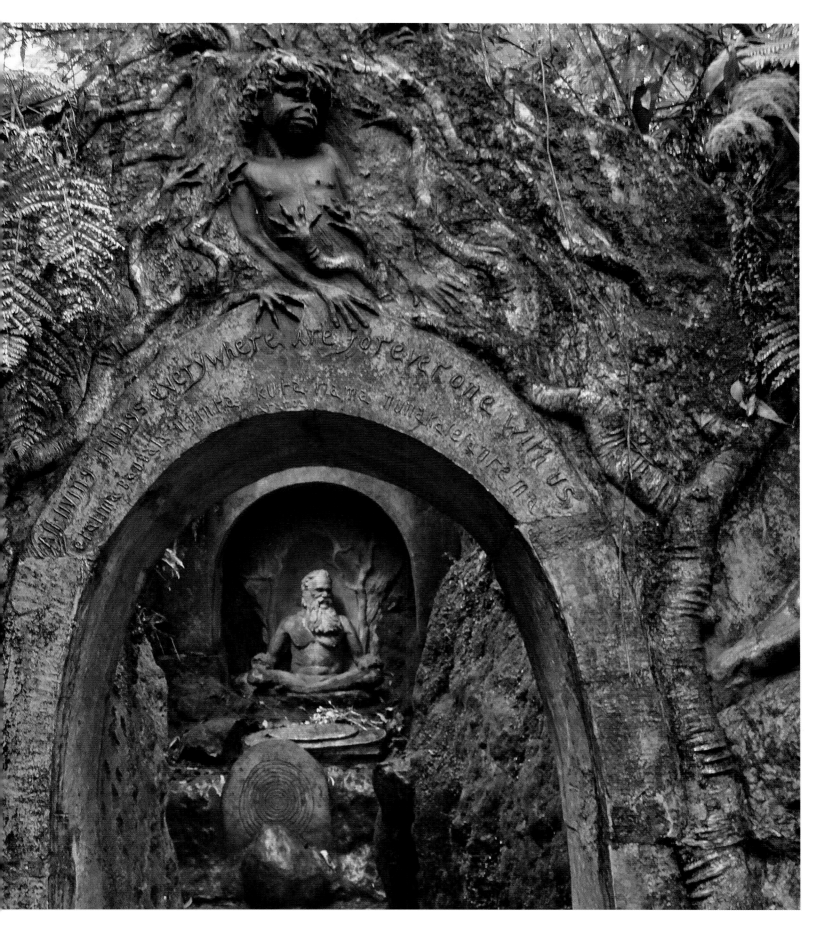

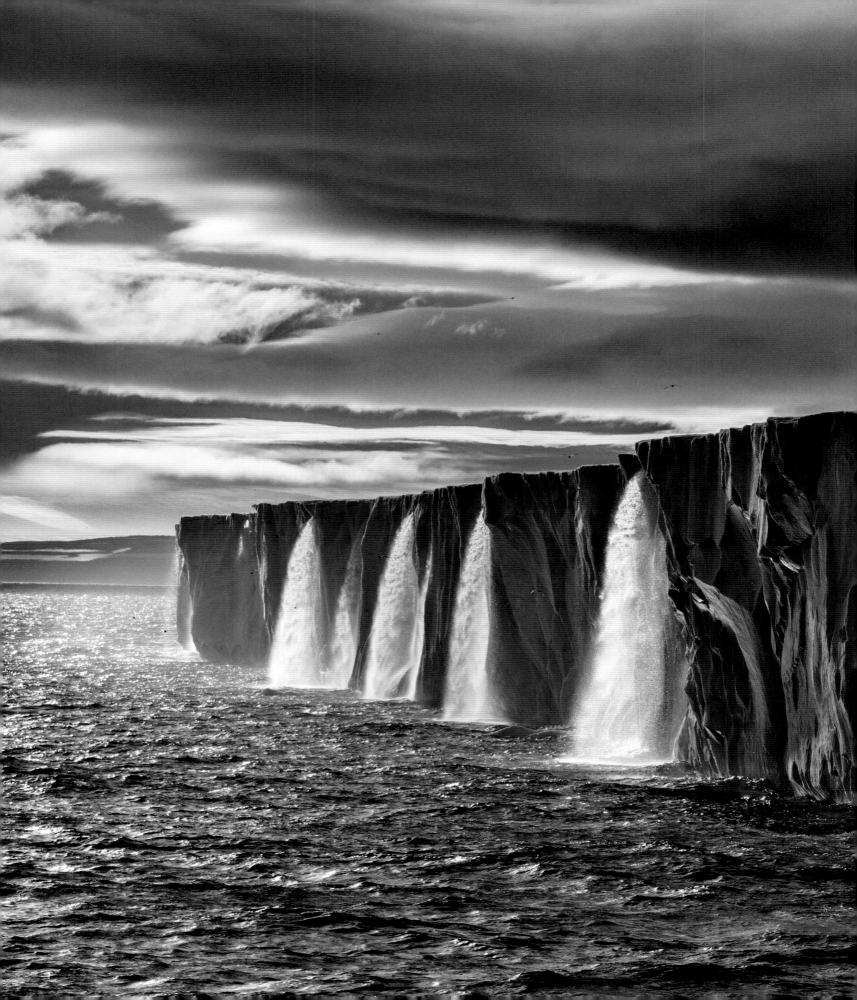

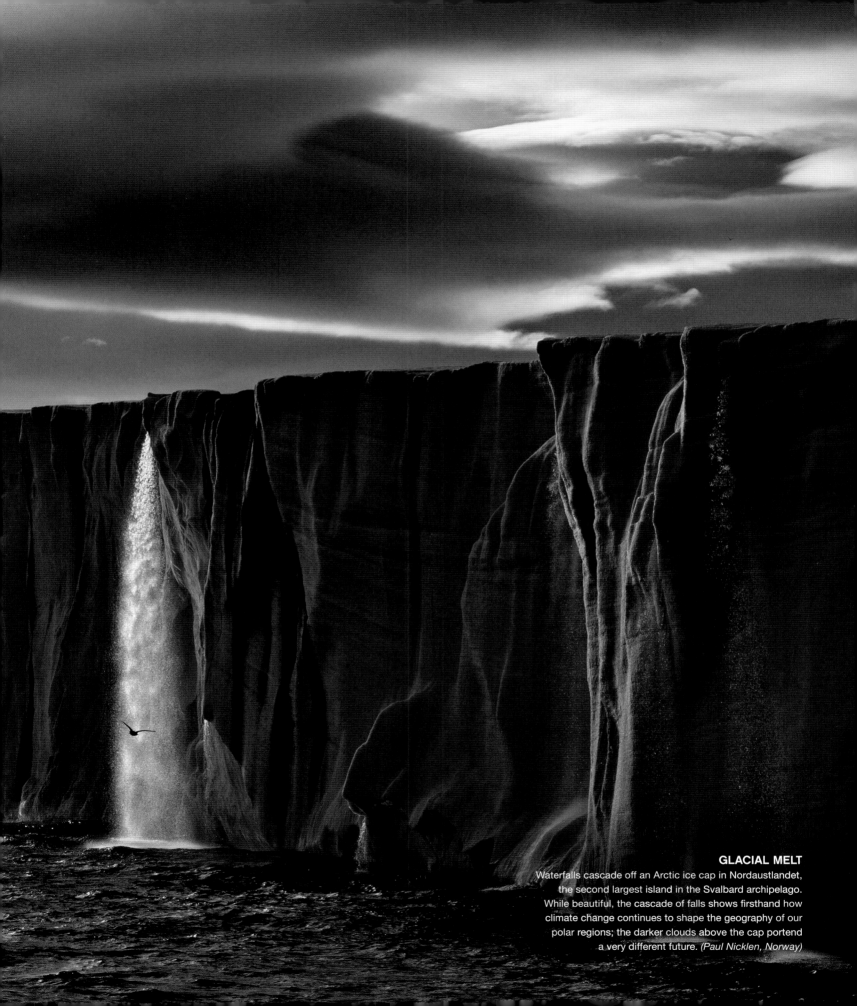

GLACIAL MELT
Waterfalls cascade off an Arctic ice cap in Nordaustlandet, the second largest island in the Svalbard archipelago. While beautiful, the cascade of falls shows firsthand how climate change continues to shape the geography of our polar regions; the darker clouds above the cap portend a very different future. *(Paul Nicklen, Norway)*

GOLDEN ROCK

Buddhist monks pray at the Golden Rock, which shines like a gem. Burnished by the sun and generations of prayer, the rock is journey's end for Buddhist pilgrims. They believe it is balanced on the edge of a cliff with a single strand of the Buddha's hair. *(Steve McCurry, Myanmar)*

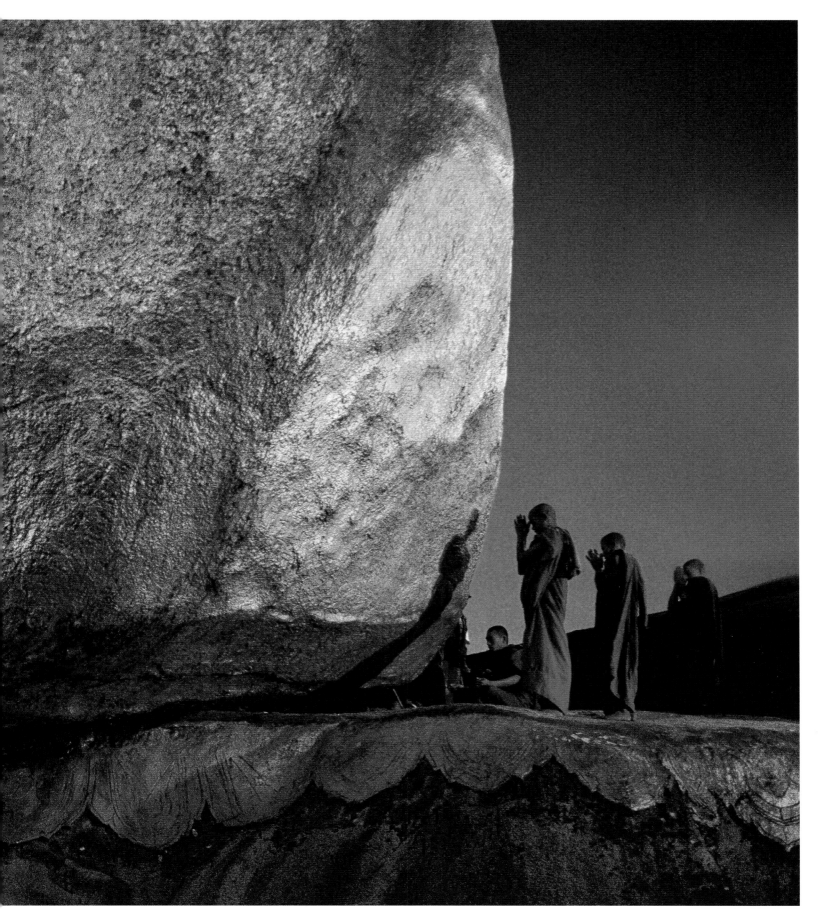

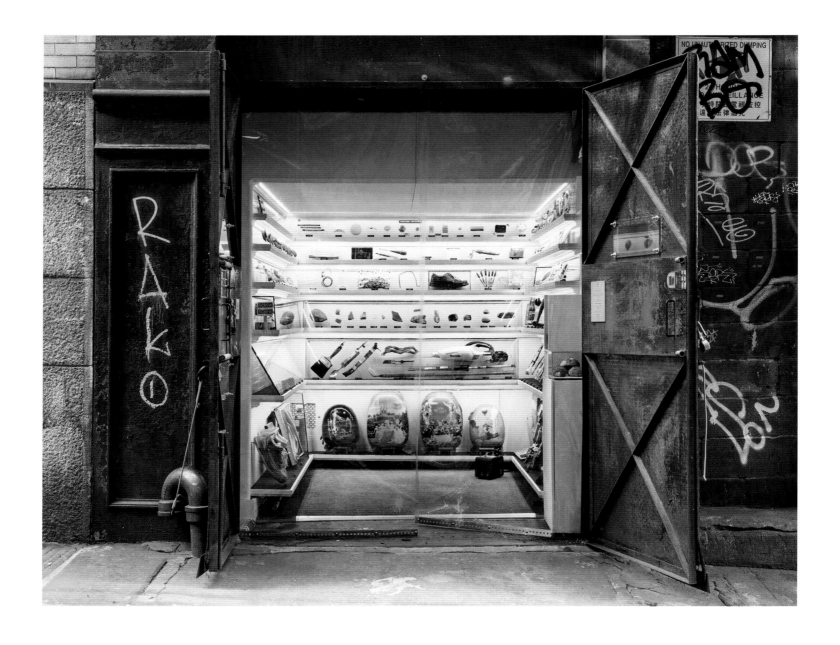

MINI-MUSEUM

Metal doors open to a small museum in Manhattan, New York, possibly the world's smallest. Located in an abandoned service elevator, the museum's 60 square feet (5.6 sq m) makes its home at the end of a littered alleyway. The eclectic collection of objects — from plastic vomit to a lottery-card paperweight — reminds visitors of the beauty and absurdity of life. *(Naho Kubota, New York City)*

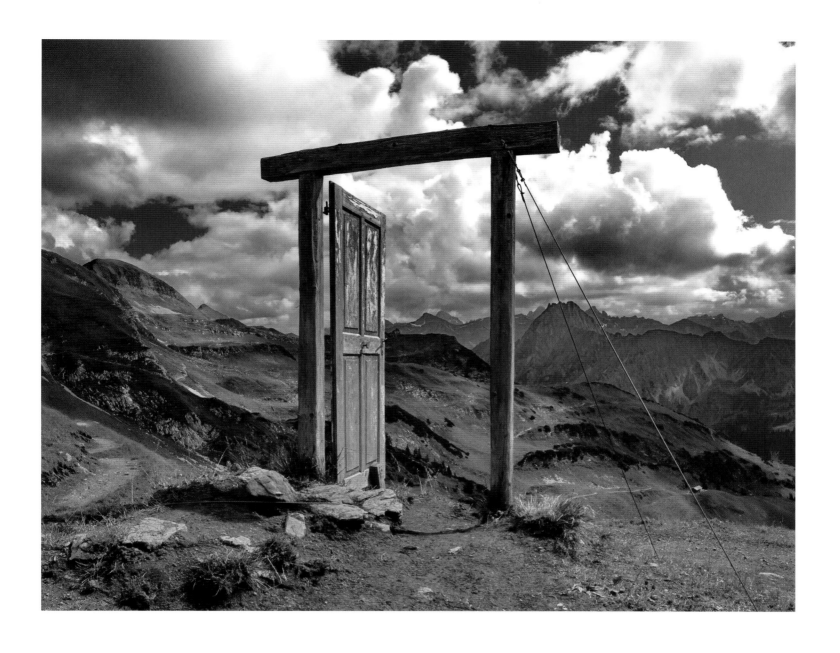

WILDERNESS DOOR
A solid wooden door on Nebelhorn Mountain frames
a stunning view of the Allgäu Alps. The scene, near Oberstdorf,
Germany, evokes the pristine grandeur of the rugged range.
The area around the village offers some 124 miles (200 km)
of hiking trails and plenty of miles of cross-country skiing
in the winter. *(James Hilgenberg, Germany)*

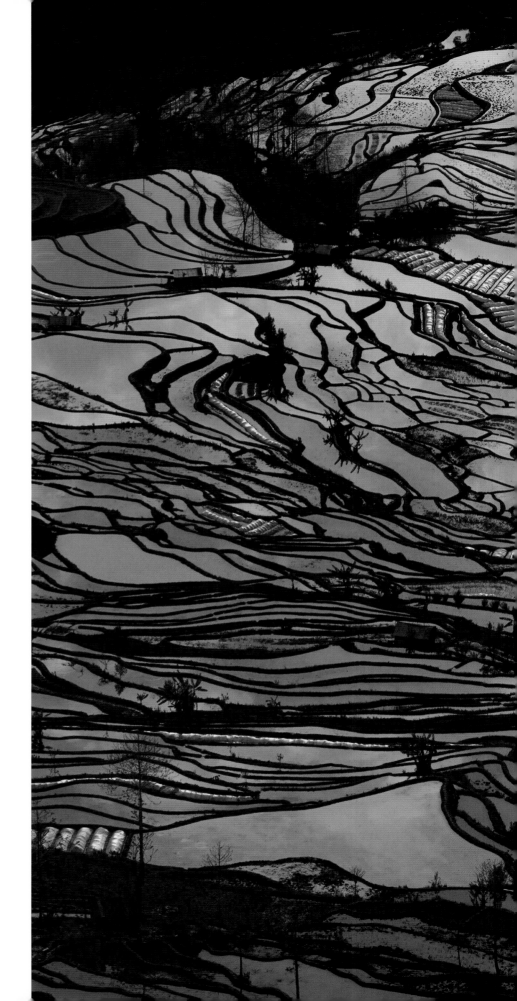

RICE PADDIES

What appears to be an elaborate piece of stained glass is really a field of rice paddies at sunset. The flooded fields in China's Yunnan Province transform with the reflection of the setting sun and the sky on the tiered terraces. The stepped terraces help decrease erosion in the area. *(Thierry Bornier, China)*

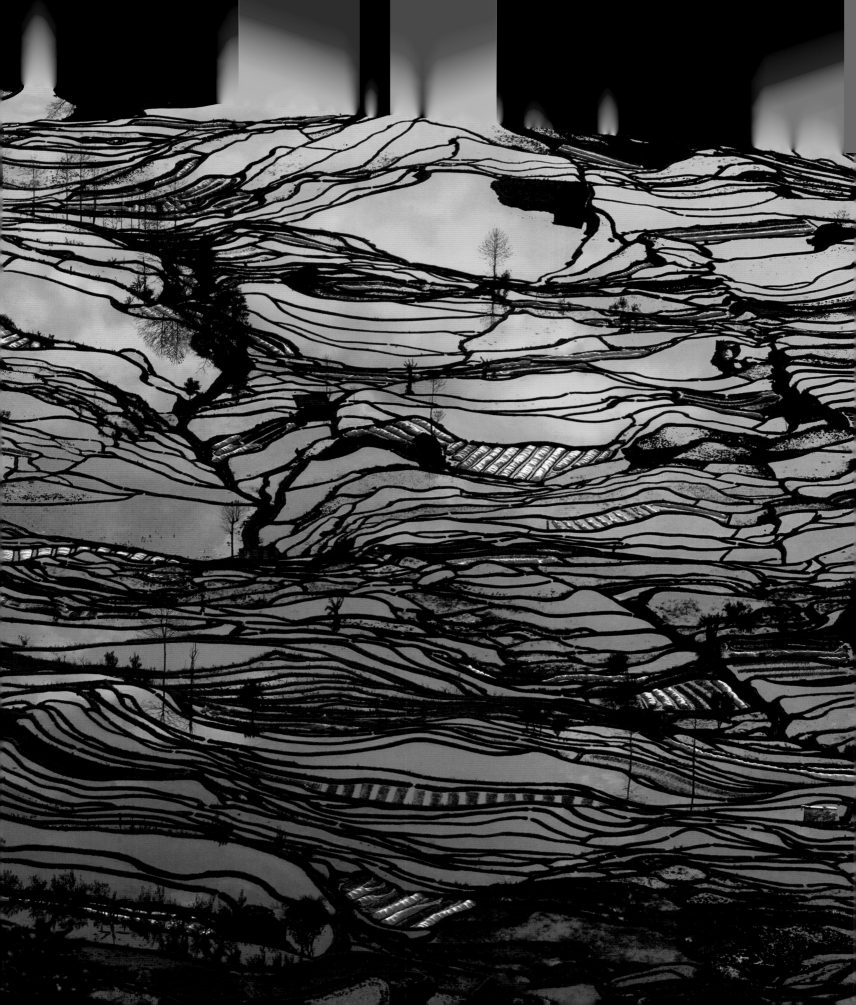

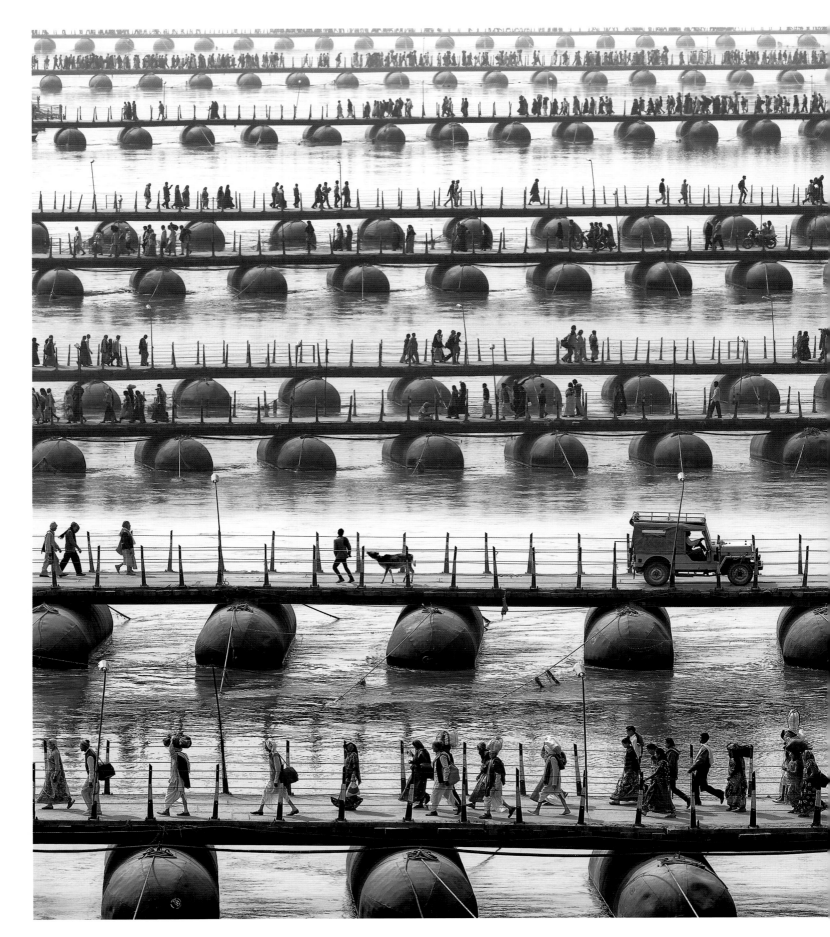

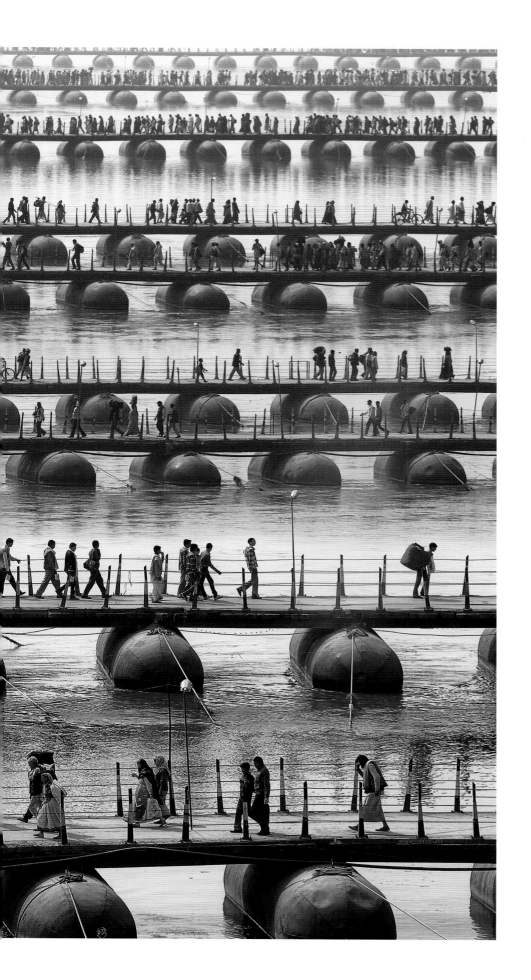

PONTOON BRIDGES

Pilgrims and devotees use temporary pontoon bridges to cross the Ganges River in Allahabad, India, to attend the Maha Kumbh Mela—the world's largest spiritual gathering. Several million Hindus make their way here every year, and then every 12th year the ritual increases by an order of magnitude. Eighteen bridges handled some 70 million people here in 2013.
(Wolfgang Weinhardt, India)

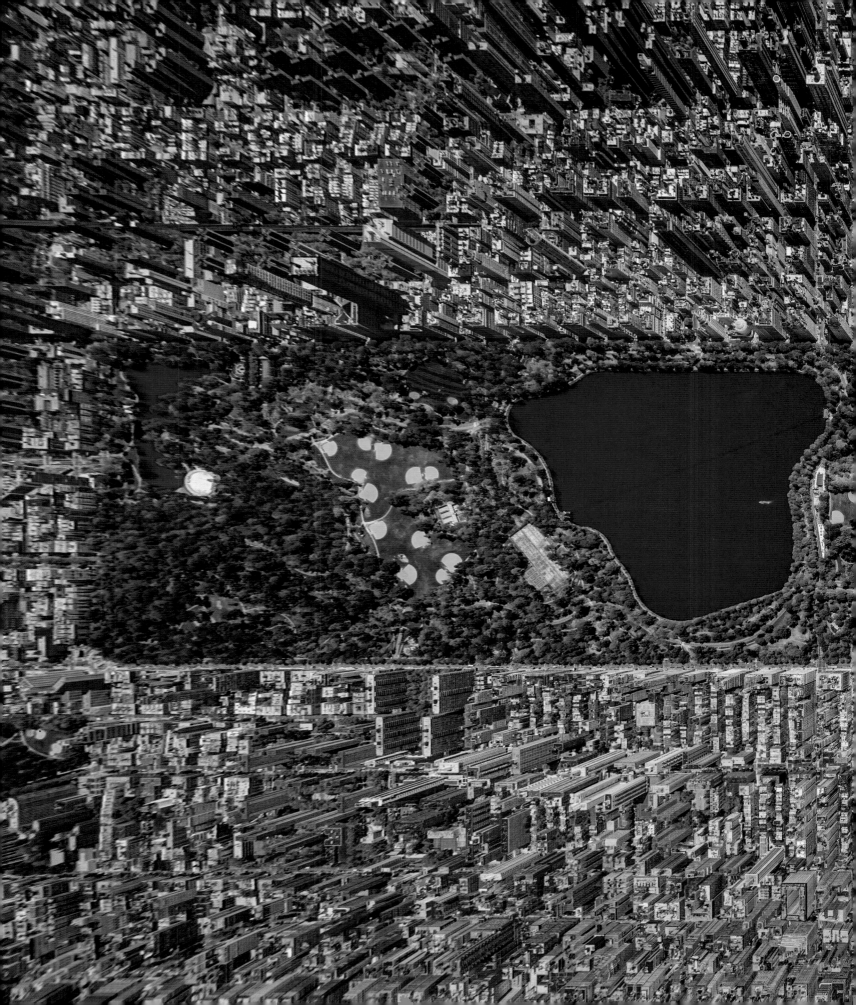

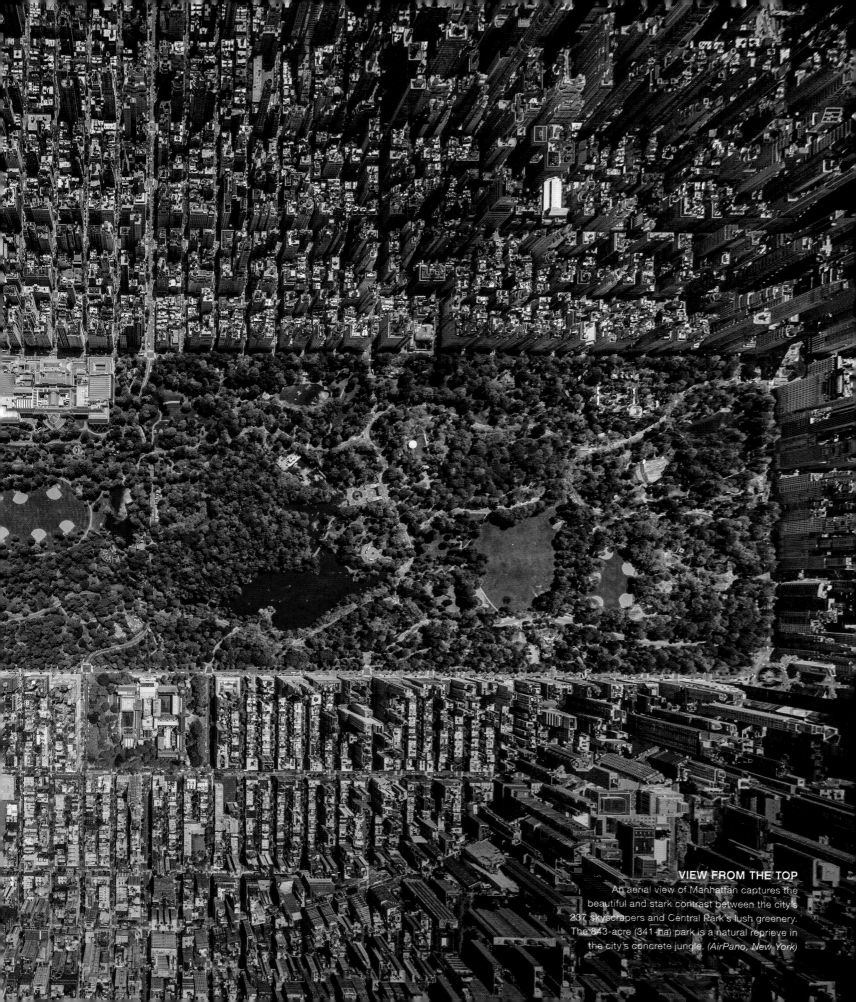

VIEW FROM THE TOP
An aerial view of Manhattan captures the
beautiful and stark contrast between the city's
237 skyscrapers and Central Park's lush greenery.
The 843-acre (341-ha) park is a natural reprieve in
the city's concrete jungle. *(AirPano, New York)*

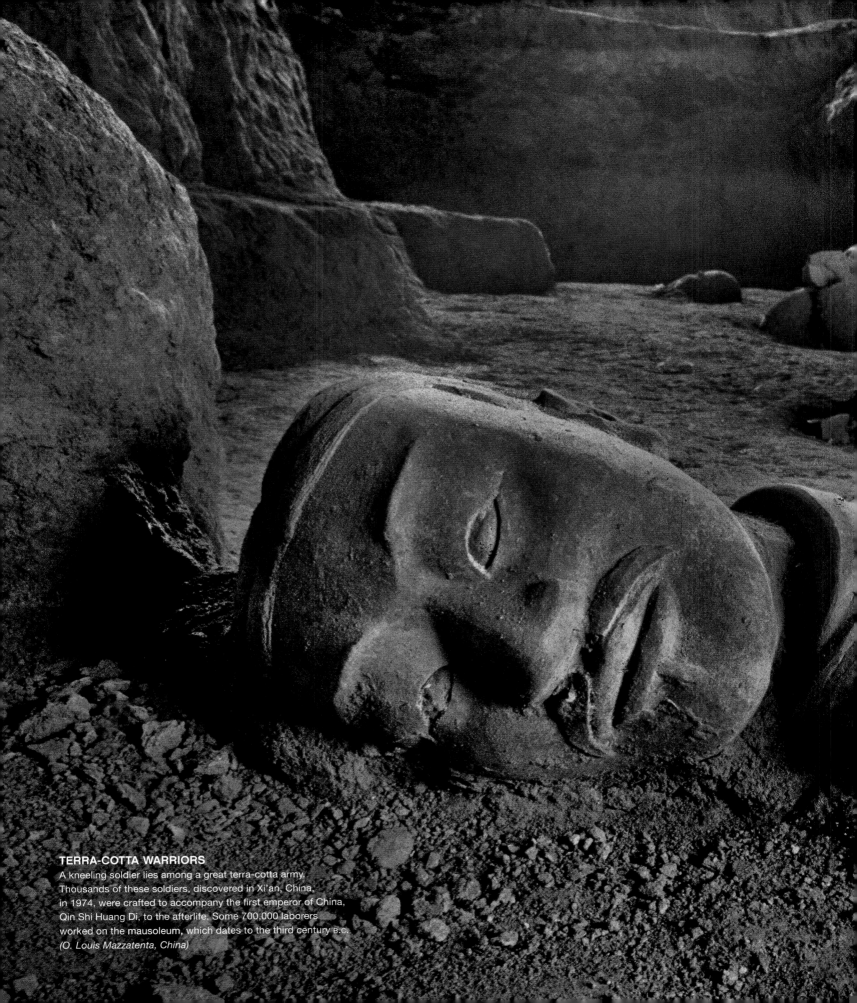

TERRA-COTTA WARRIORS
A kneeling soldier lies among a great terra-cotta army.
Thousands of these soldiers, discovered in Xi'an, China,
in 1974, were crafted to accompany the first emperor of China,
Qin Shi Huang Di, to the afterlife. Some 700,000 laborers
worked on the mausoleum, which dates to the third century B.C.
(O. Louis Mazzatenta, China)

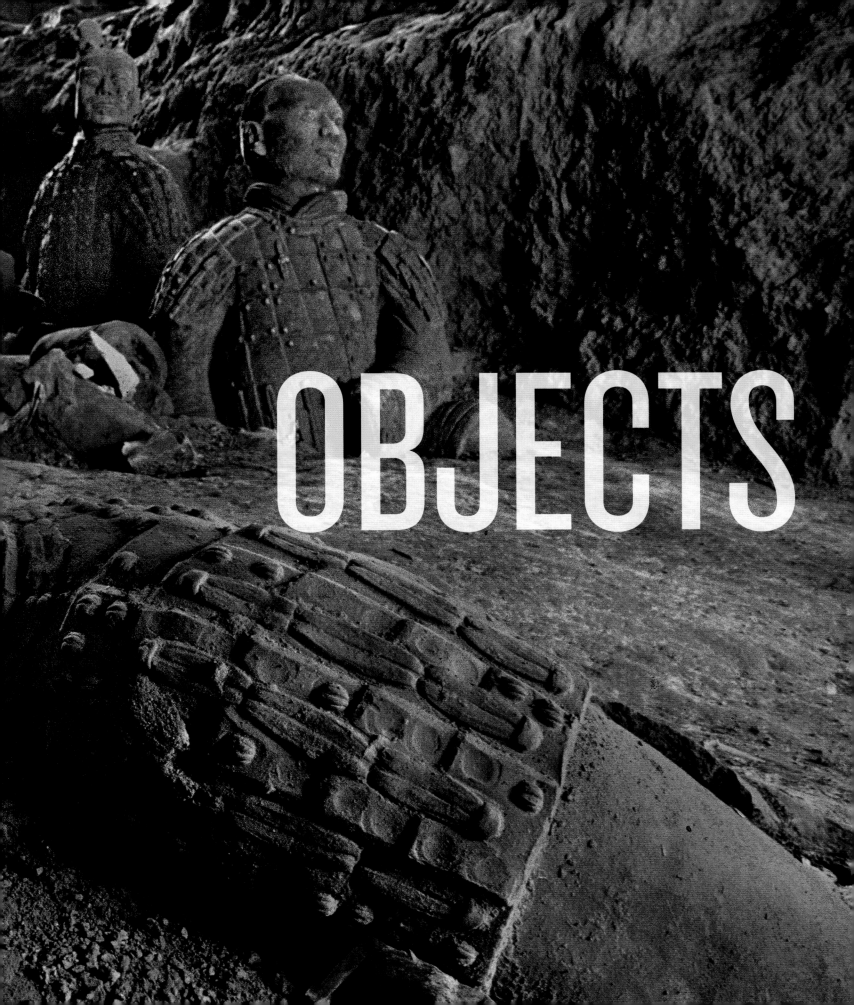

OBJECTS

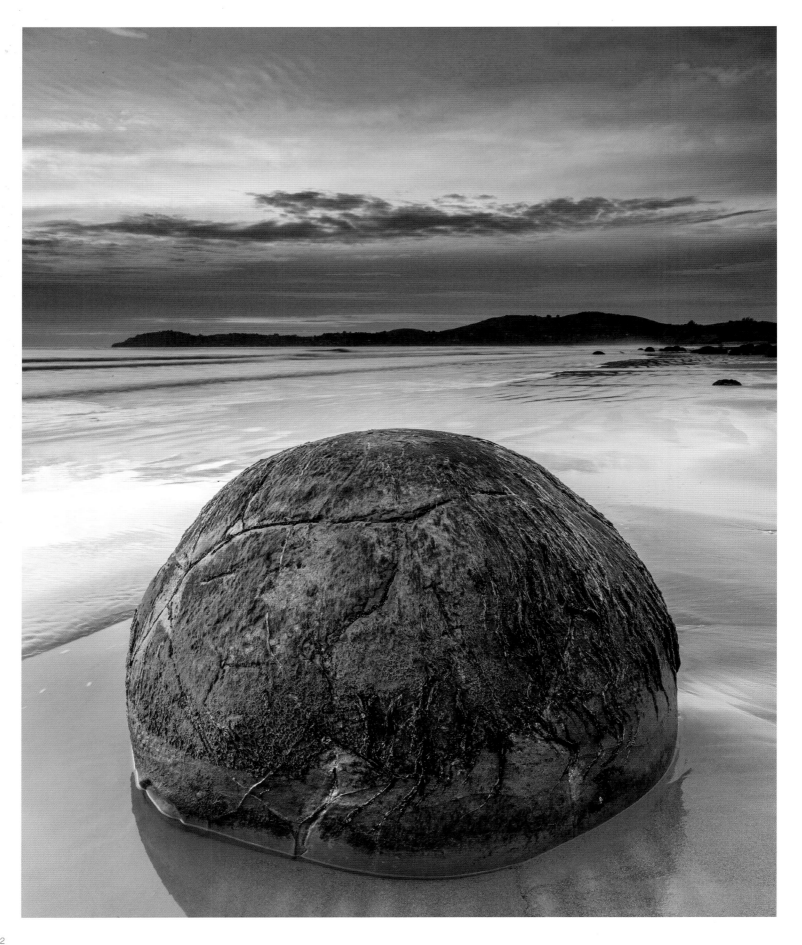

OBJECTS

A book, a photograph, the printed page—all may be two-dimensional, but great art makes the experience tactile, sensory, three-dimensional, deep and fuzzy. It can sting or it can freeze. It presents things you can touch and feel.

You can reach out and touch the moss and mold of the Moeraki boulder, the exquisite coldness of the scarab's lapis lazuli, the fragile vulnerability of hundred-year-old eggs. And even though you never will, you can stroke the oozing metal of the Titanic. You can kick the dust of the moon.

All these objects a photographer spreads before you, as the courting bowerbird brings sweet baubles to his mate. And as you gaze in and appreciate these objects so rarely seen so vividly, you find connections. A snowflake looks akin to a Petoskey stone, or to the great hallway of the Vatican, or to the long view down the core of the Large Hadron Collider at CERN, or to watch works, a butterfly egg, Central Park seen from above. Shape makes relationships where ideas cannot.

To touch, to see, and to weave threads of recognition through this world of objects. This is metaphor, this is making meaning, this is how the imagination finds one world in the cacophony of many.

OPPOSITE: **MOERAKI BOULDERS**
Early morning light bathes a Moeraki boulder on a wave-splashed Otago beach on New Zealand's South Island.
The spherical boulders formed during thousands of years as calcite precipitated in mudstone, and were then revealed
as waves eroded the mudstone. Naturally occurring cracks add character to the geological wonders. *(Vicki Mar, New Zealand)*

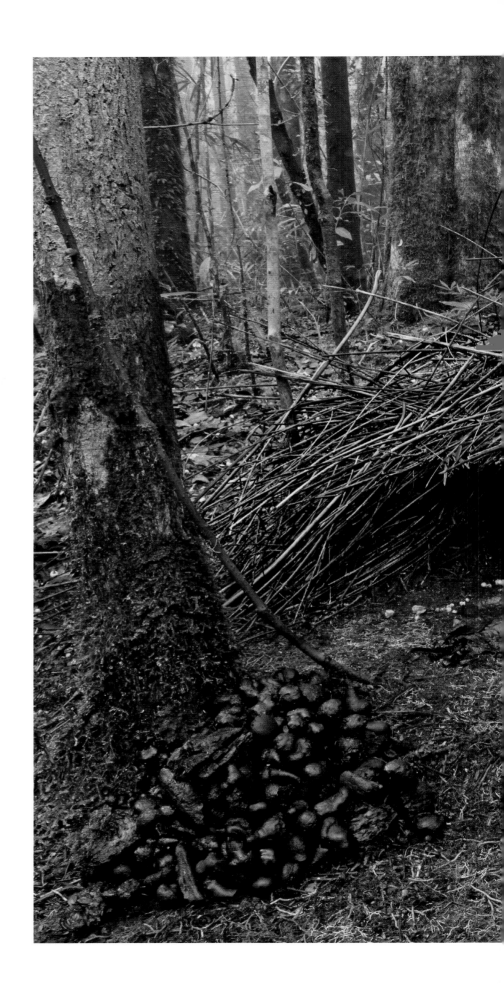

BOWERBIRD NEST

A male Vogelkop bowerbird *(Amblyornis inornatus)* collects colorful flowers and fruits to decorate his cone-shaped bower in the Arfak Mountains of Papua New Guinea. Bowerbirds use this elaborate and careful forest artistry to create masterpieces, all in an effort to woo a mate. *(Ingo Arndt, Indonesia)*

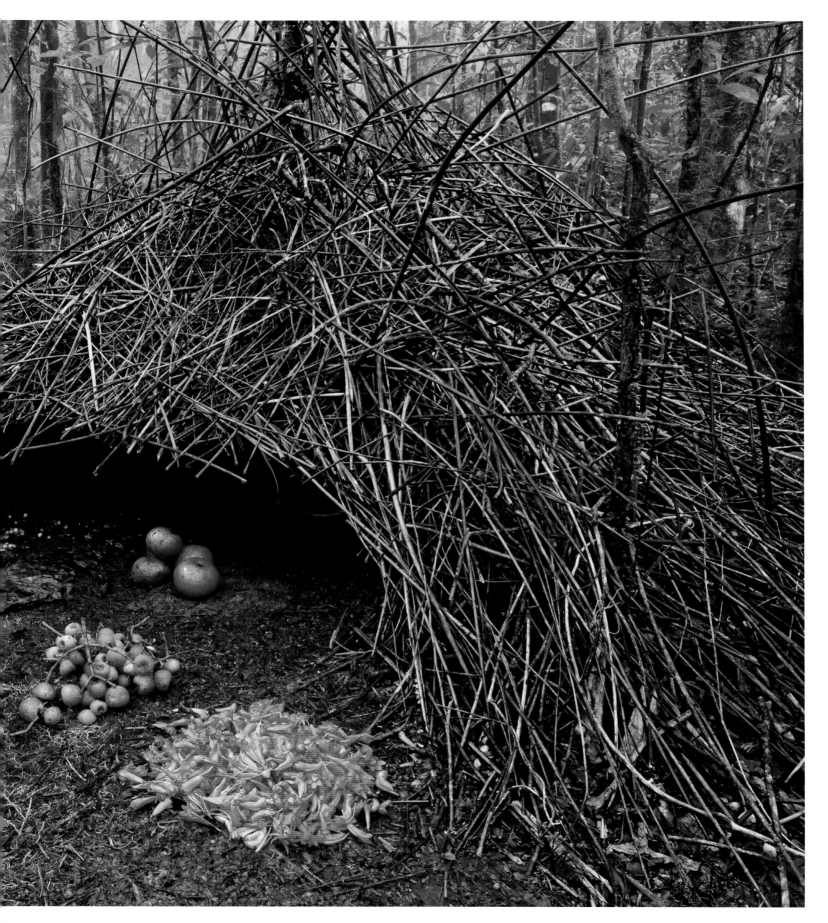

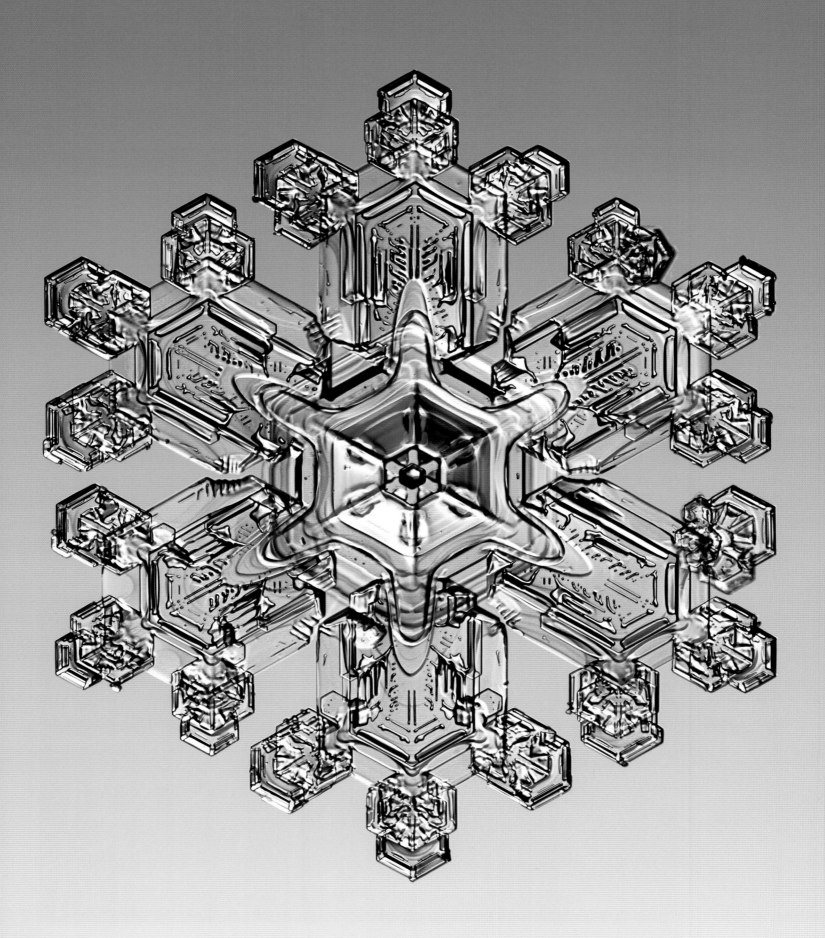

"The shape of a snowflake is determined by the path it takes as it dances through the clouds. Because no two snowflakes follow precisely the same path, no two snowflakes look exactly alike. The six arms of a single crystal travel together, however, so they grow and develop in synchrony, yielding the snowflake's characteristic six-fold symmetry."

KENNETH LIBBRECHT

OPPOSITE: **SNOWFLAKE**
Illuminated with colored light, a snow crystal takes on the polished look of a gem. This one measures
just over 0.1 inch (3 mm) from tip to tip. *(Kenneth Libbrecht, Vermont)*

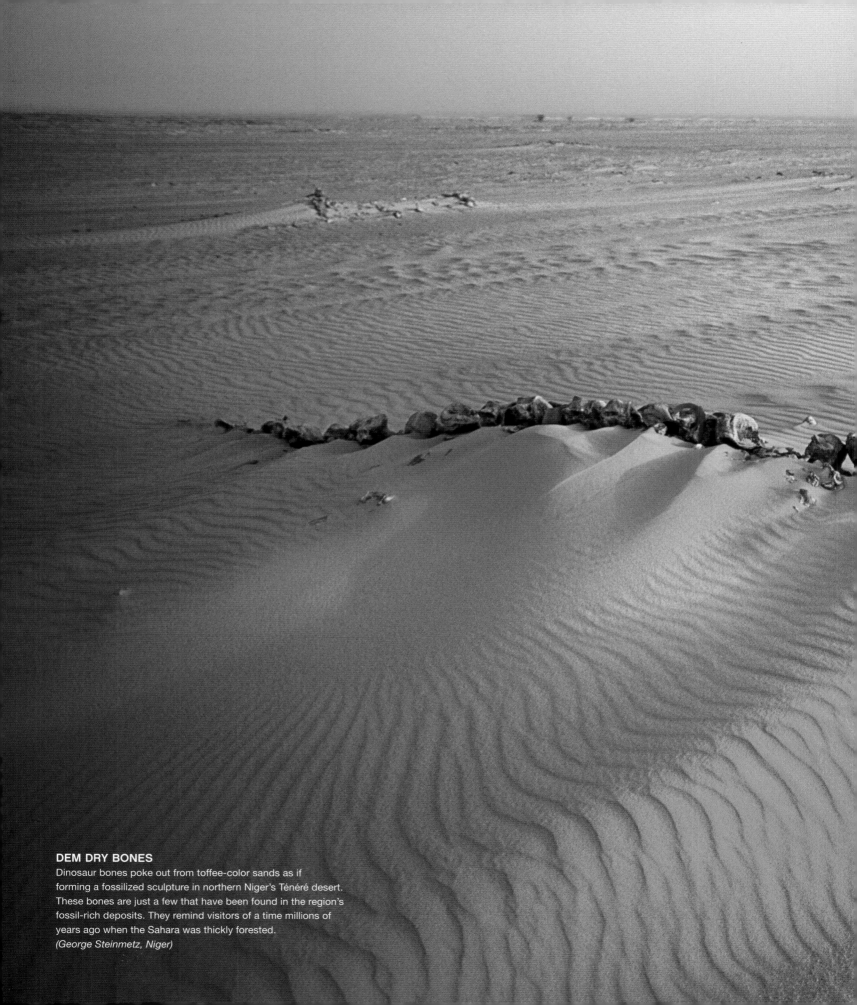

DEM DRY BONES
Dinosaur bones poke out from toffee-color sands as if forming a fossilized sculpture in northern Niger's Ténéré desert. These bones are just a few that have been found in the region's fossil-rich deposits. They remind visitors of a time millions of years ago when the Sahara was thickly forested.
(George Steinmetz, Niger)

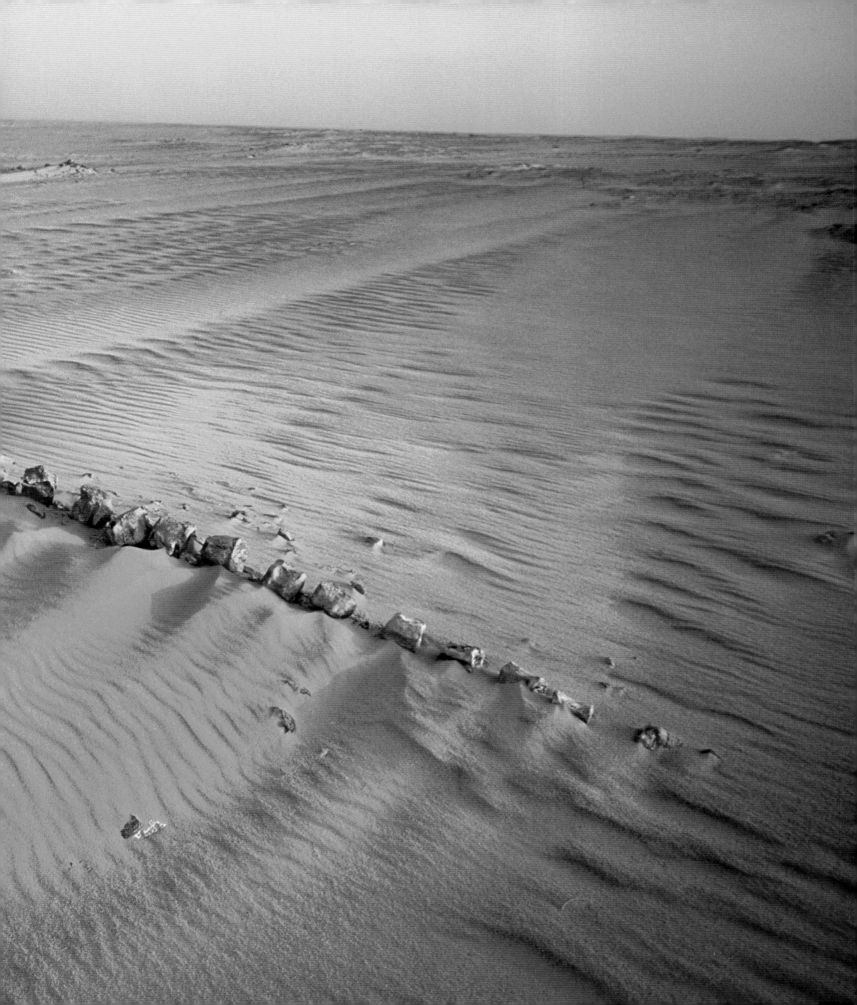

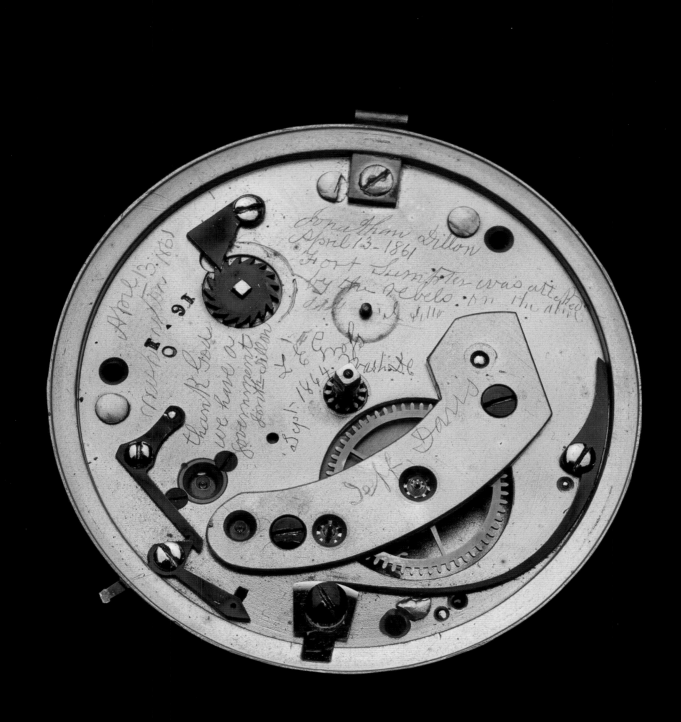

SECRET PRESIDENTIAL MESSAGE

President Abraham Lincoln's pocket harbored a secret wartime
message in its inner workings. When Fort Sumter was attacked
in 1861, Jonathan Dillon was repairing the watch. He etched inside:
"Fort Sumpter *[sic]* was attacked by the rebels on the above date
thank God we have a government." The addition of "Jeff Davis"
remains unexplained. The words were first uncovered in 2009
by the Smithsonian Institution. *(Hugh Talman, Washington, D.C.)*

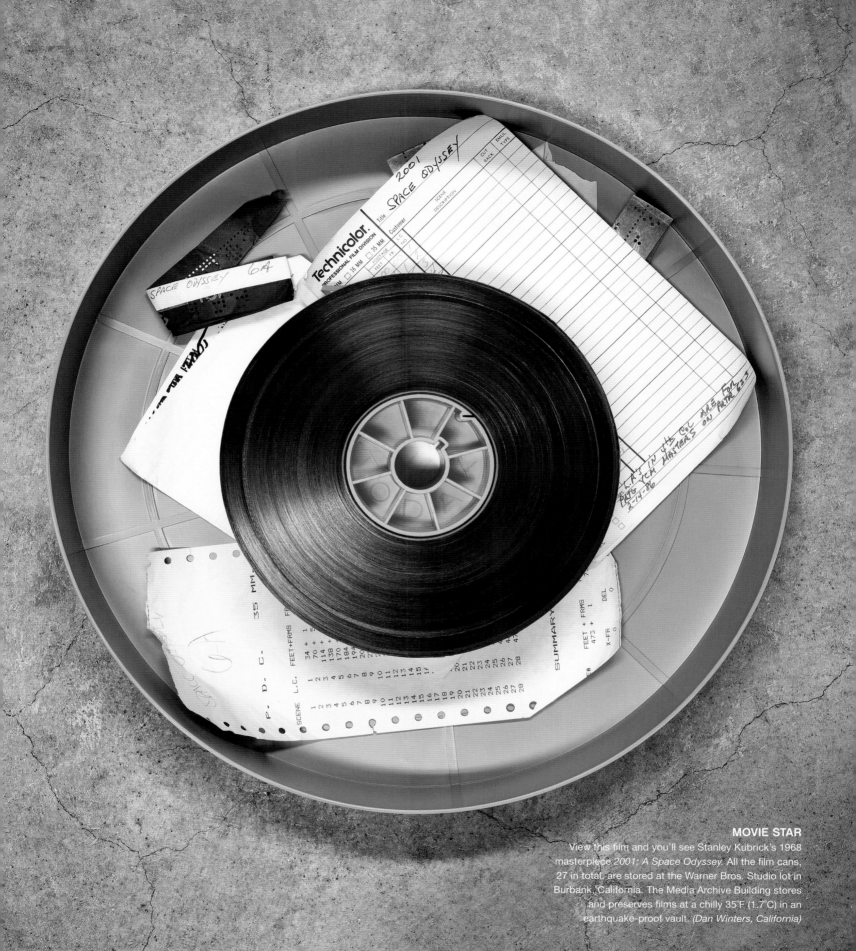

MOVIE STAR
View this film and you'll see Stanley Kubrick's 1968 masterpiece *2001: A Space Odyssey*. All the film cans, 27 in total, are stored at the Warner Bros. Studio lot in Burbank, California. The Media Archive Building stores and preserves films at a chilly 35°F (1.7°C) in an earthquake-proof vault. *(Dan Winters, California)*

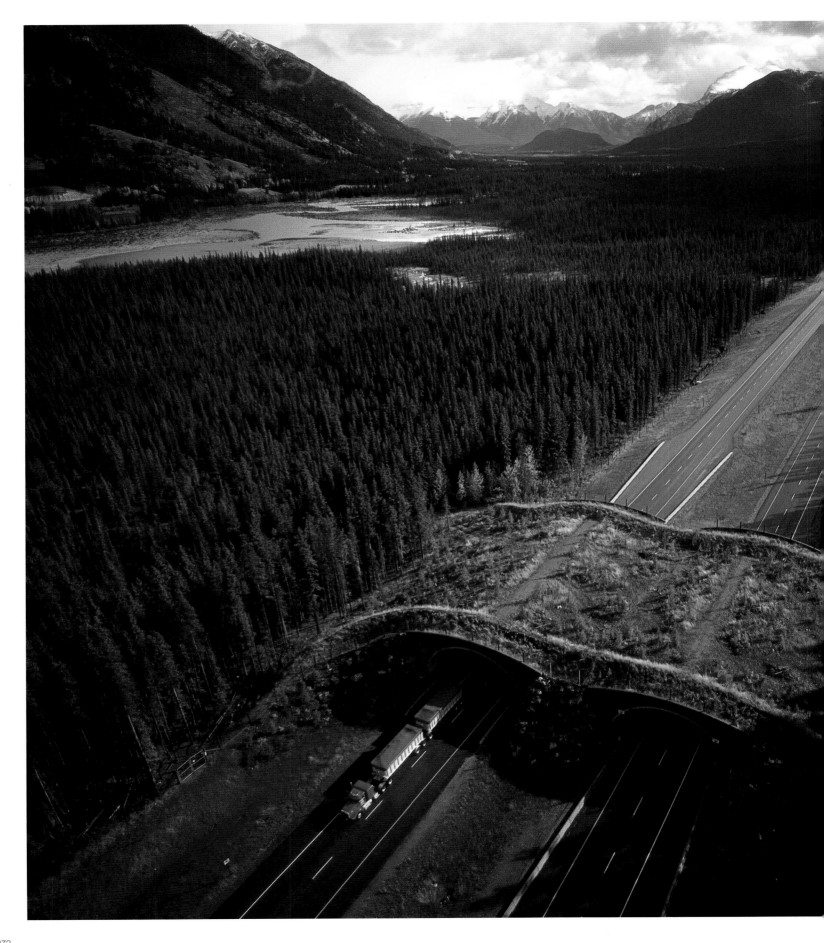

BRIDGING WILDLIFE

A wildlife bridge stretches across a ribbon of highway in Banff National Park, Canada. At 164 feet (50 m) wide, the overpass was built to protect crossing wildlife, like grizzly bears and mountain lions, from the dangerous traffic of the Trans-Canada Highway. Banff has six overpasses and 38 underpasses, which have helped reduce wildlife-vehicle collisions by nearly 80 percent. *(Joel Sartore, Canada)*

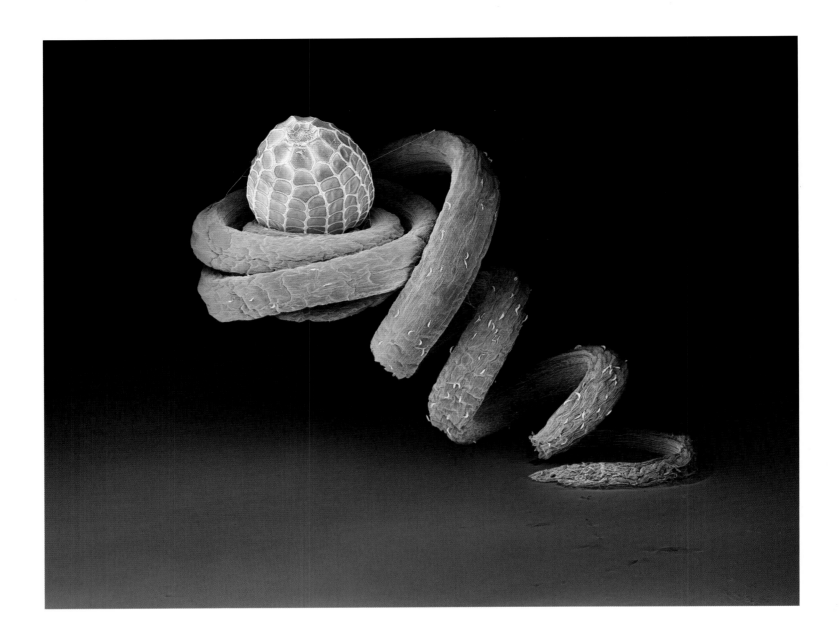

BUTTERFLY EGG

The egg of a Julia Heliconian butterfly *(Dryas iulia)* perches on
the tendril of a passionflower plant, as seen in this image from
a scanning electron microscope. Its perch may keep the egg safe
from hungry ants. This species lays its eggs almost exclusively
on this plant's twisted vines. *(Martin Oeggerli)*

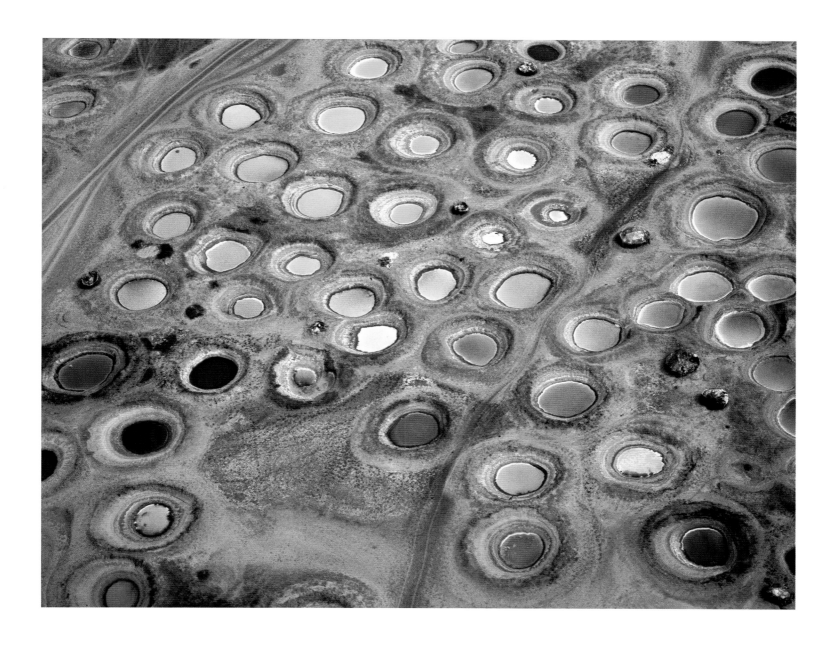

TO DYE FOR
From the air these earth-toned dyeing pits look like
multicolored watering holes in a desert. In reality, the pits,
located in the Saloum Delta on Senegal's Atlantic coast,
are used to dye cloth in a traditional, nonfactory setting.
(Bobby Haas, Senegal)

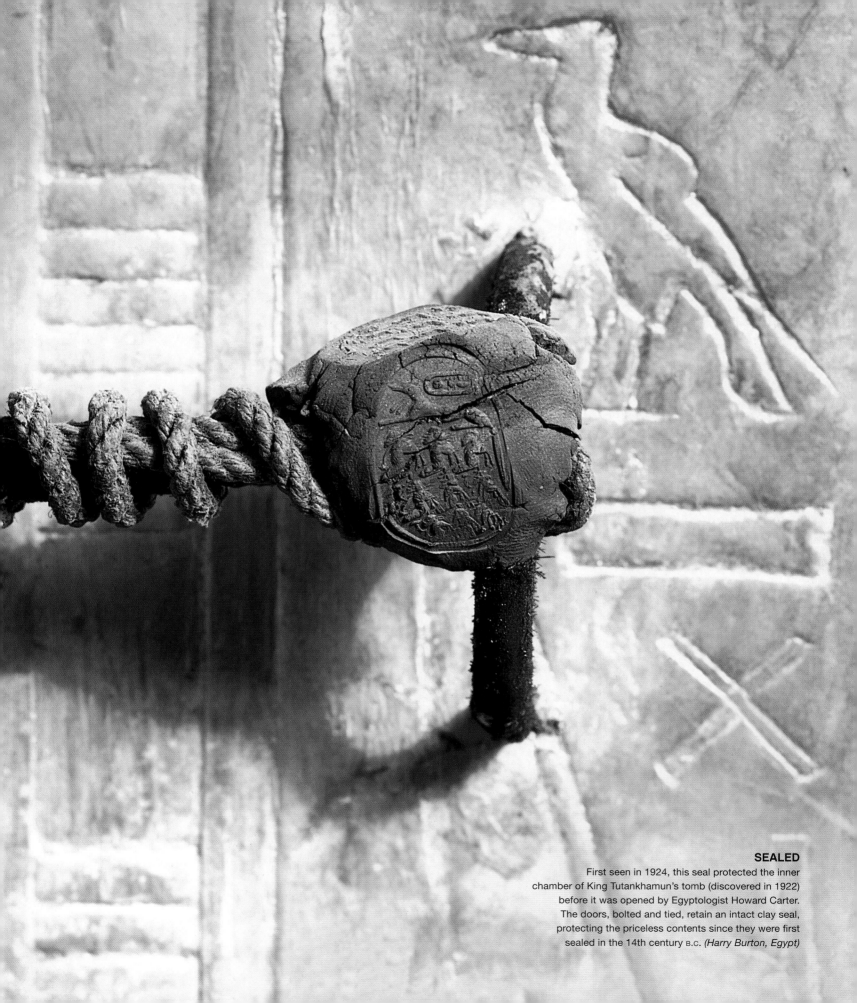

SEALED
First seen in 1924, this seal protected the inner chamber of King Tutankhamun's tomb (discovered in 1922) before it was opened by Egyptologist Howard Carter. The doors, bolted and tied, retain an intact clay seal, protecting the priceless contents since they were first sealed in the 14th century B.C. *(Harry Burton, Egypt)*

"Apatite, a calcium phosphate, is a minor but ubiquitous mineral in most rock types. Rocks rich in apatite are found scattered around the world, such as in the Russian mining town of Apatity, named for the abundance of this natural resource. This specimen is from a mine on Chumar Bakhoor in the high Himalaya of Pakistan. Crystals like the pink one here, on a matrix of muscovite, are exceedingly rare for their perfection of form and color."

JOHN RAKOVAN

PROFESSOR OF MINERALOGY, MIAMI UNIVERSITY, OXFORD, OHIO

OPPOSITE: **PINK APATITE IN MICA MATRIX**
This 4-inch (11-cm) striking pink apatite crystal stands alone in its clarity of form and color. *(James Elliott)*

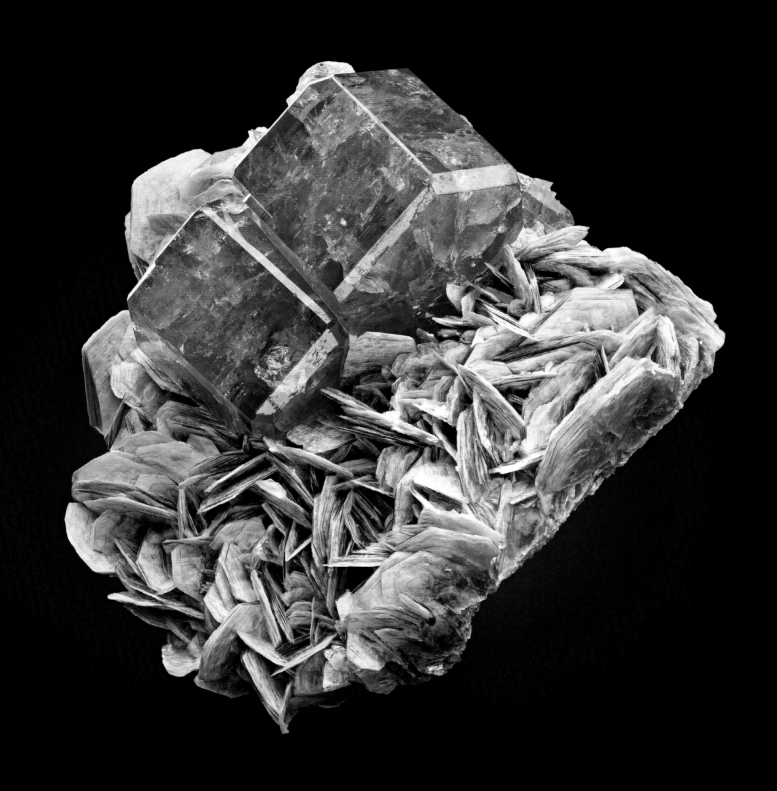

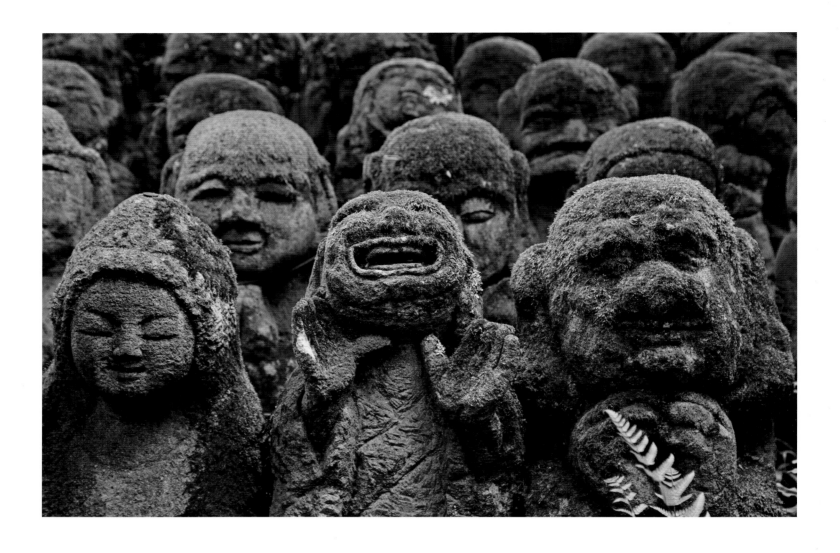

ROCKING LAUGHTER

Rakan—disciples of the historical Buddha—covered in moss
get their close-up at Otagi Nenbutsu-ji, a Buddhist temple near
Kyoto, Japan. The temple features more than 1,200 stone Rakan,
each one uniquely carved by a different sculptor, most of them
amateur. This gives each figure's playful face a different set
of emotions. *(John S. Lander, Japan)*

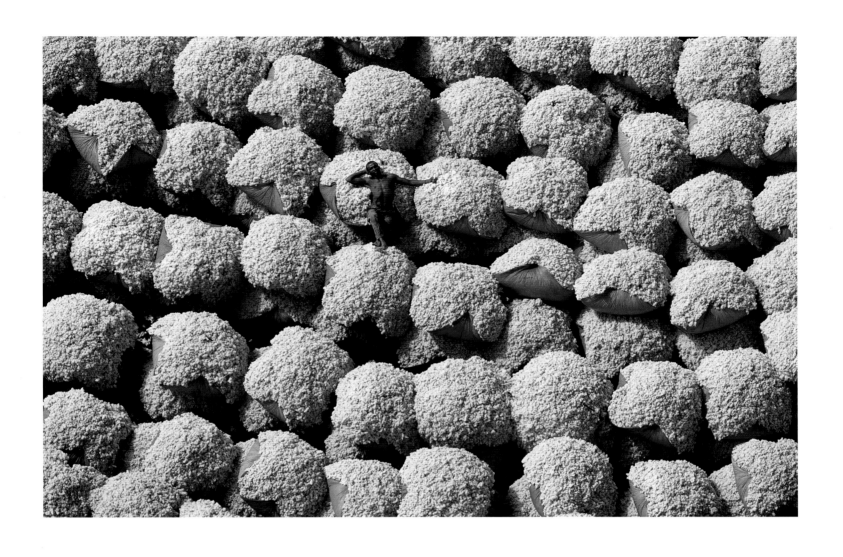

COTTON DAZE

A worker takes a rest among bales of cotton—their green wrappings mimicking leaves—in Korhogo, Côte d'Ivoire. Cotton is important to the economy of this trading town of more than 100,000 people. *(Yann Arthus-Bertrand, Côte d'Ivoire)*

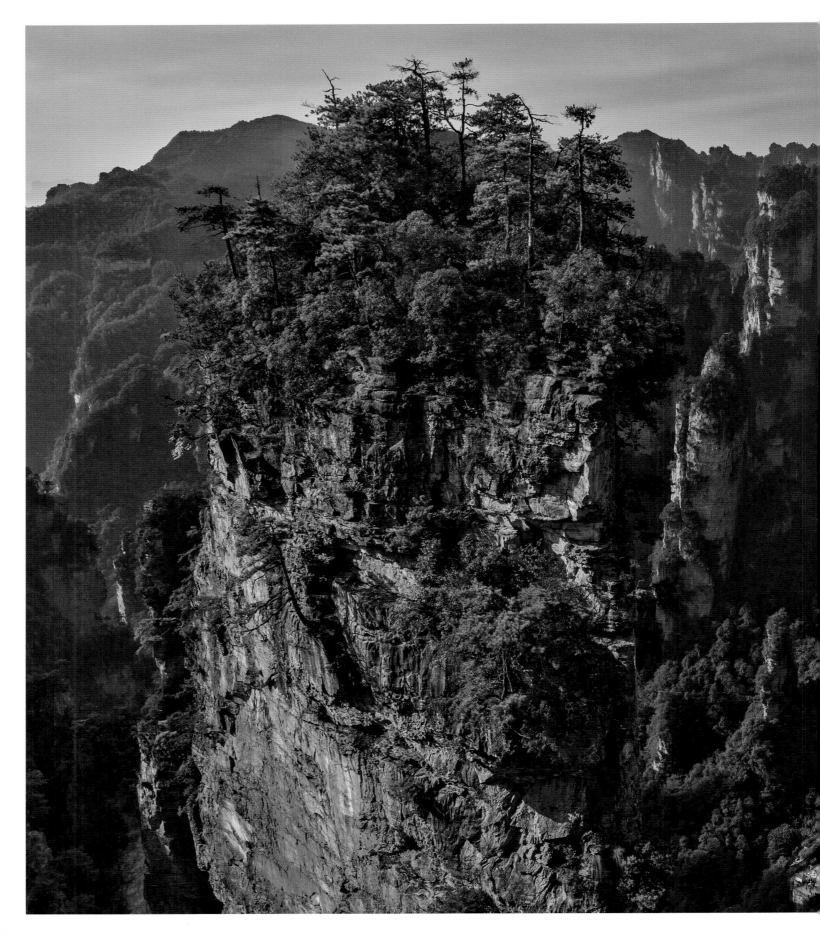

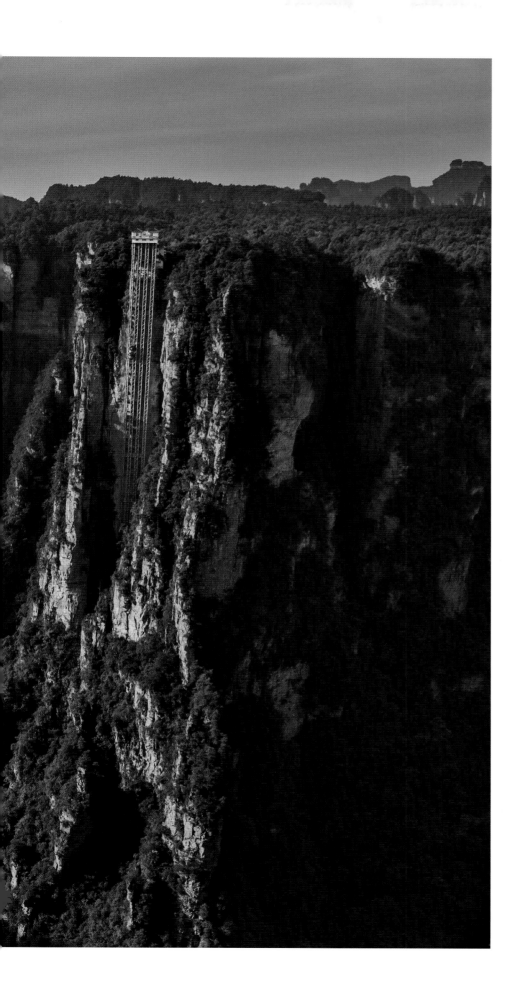

HUNDRED DRAGONS ELEVATOR

Some 3,000 sandstone peaks and spires bring a sense of tranquillity to Wulingyuan Scenic and Historic Interest Area—a World Heritage site covering more than 64,250 acres (26,000 ha) in China's Hunan Province. The Hundred Dragons Elevator, a set of three glass elevators (far right) that climbs 1,070 feet (330 m) in two minutes, clings to a mountainside and gives passengers stunning views from one of the world's tallest elevators.
(Michael S. Yamashita, Wulingyuan National Forest Park, China)

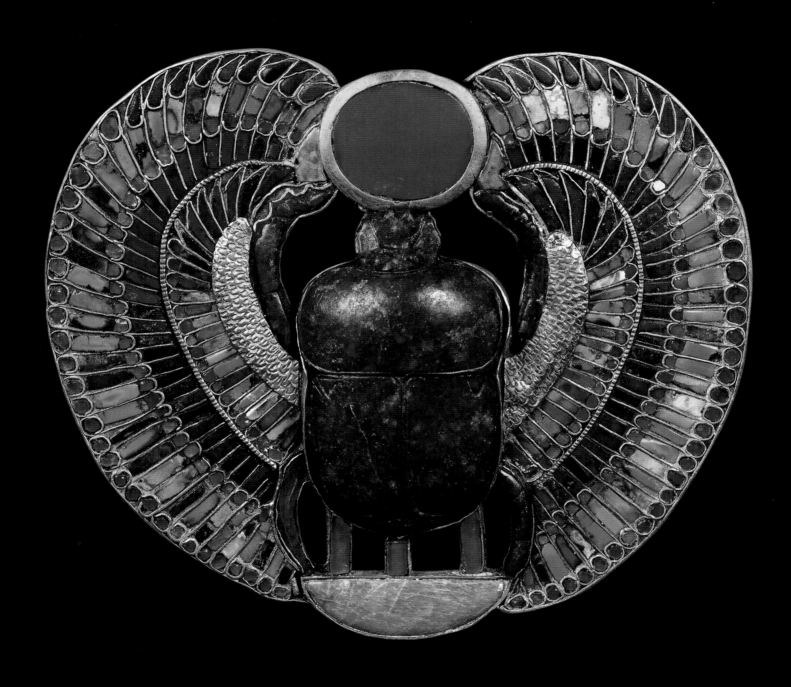

TUT SCARAB
Though a scarab jewel from King Tut's tomb in Egypt's Valley
of the Kings is more than 3,000 years old, its vivid colors still
shine radiantly. Ancient Egyptians worshipped scarabs, a
diverse family of beetles, as the embodiment of Khepri, the
sun god. *(S. Vannini)*

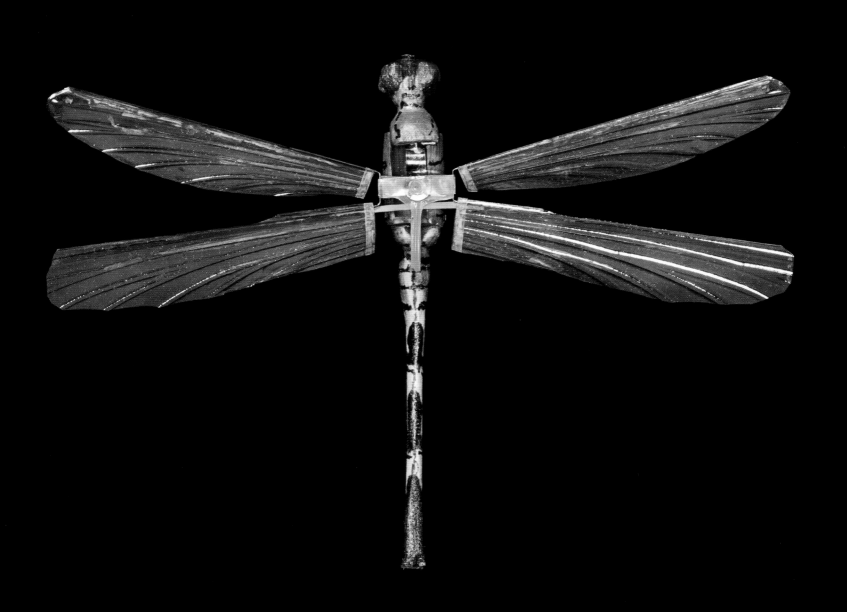

DRAGONFLY DRONE
The CIA developed this mechanical dragonfly in the 1970s as a possible intelligence-gathering machine. Called an insectothopter, it had a miniature engine that moved the wings up and down. Although it flew well in the lab, control in crosswinds outdoors became its downfall. *(Dan Winters)*

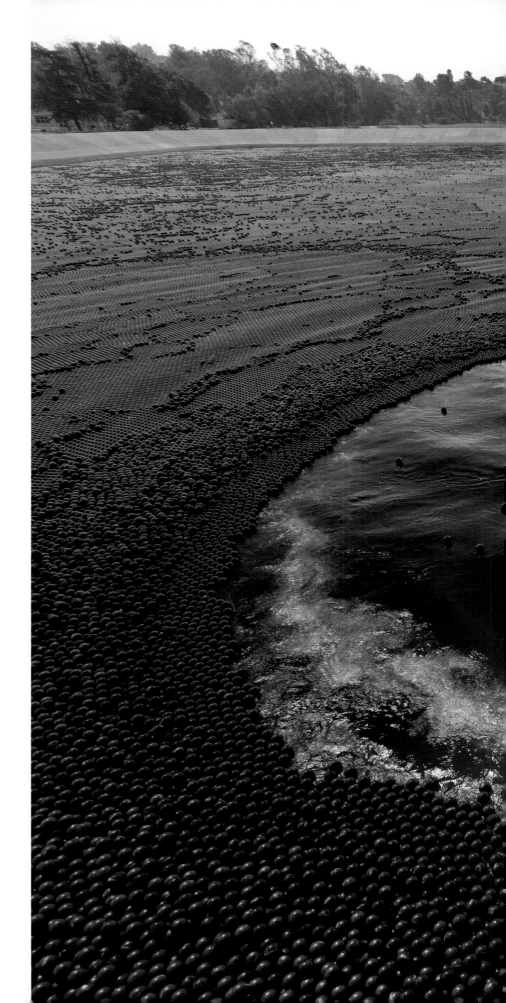

BALL PIT

Nontoxic plastic balls, millions of them, help deflect ultraviolet radiation from the Ivanhoe Reservoir in Los Angeles, California. The black balls also prevent a chemical reaction between bromide and chlorine in the water with sunlight, which creates a carcinogen. The balls, introduced in 2008, were designed to keep the birds out so they wouldn't affect drinking water quality. (Gerd Ludwig, California)

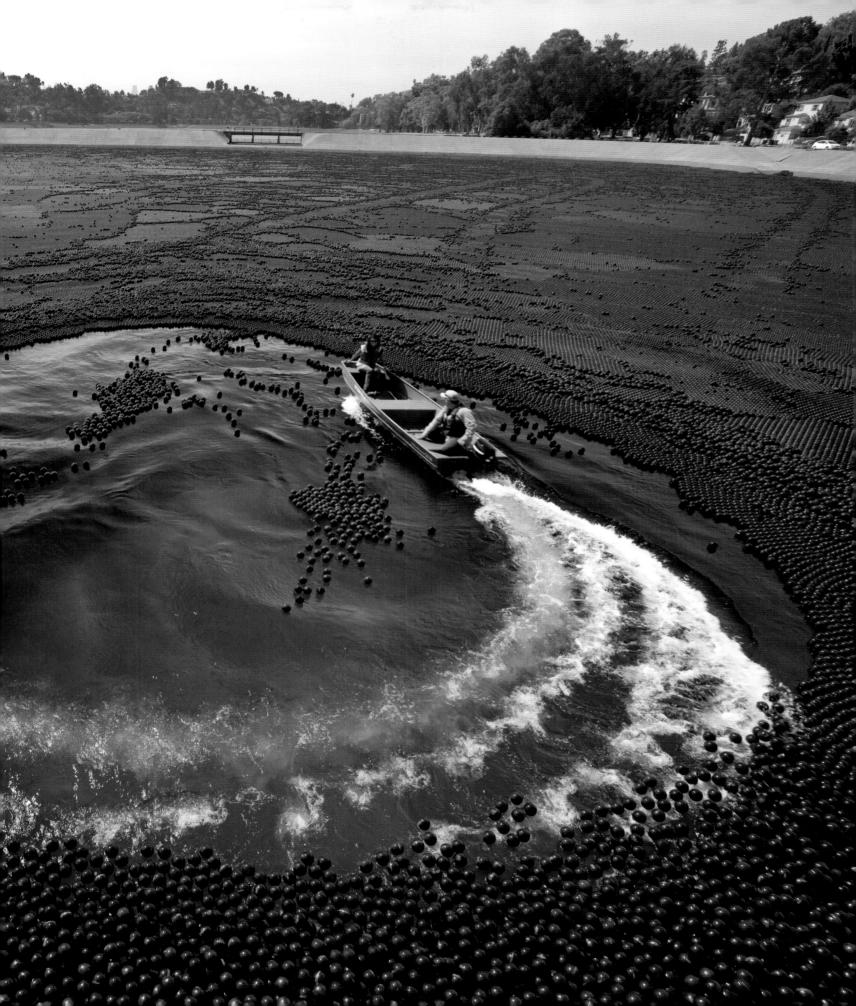

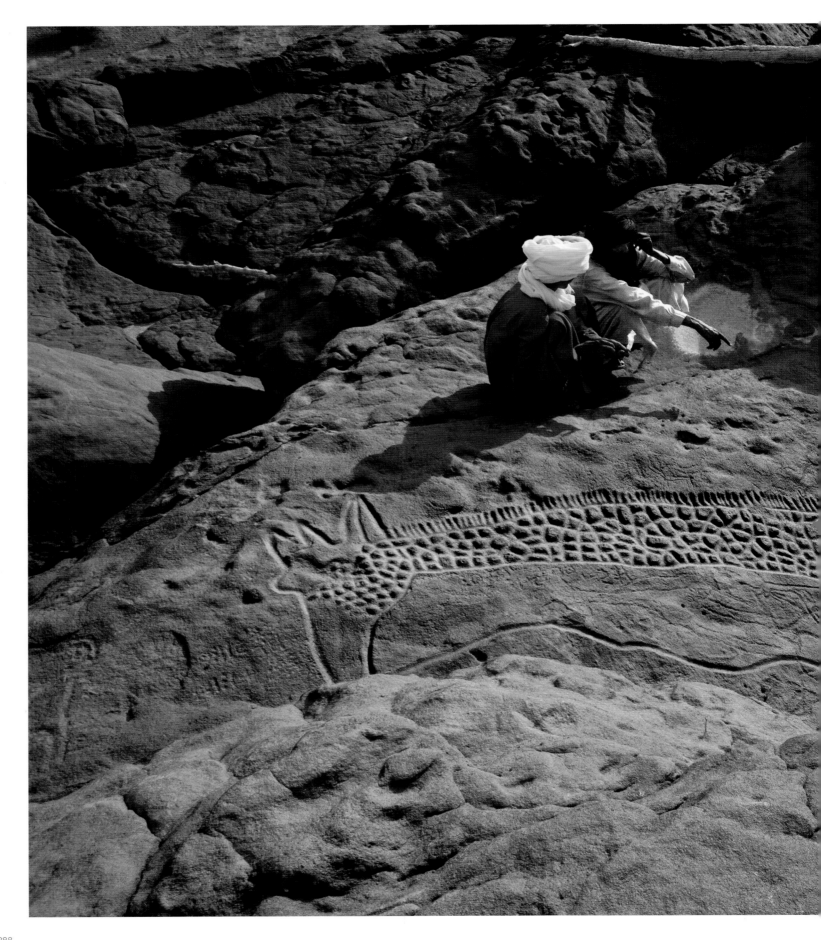

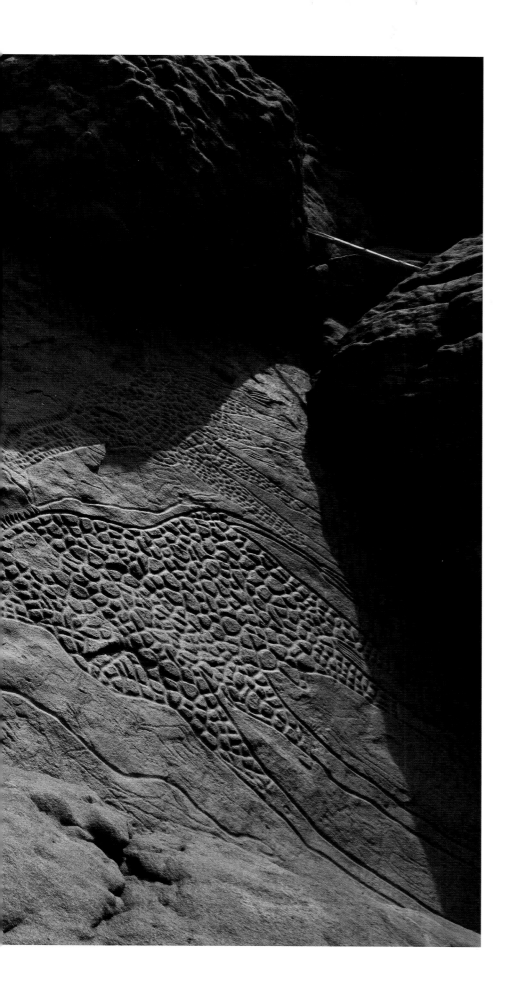

ANCIENT ROCK CARVING

An 8,000-year-old giraffe stretches its neck on a sandstone outcropping in Agadez, Niger. The giraffe, a superb example of prehistoric rock art, has a nose ring, which suggests the carvers may have practiced animal domestication. This carving is among nearly 800 others in this area. *(Mike Hettwer, Niger)*

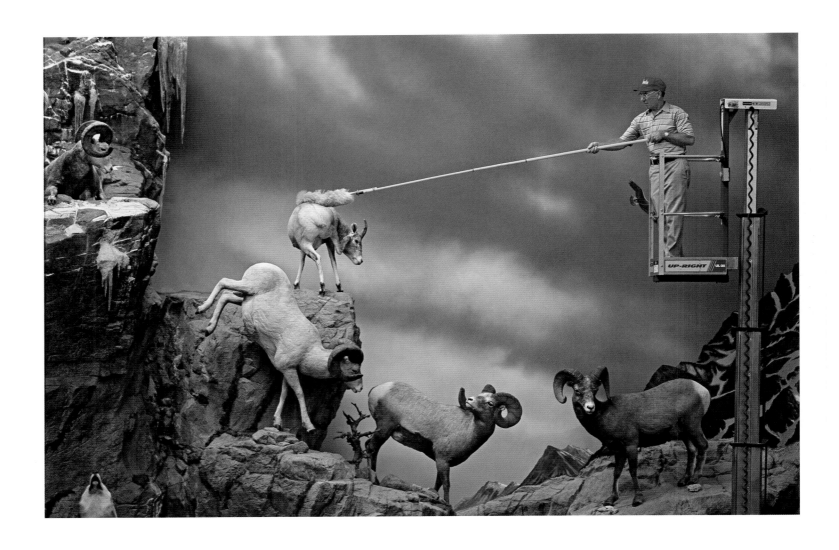

HEY, THAT TICKLES

A bighorn sheep gets a cleaning as a Cabela's employee dusts off a display at the retail store in Sidney, Nebraska. The taxidermied animals, mounted and posed in their natural environment, attract avid hunters and those who are just interested in looking. *(Joel Sartore, Nebraska)*

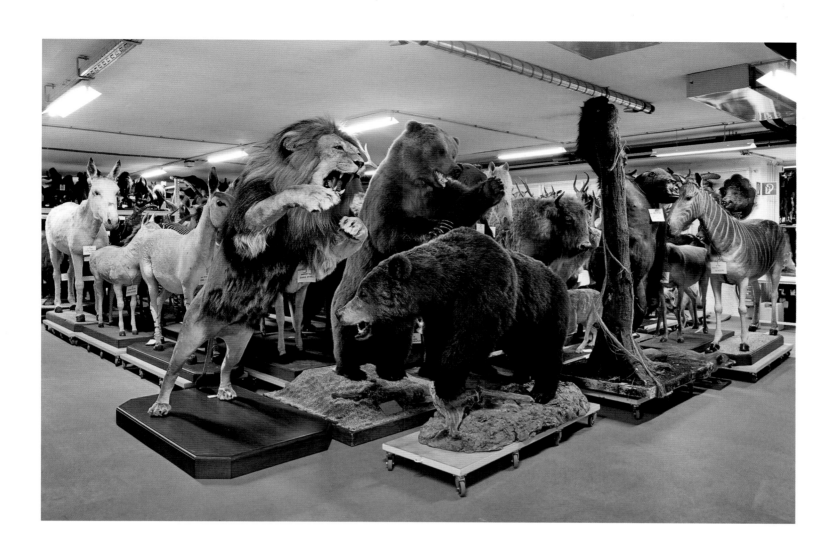

SKELETONS IN THE CLOSET
A storage room at the Museum of Natural History in Vienna, Austria, holds animals not currently on display in the exhibits. The basement room creates its own internal story—most of these species would never meet up in the wild or share such close quarters. *(Klaus Pichler, Austria)*

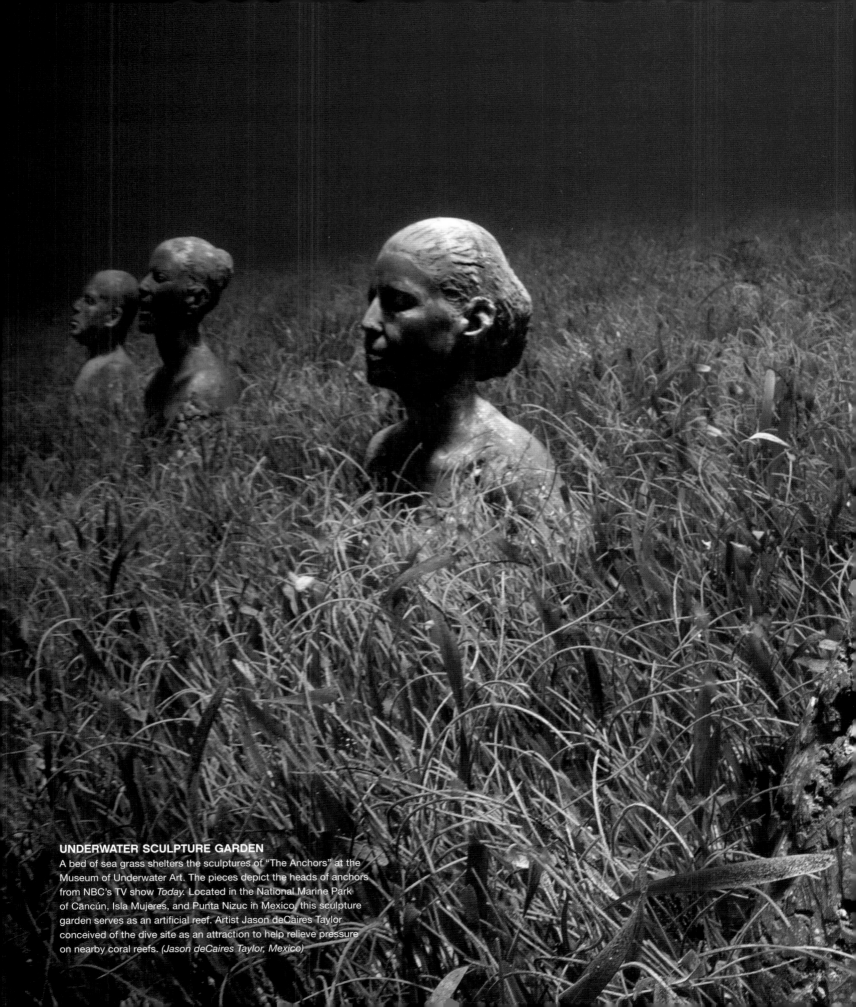

UNDERWATER SCULPTURE GARDEN
A bed of sea grass shelters the sculptures of "The Anchors" at the Museum of Underwater Art. The pieces depict the heads of anchors from NBC's TV show *Today*. Located in the National Marine Park of Cancún, Isla Mujeres, and Punta Nizuc in Mexico, this sculpture garden serves as an artificial reef. Artist Jason deCaires Taylor conceived of the dive site as an attraction to help relieve pressure on nearby coral reefs. *(Jason deCaires Taylor, Mexico)*

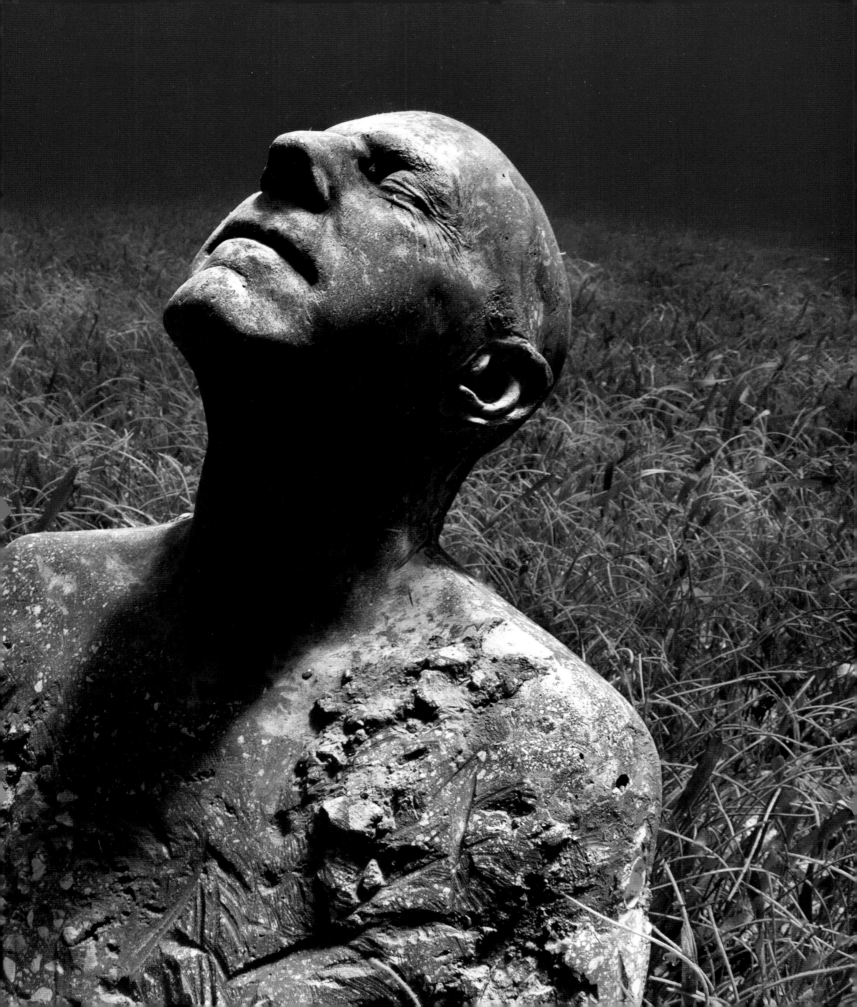

TUMBLEWEED

A tumbleweed soars through the air at the Bonneville Salt Flats, Utah. The invasive Russian thistle *(Salsola tragus)* came from the Eurasian steppes to overtake the American West. *(John Burcham, Utah)*

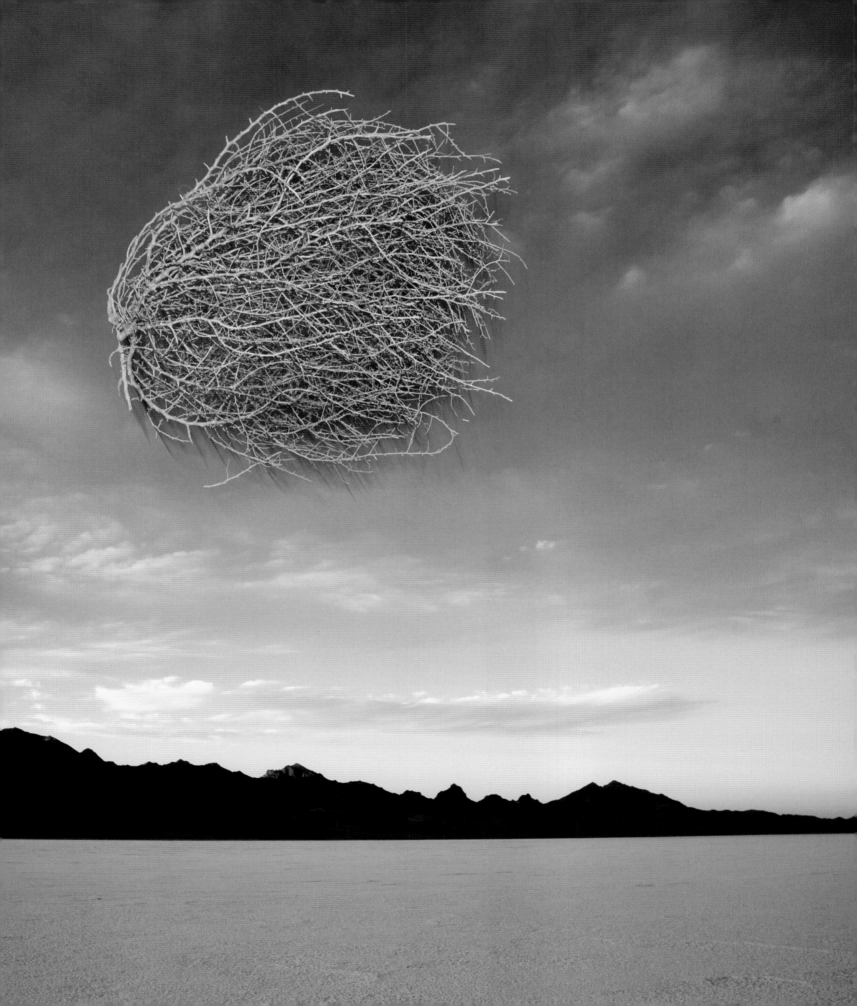

"Caddis flies are known for making protective cases with elements borrowed from their environment—usually plant fragments, small gravel, bits of snail shells. To create this version, artist Hubert Duprat placed larvae extracted from its natural case into an aquarium stashed with precious materials: gold, pearls, and semiprecious stones. The larvae then rebuilt its cocoon with the new items. But the process doesn't interfere with its evolution. It continues its metamorphosis to become a winged creature."

STATEMENT FROM

ART: CONCEPT GALLERY IN PARIS

OPPOSITE: **CADDIS FLY COCOON**
A caddis fly (order Trichoptera) creates art, making a protective case from precious gems. *(Fabrice Gousset)*

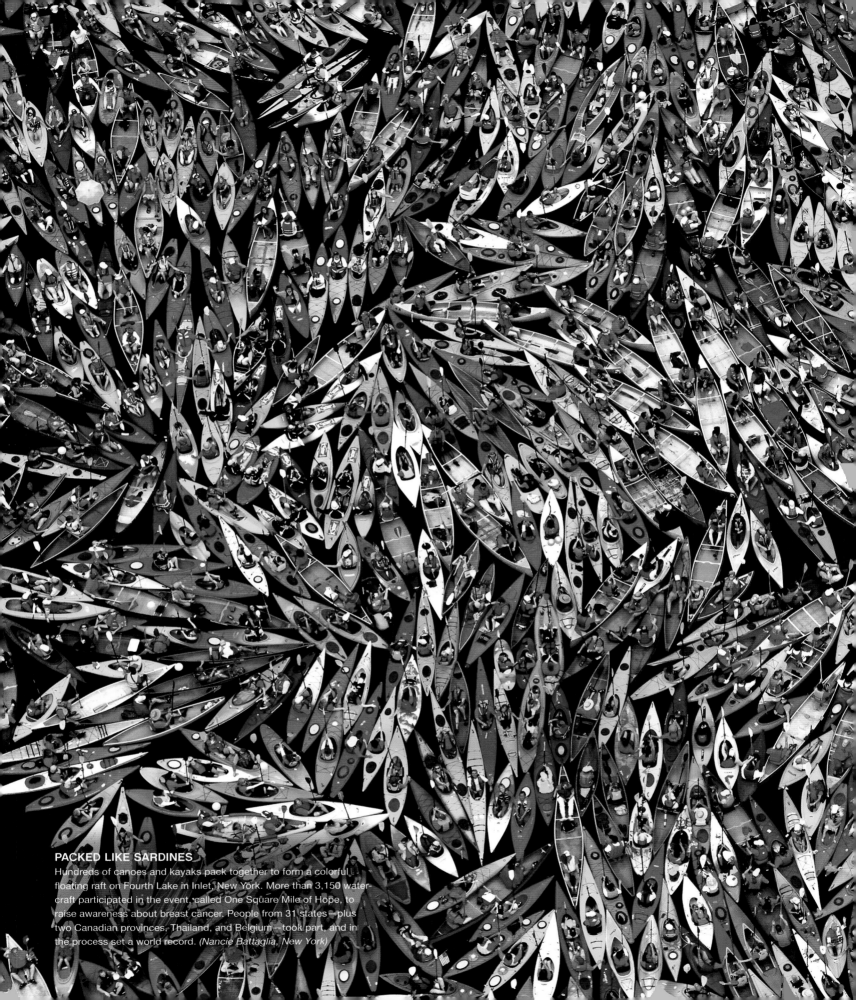

PACKED LIKE SARDINES
Hundreds of canoes and kayaks pack together to form a colorful floating raft on Fourth Lake in Inlet, New York. More than 3,150 watercraft participated in the event, called One Square Mile of Hope, to raise awareness about breast cancer. People from 31 states—plus two Canadian provinces, Thailand, and Belgium—took part, and in the process set a world record. *(Nancie Battaglia, New York)*

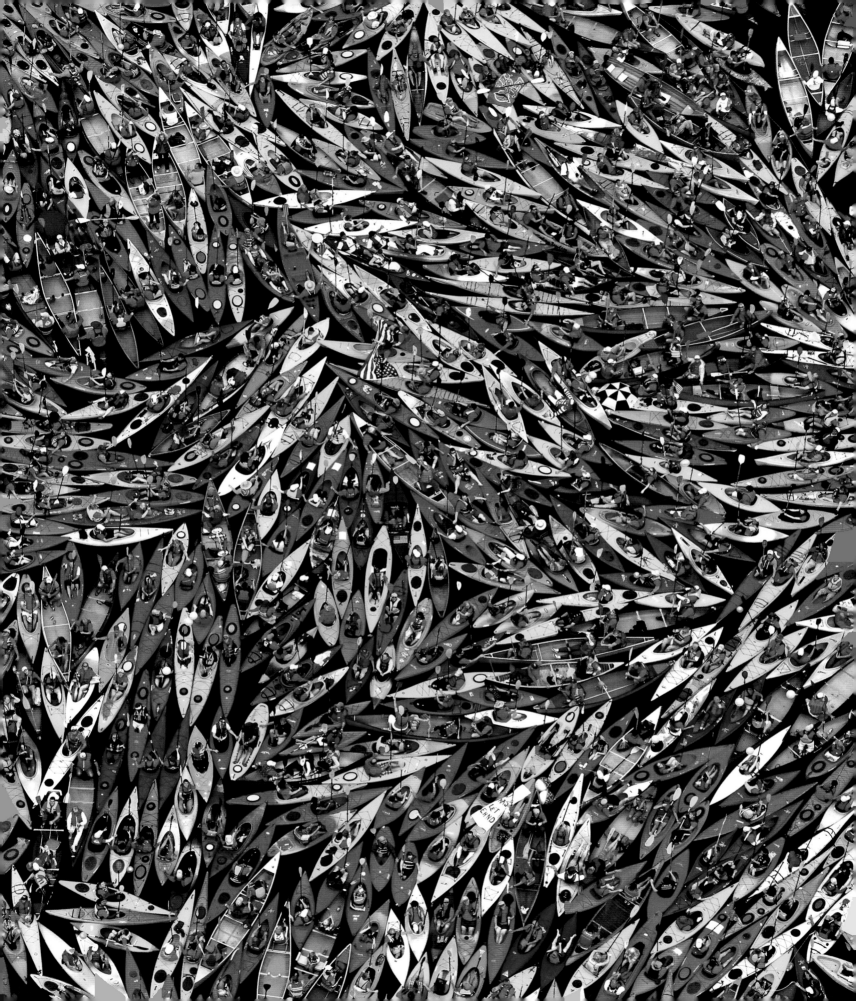

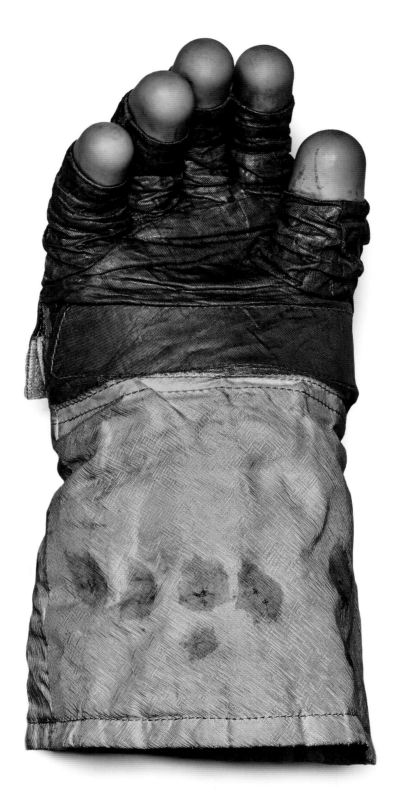

ONE SMALL GLOVE

On July 29, 1969, NASA astronaut Neil Armstrong became
the first person to walk on the moon. One of only 12 astronauts
to have this experience, he felt the lunar dust with the blue silicone
fingertips of his extravehicular gloves. Armstrong's gloves were
custom-sewn and -fit for him. *(Dan Winters)*

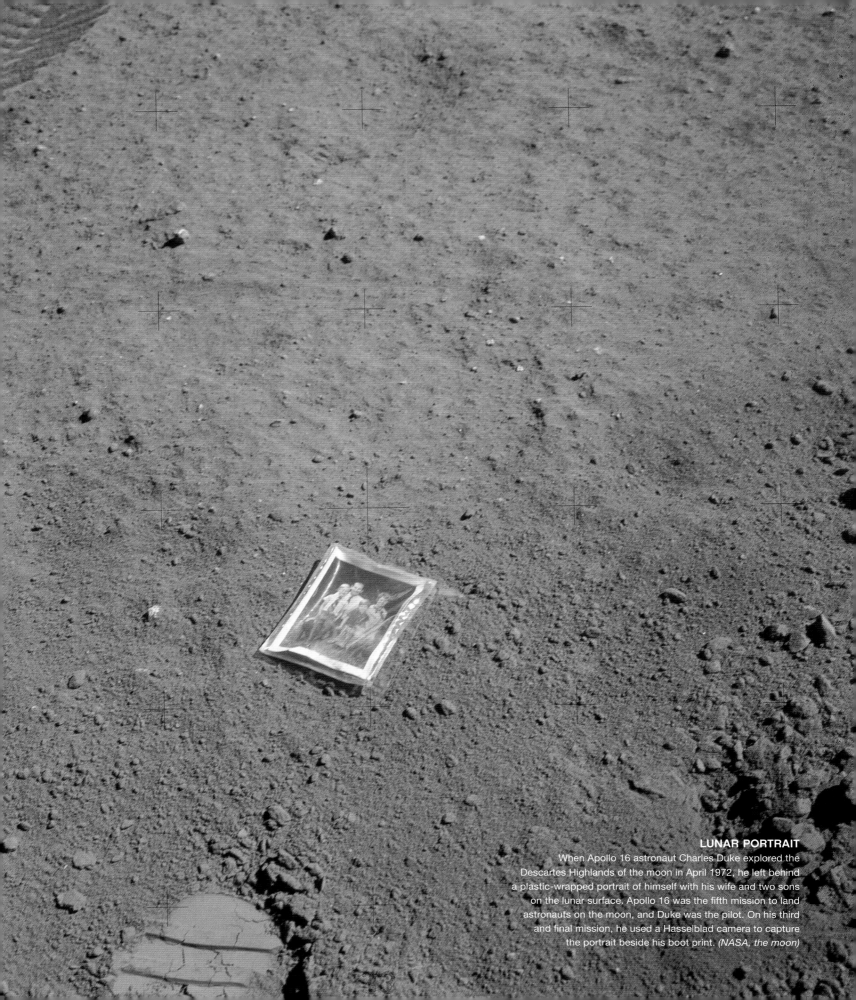

LUNAR PORTRAIT
When Apollo 16 astronaut Charles Duke explored the Descartes Highlands of the moon in April 1972, he left behind a plastic-wrapped portrait of himself with his wife and two sons on the lunar surface. Apollo 16 was the fifth mission to land astronauts on the moon, and Duke was the pilot. On his third and final mission, he used a Hasselblad camera to capture the portrait beside his boot print. *(NASA, the moon)*

GREEN PIANO

Tender leaves cover a piano in Odaka, Japan. The piano is just a small piece of the radioactive debris left from the March 2011 tsunami and subsequent meltdown of the Fukushima Daiichi nuclear power plant. While the government has vowed that evacuees will be able to return one day, the disaster cleanup has been frustrating and slow. *(Tomás Munita, Japan)*

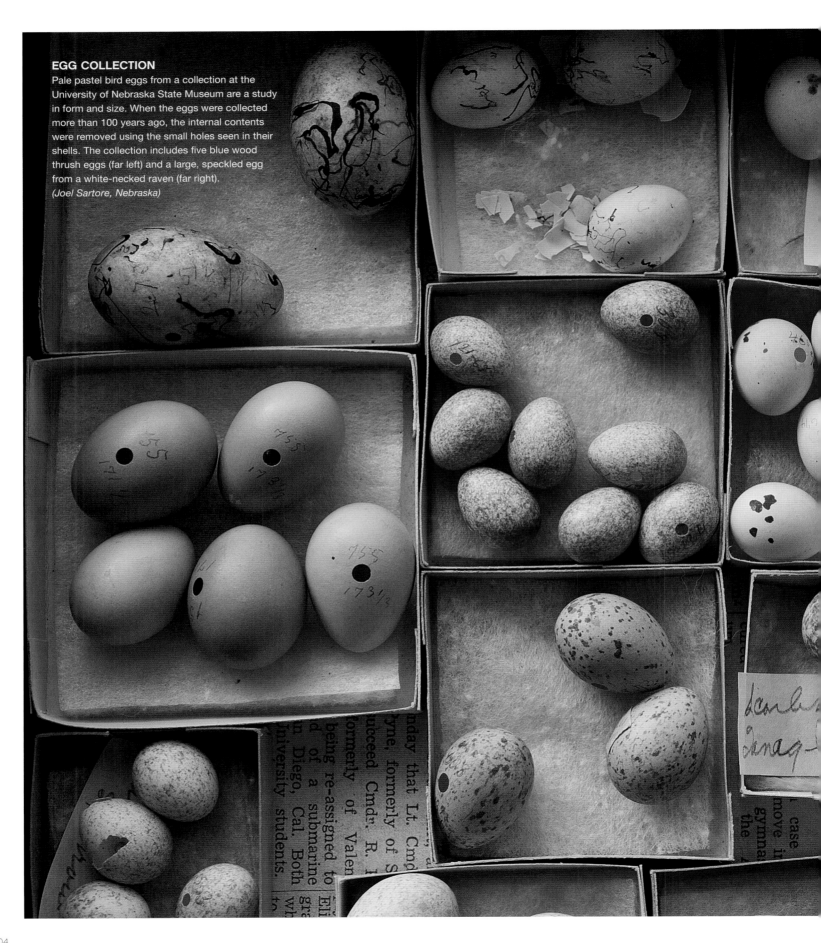

EGG COLLECTION
Pale pastel bird eggs from a collection at the University of Nebraska State Museum are a study in form and size. When the eggs were collected more than 100 years ago, the internal contents were removed using the small holes seen in their shells. The collection includes five blue wood thrush eggs (far left) and a large, speckled egg from a white-necked raven (far right).
(Joel Sartore, Nebraska)

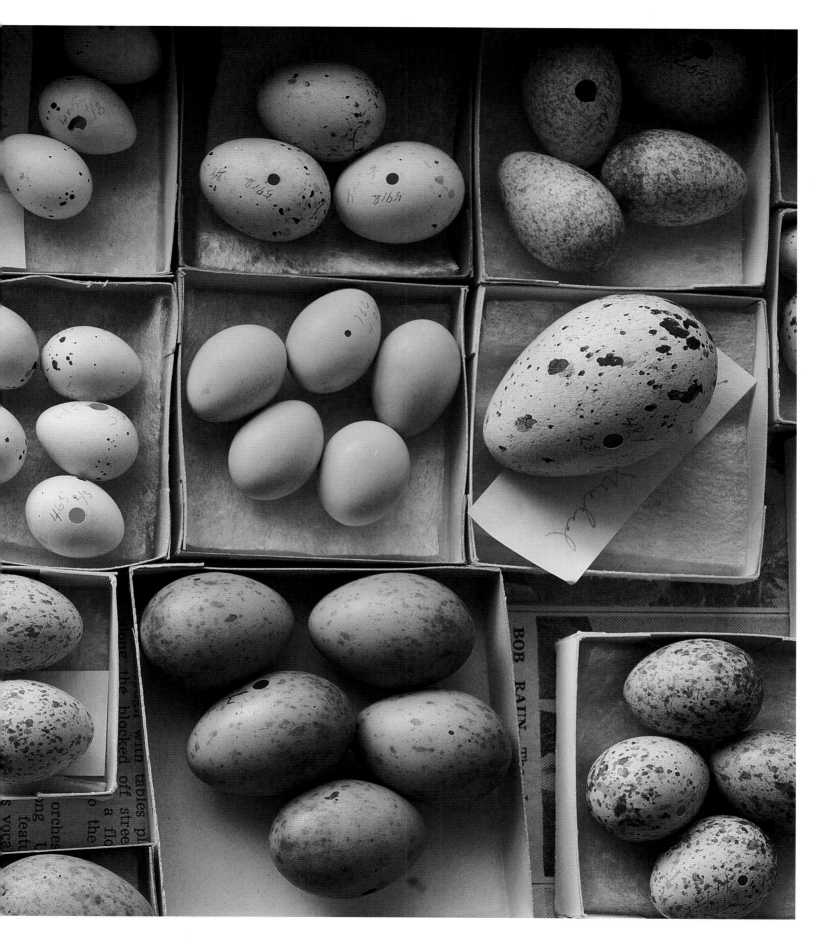

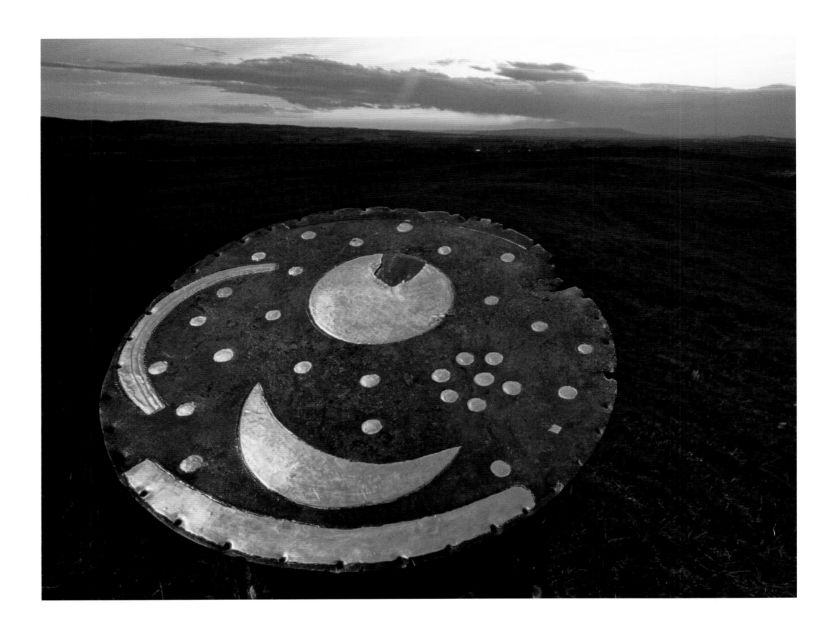

NEBRA SKY DISK

The setting sun reflects off this sky disk in central Germany. Buried on the Mittelberg hill near the town of Nebra in 1600 B.C., the disk tracks the sun's movement along the horizon. It's the oldest known depiction of the cosmos and may have served as an agricultural and spiritual calendar. *(Kenneth Garrett, Germany)*

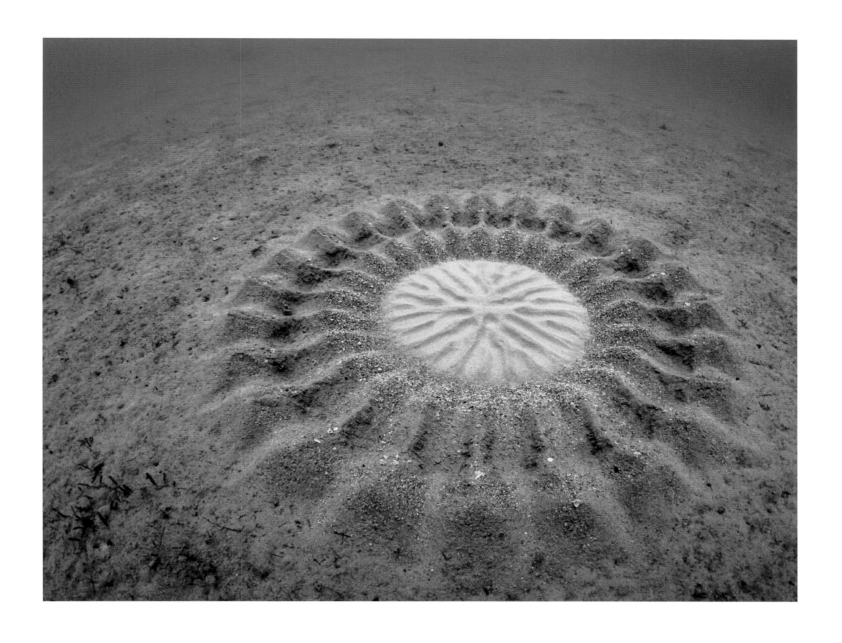

PERFECT CIRCLE
This geometric pattern wasn't left by a creative scuba diver but by a male pufferfish. The 5-inch-long (12-cm) fish use their fins to create these elaborate circles to attract mates. By flapping their fins, the fish turn up the ocean sediment and create designs that can measure 7 feet (2 m) across. *(Yoji Okata, Japan)*

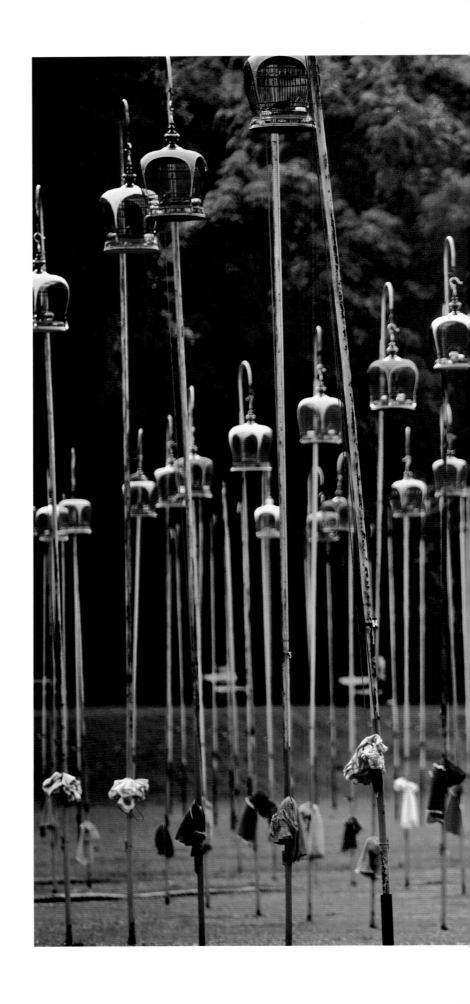

FIELD OF BIRD CAGES

A young man looks up at a field full of dove birdcages dangling
from poles in a public housing estate in Singapore. The cool
morning air surrounds these doves, which are trained to sing
in competitions—a traditional pursuit in a quickly modernizing
country. It can cost as much as $60,000 to train one dove.
(David McLain, Singapore)

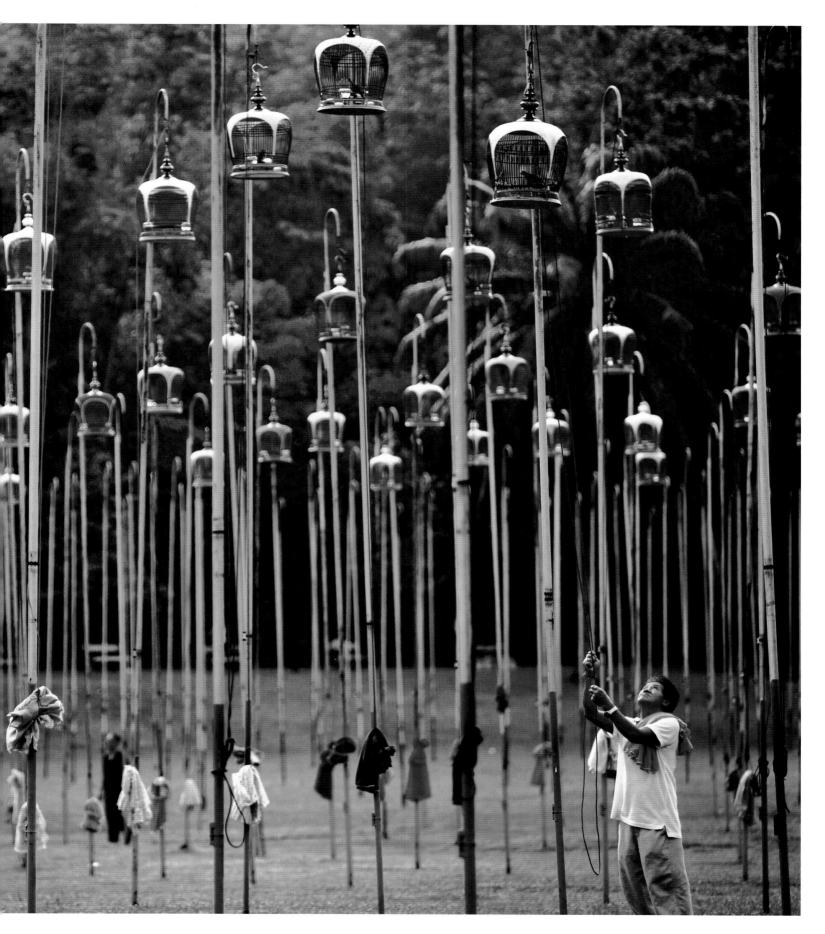

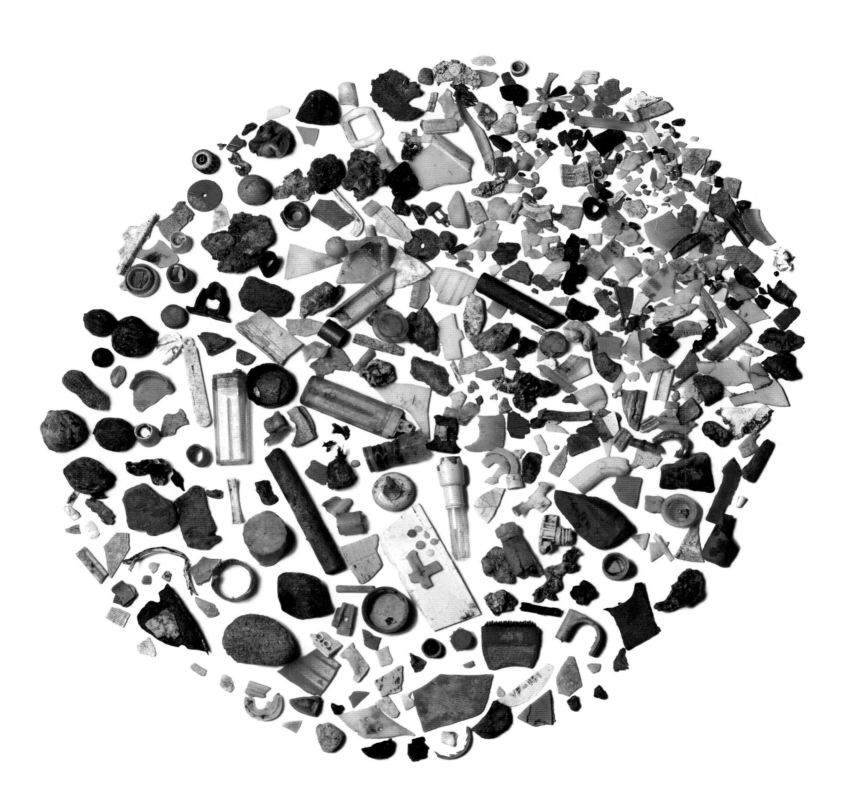

"For tens of thousands of years, albatrosses have fed off squid and flying fish eggs, which gather on the ocean surface. Now huge amounts of debris also float on the surface. One morning an albatross chick I named Shed Bird was found dead. The necropsy revealed a stomach full of plastic, cigarette lighters, several bottle caps, an aerosol pump top, a piece of a shotgun shell, broken clothespins, toys, and more. My hope is that we will rethink our use of plastics and how we dispose of them."

SUSAN MIDDLETON

OPPOSITE: **INSIDE AN ALBATROSS STOMACH**
The contents of an albatross chick may mimic modern art, but really showcase
the deadly result of wildlife living in a plastic world. (Susan Middleton)

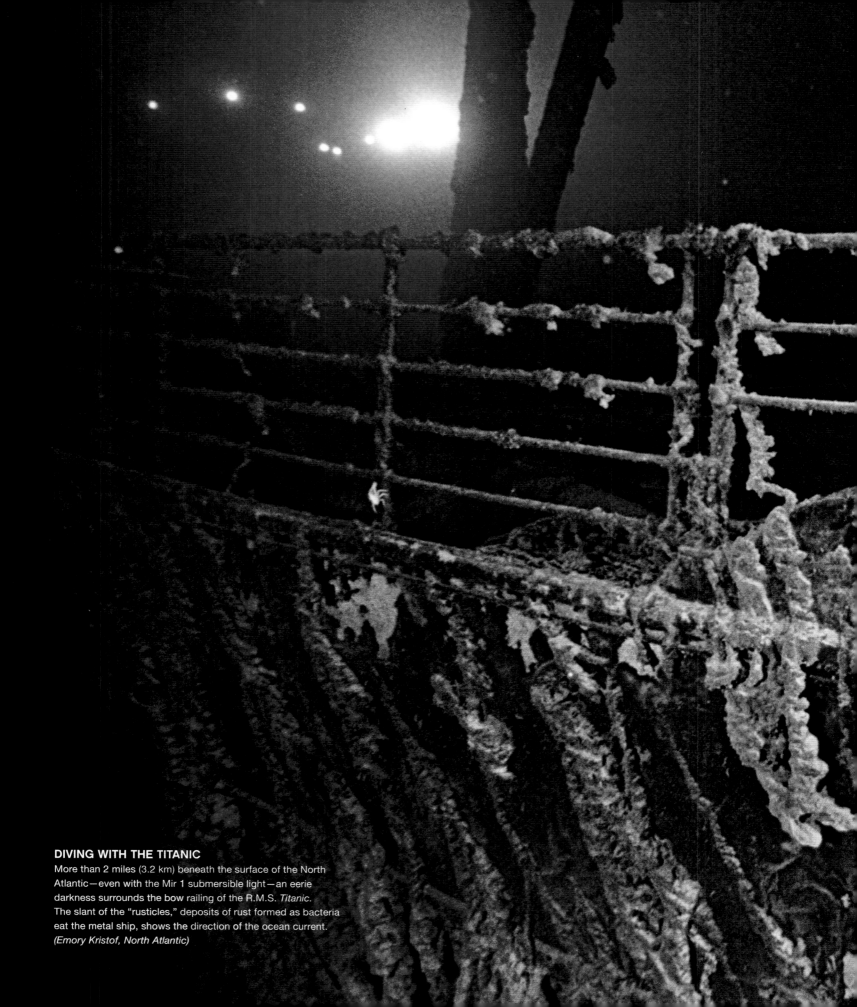

DIVING WITH THE TITANIC
More than 2 miles (3.2 km) beneath the surface of the North
Atlantic—even with the Mir 1 submersible light—an eerie
darkness surrounds the bow railing of the R.M.S. *Titanic*.
The slant of the "rusticles," deposits of rust formed as bacteria
eat the metal ship, shows the direction of the ocean current.
(Emory Kristof, North Atlantic)

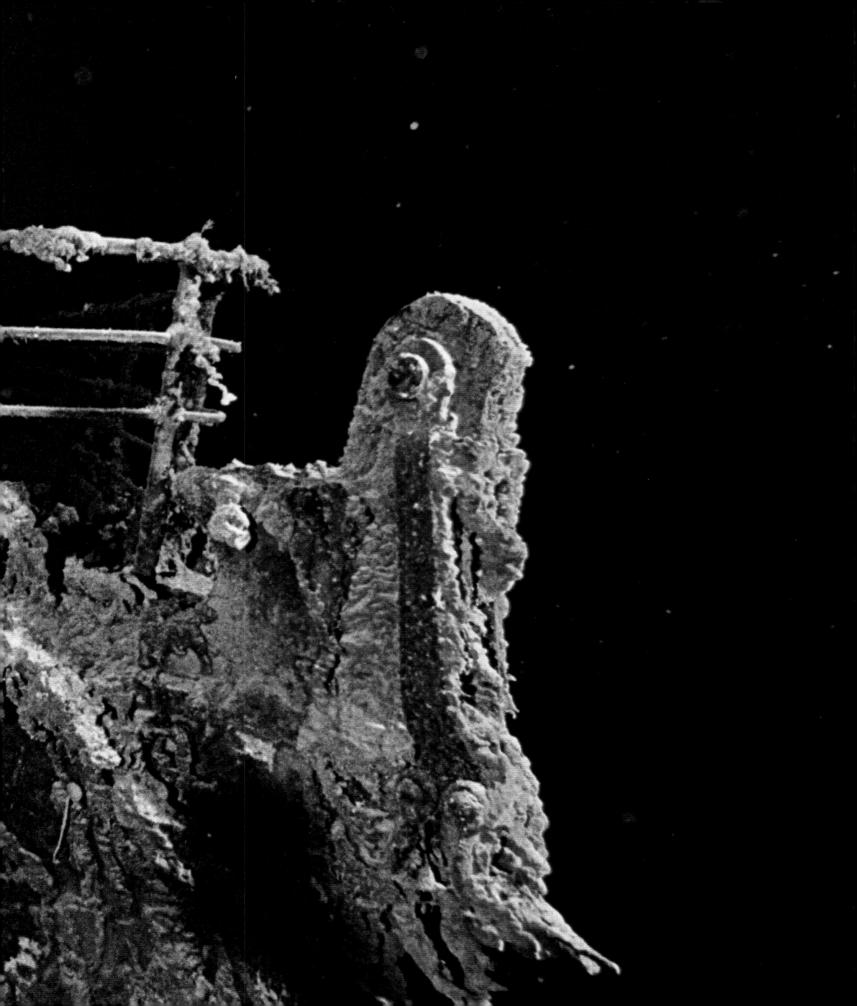

PAINTING OF THE APES
The hands that painted "Digit Master" are only slightly removed from those of our own. The artist—in this case, a chimpanzee named Bakhari—makes the St. Louis Zoo her home. The zoo's keepers give some of the animals the chance to paint on canvas as an enrichment activity. *(Rob Eagle, Missouri)*

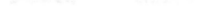

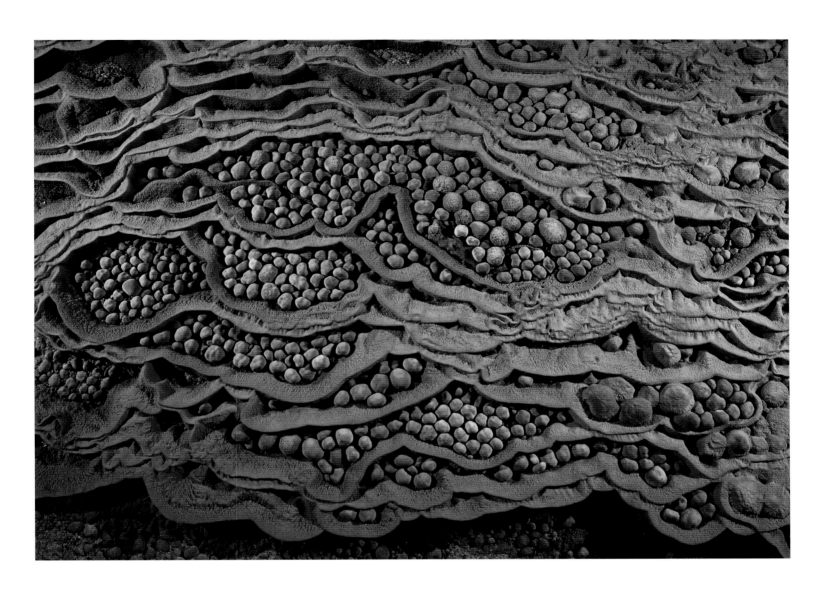

CAVE PEARLS

Rare cave pearls fill dried-out terrace pools to create a tapestry of brown in Hang Son Doong ("mountain river cave") in central Vietnam. This unusually large collection of stone spheres formed drip by drip for centuries, as calcite crystals, left behind by water, layered themselves around grains of sand and enlarged over time. *(Carsten Peter, Vietnam)*

STANDING STONES

The Mên-an-Tol stones near Penzance in Cornwall, England, contain echoes of earlier times. The megalithic rocks, possibly part of an ancient circle, have no clear explanation. Local legend holds that a person who passes through the rare holed stone can be cured of many ailments, including rickets and back problems. *(Helen Hotson, England)*

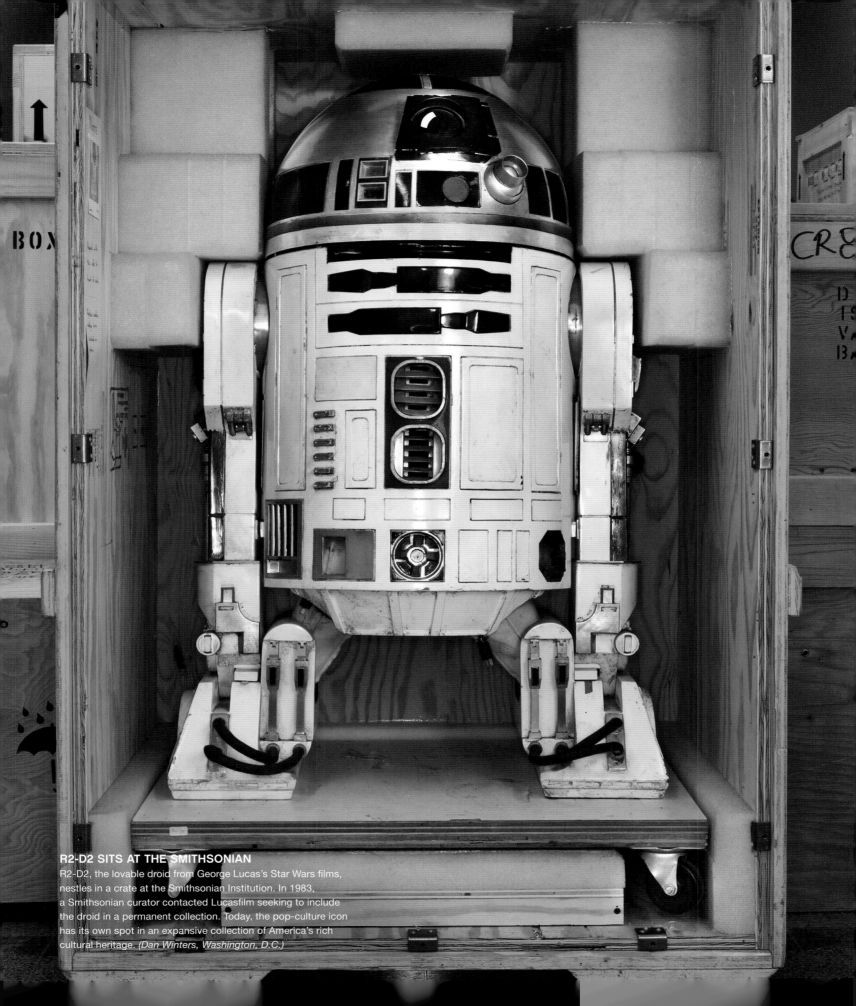

R2-D2 SITS AT THE SMITHSONIAN
R2-D2, the lovable droid from George Lucas's Star Wars films,
nestles in a crate at the Smithsonian Institution. In 1983,
a Smithsonian curator contacted Lucasfilm seeking to include
the droid in a permanent collection. Today, the pop-culture icon
has its own spot in an expansive collection of America's rich
cultural heritage. *(Dan Winters, Washington, D.C.)*

IMPERIAL FABERGÉ EGG

In 2012, a scrap dealer paid about $14,000 for this egg—and what a deal he got. The Imperial Easter Egg was created by Peter Carl Fabergé, the famed designer for the Russian imperial family, and is appraised at $33 million. This egg was originally an Easter gift to Empress Marie Feodorovna from Emperor Alexander III in 1887. *(Wartski)*

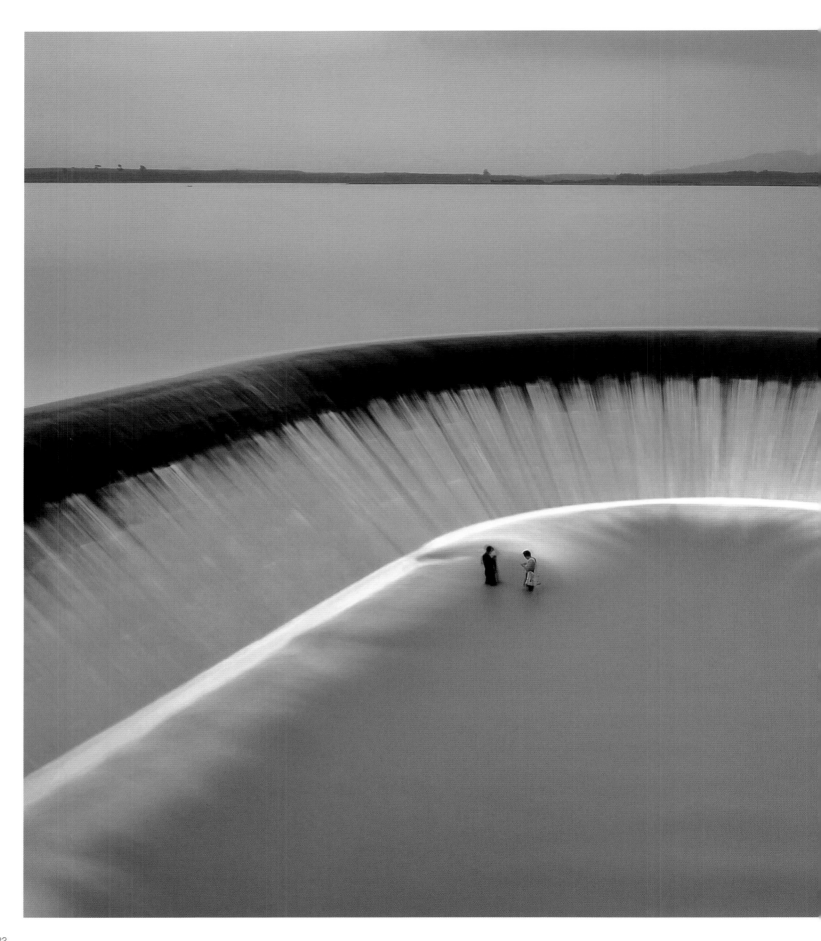

RAYONG DAM
Fishermen look like just a drop in the water standing inside the overflow spillway of the Khlong Yai Reservoir in Rayong, southern Thailand. This dam provides the region with inexpensive electrical power. *(Tonnaja Anan Charoenkal, Thailand)*

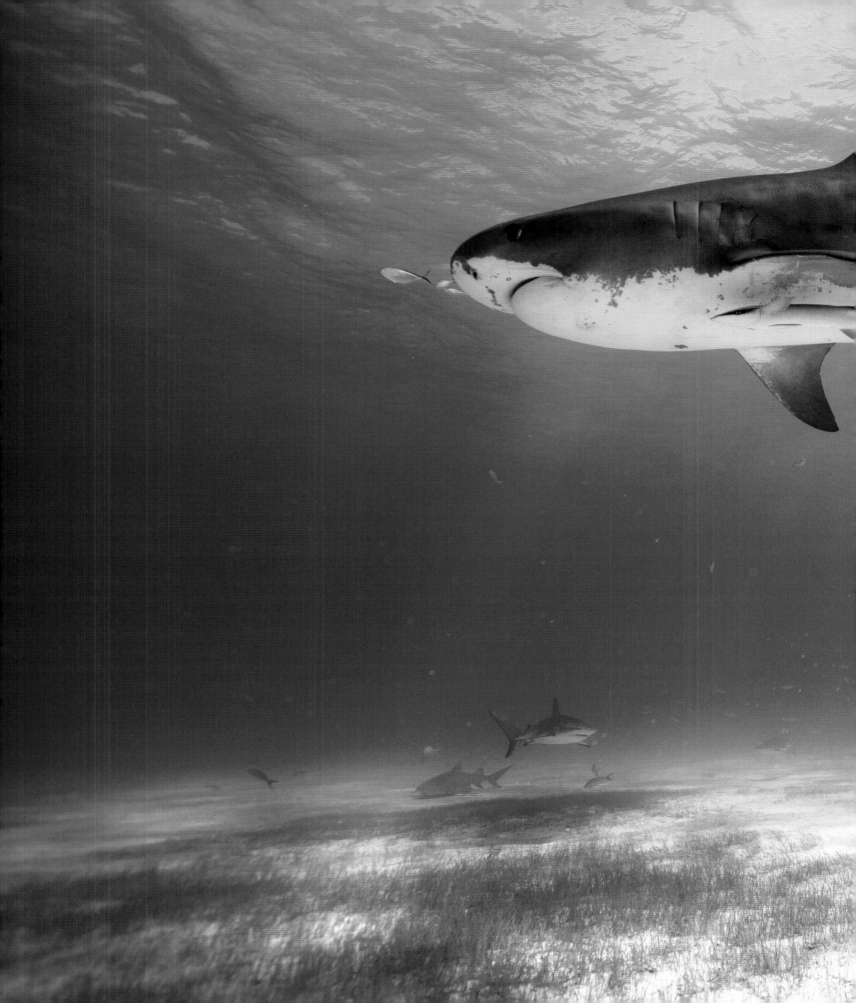

MOMENTS

TIGER SHARK
A free diver and a tiger shark share the ocean at Tiger Beach in the Bahamas. The largest of blunt-nosed sharks, these predators can reach 25 feet (7.5 m). Their diet includes everything from sea turtles and sea snakes to stingrays and seals. *(Eusebio Saenz de Santamaria, Bahamas)*

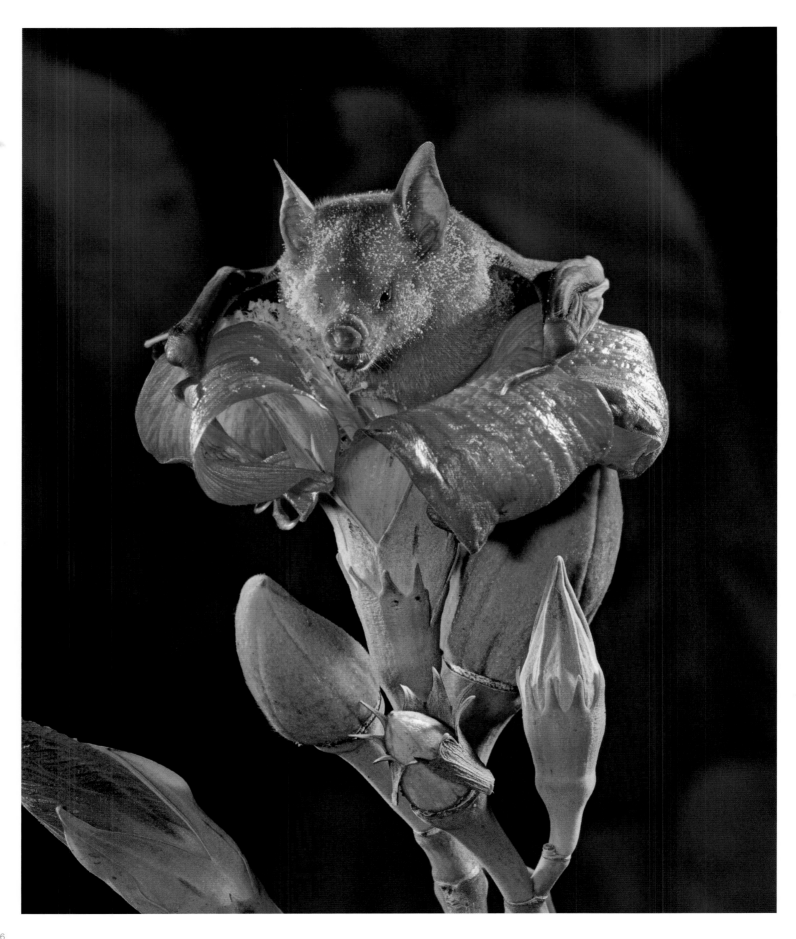

MOMENTS

A photograph is a slice of time. It is a vision in a moment. In admiring it, we trust that someone, some human just like me, was witness to that time in that place in order to take that picture. Photoshopping aside, the artful photographer affirms for us, *This moment really happened.* It may never happen again, or it may happen again and again with no one there to see—but this moment happened, and I was there . . . which makes every one of these extraordinary photographs all the more rare and delicious.

As an alligator hatched. As the lightning struck just so. As the pop smiled, as the wave broke, as the candle floated and flickered. As a diver took the dare and plunged through the air—a photographer was there seeing, and hence so are we.

Every one of the photographs in this book is a moment rarely seen and yet a moment that really happened. Every one of these phenomena occurred. Every creature really lived, every object existed. These places—they are real. We trust the camera and the eye of the artist.

And to the photographers who captured these moments, all we can say is, *Thank you. Thank you for being there. Thank you for being there in that moment.*

OPPOSITE: **A POLLINATED BAT**
A fruit bat, its fur covered in pollen, emerges from the flower of a blue mahoe tree. This medium-size bat makes its home in eastern Cuba, in a colony of more than one million, where it drinks nectar and, in return, pollinates the trees. *(Merlin Tuttle, Cuba)*

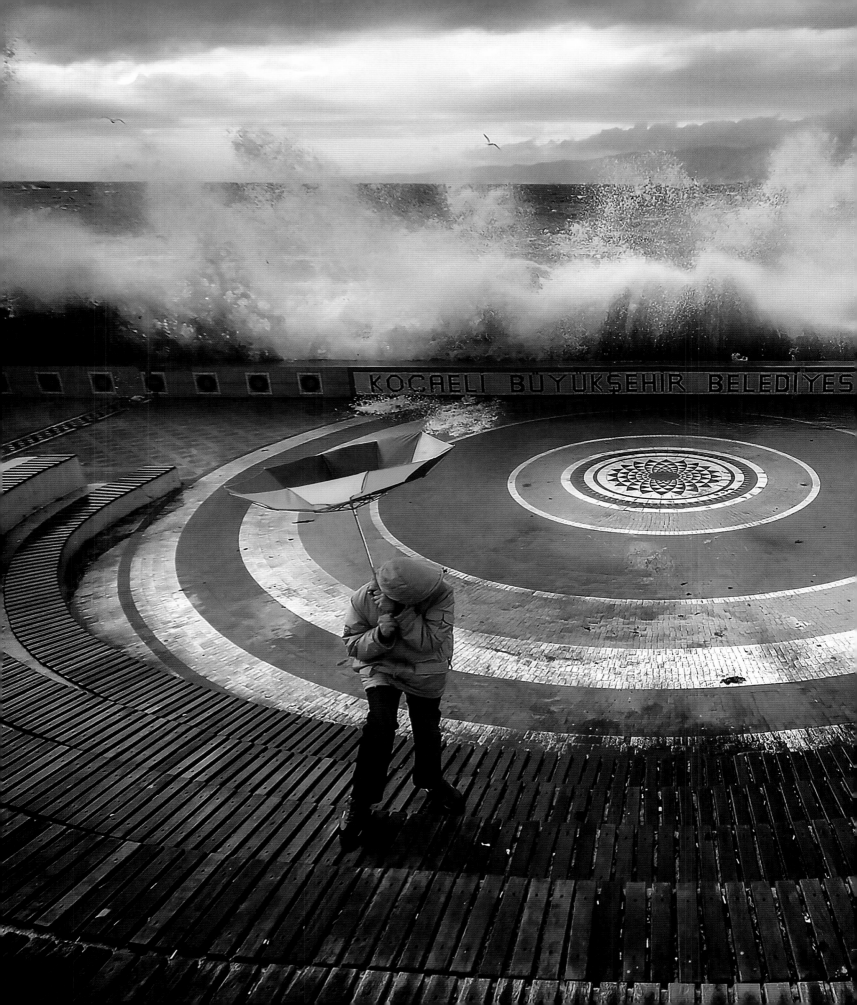

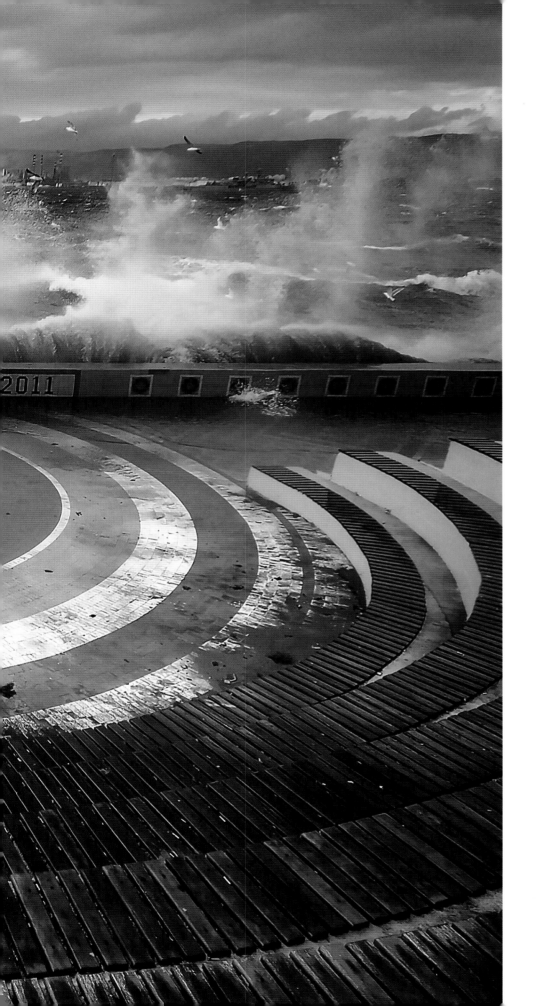

SPLASH

A brewing storm sends waves splashing over
a retaining wall in Kocaeli Province, Turkey.
As the winds picked up, a passerby's rainbow
umbrella turned inside out. *(Aytül Akbaş, Turkey)*

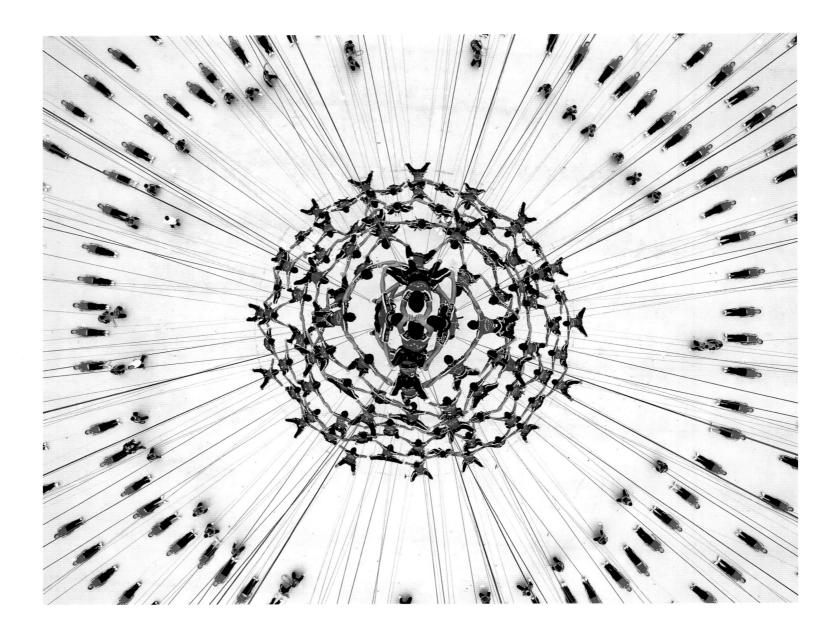

ACROBATIC FEATS

Young performers from the Tagou Martial Arts School in China's Henan Province train for the opening ceremony of the Nanjing 2014 Youth Olympic Games. Ropes lifted 120 performers into the air to create a human tower that soared in the sky during their aerial dance, "Build the Dream." *(Xinhua, China)*

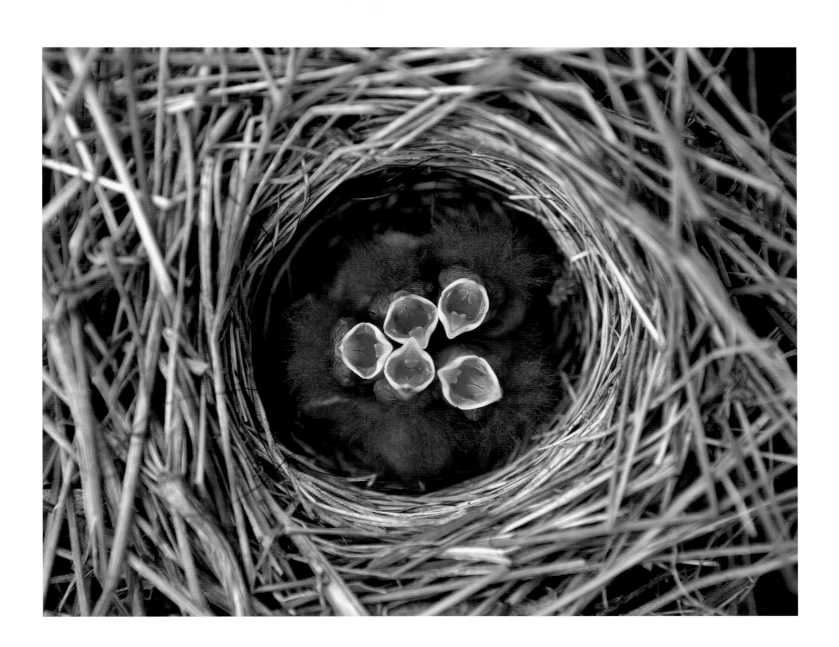

OPEN WIDE
Hungry hatchlings open their mouths to sing for food from the safety of their nest. After a few more weeks of care, if these five birds make it, they will take to the sky. *(Art Wolfe, Mongolia)*

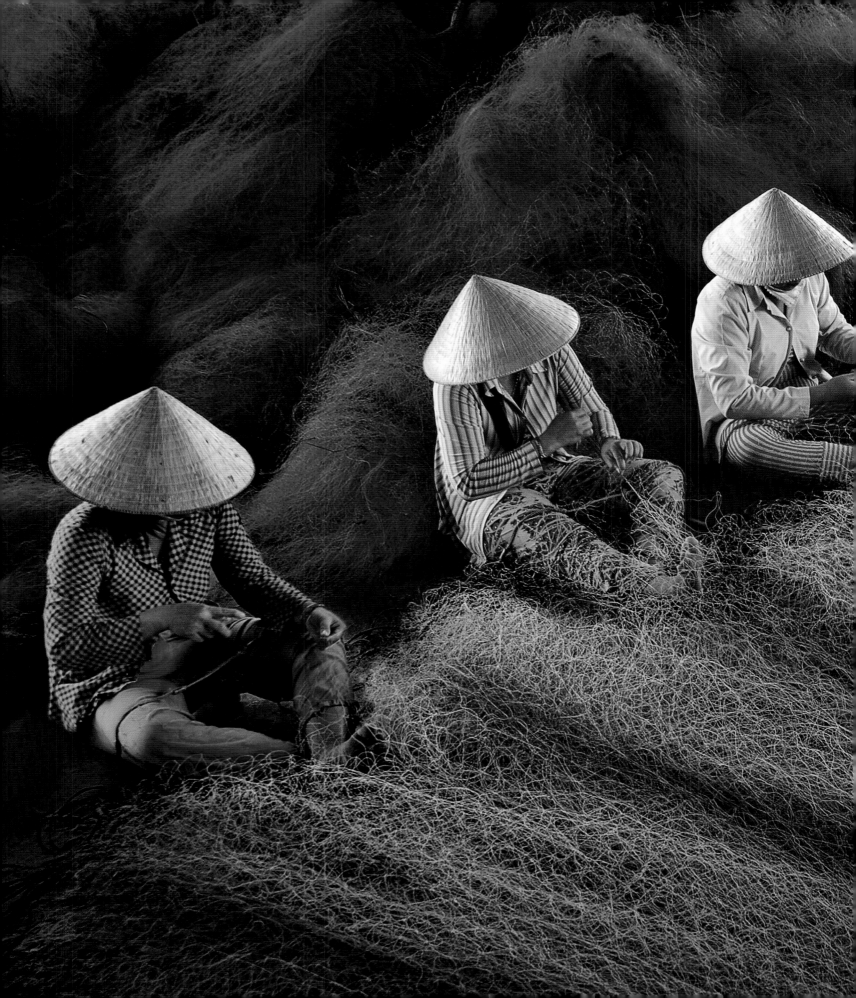

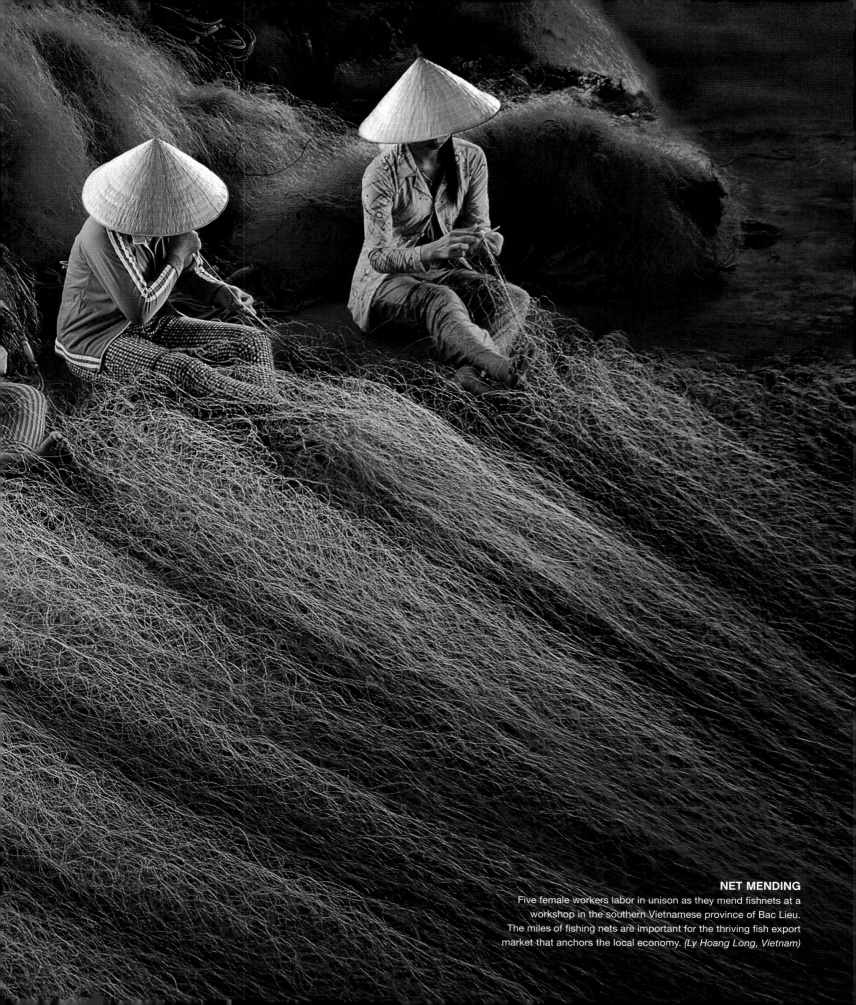

NET MENDING
Five female workers labor in unison as they mend fishnets at a workshop in the southern Vietnamese province of Bac Lieu. The miles of fishing nets are important for the thriving fish export market that anchors the local economy. *(Ly Hoang Long, Vietnam)*

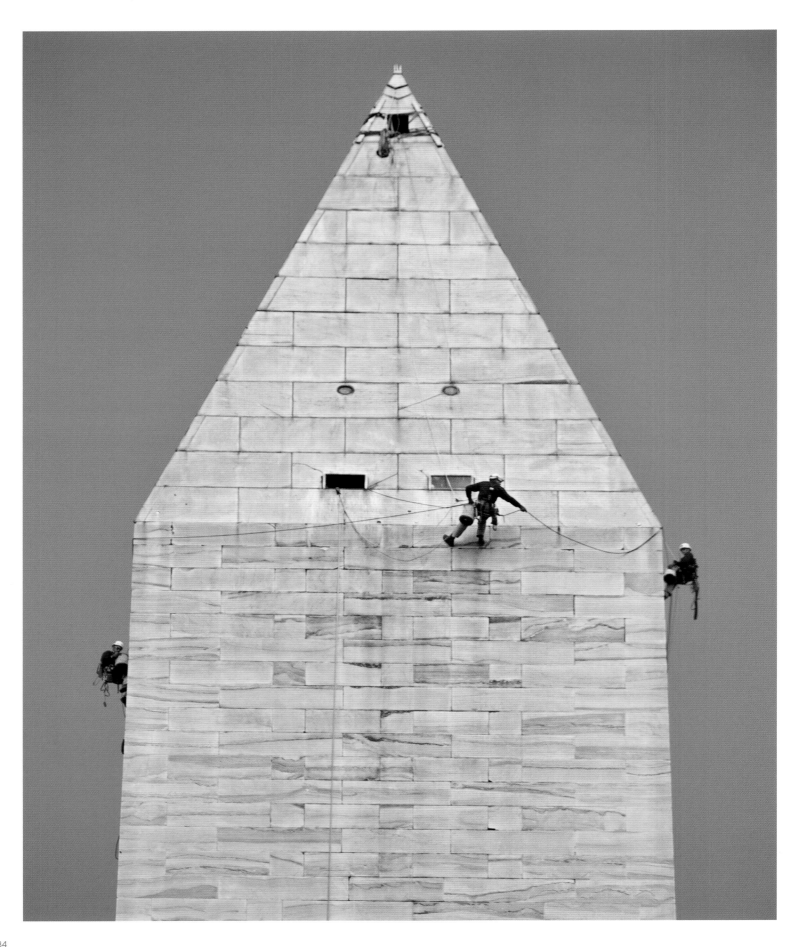

"I lined up this shot dead center so I could capture the workers on both sides and include the little window they used to crawl out of to do this. I marveled that this was a bit of a thrill to see this iconic monument peppered with three humans. We never see this. They were checking for cracks caused by a 5.8 magnitude earthquake that occurred 84 miles (135 km) southwest of D.C."

KEN CEDENO

OPPOSITE: **REPAIRING WASHINGTON**
Engineers rappel down the Washington Monument as they inspect damage from the August 2011
earthquake that shook the D.C. landmark. *(Ken Cedeno, Washington, D.C.)*

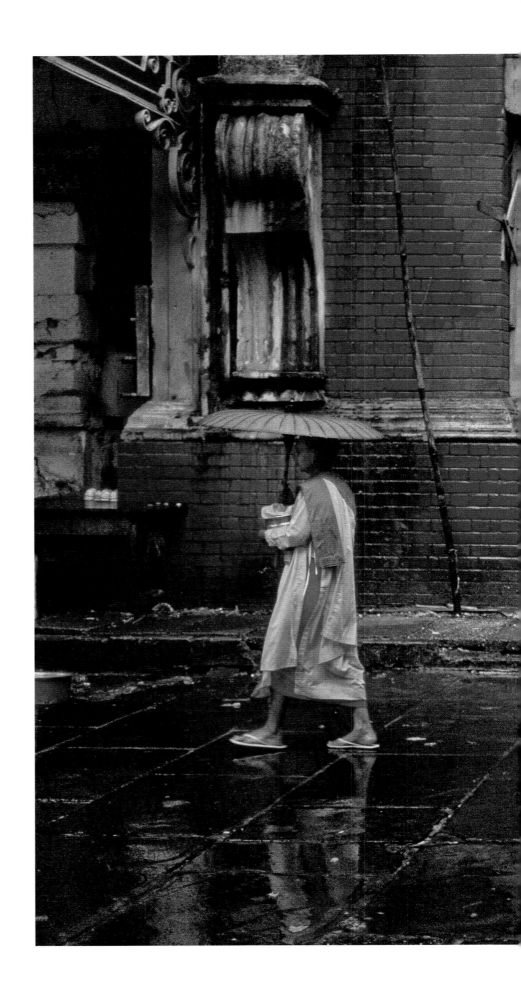

PINK PARADE

Four nuns walk in procession in Rangoon, Myanmar, on a rain-splashed street. These Buddhist nuns make a circuit around the city each day. Given permission to join them, the photographer captured the striking colors of both the nuns' clothing and the bright buildings of this residential area. *(Steve McCurry, Myanmar)*

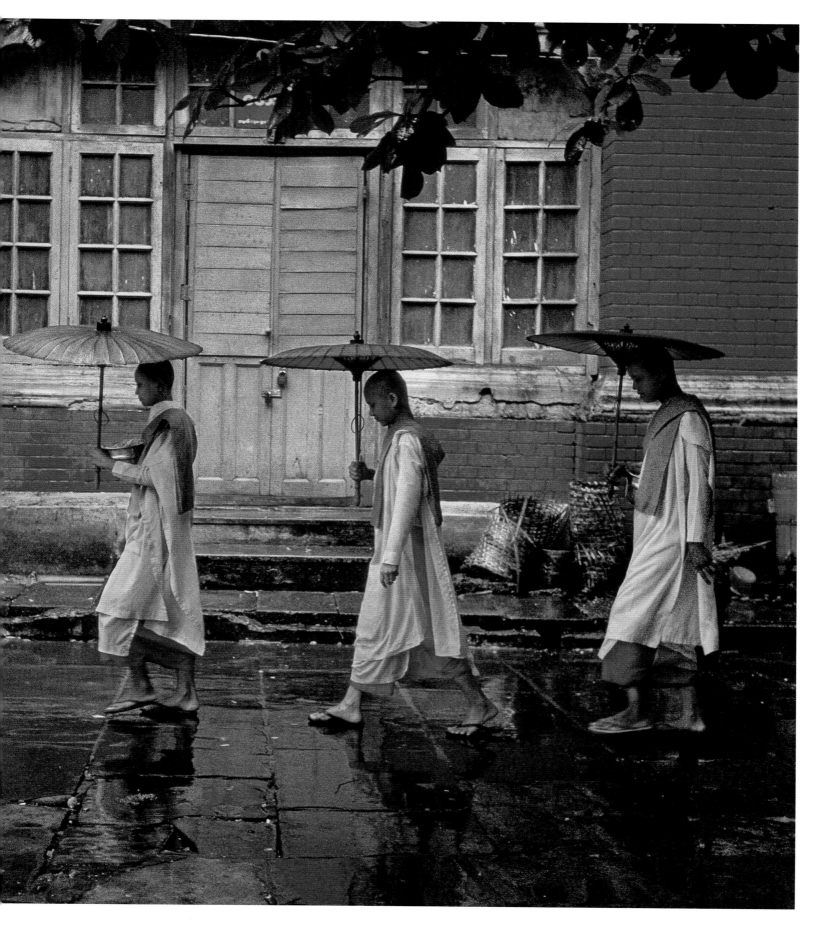

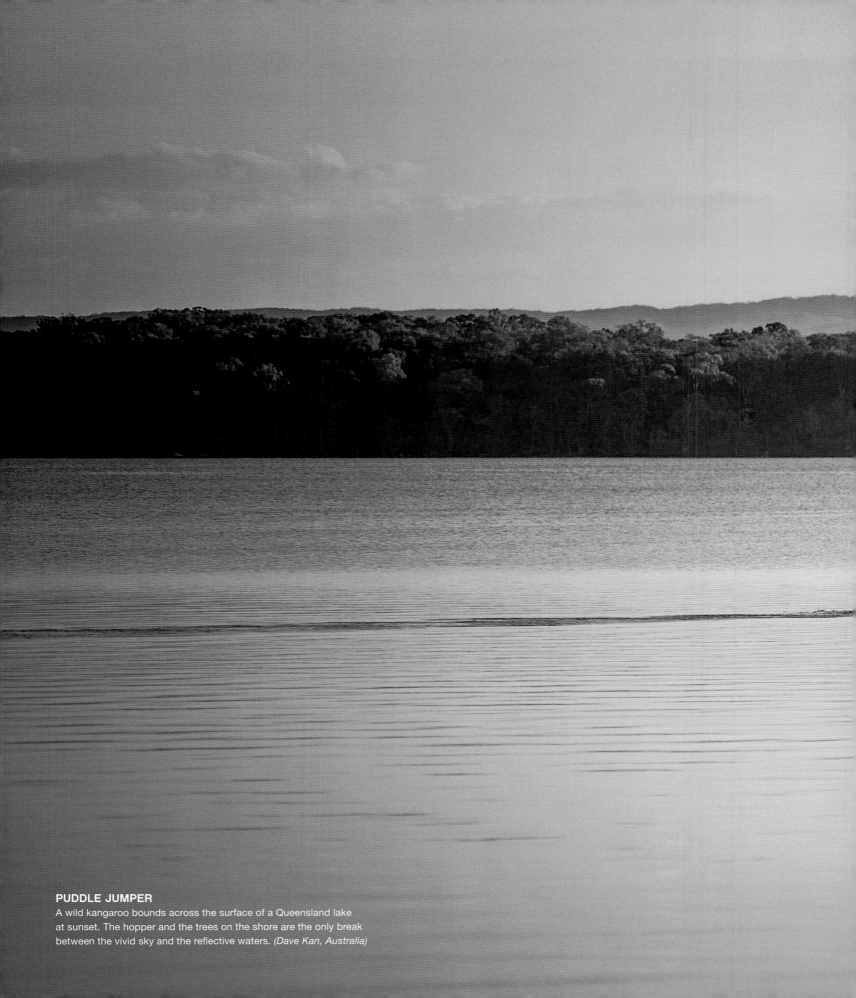

PUDDLE JUMPER
A wild kangaroo bounds across the surface of a Queensland lake
at sunset. The hopper and the trees on the shore are the only break
between the vivid sky and the reflective waters. *(Dave Kan, Australia)*

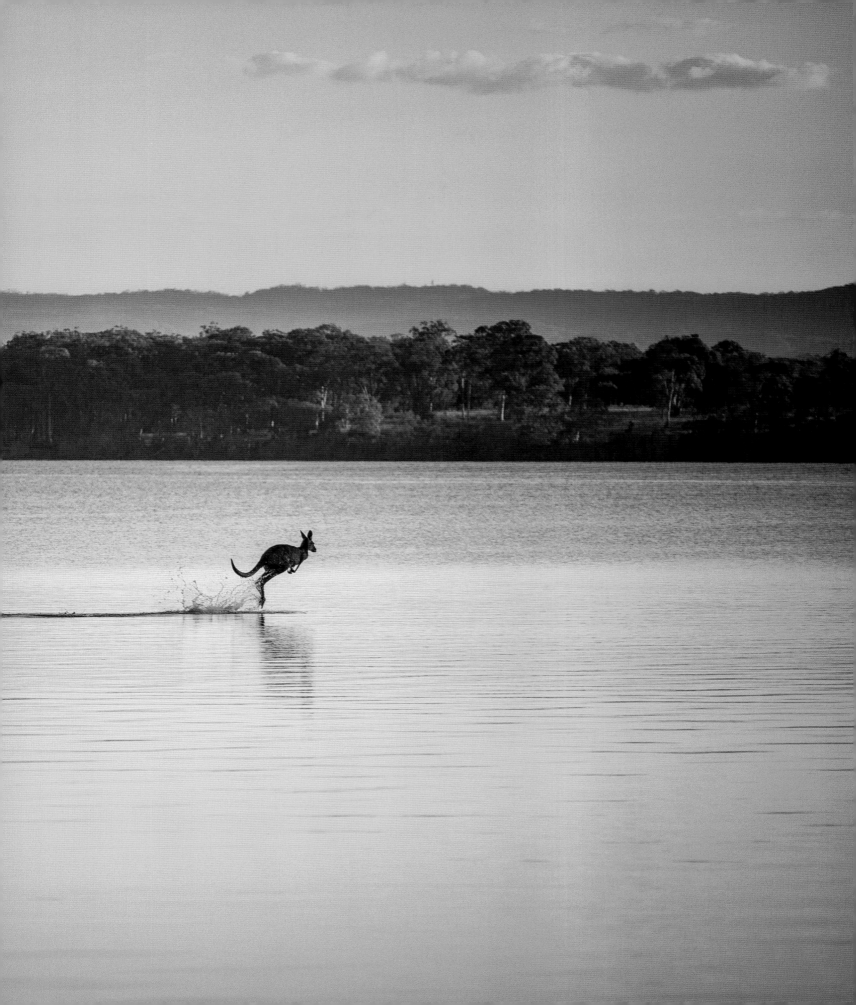

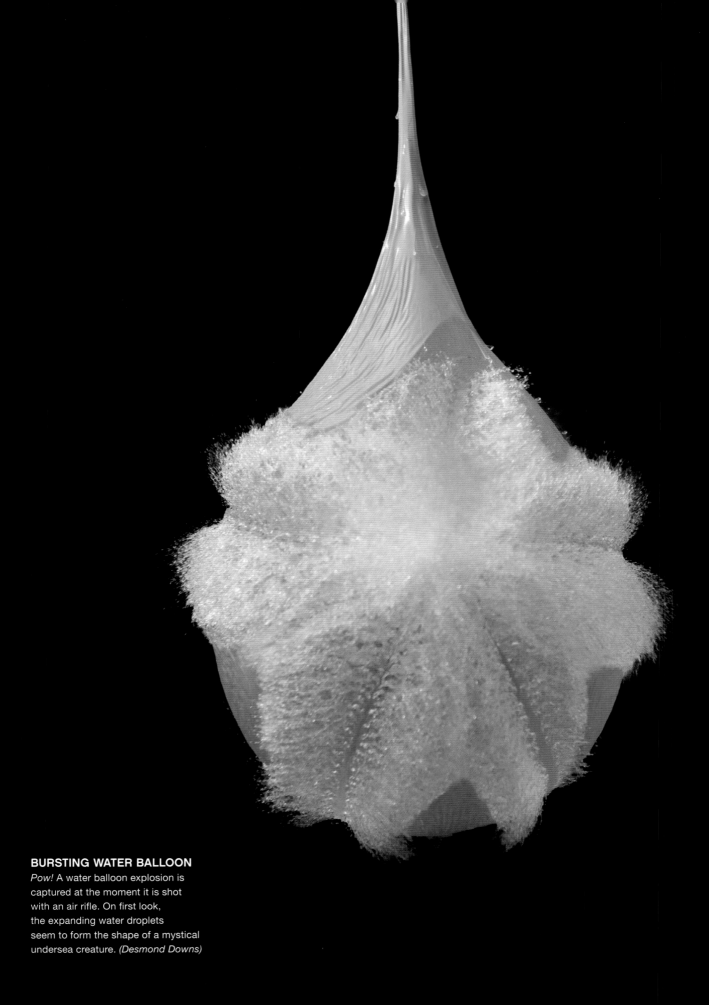

BURSTING WATER BALLOON

Pow! A water balloon explosion is captured at the moment it is shot with an air rifle. On first look, the expanding water droplets seem to form the shape of a mystical undersea creature. *(Desmond Downs)*

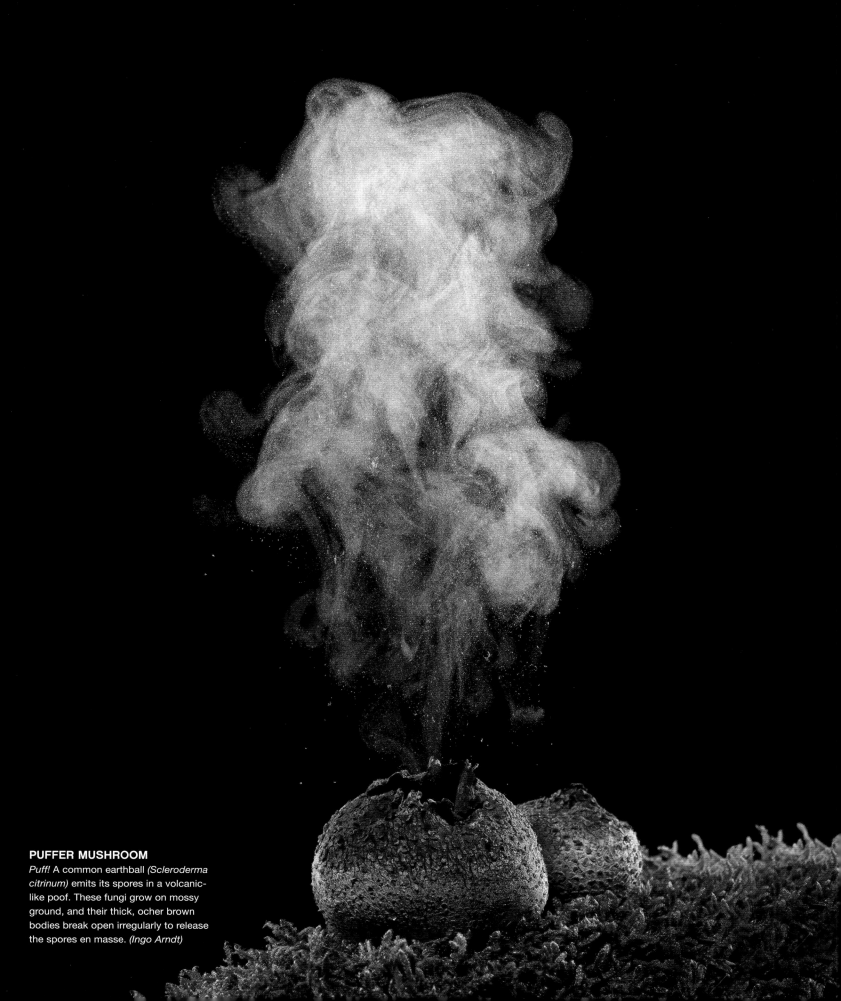

PUFFER MUSHROOM

Puff! A common earthball *(Scleroderma citrinum)* emits its spores in a volcanic-like poof. These fungi grow on mossy ground, and their thick, ocher brown bodies break open irregularly to release the spores en masse. *(Ingo Arndt)*

PENGUIN PAPARAZZI
Ecotourists set up behind orange safety cones to photograph a lone Adélie penguin waddling on the ice in the Weddell Sea, Antarctic Sound. As the photographers maneuver to get the shot, they show our eagerness to document our encounters with nature. *(Sisse Brimberg & Cotton Coulson, Antarctica)*

"People have always documented their leaders with the best technology available, and the Smithsonian collects the results as sculptures, paintings, and photographs in the National Portrait Gallery. We added a new twist to the genre by creating the first 3-D–printed portrait of a sitting president based on the accurate measurements derived from the 80 photographs taken by Dr. Paul Debevec's Mobile Light Stage, shipped all the way from the University of Southern California for the historic occasion."

GÜNTER WAIBEL

DIRECTOR OF THE SMITHSONIAN'S DIGITIZATION PROGRAM OFFICE

OPPOSITE: **PRESIDENT OBAMA SITS FOR HIS 3-D PORTRAIT**
Inspired by a life mask of Lincoln, the Smithsonian Institution asked President Obama to be the first
American president to pose for a 3-D portrait. The data were used to create a 3-D bust. *(Pete Souza, Washington, D.C.)*

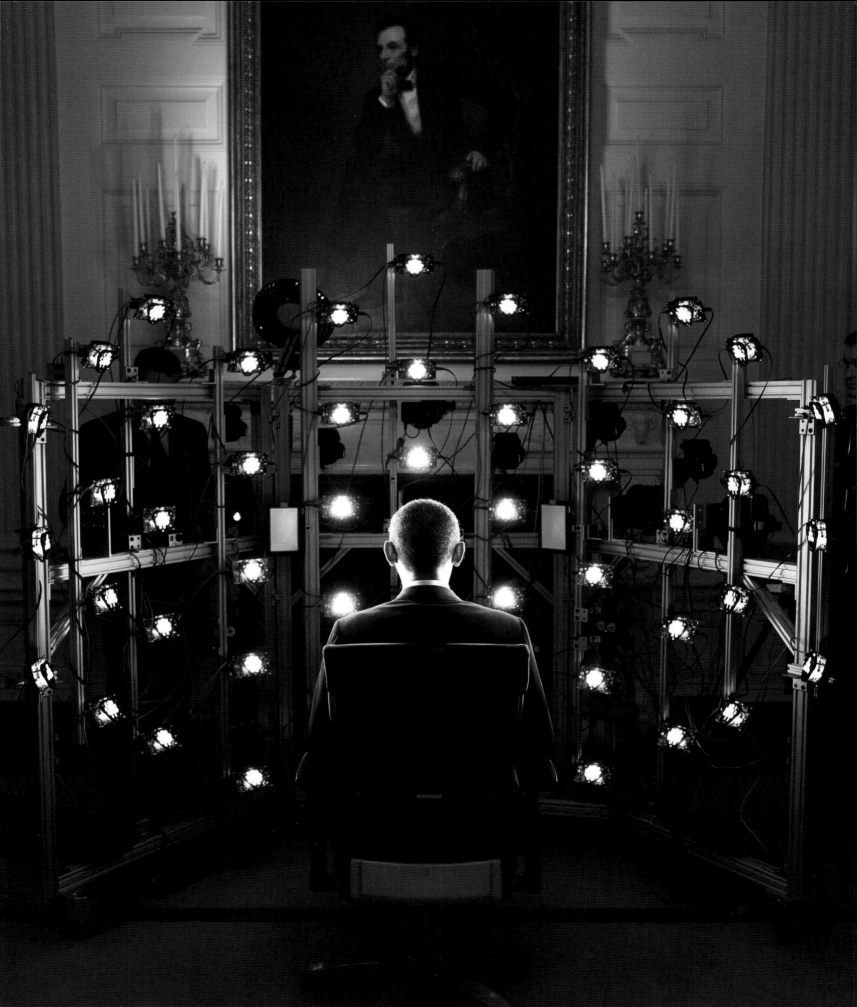

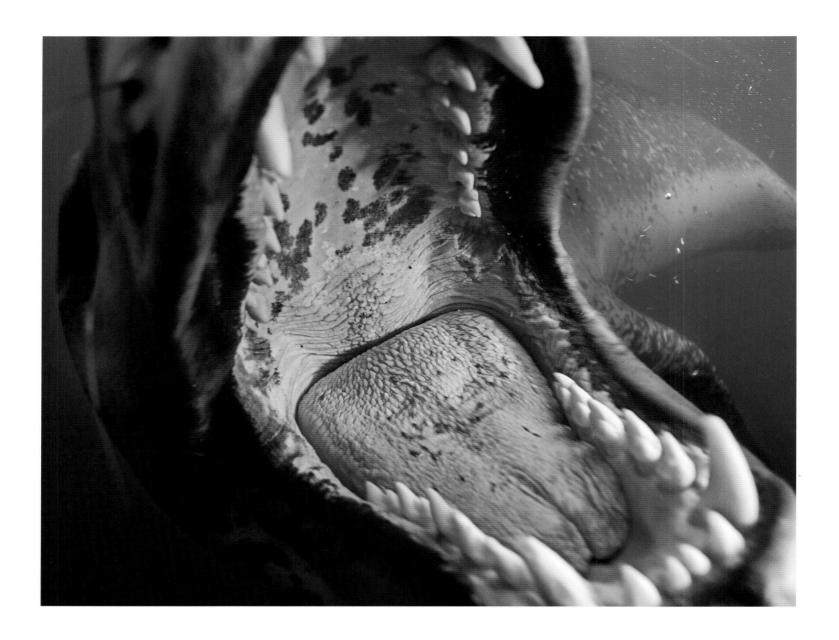

JAW BREAKER

The speckled mouth of a leopard seal opens wide to show off
the predator's sharp, powerful teeth. Luckily for this photographer,
this seal flashed its teeth only in warning. These massive seals,
native to Antarctica, can weigh more than 1,000 pounds (450 kg).
(Paul Nicklen, Antarctica)

HELLO WORLD

It may look like a scene from *Jurassic Park*, but this hatchling is a baby crocodile breaking free during a hatching festival at a zoo east of Bangkok. An egg tooth on its upper jaw aids in breaking free. The zoo is home to some 100,000 crocodiles. *(Sukree Sukplang, Thailand)*

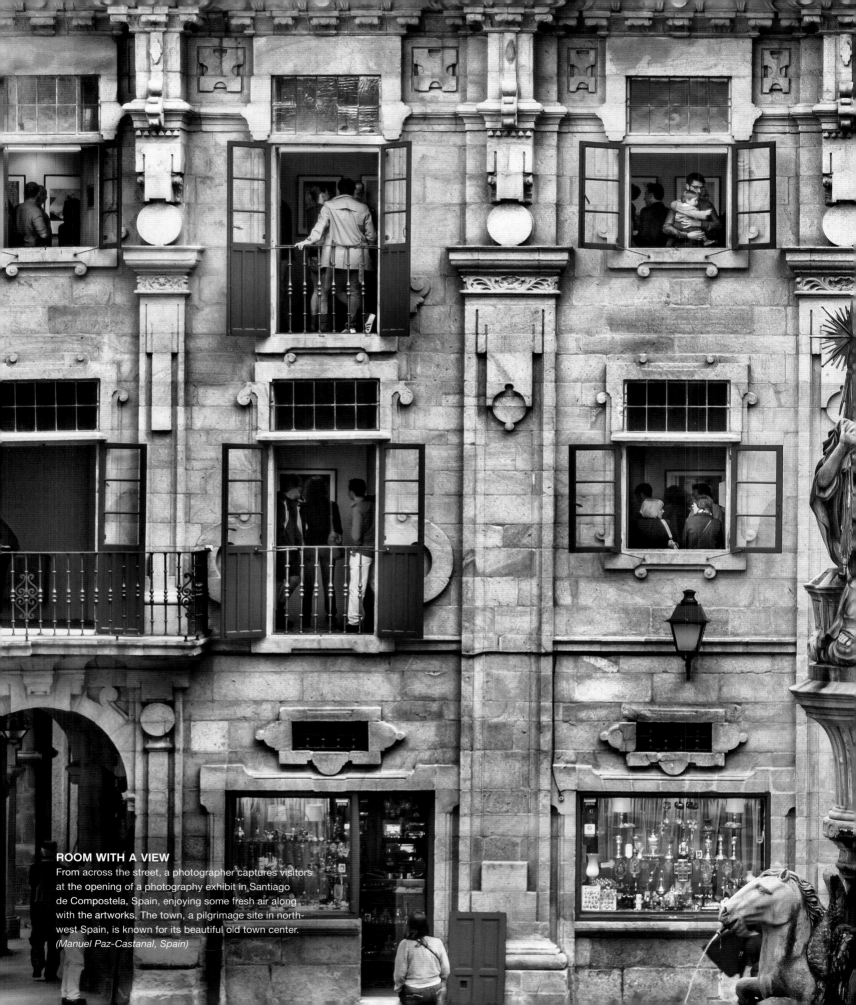

ROOM WITH A VIEW
From across the street, a photographer captures visitors at the opening of a photography exhibit in Santiago de Compostela, Spain, enjoying some fresh air along with the artworks. The town, a pilgrimage site in north-west Spain, is known for its beautiful old town center.
(Manuel Paz-Castanal, Spain)

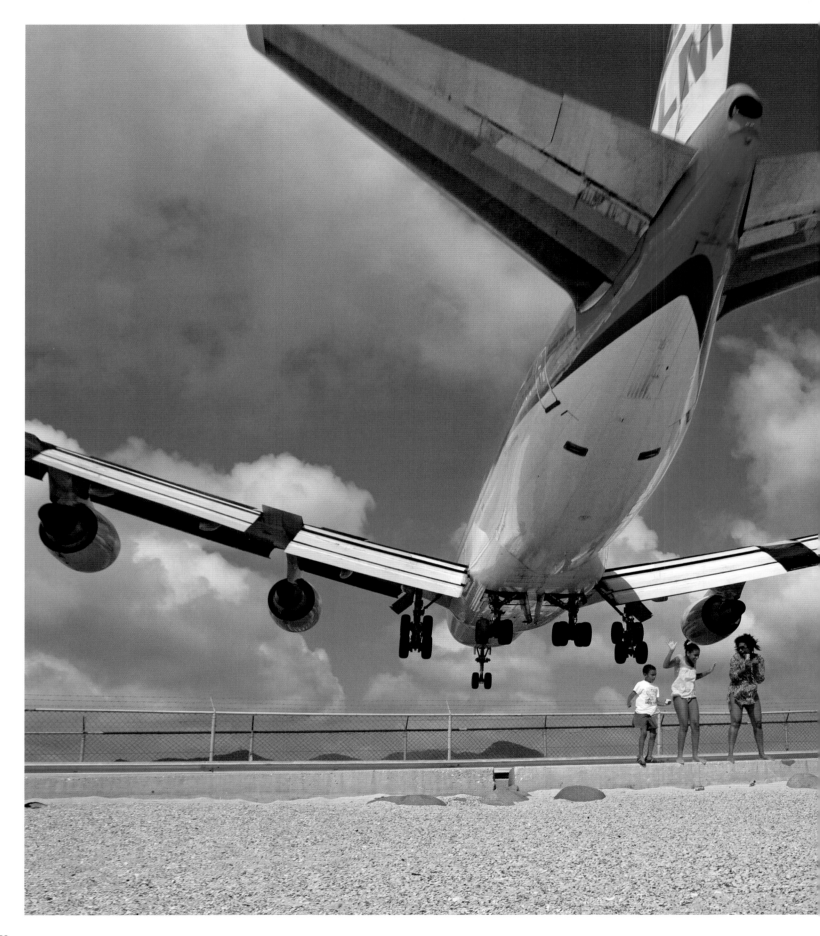

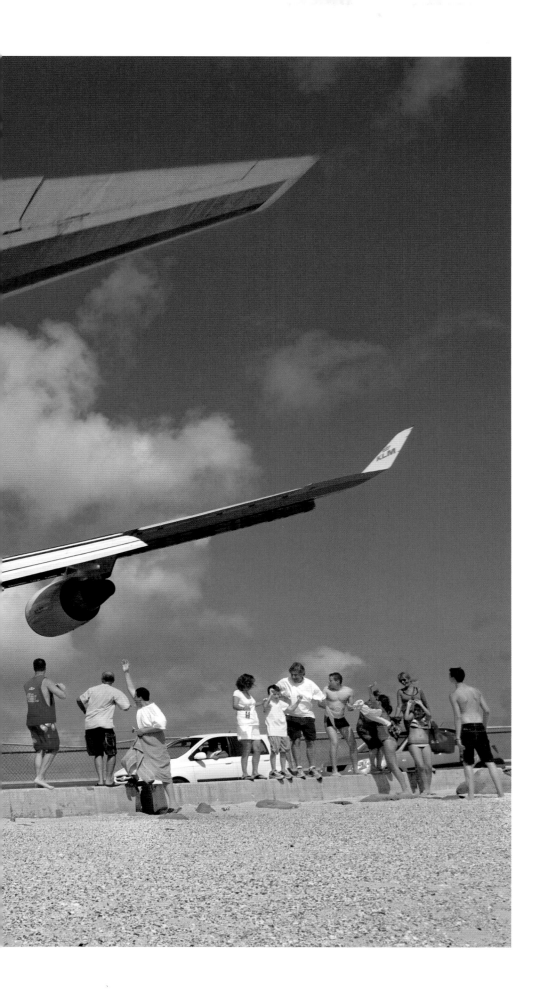

HEADS UP

A Boeing 747 comes in for a landing on the small Caribbean island of St. Martin. Planes fly directly over Maho Beach and give visitors and plane-spotters a thrill as the jets fly almost too close for comfort above this sun-kissed tourist destination. *(Fabi Fliervoet, St. Martin)*

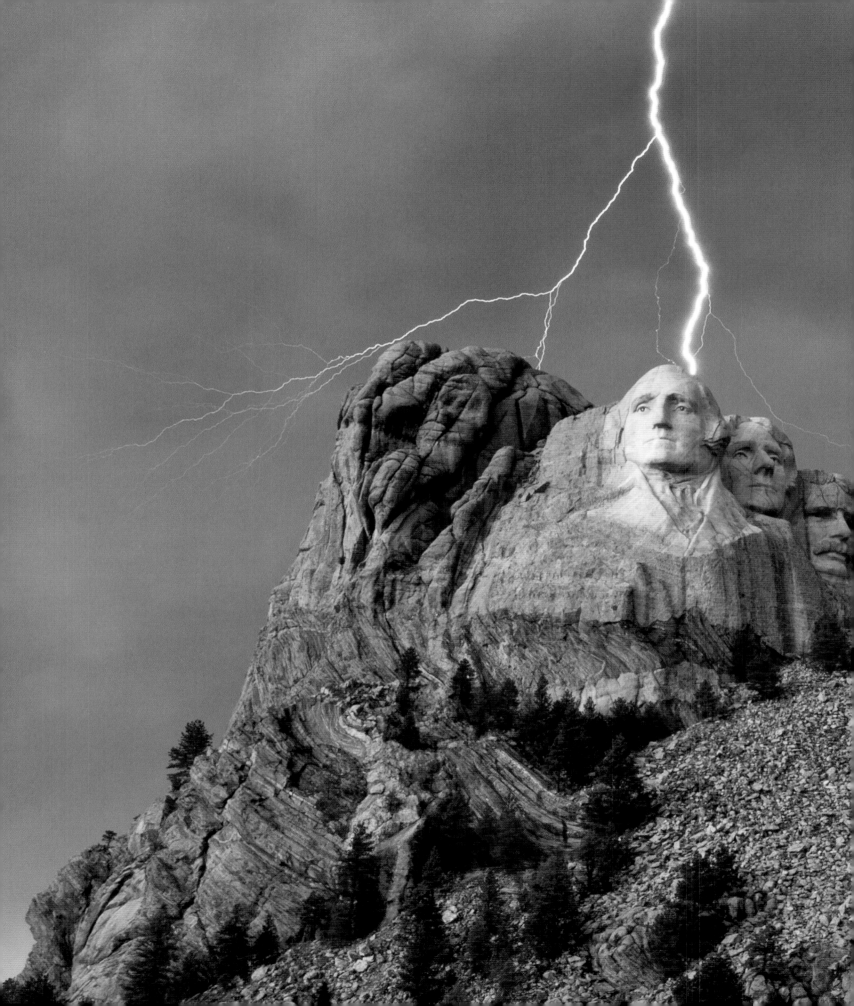

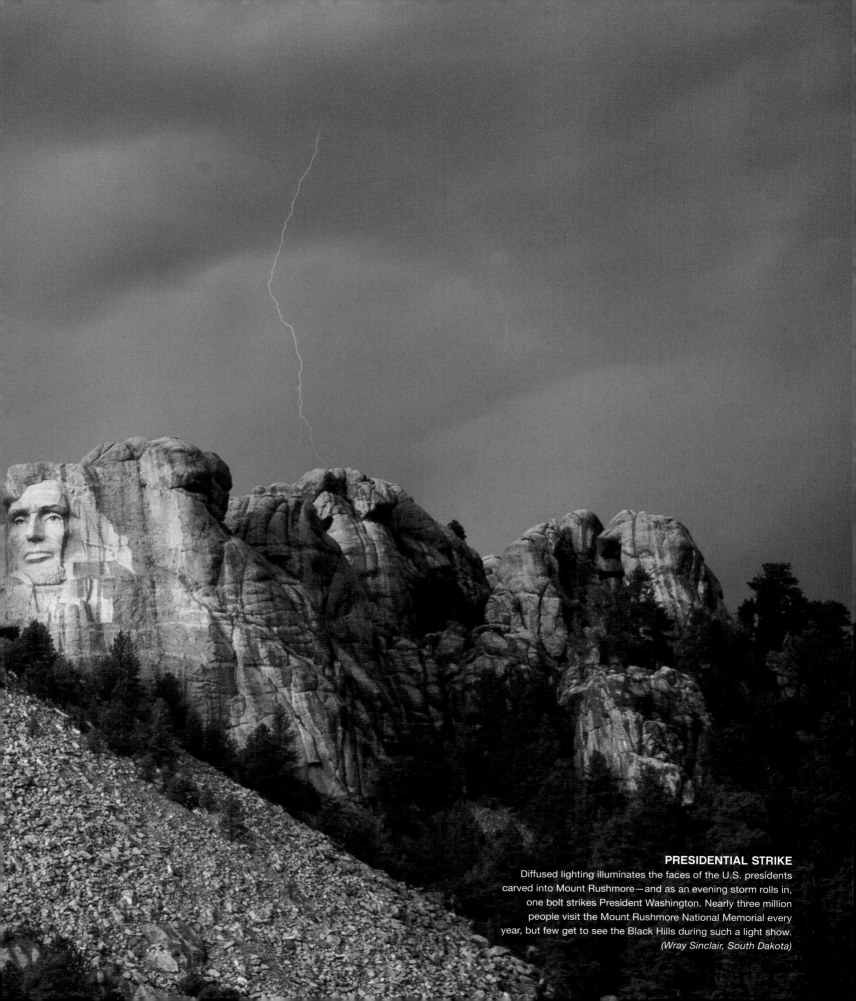

PRESIDENTIAL STRIKE
Diffused lighting illuminates the faces of the U.S. presidents carved into Mount Rushmore—and as an evening storm rolls in, one bolt strikes President Washington. Nearly three million people visit the Mount Rushmore National Memorial every year, but few get to see the Black Hills during such a light show.
(Wray Sinclair, South Dakota)

SELFIE WITH THE POPE

A young girl includes Pope Francis in her selfie. The charismatic pontiff is known for stopping for such portraits, almost always with a younger admirer. The first Jesuit and the first Latin American pope, Pope Francis took his name from St. Francis of Assisi, champion of the poor. *(Dave Yoder, Vatican City)*

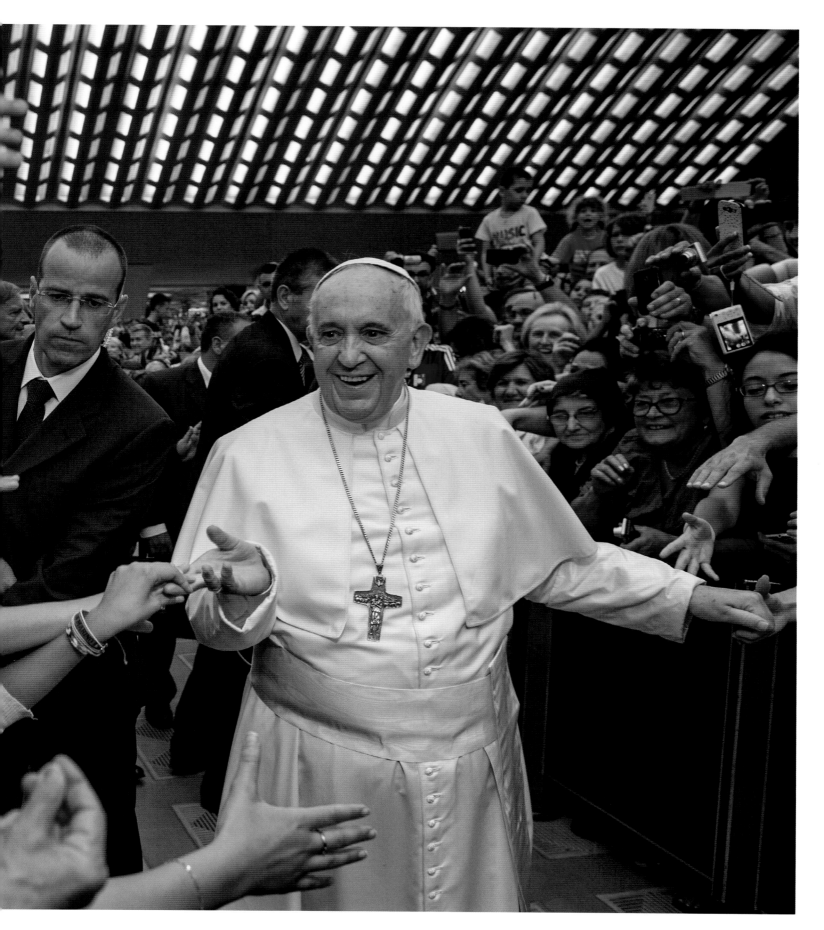

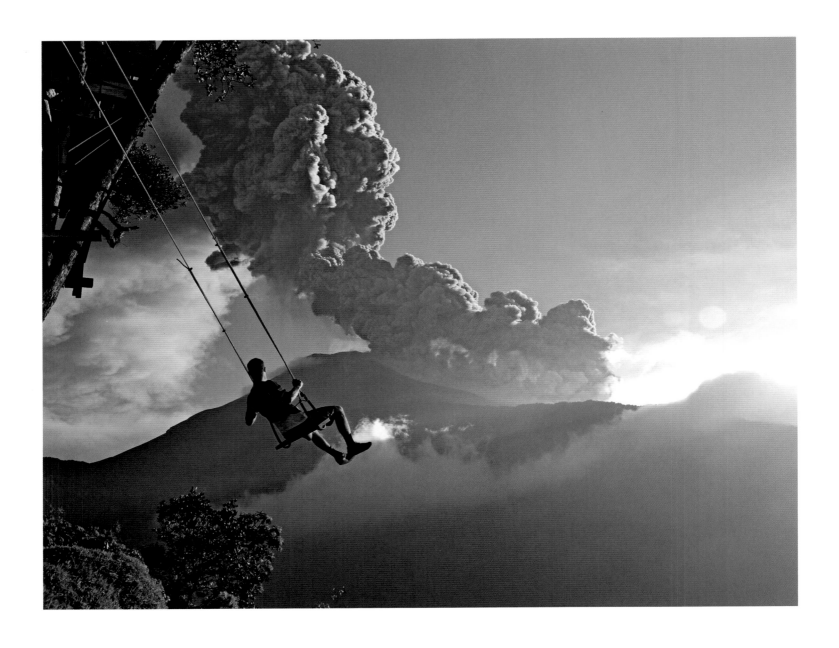

END OF THE WORLD SWING

A man swings out over a cliff-side abyss on a swing,
aptly named the "end of the world," in Baños, Ecuador,
as Mount Tungurahua spews ash miles high during a February
2014 eruption. Just minutes after this photo was taken,
an incoming ash cloud from the stratovolcano caused
the swingers to evacuate. *(Sean Hacker Teper, Ecuador)*

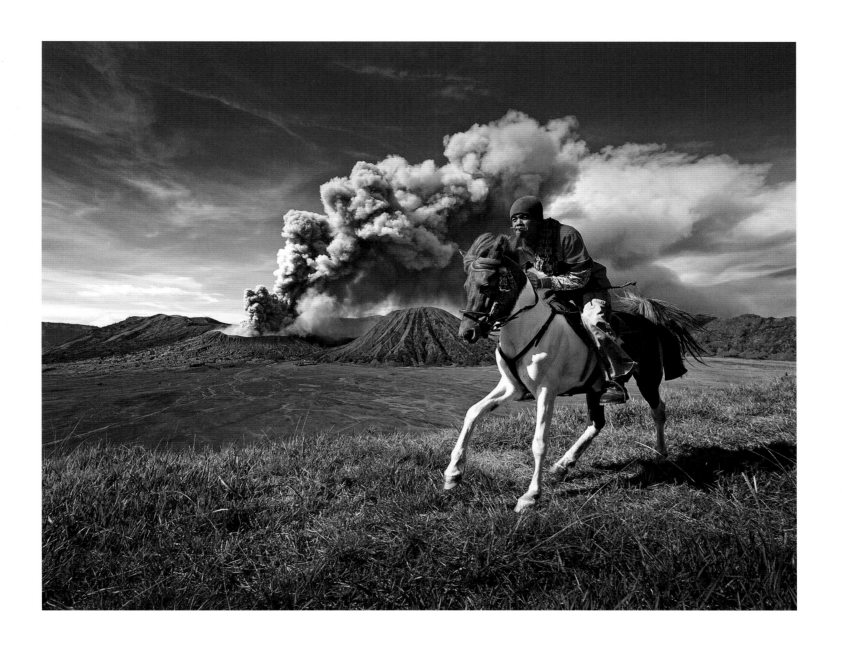

RACING AN ERUPTION

Located in an active seismic zone, Mount Bromo in the Tengger caldera on the island of Java was just getting started in November 2010, when this shot was taken. The horseman races away from spewing ash and gases, which continued to pour out into the middle of 2012. *(Yaman Ibrahim, Indonesia)*

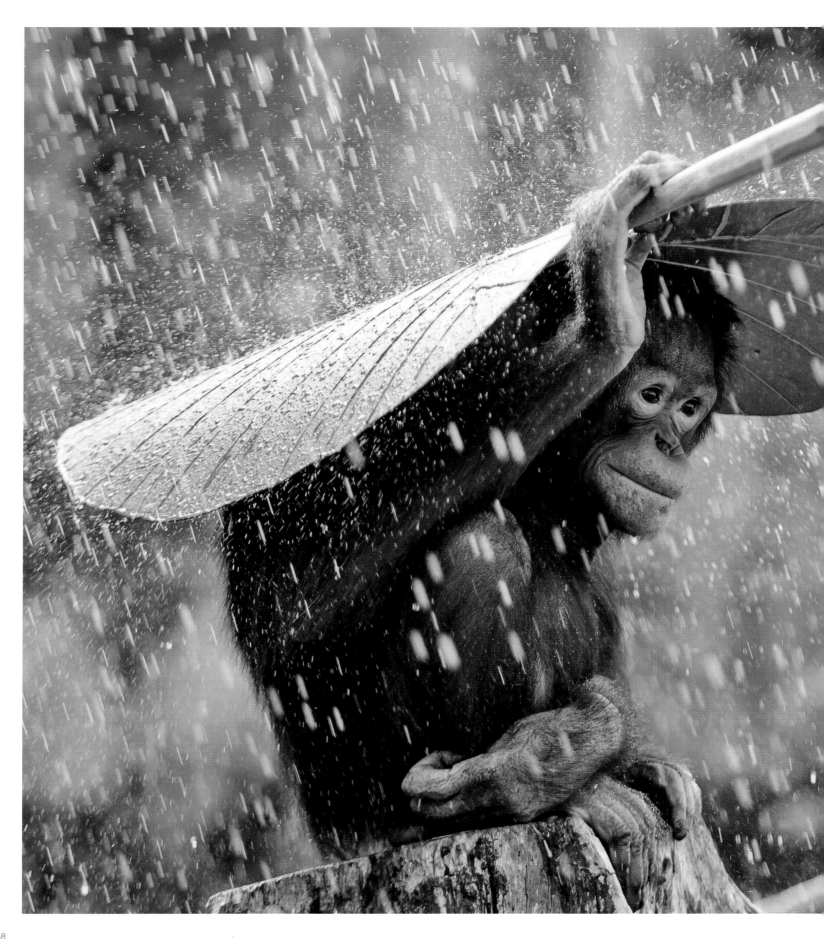

RAIN, RAIN, GO AWAY

An orangutan creates an umbrella out of a banana leaf to hide from the rain in Bali, Indonesia. Wild populations of the endangered primate are under threat from habitat destruction, as their natural ranges are being destroyed for agriculture and timber harvests. *(Andrew Suryono, Indonesia)*

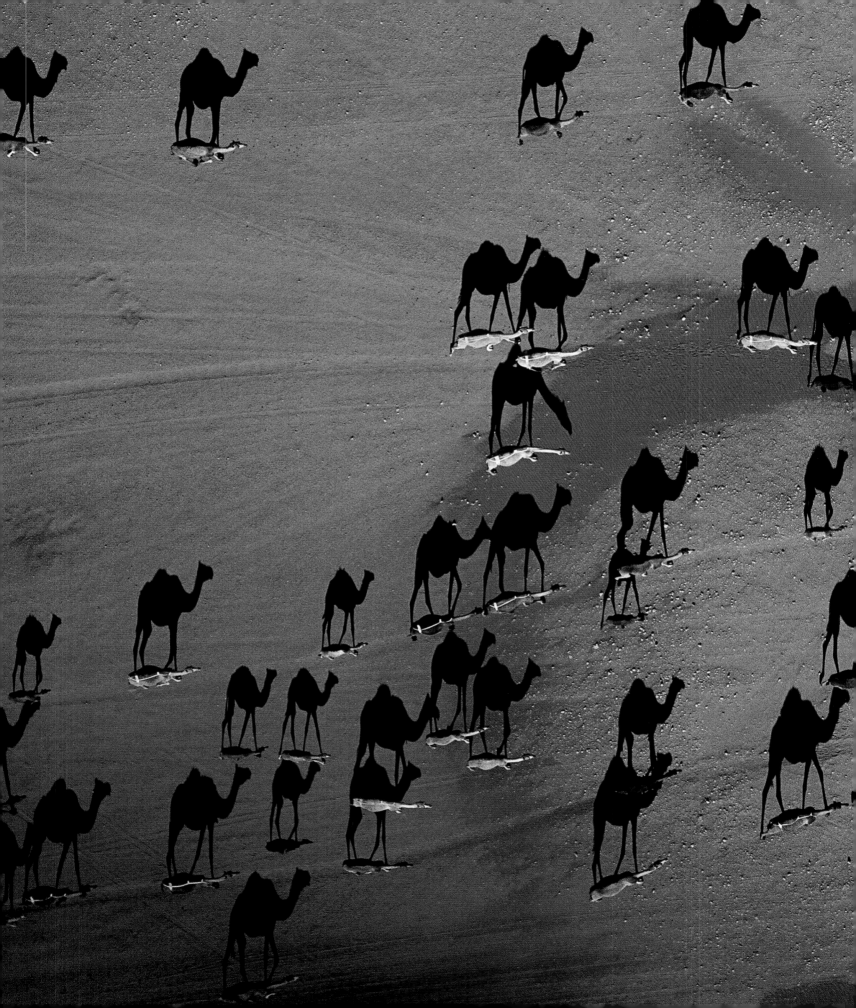

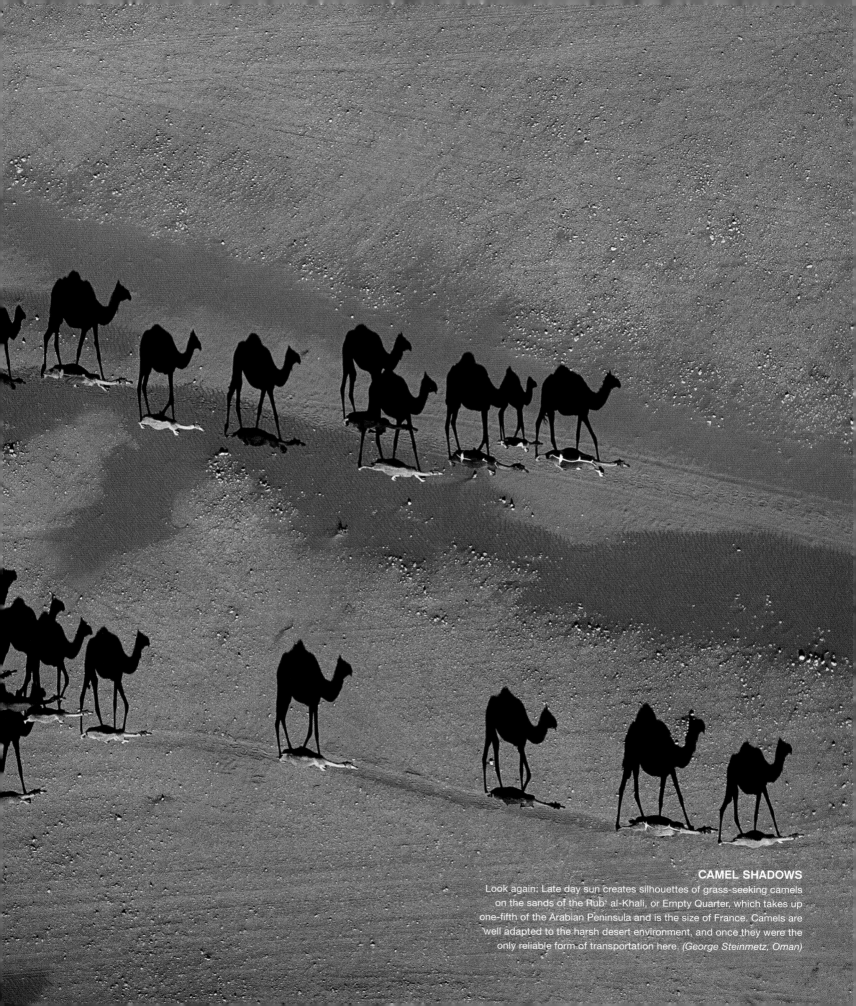

CAMEL SHADOWS
Look again: Late day sun creates silhouettes of grass-seeking camels on the sands of the Rub' al-Khali, or Empty Quarter, which takes up one-fifth of the Arabian Peninsula and is the size of France. Camels are well adapted to the harsh desert environment, and once they were the only reliable form of transportation here. *(George Steinmetz, Oman)*

"In the end of December 2012, great white egrets gathered in an ice-free lake in the Pusztaszeri Landscape Protection Area in Hungary. The blind I was sitting in was built halfway underwater with a semipermeable glass in front, making it possible to photograph the fishing birds from close proximity and a frog's perspective. This image shows prey in the solid, knifelike bill of the bird after a successful catch."

ERLEND HAARBERG

OPPOSITE: **EGRET EATING**
A great white egret's bill mimics a sharp pair of chopsticks as it snags a fish from the water. *(Erlend Haarberg, Hungary)*

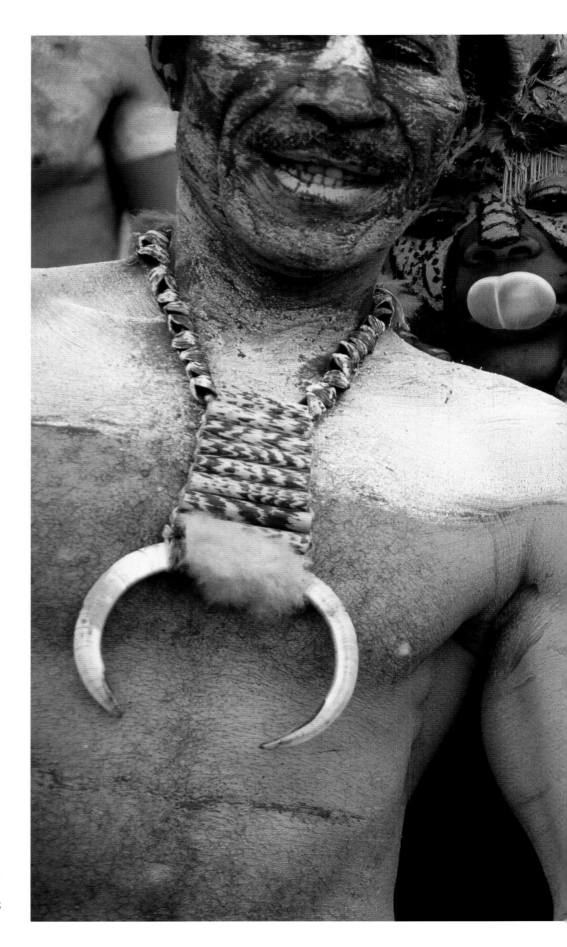

BLOWING BUBBLES

Bubblegum brings a surprisingly modern touch to the Highlands Festival—a large annual gathering of tribal communities in the town of Mount Hagen, Papua New Guinea. More than 20,000 competitors present authentic costumes, dances, and chants to the judges. These two boys made sure to pop their bubblegum only during a break. *(Cristina Mittermeier, Papua New Guinea)*

STUCK IN THE MIDDLE

A hot-air balloon hangs between two columns of an iceberg near Arctic Bay, Nunavut, Canada. The balloon creates a shocking splash of color in the strikingly white and blue abyss of the Arctic. A tourist and his family used the balloon and two helicopters to experience once-in-a-lifetime views of the Arctic. *(Michelle Valberg, Arctic)*

LOOKING FOR A SIGNAL
Impoverished African migrants crowd the shore of Djibouti, trying
to capture inexpensive cell signals from neighboring Somalia—
a tenuous link to relatives abroad. Migrants, mostly young men,
travel through Djibouti often in the hope of reaching Saudi Arabia
for well-paying work. *(John Stanmeyer, Djibouti)*

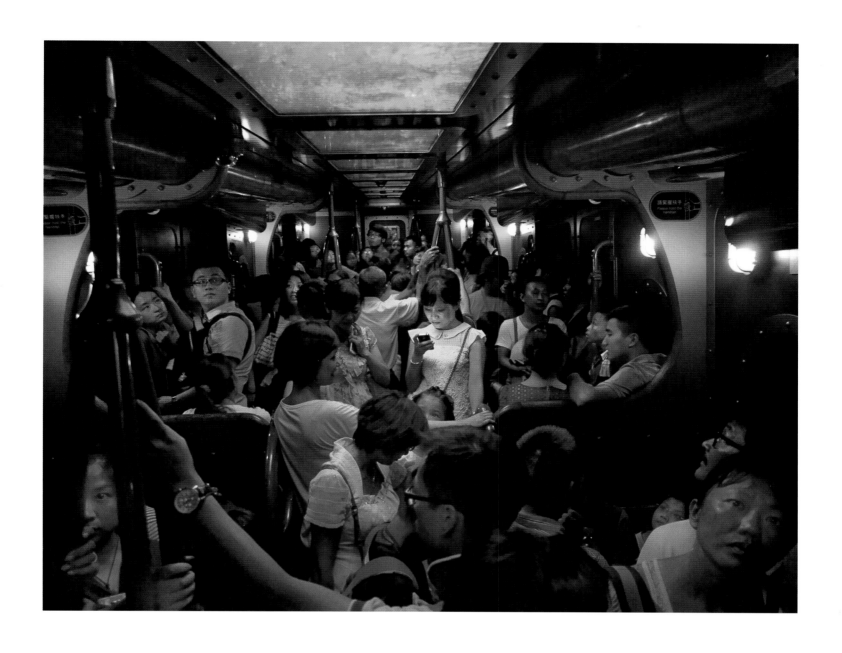

MISSED CONNECTION
A cell phone offers a moment of solitary reflection for this passenger, sandwiched in a packed train. In our wired world, the warm glow from a phone can be an escape from the physical confines of the train car, helping you focus your attention elsewhere. *(Brian Yen, Hong Kong)*

PRONKING BOK

A springbok takes flight in the tall grass of South Africa's Mountain Zebra National Park. The acrobatic antelope jumps up in the air with an arched back, in a display of grace known as pronking. The medium-size antelope pronks to attract a mate or ward off a predator, or as an impromptu celebration over finding tasty grass. *(Charles Jorgensen, South Africa)*

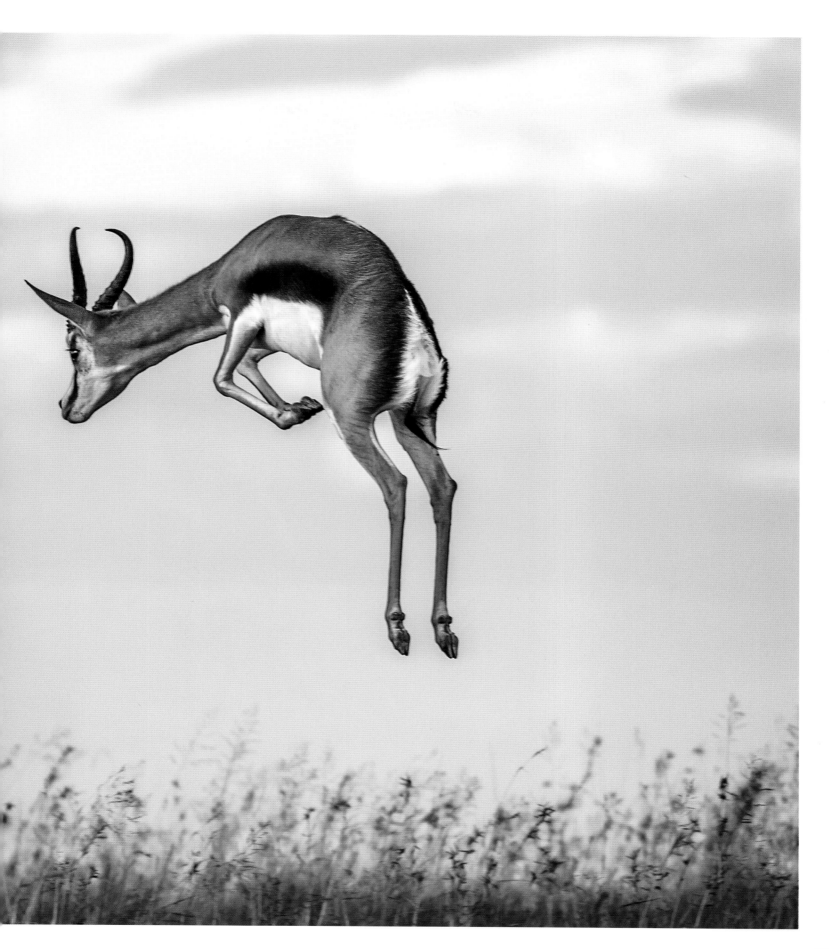

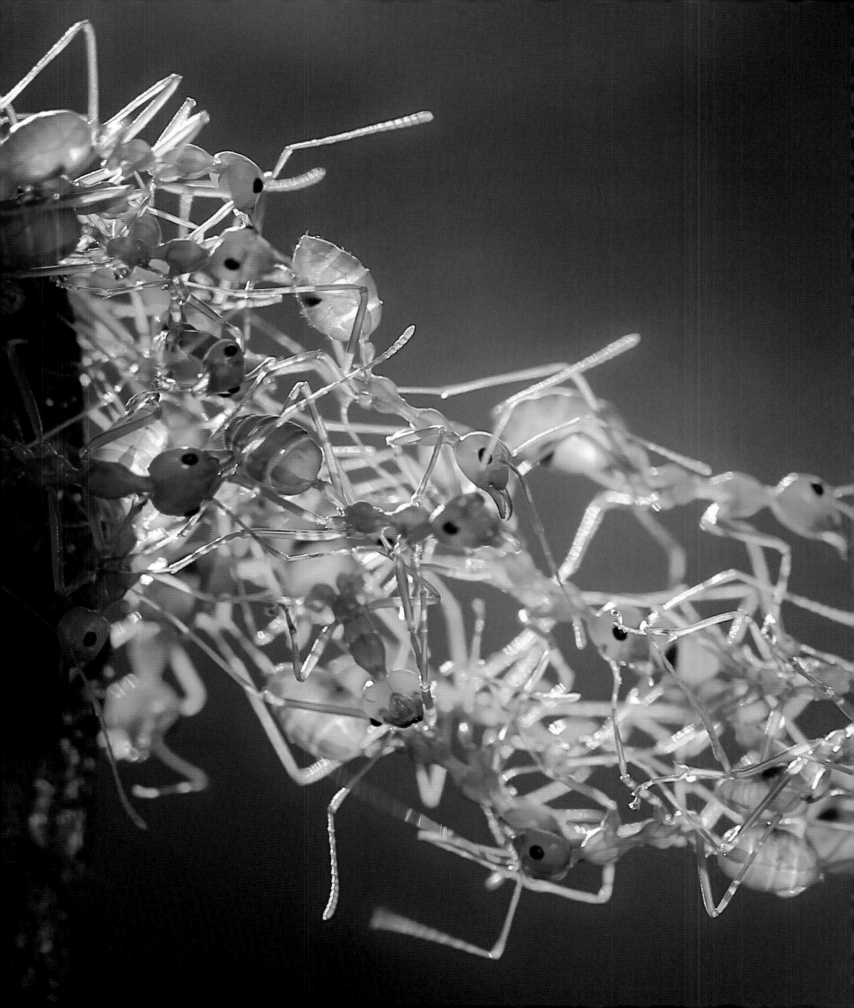

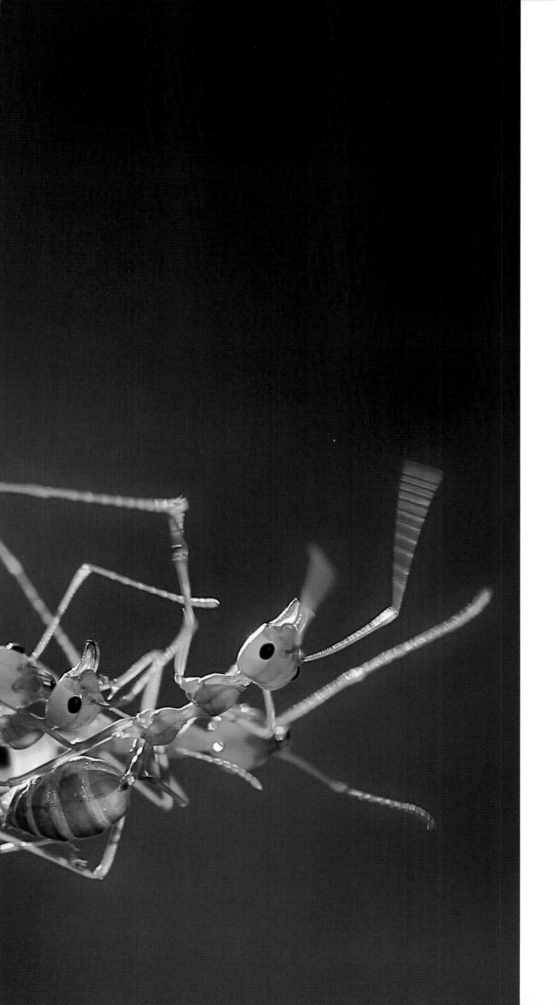

ANTS GO BRIDGING
Worker ants stretch out to build a bridge by climbing on top of one another. These ants were attempting to reach higher branches and thus more food. Because they are backlit by the sun, the ants' translucency shines through. *(Adhi Prayoga, Indonesia)*

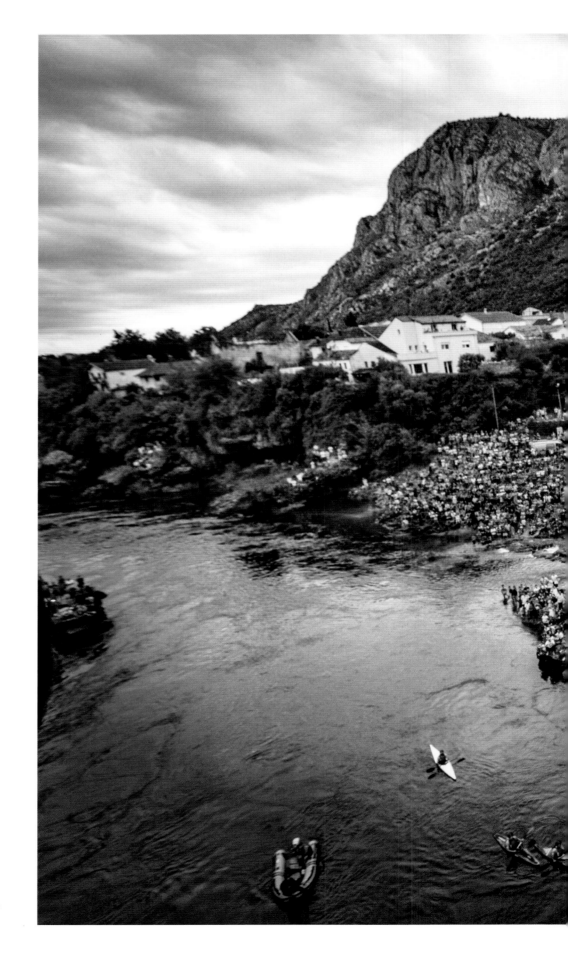

HIGH DIVE

Lorens Listo takes flight with a jump off the Old Bridge (or Stari Most) in Mostar, Bosnia and Herzegovina. Diving competitions have been held here since the bridge was built in A.D. 447. Divers plummet some 79 feet (24 m) into the Neretva River below. *(Haris Begić, Bosnia and Herzegovina)*

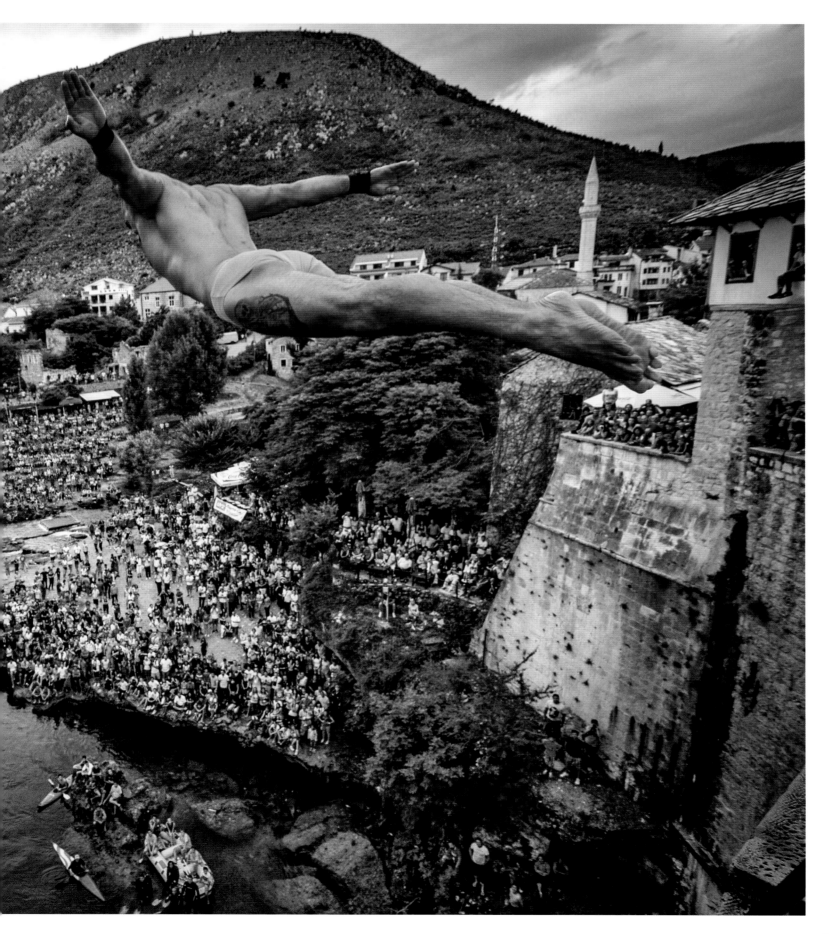

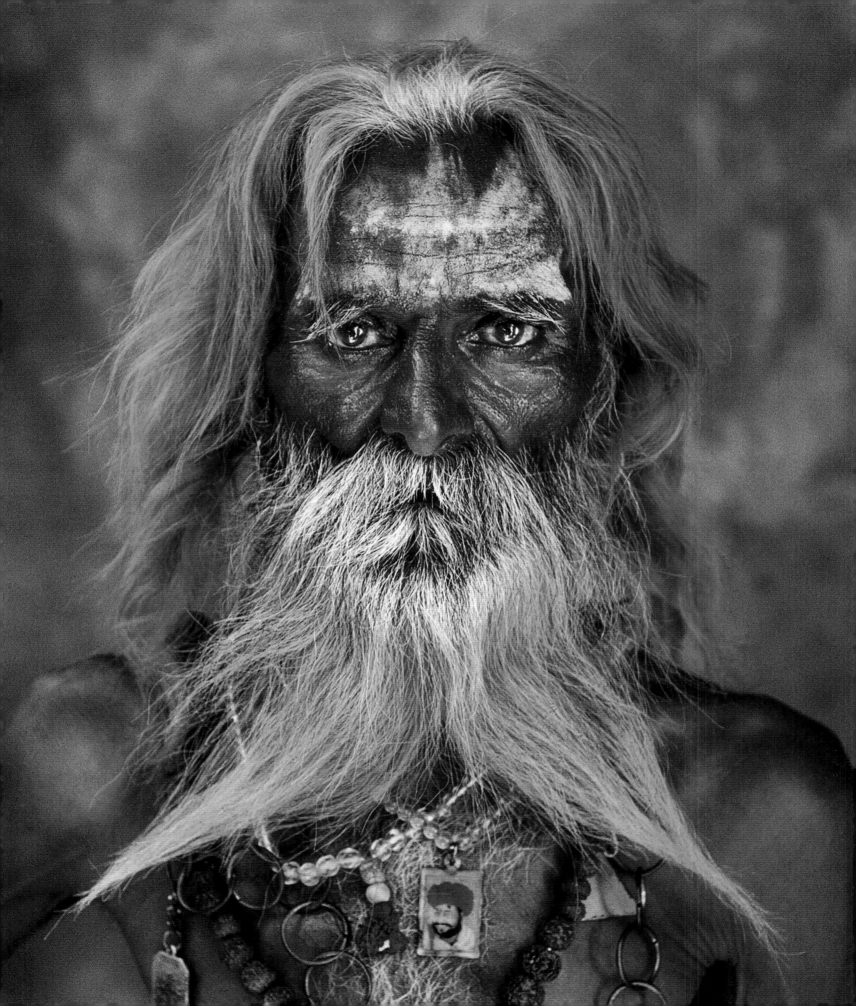

"The color in Kodachrome film was sublime—rich but not garish, it was the best rendition of reality. So when I realized that this was coming to an end, I wanted to write the last chapter of my working with Kodachrome. When you only have 36 frames, you want to make each one special, and each picture has to count."

STEVE MCCURRY

OPPOSITE: **LAST ROLL OF KODACHROME**
A Rabari tribal elder poses for a portrait, taken on the last roll of Kodachrome film ever processed. *(Steve McCurry, India)*

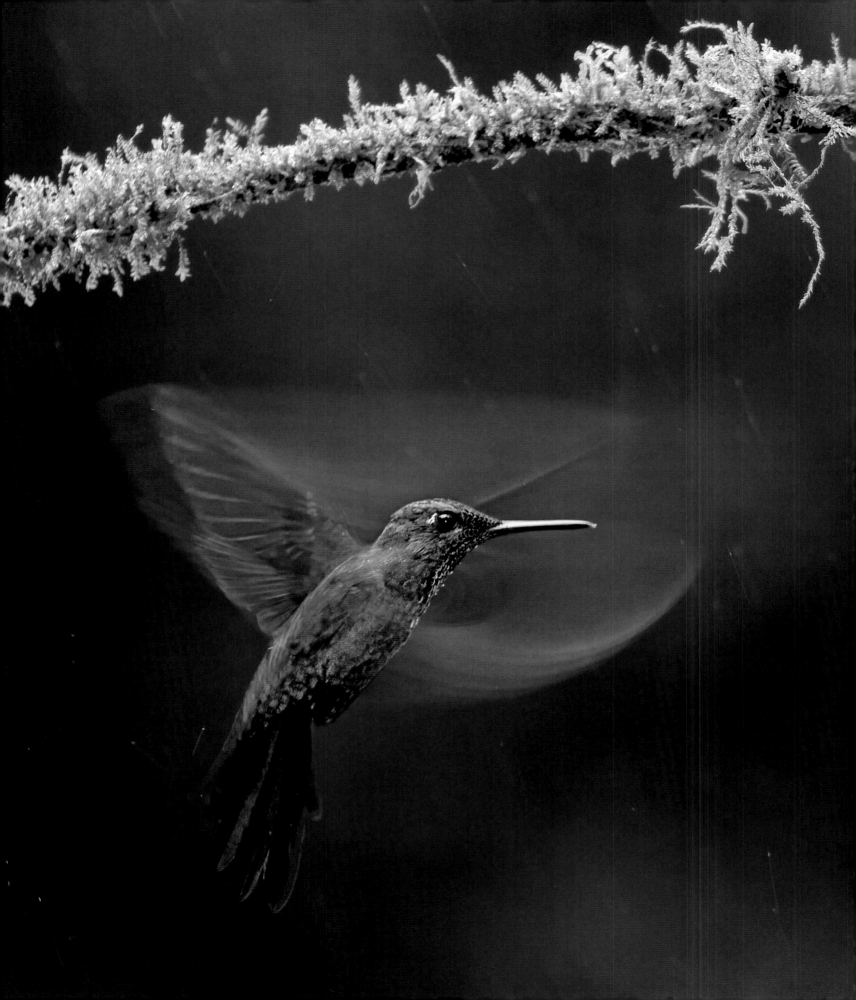

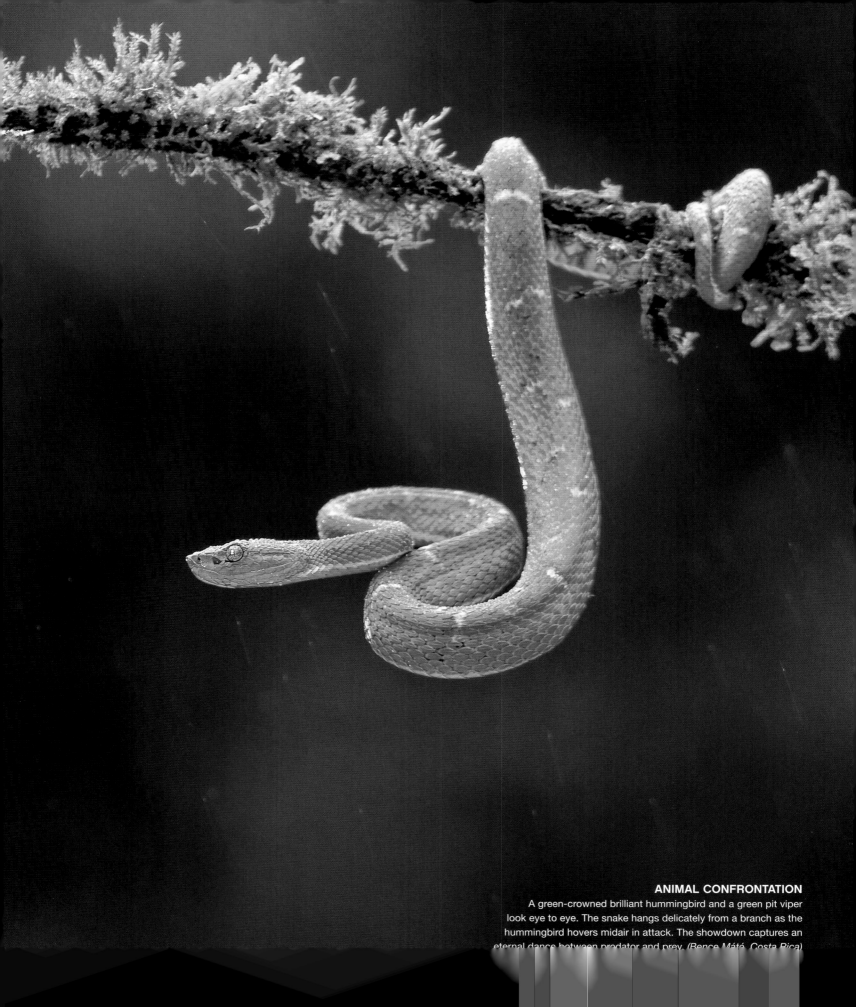

ANIMAL CONFRONTATION

A green-crowned brilliant hummingbird and a green pit viper look eye to eye. The snake hangs delicately from a branch as the hummingbird hovers midair in attack. The showdown captures an eternal dance between predator and prey. (Bence Máté, Costa Rica)

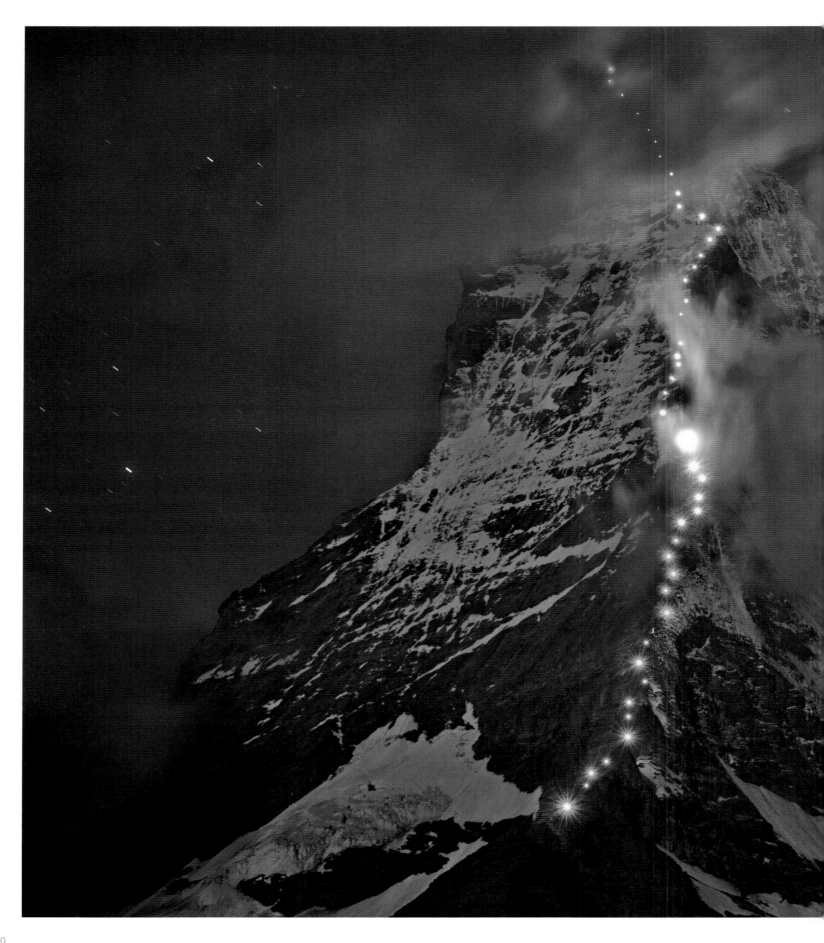

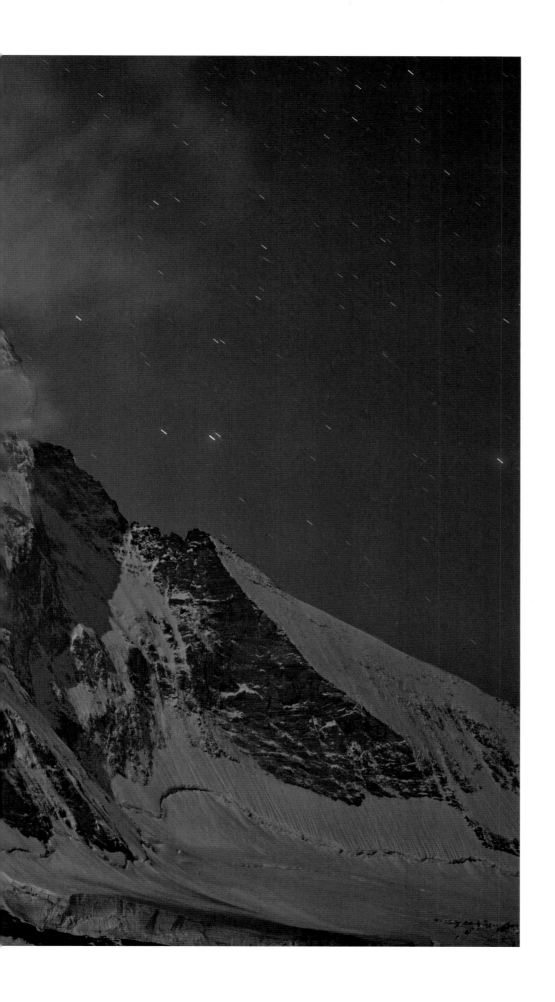

MATTERHORN LIGHTS

To celebrate the 150th anniversary of the first ascent of the Matterhorn, Mammut and Zermatt mountain guides climb the Hörnli Ridge with red lights to illuminate Edward Whymper's 1865 path. Clouds obscure the summit of the Matterhorn, a peak that straddles the border between Italy and Switzerland at 14,692 feet (4,478 m).

(Robert Boesch, Switzerland)

GONNA GET YOU

Lily, a California sea lion at Seneca Park Zoo in Rochester, New York, easily catches her dinner. Lily was found stranded on a beach in Los Angeles County, California. These sea lions usually prefer just a few fish species from their home waters, but they will feed on a variety of prey. *(Wayne Panepinto, New York)*

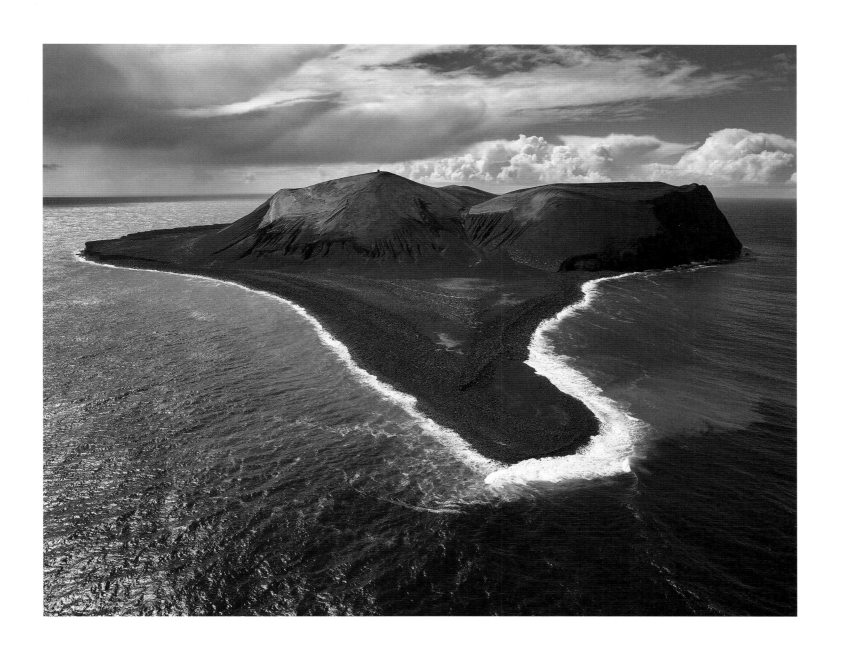

THE BIRTH OF AN ISLAND

In 1963, a cook aboard a trawler noticed black smoke rising from the water as the crew sailed across the Atlantic Ocean. As they investigated, a new island—Surtsey, off the south coast of Iceland—greeted the world. It took three and a half years of undersea volcanic eruptions to form the island, giving scientists the chance to study colonization patterns. The island now harbors fungi, vascular plants, and birds. *(Arctic-Images, Atlantic Ocean)*

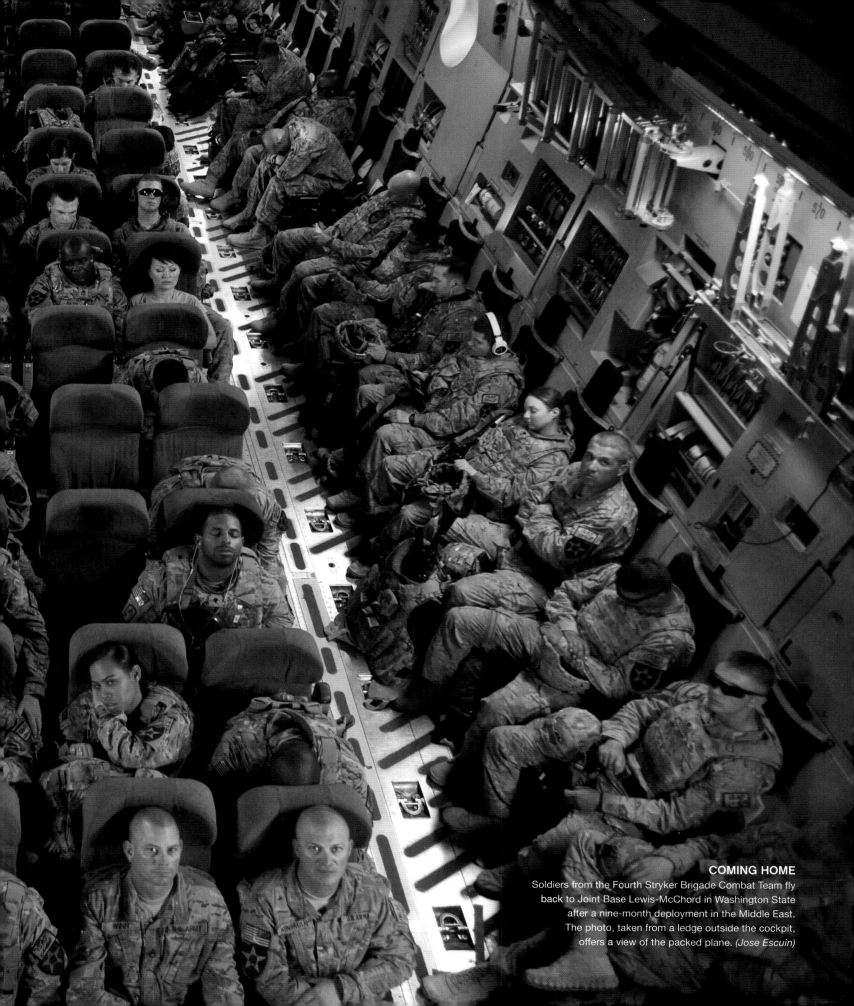

COMING HOME
Soldiers from the Fourth Stryker Brigade Combat Team fly back to Joint Base Lewis-McChord in Washington State after a nine-month deployment in the Middle East. The photo, taken from a ledge outside the cockpit, offers a view of the packed plane. *(Jose Escuin)*

"An hour into a flight in July 2011, the pilot mentioned we could possibly see the space shuttle *Atlantis* on its final takeoff. About a half hour before we landed, we passed over Cape Canaveral. Suddenly we saw the shuttle shoot up through the clouds and within a few seconds fly out of sight. The plane erupted in applause. Everyone shared an incredible feeling of excitement and wonder as the last people to see the final shuttle launch. It was truly a one-in-a-million chance."

RYAN GRAFF

OPPOSITE: **SHUTTLE ATLANTIS LAUNCH**
The trail of the space shuttle *Atlantis* (STS-135) punctures the clouds above
Cape Canaveral on its final flight in July 2011. *(Ryan Graff, Florida)*

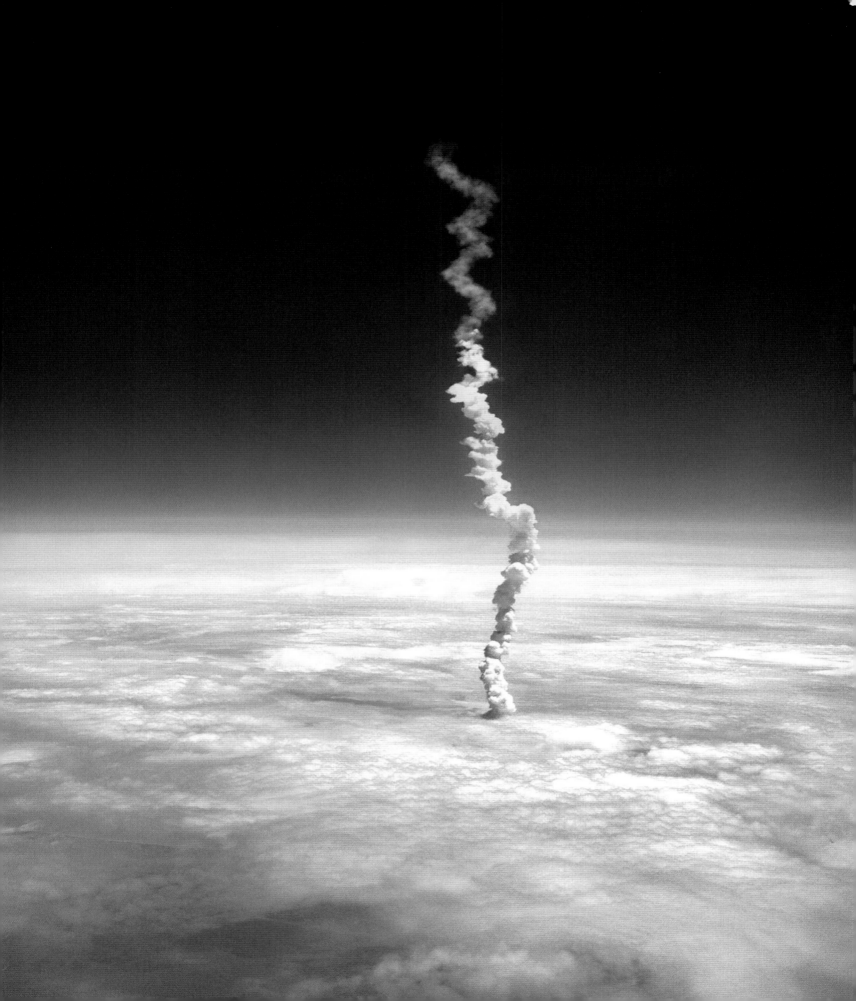

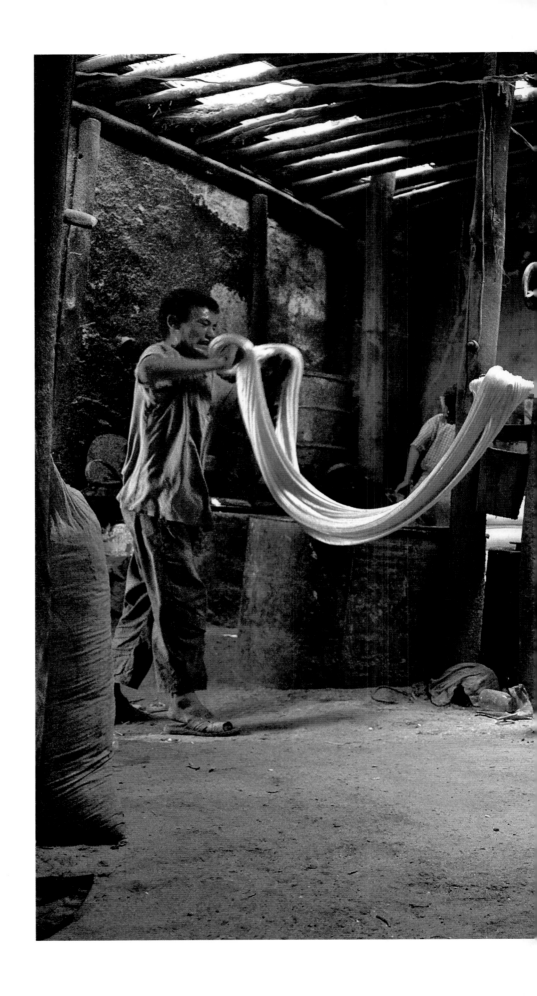

CANDY MAKERS

Human muscle turns ropes of sugar paste into hard candy in Kabul, Afghanistan. In 2007, when this image was made, the future of the Hazaras— an ethnic group considered heretics by the Sunni majority—seemed uncertain. Today, that still remains the case. *(Steve McCurry, Afghanistan)*

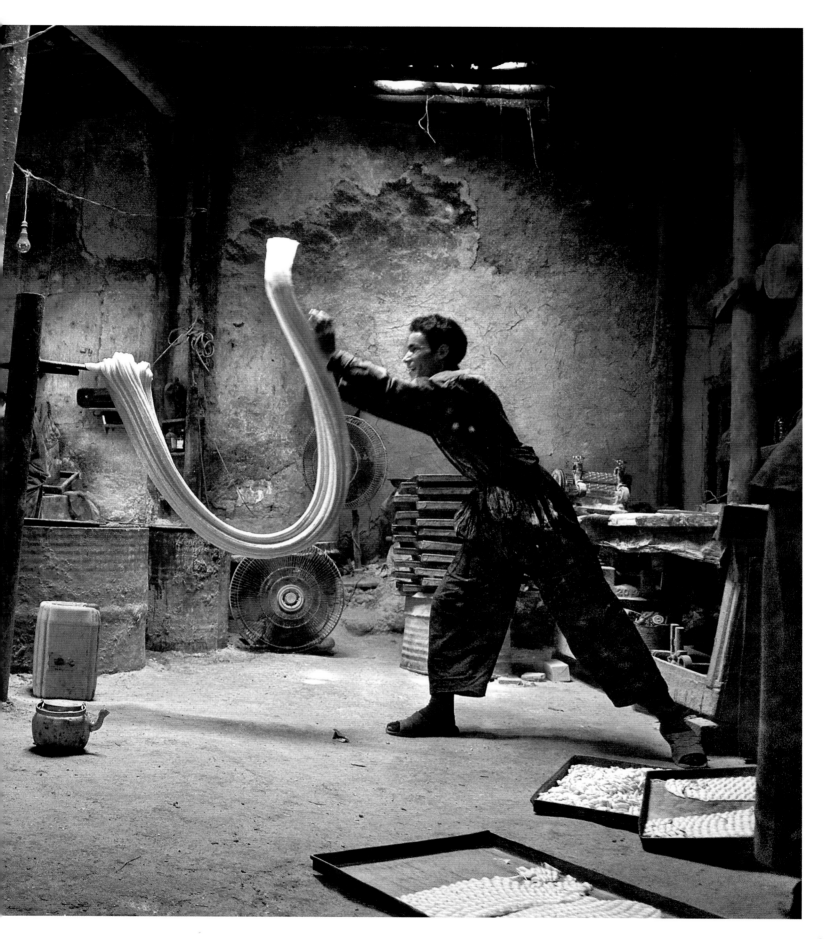

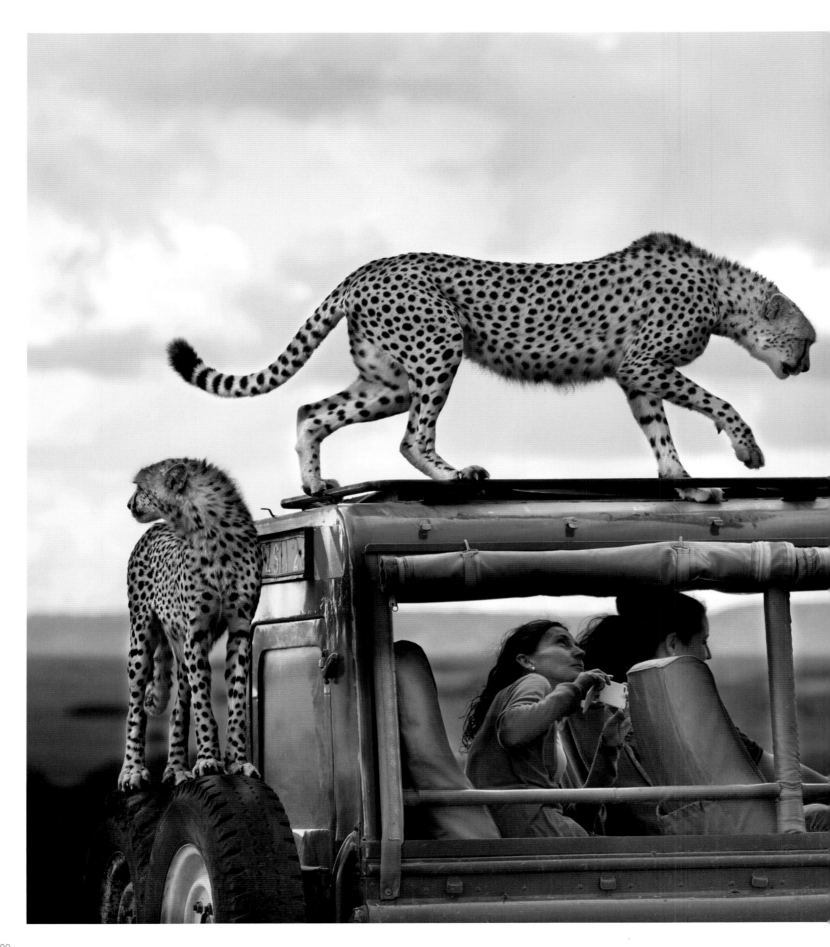

SPOTTED TOUR GUIDES
Cheetahs offer an up close and personal view to visitors at Kenya's Masai Mara National Reserve. It's unusual to get so close to these stealthy hunters, who appear as curious as the tourists. Habitat loss, fragmentation, and hunting for pelts threaten these magnificent cats. *(Yanai Bonneh, Kenya)*

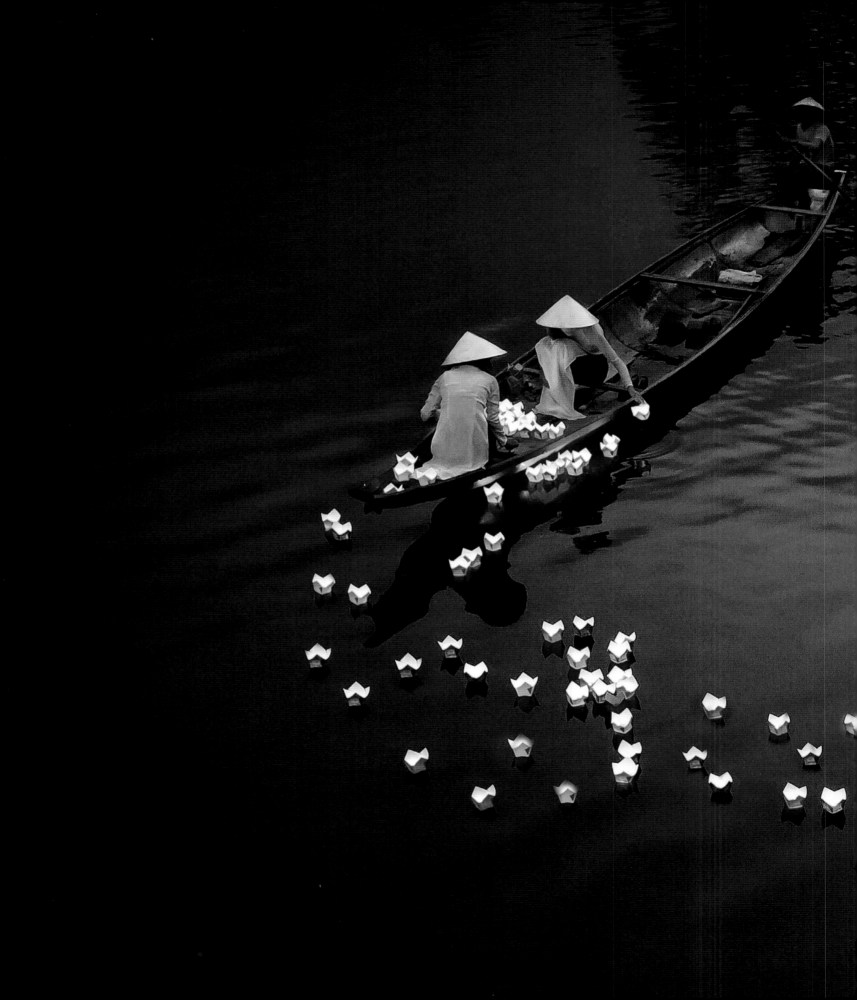

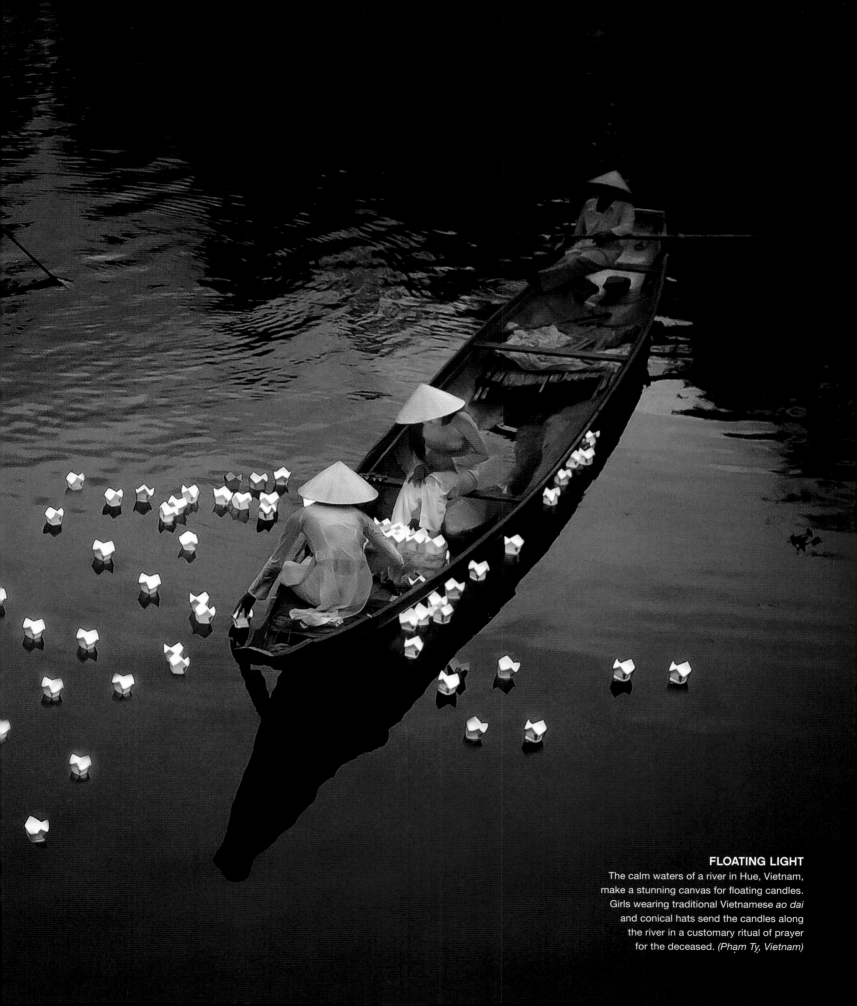

FLOATING LIGHT
The calm waters of a river in Hue, Vietnam,
make a stunning canvas for floating candles.
Girls wearing traditional Vietnamese *ao dai*
and conical hats send the candles along
the river in a customary ritual of prayer
for the deceased. *(Phạm Ty, Vietnam)*

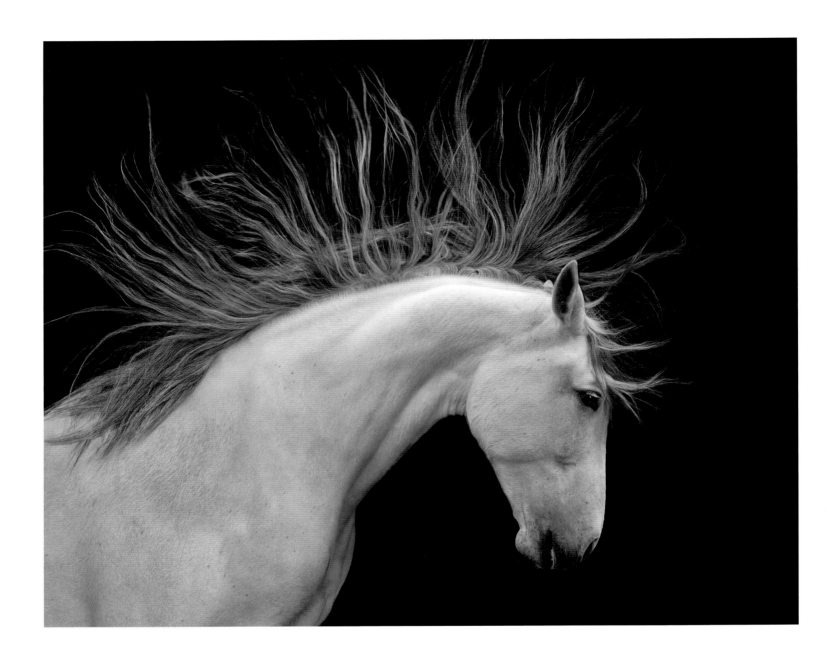

HE WHIPS HIS MANE

The mane of an Andalusian horse fans out in stunning symmetry. The Iberian breed, bred throughout generations, is known for its agility and majesty. *(Art Wolfe, Washington)*

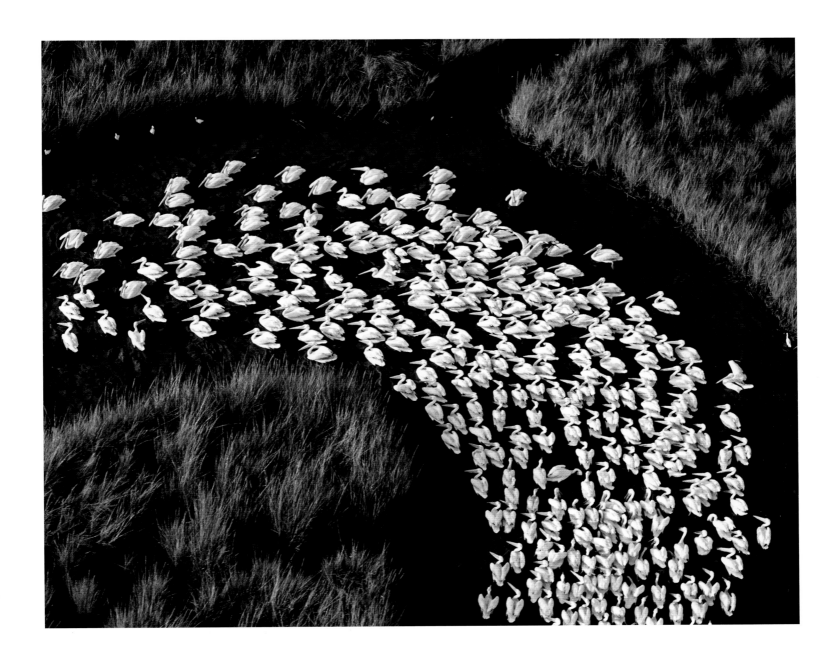

PELICAN CURVE

A floating group of white pelicans curve along a stream to feed in the waters of the Mississippi Delta. One of the largest birds in North America, they use their pouched bills to scoop up fish. *(Annie Griffiths, Mississippi)*

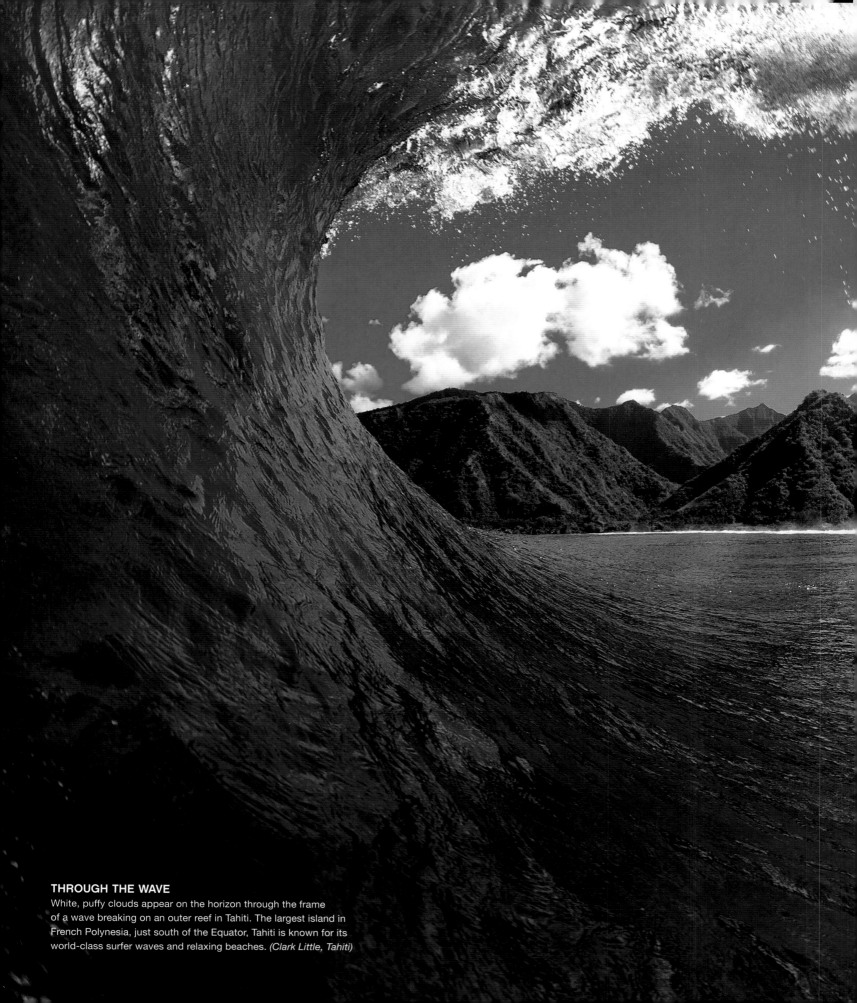

THROUGH THE WAVE
White, puffy clouds appear on the horizon through the frame of a wave breaking on an outer reef in Tahiti. The largest island in French Polynesia, just south of the Equator, Tahiti is known for its world-class surfer waves and relaxing beaches. *(Clark Little, Tahiti)*

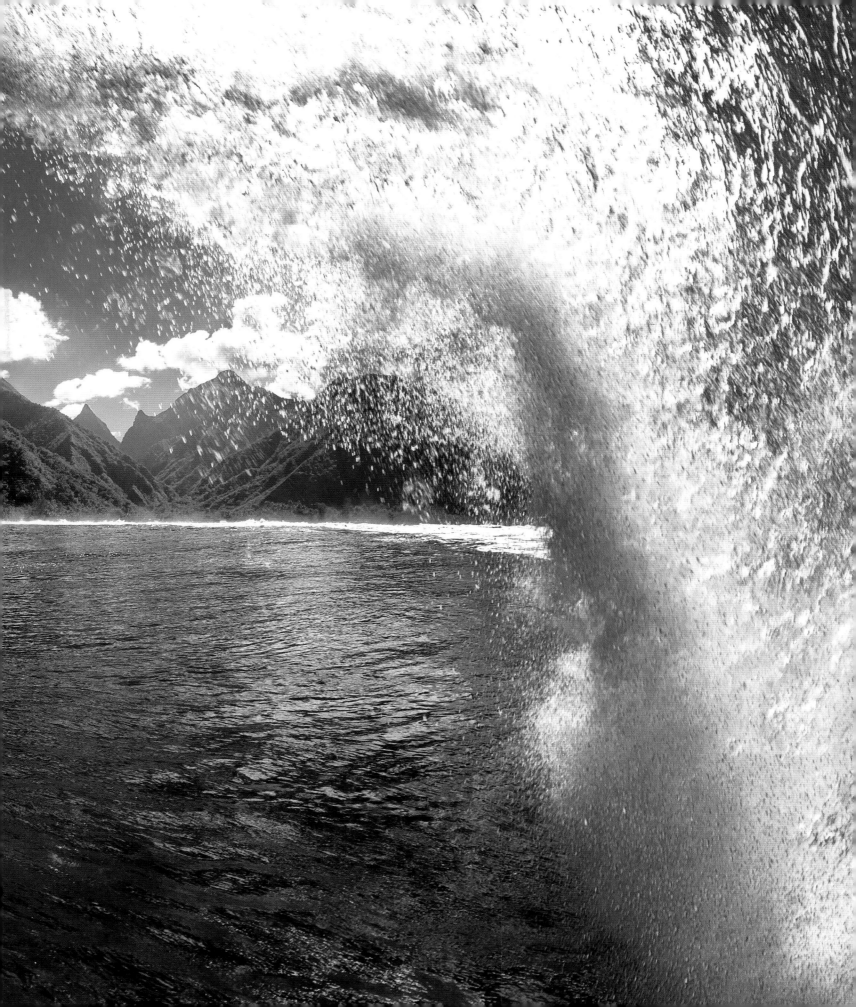

ADDITIONAL CREDITS

Cover, Alamy; 2-3, 500px Prime; 4, 500px Prime; 6-7, National Geographic Creative; 8-9, Getty Images; 10-11, National Geographic Creative; 14-5, National Geographic Your Shot; 18-9, National Geographic Creative; 26, National Geographic Creative; 27, National Geographic Your Shot; 28-9, ADDIE studio; 30, National Geographic Your Shot; 32-3, HougaardMalan.com; 34-5, Corbis; 36, Alamy; 37, with B. Babcock, W. Carlos, S. Martin, D. Seaton/Science Faction/Corbis; 38-9, Speleoresearch & Films/National Geographic Creative; 41, Rex Features via AP Images; 42, National Geographic Creative; 43, NHPA/Photoshot; 44-5, GuyTal.com; 46-7, National Geographic Your Shot; 50, National Geographic Creative; 51, Panos Pictures; 52-3, www.mrietze.com; 54-5, National Geographic Creative; 59, Alamy; 61, Panos Pictures; 62-3, Getty Images; 64, Getty Images; 70-71, National Geographic Creative; 72-3, Getty Images; 75, Alamy; 78-9, Corbis; 80-81, Aurora Photos; 82, Stringer/Getty Images; 84-5, 500px Prime; 86-7, PA Images; 89, www.artwolfe.com; 90-91, AP Photo; 96-7, Getty Images; 98, Getty Images; 99, Minden Pictures/National Geographic Creative; 100-101, www.lukas-gawenda.de; 102, 500px Prime; 108, Getty Images; 110-11, National Geographic Creative; 113, National Geographic Creative; 114, Magnum Photos; 115, AP Images; 116-17, National Geographic Creative; 118-19, TandemStock.com; 122, heidihanskoch.com; 123, 500px Prime; 124-5, Getty Images; 126-7, Corbis; 129, National Geographic Creative; 130-131, NPL/Minden Pictures; 133, Minden Pictures; 134-5, Getty Images; 136-7, naturepl.com; 144-5, Panos Pictures; 146-7, National Geographic Your Shot; 148, National Geographic Creative; 149, National Geographic Creative; 150-151, Getty Images; 154-5, National Geographic Creative; 156, STR/AFP/Getty Images; 157, National Geographic Your Shot; 160-161, National Geographic Creative; 162, Minden Pictures; 164-5, www.artwolfe.com; 168-9, Minden Pictures/Corbis; 174, Science Source; 176-7, National Geographic Creative; 180, 500px Prime; 186-7, JAI/Corbis; 190-191, Caters News Agency; 192-3, National Geographic Creative; 194, Panos Pictures; 195, Panos Pictures; 196-7, National Geographic Creative; 199, 500px Prime; 200, National Geographic Creative; 204-205, National

NATIONAL GEOGRAPHIC RARELY SEEN
PHOTOGRAPHS OF THE EXTRAORDINARY

SUSAN TYLER HITCHCOCK

PREPARED BY THE BOOK DIVISION

Hector Sierra, *Senior Vice President and General Manager*

Lisa Thomas, *Senior Vice President and Editorial Director*

Jonathan Halling, *Creative Director*

Marianne R. Koszorus, *Design Director*

Hilary Black, *Senior Editor*

R. Gary Colbert, *Production Director*

Jennifer A. Thornton, *Director of Managing Editorial*

Susan S. Blair, *Director of Photography*

Meredith C. Wilcox, *Director, Administration and Rights Clearance*

STAFF FOR THIS BOOK

Allyson Dickman, *Associate Editor*

Anne Smyth, *Associate Editor*

Melissa Farris, *Art Director*

Laura Lakeway, *Photo Editor*

Michelle Harris, *Researcher, Caption Writer*

Patrick J. Bagley, *Photo Assistant*

Marshall Kiker, *Associate Managing Editor*

Judith Klein, *Senior Production Editor*

Constance Roellig, Rock Wheeler, *Rights Clearance Specialists*

Lisa A. Walker, *Production Manager*

Katie Olsen, *Design Production Specialist*

Nicole Miller, *Design Production Assistant*

Rachel Faulise, *Manager, Production Services*

Neal Edwards, *Imaging*

Since 1888, the National Geographic Society has funded more than 12,000 research, exploration, and preservation projects around the world. National Geographic Partners distributes a portion of the funds it receives from your purchase to National Geographic Society to support programs including the conservation of animals and their habitats.

National Geographic Partners
1145 17th Street NW
Washington, DC 20036-4688 USA

Get closer to National Geographic explorers and photographers, and connect with our global community. Join us today at nationalgeographic.com/join

For information about special discounts for bulk purchases, please contact National Geographic Books Special Sales: specialsales@natgeo.com

For rights or permissions inquiries, please contact National Geographic Books Subsidiary Rights: bookrights@natgeo.com

ISBN: 978-1-4262-1561-2

Printed in China

18/PPS/5